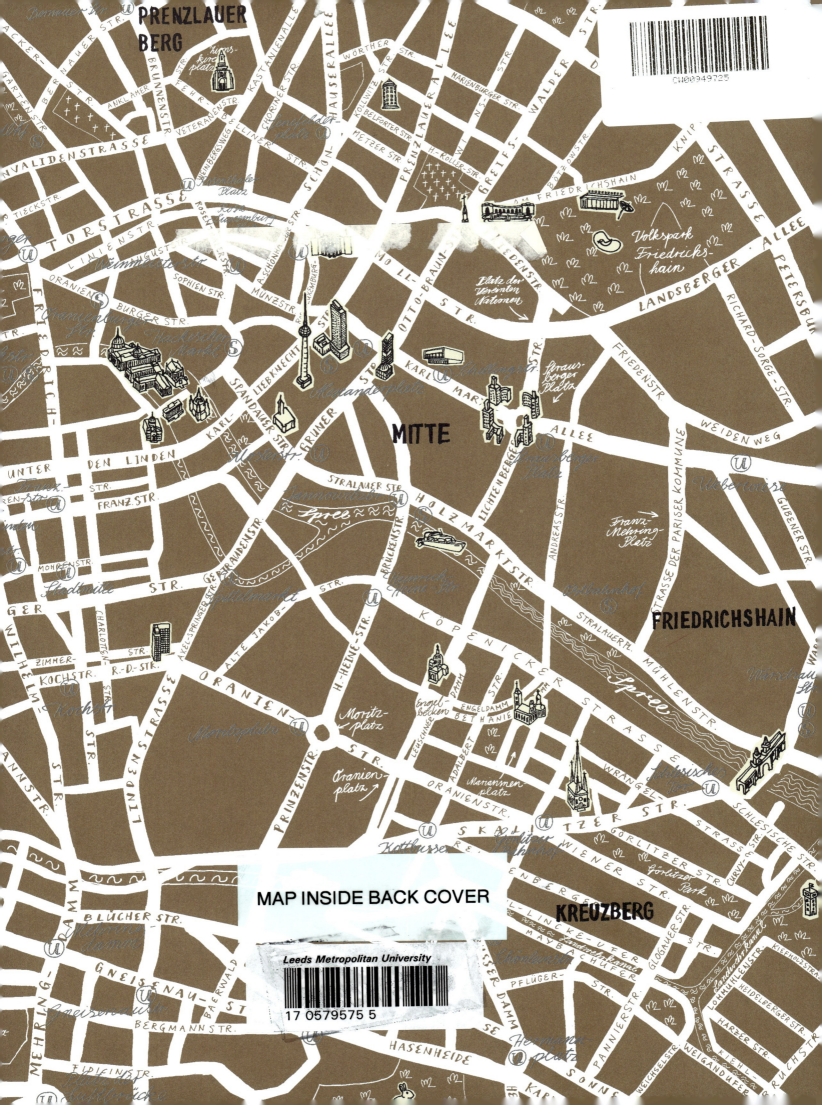

TASCHEN's Berlin
Hotels, Restaurants & Shops

Photos Thorsten Klapsch

TASCHEN's Berlin
Hotels, Restaurants & Shops

Angelika Taschen

TASCHEN

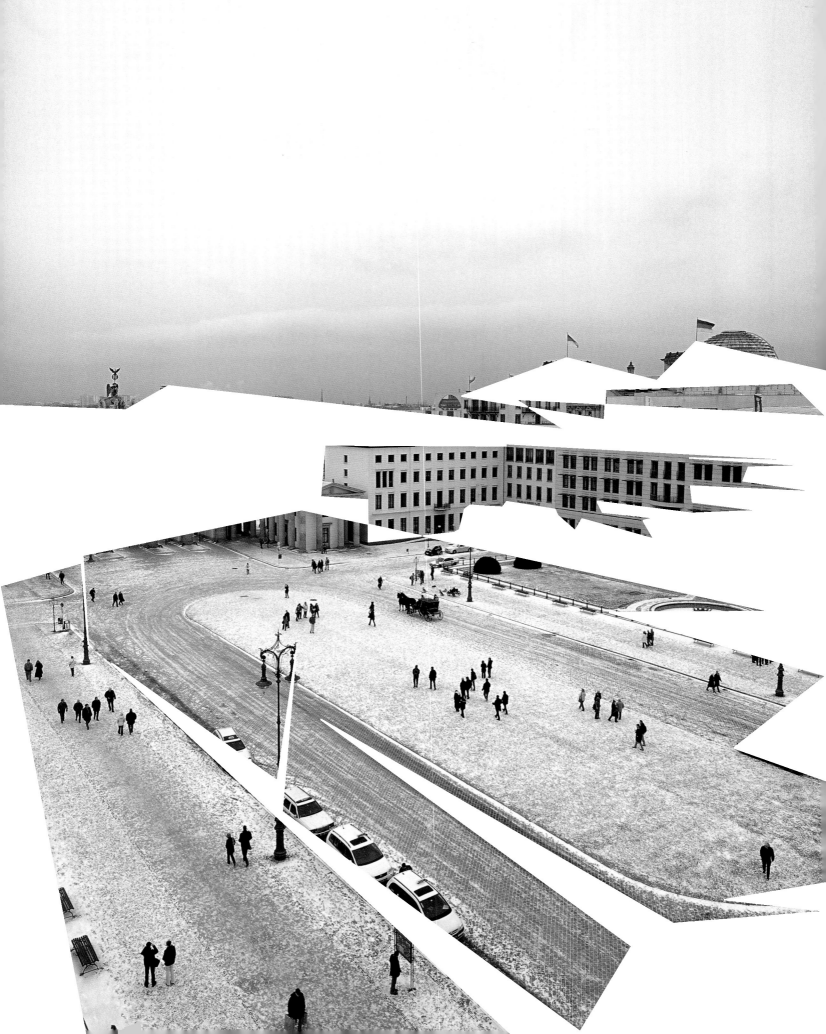

Hotels

8	Preface/Vorwort/Préface Angelika Taschen	94 100 106 112	Hotel de Rome Park Inn Alexanderplatz Lux 11 Honigmond
	Charlottenburg		
16	Askanischer Hof		Prenzlauer Berg
24	Casa Hotel	118	Ackselhaus
30	Hotel Q!		
38	Savoy		Kreuzberg
44	Pension Funk	124	Die Fabrik
52	Nürnberger Eck		
62	Ellington Hotel Berlin		Friedrichshain
		130	Eastern Comfort Hostelboat
	Tiergarten \| Mitte		
68	Grand Hyatt Berlin		Grunewald
74	The Regent Berlin	138	Schlosshotel im Grunewald
82	Clipper City Home		
88	Hotel Adlon		

Price categories (usually including breakfast):
€ up to 75
€€ 75–150
€€€ 150–250
€€€€ from 250

Preiskategorien (meist inklusive Frühstück):
€ bis 75
€€ 75–150
€€€ 150–250
€€€€ ab 250

Catégories de prix (petit déjeuner inclus le plus souvent) :
€ jusqu'à 75
€€ de 75 à 150
€€€ de 150 à 250
€€€€ à partir de 250

Restaurants

Charlottenburg | Wilmersdorf Schöneberg
- 150 Times Bar
- 152 Paris Bar
- 156 Diener Tattersall
- 160 Adnan
- 162 Café im Literaturhaus
- 166 Rum Trader
- 170 Galerie Bremer
- 172 Manzini
- 176 Big Window
- 180 Green Door
- 184 Café Einstein

Kreuzberg
- 192 Henne
- 198 Hasir
- 202 Ankerklause

Tiergarten | Mitte
- 208 Victoria Bar
- 212 Edd's
- 216 Kumpelnest 3000
- 220 Vox Bar
- 222 Zur letzten Instanz
- 224 Borchardt
- 228 Grill Royal
- 232 Dolores
- 236 Barcomi's Deli
- 240 Greenwich
- 244 Clärchens Ballhaus

Prenzlauer Berg
- 250 Galão A Pastelaria
- 252 Der Imbiss W
- 256 Prater Garten
- 262 Konnopke's Imbiß
- 264 Si An
- 266 Wohnzimmer

Friedrichshain
- 272 Restaurant Schönbrunn
- 276 CSA Bar
- 280 Miseria e Nobiltà
- 284 Schneeweiß

Shops

	Charlottenburg	Wilmersdorf	350	Andreas Murkudis
294	Jil Sander		354	Adidas Originals Store
296	Chocolatier Erich Hamann		356	Lebensmittel in Mitte
300	Manufactum		358	Blush & Balls
302	Bücherbogen am Savignyplatz		362	Buffalo
306	Emma & Co.		366	Bless Shop
310	Galerie Hans-Peter Jochum		370	R.S.V.P. Papier in Mitte
312	Steiff		374	Erzgebirgskunst Original
314	Harry Lehmann		376	Thomas Wild Teppich- & Textilkunst
	Kreuzberg		378	Jünemann's Pantoffeleck
318	Paul Knopf			
322	DIM			Prenzlauer Berg
			382	Wochenmarkt am Kollwitzplatz
	Mitte			
326	TASCHEN		386	in't Veld Schokoladen
330	Departmentstore Quartier 206		390	Santi & Spiriti
334	Fundusverkauf			Grunewald
338	KPM		394	Villa Harteneck
340	The Corner Berlin			
344	1. Absinth Depot Berlin		398	Index
348	Schönhauser Design		400	Imprint/Impressum/Imprint

Preface | Vorwort | Préface

No city in the world is like Berlin. It was the seat of the German Empire, scene of the legendary Golden Twenties, the headquarters of Hitler's Third Reich, a wasteland of ruins after the Second World War that was rebuilt by the so-called "rubble women", then partitioned by the Wall and paralysed for decades as a divided city, the pawn of the superpowers USA and USSR. It saw the fall of the Wall in 1989 and reunification in 1990 with its complicated and costly consequences. Now Berlin is the capital of a united Germany. That's a lot of history for only one century!

Today Berlin is bankrupt, and money no longer rules the scene. Berlin's movers and shakers are the people with ideas and ideals. Hundreds of artists and creative spirits are moving to the city, attracted by reasonable rents and the high quality of life. They also come because it is inspiring to see and feel the scars of history everywhere. Villas of the haute bourgeoisie on the waterside, socialist prefabricated concrete blocks of flats, avant-garde Bauhaus workers' estates: you'll find just about everything here.

Each neighbourhood has its own character, be it Charlottenburg, Kreuzberg, Mitte, Prenzlauer Berg, Friedrichshain or Zehlendorf. Western districts like Charlottenburg and Wilmersdorf have changed very little since 1989, but eastern districts like Berlin-Mitte and Prenzlauer Berg have seen a radical transformation. The crowning glory of Berlin-Mitte is the Museum Island, where you'll find the Neues Museum (New Museum), Pergamon Museum, the Alte Nationalgalerie (Old National

Berlin ist mit keiner anderen Hauptstadt der Welt zu vergleichen: Die Stadt war Regierungssitz des deutschen Kaiserreiches, Schauplatz der legendären Goldenen Zwanziger, Befehlszentrum des Dritten Reiches, Ruinenwüste am Ende des Zweiten Weltkriegs, sie wurde durch die sogenannten Trümmerfrauen wieder aufgebaut, durch den Bau der Mauer getrennt, Jahrzehnte als geteilte Stadt paralysiert und zum Spielball der Supermächte USA und UdSSR, erlebte 1989 den Mauerfall sowie 1990 die Wiedervereinigung, muss die ebenso komplizierten wie kostspieligen Folgen tragen und ist jetzt Hauptstadt des vereinigten Deutschlands – und dies alles in einem einzigen Jahrhundert!

Heute ist Berlin pleite, und es regiert meist nicht das Geld, sondern Menschen mit Ideen und Idealen. Künstler und Kreative ziehen zu Hunderten in die Stadt, weil die Mieten günstig sind und die Lebensqualität hoch und weil es inspirierend ist, allerorten die Narben der Geschichte zu sehen und zu spüren. Großbürgerliche Villen am Wasser, realsozialistischer Plattenbau, avantgardistische Arbeitersiedlungen des Bauhauses: Es gibt nichts, was es nicht gibt.

Jeder Kiez hat seinen spezifischen Flair, ob Charlottenburg, Kreuzberg, Mitte, Prenzlauer Berg, Friedrichshain oder Zehlendorf. Westbezirke wie Charlottenburg oder Wilmersdorf haben sich seit 1989 kaum verändert, Ostbezirke wie Mitte und Prenzlauer Berg dagegen radikal. Die Krönung der neuen Berliner Mitte ist die weltweit einzigartige Museumsinsel mit dem Neuen Museum, Pergamon-

Berlin n'est comparable à aucune autre capitale au monde : siège du pouvoir de l'Empire allemand, au cœur des légendaires années 1920, centre de commandement du Troisième Reich d'Hitler, désert de ruines à la fin de la Seconde Guerre mondiale, reconstruite par les fameuses « femmes des ruines », témoin de la construction du Mur, paralysée pendant des décennies à cause du partage de la ville et jouet des superpuissances USA et URSS, elle a vu la chute du Mur en 1989, en 1990 la réunification avec ses conséquences aussi compliquées que coûteuses et est désormais capitale d'une Allemagne réunifiée – et ce, en l'espace d'un siècle !

De nos jours, Berlin fait face à de grosses difficultés financières. Toutefois, le plus souvent ce n'est pas l'argent qui gouverne, mais des hommes ayant des idées et des idéaux. Ils sont des centaines d'artistes et de créatifs à s'installer ici parce que les loyers sont intéressants et que la qualité de vie est élevée. Et puis quelle source d'inspiration que de voir et ressentir partout les cicatrices de l'histoire ! De grandes villas bourgeoises au bord de l'eau, des immeubles en béton socialistes, des cités ouvrières avant-gardistes du Bauhaus : il y a de tout.

Charlottenbourg, Kreuzberg, Mitte, Prenzlauer Berg, Friedrichshain ou Zehlendorf – chaque quartier a son charme. Des districts situés à l'ouest comme Charlottenbourg ou Willmersdorf n'ont pas beaucoup changé depuis 1989, alors que la transformation est radicale dans les districts situés à l'est comme Mitte et Prenzlauer Berg. La cerise sur le gâteau de ce nouveau

llery), the Bode Museum and the Antikenmuseum (Museum of Antiquities), all superbly refurbished. A very special treat! The stately boulevard Unter den Linden is pure Prussian glamour, and leads to the Brandenburg Gate, which along with the Television Tower is Berlin's landmark (a pretty remarkable pairing, by the way!). The most upmarket restaurants and shopping street in the city are just around the corner, at Gendarmenmarkt and Friedrichstraße. Not far away you can search hip boutiques for the Berlin look, as well as discover unusual shops, specialising in everything from absinthe to figures from the Erzgebirge.
This book helps you to find your way in this city of endless variety, and also serves as a compact guide to the best of Berlin, complete with addresses and short descriptions of all our favourite places. It reveals the essence of the place, the typical, unique Berlin flavour. Berlin changes so fast that it is a good idea to check on the spot about what's "in" at the moment. That is the beauty of Berlin. As the city is in a constant state of flux, it can never be boring. And that's why you can, or rather you should, visit Berlin time and again.

Auf Wiedersehen!

museum, Alter Nationalgalerie, Bode- und Antikenmuseum – alles aufs Wunderbarste renoviert. Ein Hochgenuss! Die Prachtallee Unter den Linden ist preußisch glamourös und führt zum Brandenburger Tor, neben dem Fernsehturm das Wahrzeichen Berlins (eine denkwürdige Mischung übrigens). Die glamourösesten Restaurants und die wichtigste Einkaufsmeile der Stadt liegen um die Ecke am Gendarmenmarkt und an der Friedrichstraße. Unweit davon findet man hippe Boutiquen für den Berliner Look und originelle Läden, die zum Beispiel auf Absinth oder Figuren aus dem Erzgebirge spezialisiert sind. Dieses Buch hilft Ihnen, sich in dem uferlosen Angebot der Stadt zurechtzufinden, und beschreibt in kompakter Form die besten Adressen, die Berlin zu bieten hat. Es zeigt die Essenz der Stadt, das typische, einzigartige Berliner Flair. Zuweilen verändert sich das Angebot so rasant, dass es empfehlenswert sein kann, sich vor Ort zu erkundigen, was gerade angesagt ist. Das ist das Schöne an Berlin: Die Stadt wandelt sich permanent und wird daher nie langweilig. Deshalb kann, nein, sollte man immer wieder kommen.

Auf Wiedersehen!

Berlin-Mitte est l'île des musées, unique au monde, avec le Nouveau musée, le musée Pergame, l'Ancienne Galerie Nationale, le musée Bode et le musée des Antiquités – merveilleusement restaurés. Un vrai bonheur ! Le majestueux boulevard Unter den Linden, où bat encore le cœur de la capitale prussienne, mène à la porte de Brandebourg, à côté de la Tour de télévision emblématique (un curieux mélange d'ailleurs). Les restaurants les plus glamour et la plus grande rue commerçante de la ville se trouvent au coin du Gendarmenmarkt et de la Friedrichstraße. Non loin de là, on trouve des boutiques tendance permettant d'adopter le look berlinois et des magasins atypiques, spécialisés par exemple dans l'absinthe ou les figurines du Erzgebirge.
Cet ouvrage vous aide à vous repérer dans cette ville aux multiples tentations et vous décrit sous forme compacte les meilleures adresses. Son objectif est de vous montrer ce qui fait la nature unique de Berlin.
Quelquefois, l'offre change si rapidement qu'il est recommandé de s'informer sur place de ce qui est tendance. Mais c'est l'un des atouts majeurs de Berlin : la ville en constante évolution n'est jamais ennuyeuse. C'est pourquoi on peut, non, on doit toujours y revenir.

Auf Wiedersehen!

Angelika Taschen

Hotels

	Charlottenburg	100	Park Inn Alexanderplatz	
16	Askanischer Hof	106	Lux 11	
24	Casa Hotel	112	Honigmond	
30	Hotel Q!			
38	Savoy		Prenzlauer Berg	
44	Pension Funk	118	Ackselhaus	
52	Nürnberger Eck			
62	Ellington Hotel Berlin		Kreuzberg	
		124	Die Fabrik	
	Tiergarten	Mitte		Friedrichshain
68	Grand Hyatt Berlin	130	Eastern Comfort Hostelboat	
74	The Regent Berlin			
82	Clipper City Home		Grunewald	
88	Hotel Adlon	138	Schlosshotel im Grunewald	
94	Hotel de Rome			

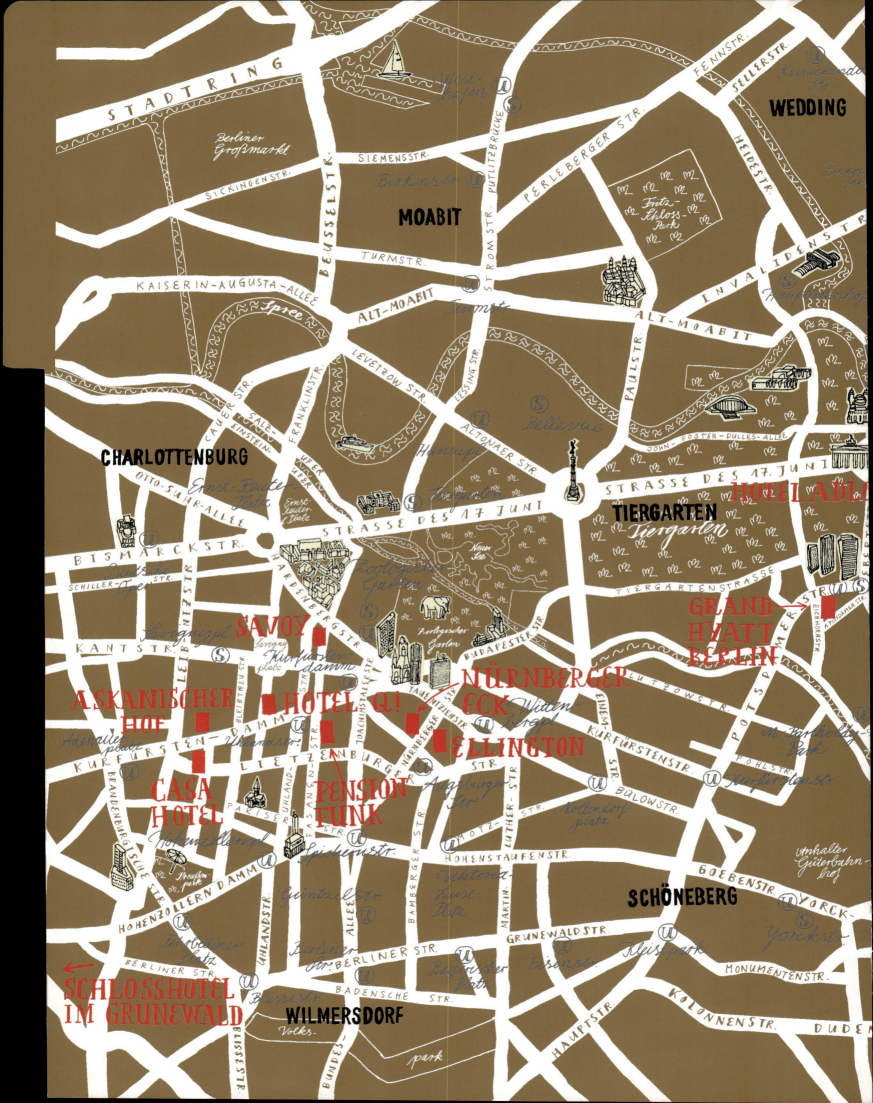

Hotels

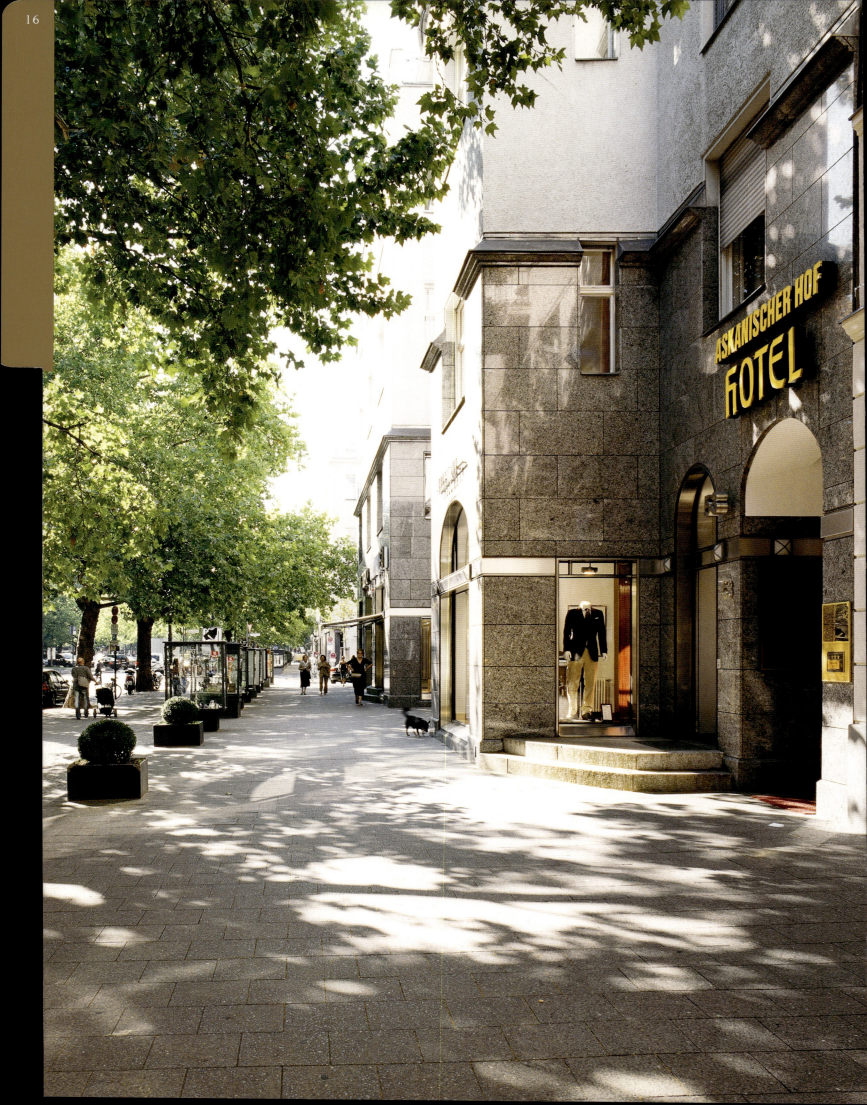

Askanischer Hof

Kurfürstendamm 53, 10707 Berlin
☎ +49 30 8 81 80 33/34 📠 +49 30 8 81 72 06
info@askanischer-hof.de
www.askanischer-hof.de
Ⓢ Savignyplatz Ⓤ Adenauerplatz

This delightful hotel opened on elegant Kurfürstendamm in the 1930s, and it rapidly became one of the most popular residences of the great UFA stars. Berlin was the film capital of the world at the time. Today, autographed movie-star pictures still decorate the walls of the breakfast room, which has been kept in its original style. The stars of yesteryear have been joined by other famous guests, like David Bowie, Arthur Miller, Robert Wilson, Michel Piccoli and Tilda Swinton. Stylish, cosy and friendly, the hotel is a magnet for artists. The atmosphere recalls the film "Cabaret" and Liza Minnelli, and has inspired photographers like Helmut Newton and Nan Goldin, who took some of their best-known photos here. Each one of the 16 rooms is individually furnished with pieces from the 1920s and 30s. The wallpaper, antiques, lamps and curtains are an encyclopaedia of German taste, a classic Berlin atmosphere. Plus, there's a sense of space found only in Berlin: high-corniced ceilings and huge rooms that are bigger than the suites in modern luxury hotels.

Price category: €€.
Rooms: 15 rooms, 1 suite.
Restaurant: The hotel serves an all-day breakfast in its breakfast room.
History: Started as Pension Continental in 1930, when a single room cost 3 Reichsmarks. It has had its present name since 1983.
X-Factor: The proprietor has good recommendations for plays and concerts, and will reserve tickets on request.

In den 1930ern wurde dieses wunderbare Hotel am eleganten Kurfürstendamm eröffnet. Das Haus avancierte schnell zu einem der beliebtesten Domizile der großen UFA-Stars. Damals war Berlin die Filmmetropole der Welt. Neben Autogrammkarten im original belassenen Frühstücksraum hängen signierte Fotos berühmter Gäste wie David Bowie, Arthur Miller, Robert Wilson, Michel Piccoli und Tilda Swinton. Das Ambiente – man denke dabei an den Film „Cabaret" mit Liza Minnelli – inspirierte Fotografen wie Helmut Newton und Nan Goldin, die hier einige ihrer berühmtesten Fotos machten. Jedes der 16 Zimmer ist individuell mit Möbeln aus den 1920ern und 1930ern eingerichtet. Das Arrangement von Tapeten, Antiquitäten, Lampen und Gardinen verdichtet deutschen Geschmack und schafft gekonnt eine typisch Berliner Atmosphäre. Dazu kommt ein Raumgefühl, das es so nur in Berlin gibt: hohe Decken mit Stuck und riesige Zimmer, deren Größe die Suiten in modernen Luxushotels übertreffen.

Preiskategorie: €€.
Zimmer: 15 Zimmer, 1 Suite.
Restaurant: Das Hotel Garni hat nur einen Frühstücksraum, in dem man zu jeder Tageszeit frühstücken kann.
Geschichte: 1930 eröffnete das Haus als Pension Continental (das Einzelzimmer kostete 3 Reichsmark). Seit 1983 trägt es den heutigen Namen.
X-Faktor: Die Besitzerin verrät Tipps für Theaterabende und reserviert auf Wunsch die Eintrittskarten.

Cet hôtel original et agréable a ouvert ses portes dans les années 1930 sur l'élégant Kurfürstendamm. Il est rapidement devenu l'une des adresses préférées des grandes stars des studios de cinéma UFA. Leurs autographes tapissent encore les murs de la salle où l'on sert les petits déjeuners, toujours en son état d'origine. À côté figurent les photographies signées d'hôtes célèbres tels que David Bowie, Arthur Miller, Robert Wilson, Michel Piccoli et Tilda Swinton. L'atmosphère rappelle le film « Cabaret » avec Liza Minnelli. Il a aussi inspiré des photographes comme Helmut Newton et Nan Goldin qui y ont réalisé quelques-unes de leurs plus célèbres prises de vues. Chacune des 16 chambres est meublée différemment dans le style des années 1920 et 1930. Les papiers peints, antiquités, lampes et rideaux créent une ambiance typiquement berlinoise, rehaussée par une impression d'espace qui n'existe ainsi qu'à Berlin : de hauts plafonds ornés de stuc et des chambres dont les dimensions rivalisent avec les suites des hôtels de luxe modernes.

Catégorie de prix : €€.
Chambres : 15 chambres, 1 suite.
Restauration : Petit déjeuner en salle à toute heure de la journée.
Histoire : Pension Continental à son ouverture en 1930, il porte son nom actuel depuis 1983.
Le « petit plus » : La propriétaire vous informe du programme des spectacles et réserve vos billets, si vous le souhaitez.

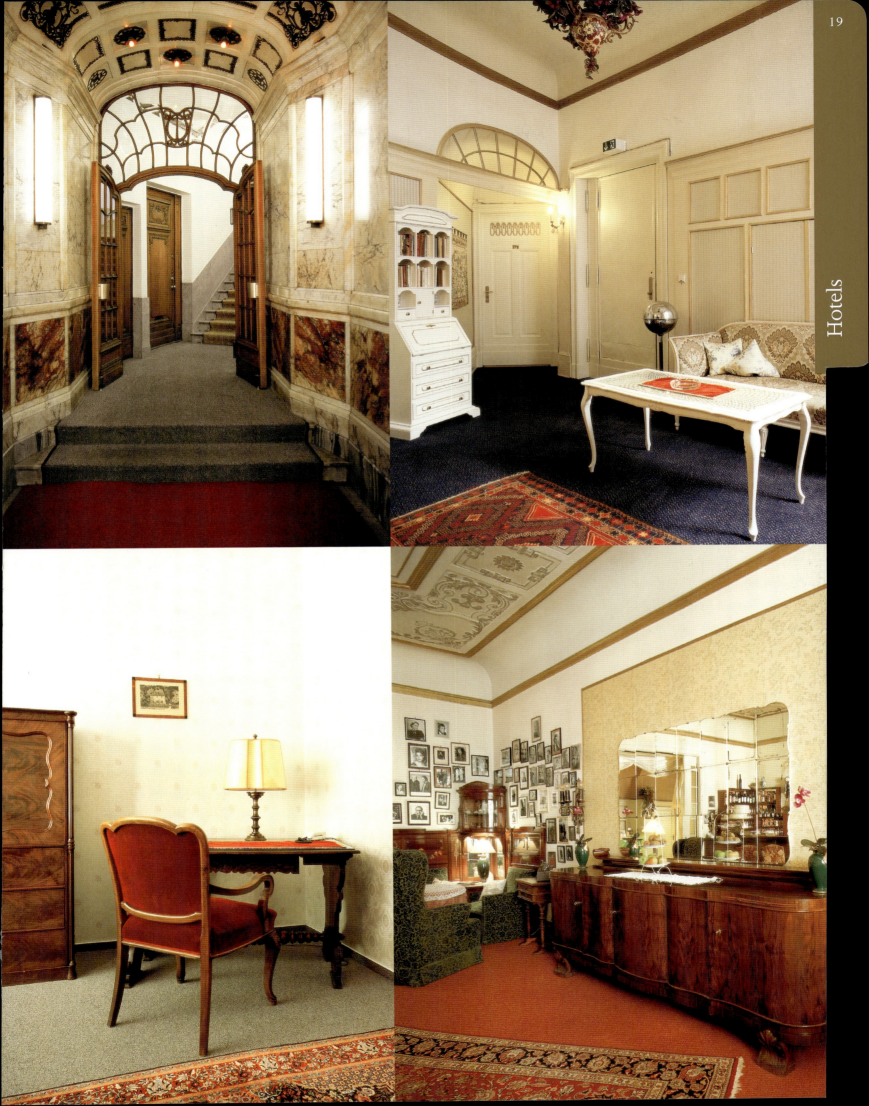

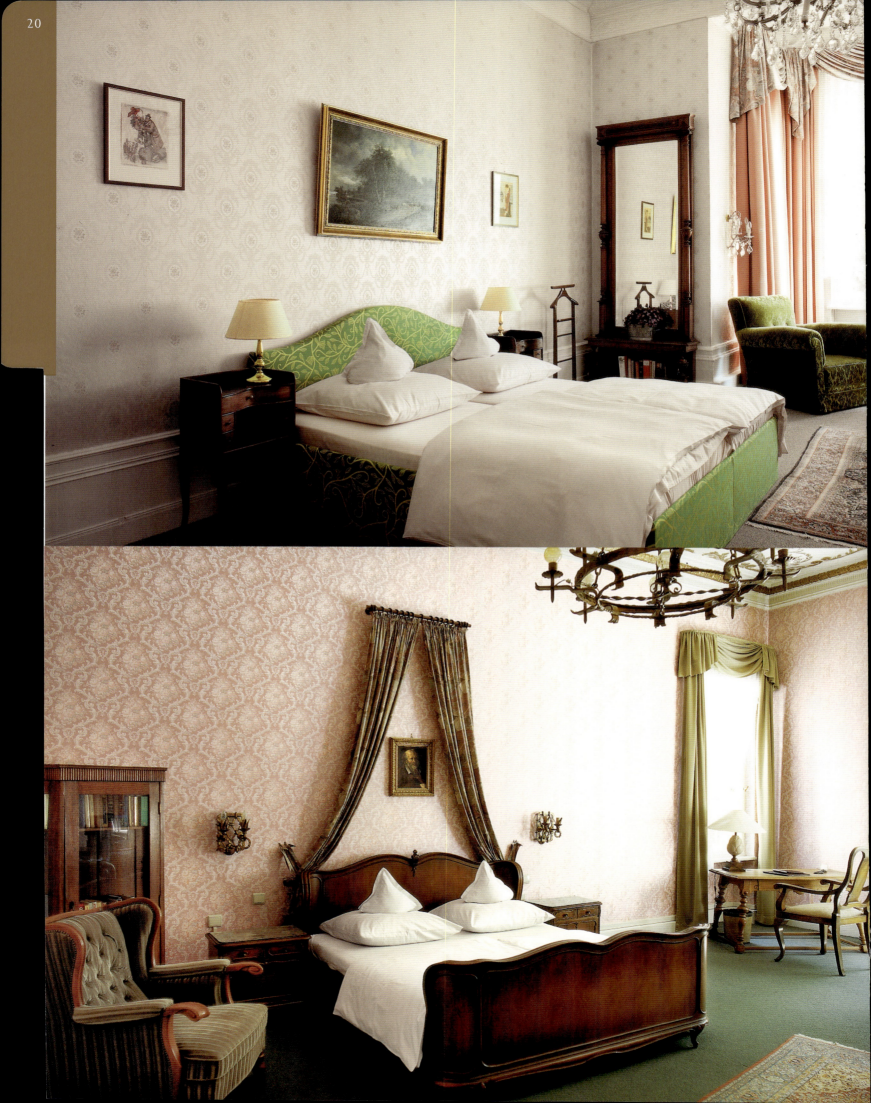

Hotels

Hotels

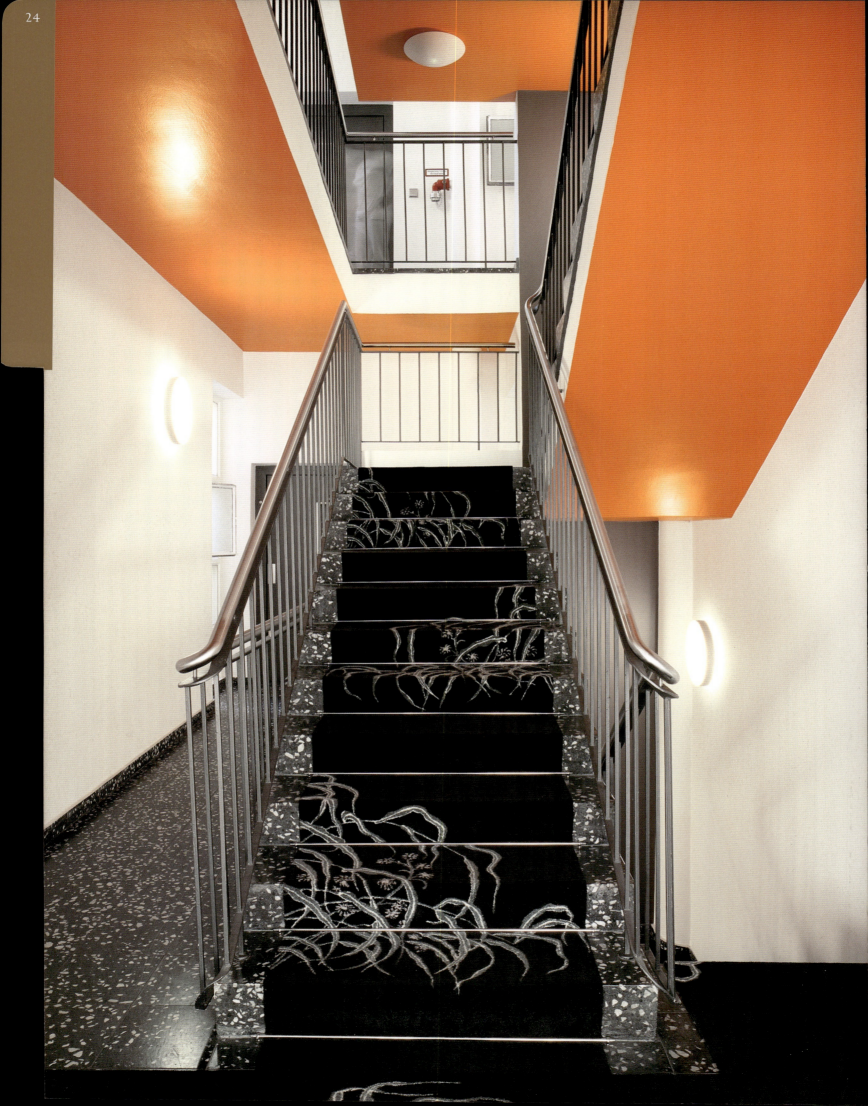

Casa Hotel

Schlüterstraße 40, 10707 Berlin
☎ +49 30 28 03 00-0 📠 +49 30 28 03 00-60
info@hotel-casa.de
www.hotel-casa.de
Ⓢ Savignyplatz Ⓤ Uhlandstraße, Adenauerplatz

On a peaceful side street, just a few steps away from Kurfürstendamm, there is a small but elegantly designed hotel that opened in 2005. The atmosphere is light, airy and feminine. White is the dominant colour, with just a few touches of orange. The 29 rooms are pleasantly quiet, comfortable and equipped with cutting-edge technology. The rooms on the first floor even have wooden floors. (Why do hotels love to carpet their rooms when wooden or Italian terrazzo floors are so much more attractive and hygienic?) The bathrooms, as well, have a contemporary and intelligent design, and are equipped with Philippe Starck fittings. Another point in its favour: the Casa's guests can enjoy breakfast until midday in a lounge bar with an Italian café. There is a phrase that I don't like to use but fits this hotel: the value-for-money ratio is absolutely spot on.

Price category: €€.
Rooms: 29 designer rooms.
Restaurant: Casa coffee & lounge (Italian café and cocktail bar). Breakfast is served until midday.
History: The former Hotel Ahorn was refurbished in February 2005 to become the modern and stylish Casa Hotel.
X-Factor: Interesting theme-package offers for short breaks (e.g. "Design in Berlin" and "Take me to the river").

In einer ruhigen, wenige Meter vom Kurfürstendamm entfernten Seitenstraße liegt ein kleines und feines Designhotel, das 2005 eröffnet wurde. Die Atmosphäre ist leicht, klar und feminin. Als Farbe dominiert Weiß mit ein paar orangenen Farbakzenten. Die 29 Zimmer sind angenehm ruhig und trotz des schlichten Designstils gemütlich und mit allem technischen Komfort ausgerüstet. In der ersten Etage haben die Zimmer sogar Holzböden (man fragt sich, warum weltweit in Hotels Teppichböden vorherrschen, wo doch Holz- oder italienische Terrazzoböden viel schöner und hygienischer sind). Auch die Badezimmer sind modern und intelligent konzipiert und mit Philippe-Starck-Armaturen ausgestattet. Ein weiterer Pluspunkt: Das Casa bietet seinen Gästen eine Lounge-Bar mit italienischem Café, wo man bis 12 Uhr entspannt frühstücken kann. Ein Satz, den ich sonst nicht besonders mag, trifft auf dieses Hotel zu: Das Preis-Leistungs-Verhältnis stimmt.

Preiskategorie: €€.
Zimmer: 29 Designerzimmer.
Restaurant: Casa coffee & lounge (italienisches Café und Cocktailbar). Frühstück wird bis 12 Uhr serviert.
Geschichte: Aus dem ehemaligen Hotel Ahorn wurde im Februar 2005 das modern gestaltete Casa Hotel.
X-Faktor: Interessante mehrtägige Themen-Packages (z. B. „Design in Berlin" und „Berlin zu Wasser").

Ce petit hôtel design raffiné, situé dans une rue tranquille à quelques mètres du Kurfürstendamm, a ouvert ses portes en 2005. Son décor crée une atmosphère légère, épurée et féminine. Le blanc y domine avec quelques touches d'orange. Les 29 chambres sont bien équipées et apportent ainsi tranquillité et confort malgré la simplicité de leur design. Au premier étage, les chambres sont même parquetées (on se demande bien pourquoi dans tous les hôtels du monde la moquette est reine, alors que le parquet ou les revêtements Terrazzo italiens sont bien plus jolis et surtout beaucoup plus hygiéniques). Les salles de bains modernes sont agencées de manière intelligente et équipées d'armatures Philippe Starck. Un avantage supplémentaire : le Casa offre à ses clients un bar lounge avec un café italien où l'on peut prendre son petit déjeuner jusqu'à midi. Même si je ne suis pas vraiment adepte de cette petite phrase, je dois avouer qu'elle convient tout à fait ici : un bon rapport qualité-prix.

Catégorie de prix : €€.
Chambres : 29 chambres design.
Restauration : Casa coffee & lounge (café italien et Cocktail-Bar). Le petit déjeuner est servi jusqu'à midi.
Histoire : L'ancien hôtel Ahorn est devenu en février 2005 le Casa moderne.
Le « petit plus » : Offres intéressantes à thèmes de plusieurs jours (par ex. le « Design à Berlin » et « Berlin sur l'eau »).

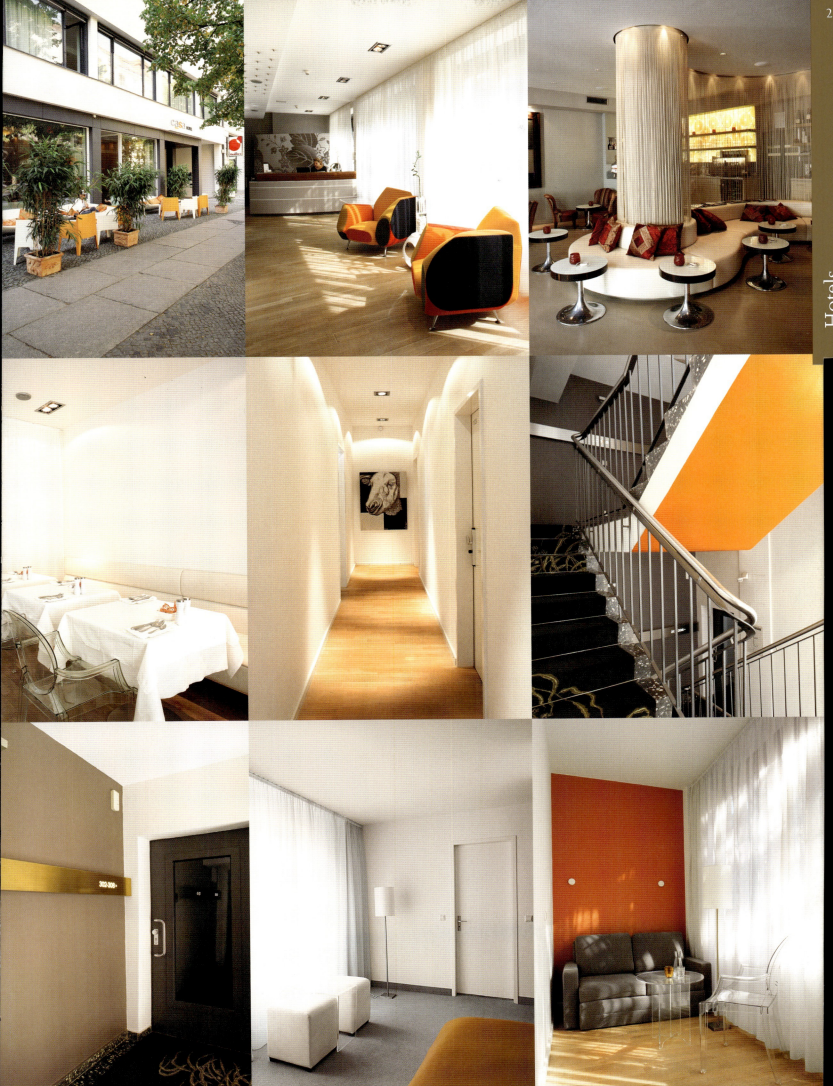

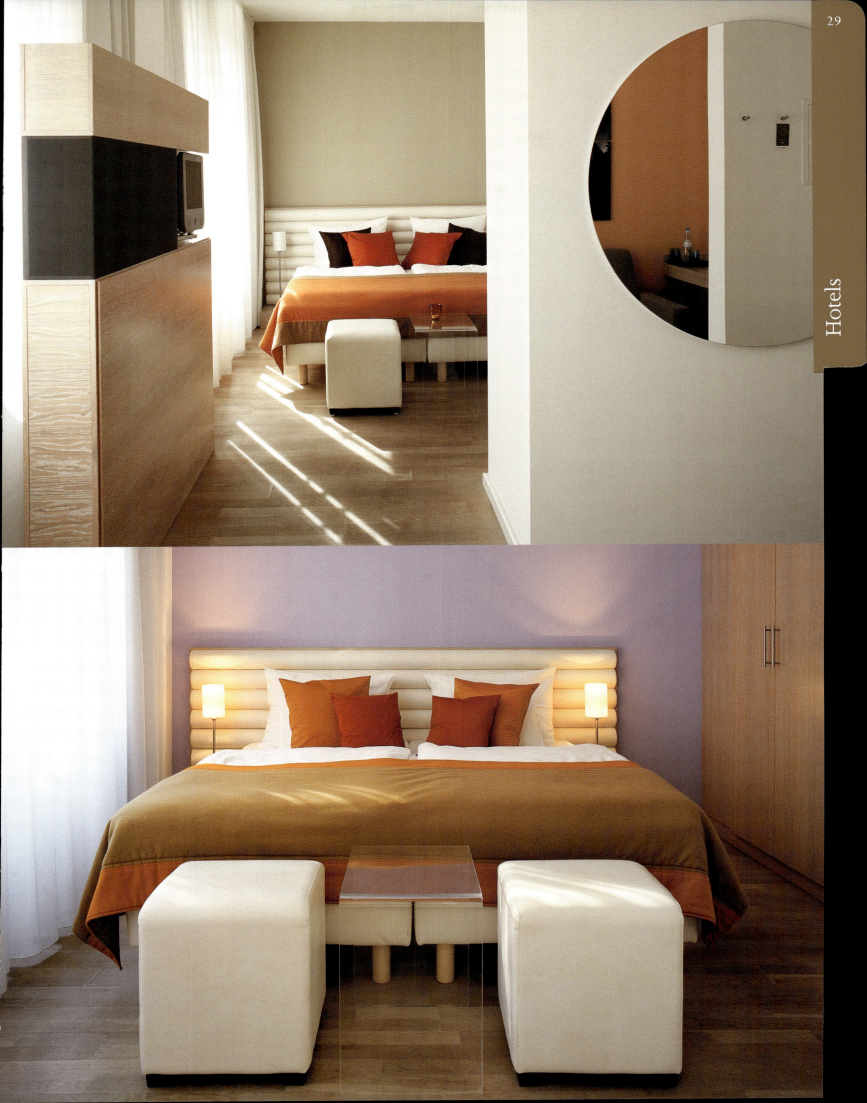

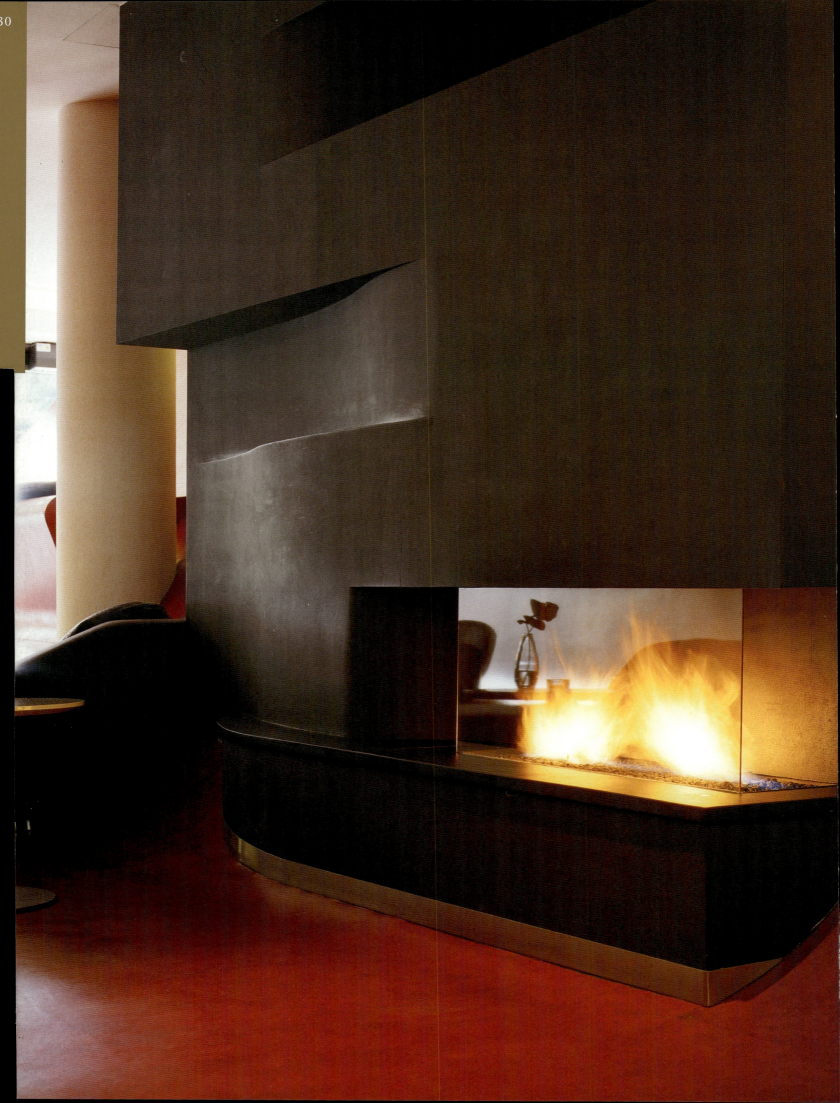

Hotel Q!

Knesebeckstraße 67, 10623 Berlin
☏ +49 30 81 00 66-0 +49 30 81 00 66-666
q-berlin@loock-hotels.com
www.loock-hotels.com
Ⓢ Savignyplatz Ⓤ Uhlandstraße

The Graft architect team, whose clients include Brad Pitt, has designed Hotel Q! so unconventionally that it takes a moment to recover from the shock of entry. The organic forms and unusual space concept are reminiscent of "Star Trek". In the large and airy rooms, the bathtub is right next to the bed, the sofas in the lounge flow wavelike into the walls and the walls are upholstered with white imitation ostrich leather. The extremely hip bar is for members and hotel guests only. You'll feel as snug in front of the fireplace as you would in a living room. The Q! boasts a spa with a Japanese bathing area, and a Finnish sauna and relaxation room with a sand-covered floor. The spa uses products from the Greek cosmetic company Korres. Another plus: the hotel is situated in the heart of Charlottenburg, between Kurfürstendamm and Savignyplatz.

Price category: €€€.
Rooms: 77 rooms, 4 studios, 1 penthouse.
Restaurants: Q! Restaurant (fusion cuisine & private cooking), Q! Bar (hotel guests and club members only).
History: Designed by the Graft architect team, and opened in spring 2004.
X-Factor: Aveda products in the bathrooms and a purist spa with sauna and massage.

Das Architektenteam Graft – es arbeitet unter anderem für Brad Pitt – hat das Hotel Q! so kompromisslos gestaltet, dass man beim Betreten erstmal einen kleinen Schock überwinden muss. Die organischen Formen und ungewöhnlichen Raumkonzepte wirken wie eine Interpretation von „Raumschiff Enterprise". Die Badewanne ist direkt neben dem Bett; die Sofas in der Lounge sind wellenförmig in die Wände integriert; die Wände der großzügigen und hellen Zimmer sind mit weißem Straußenleder-Imitat bezogen. Die populäre Bar ist nur für Mitglieder und Hotelgäste, sodass man sich vor dem Kamin geborgen fühlt wie in einem spacigen Wohnzimmer. Das Q! hat ein Spa mit japanischer Badezone, einer finnischen Sauna und einem mit Sand aufgeschütteten Ruheraum. Hier werden Produkte der griechischen Kosmetikfirma Korres verwendet. Ein weiterer Pluspunkt: Das Hotel liegt im Herzen von Charlottenburg zwischen Kurfürstendamm und Savignyplatz.

Preiskategorie: €€€.
Zimmer: 77 Zimmer, 4 Studios, 1 Penthouse.
Restaurants: Q! Restaurant (Fusion Cuisine & Private Cooking), Q! Bar (nur für Hotelgäste und Klubmitglieder).
Geschichte: Vom Architekturbüro Graft entworfen und im Frühjahr 2004 eröffnet.
X-Faktor: Aveda-Produkte in den Bädern sowie ein puristisches Spa mit Sauna und Massage.

Le bureau d'architectes Graft – travaillant, entre autres, pour Brad Pitt – a réalisé ici un projet de manière si rigoureuse que le client doit tout d'abord se remettre du petit choc éprouvé en entrant. Les formes organiques et l'incroyable répartition de l'espace évoquent la série « Star Trek ». La baignoire se trouve juste à côté du lit ; les canapés du salon ondoient le long des murs dans lesquels ils sont intégrés ; les murs des chambres claires et spacieuses sont recouverts d'une imitation de cuir d'autruche blanc. Le bar, à ne pas rater, est fréquenté uniquement par les membres du club ou les clients de l'hôtel, si bien que l'on se sent devant la cheminée comme dans un vaste salon. L'hôtel Q! dispose d'un spa avec une salle d'eau japonaise, un sauna finnois et une salle de repos au sol couvert de sable. Les produits cosmétiques utilisés dans le spa sont ceux de Korres, une marque grecque. Un avantage supplémentaire : l'hôtel est situé au cœur de Charlottenbourg entre le Kurfürstendamm et Savignyplatz.

Catégorie de prix : €€€.
Chambres : 77 chambres, 4 studios, 1 penthouse.
Restauration : Q! Restaurant (cuisine fusion & leçons particulières de cuisine), Q! Bar (réservé aux clients de l'hôtel et membres du club).
Histoire : Conçu par le bureau d'architectes Graft. A ouvert ses portes au printemps 2004.
Le « petit plus » : Des produits Aveda dans les salles de bains ainsi qu'un spa puriste avec sauna et massages.

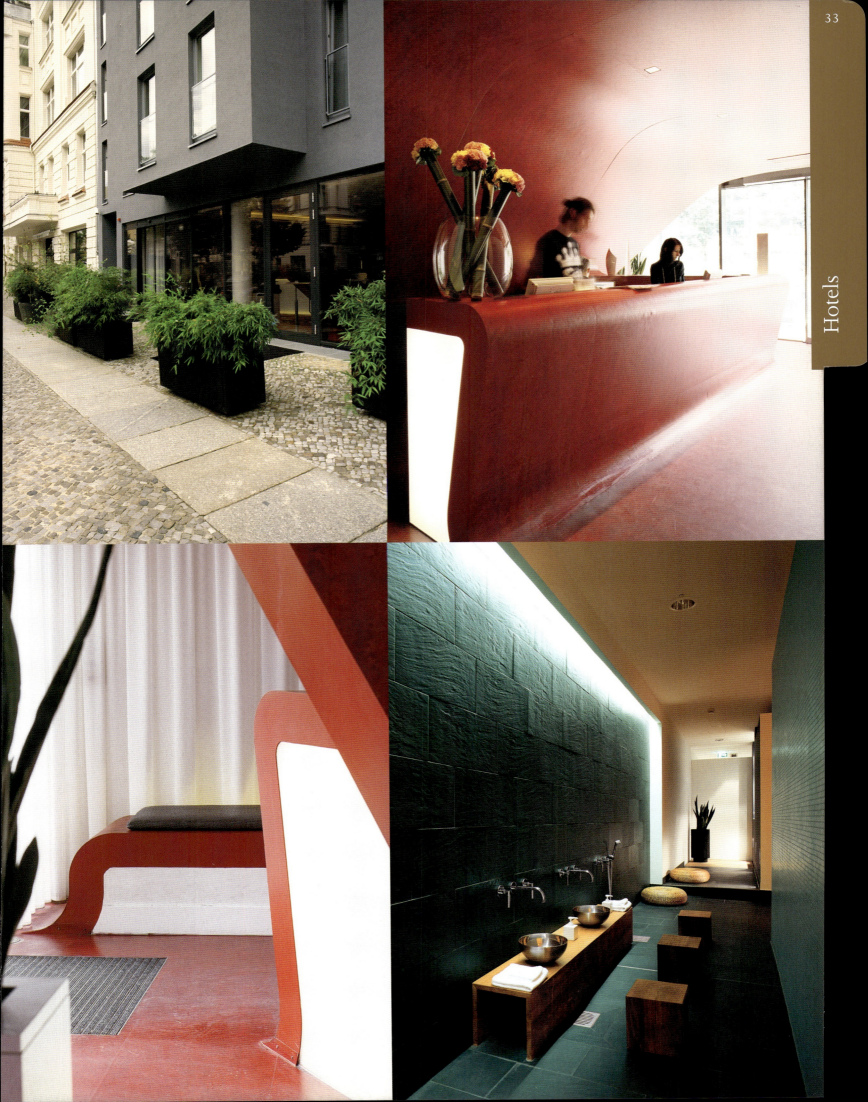

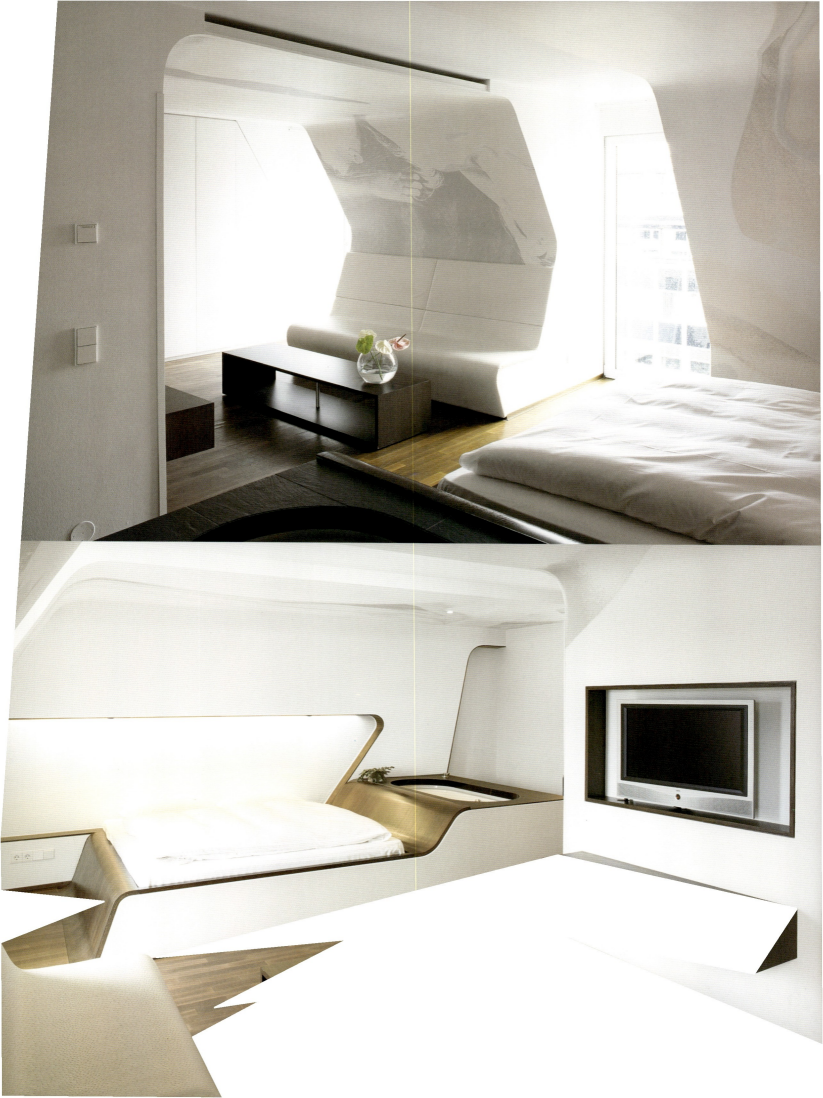

Hotels

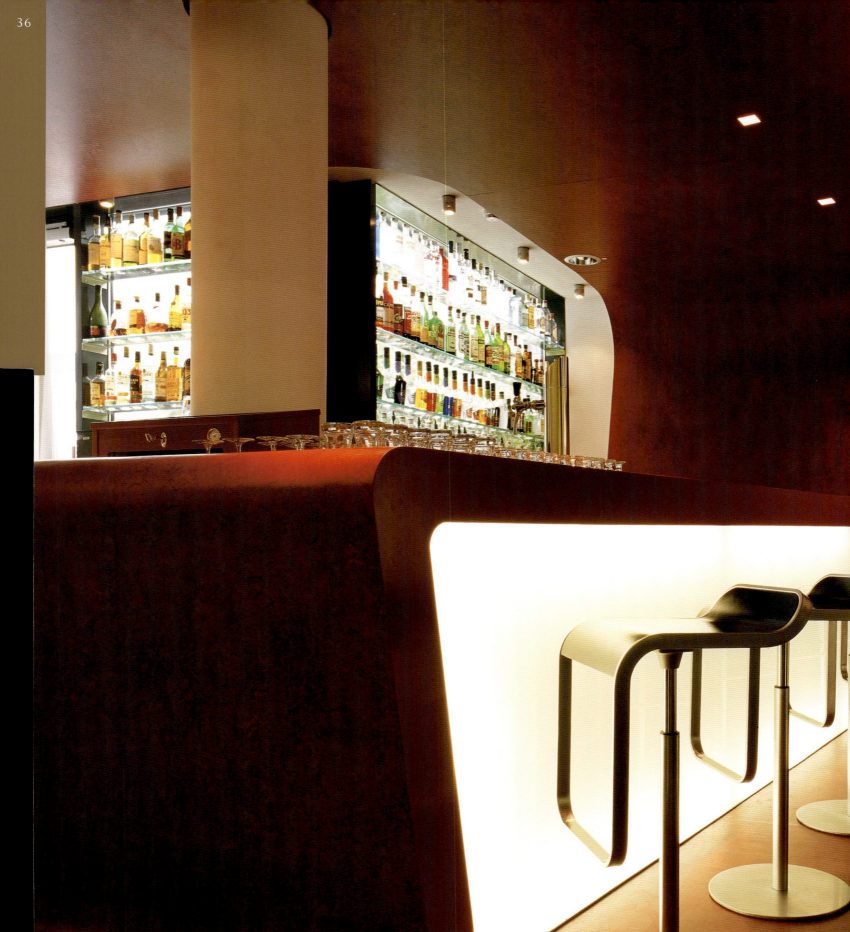

Hotels

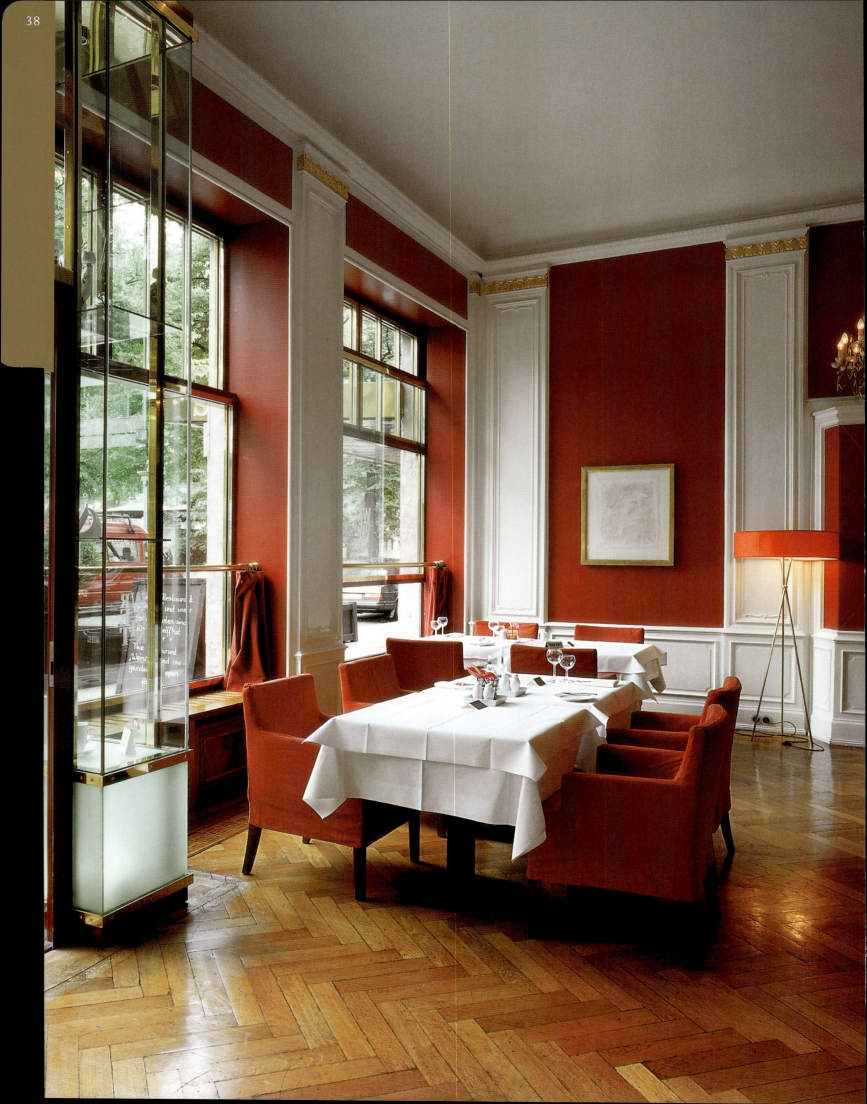

Savoy

Fasanenstraße 9–10, 10623 Berlin
☎ +49 30 3 11 03-0 📠 +49 30 3 11 03-333
info@hotel-savoy.com
www.hotel-savoy.com
Ⓢ Savignyplatz Ⓤ Uhlandstraße, Zoologischer Garten

Thomas Mann once wrote, "We went to our intimate Savoy Hotel at Fasanenstraße. A small hotel, I don't know if any of you know it, but so pleasant and comfortable." Today, this small grand hotel, which opened in a quiet street off the Kurfürstendamm in 1929, is a household name worldwide. The classic rooms were redesigned in 2005, but the results, unfortunately, were a little shaky, style-wise. Thankfully, the plasterwork, pillars and chandeliers survived the refurbishing. The Times Bar largely retains its orginal look, and the cocktails prepared here are heavenly. With a vodka martini in one hand and a Cohiba Robusto in the other, you can savour the thrill of staying in the very same hotel where Thomas Mann, Maria Callas, Romy Schneider, Herbert von Karajan, Heinrich Böll, Helmut Newton and Peter Zadek all spent the night.

Price category: €€.
Rooms: 21 singles, 86 doubles, 18 suites.
Restaurants: Weinrot (seasonal cuisine), Times Bar (classic, with cigar lounge).
History: The Savoy was opened in 1929 and was the first Berlin hotel to have a bathroom in every room.
X-Factor: A non-medical practitioner gives reflexology massages and acupuncture.

Thomas Mann schrieb: „Wir suchten unser schon vertrautes Hotel Savoy in der Fasanenstraße auf. Ein kleines Hotel, von dem ich nicht weiß, ob es jemandem von Ihnen bekannt ist, aber so sympathisch und behaglich." 1929 in einer ruhigen Seitenstraße des Kurfürstendamms eröffnet, ist das kleine Grand Hotel heute weltweit ein Begriff. 2005 wurden die klassizistischen Räume neu gestaltet – leider nicht immer geschmackssicher. Stuck, Säulen und Kristallleuchter aus den 1930ern haben die Renovierung glücklicherweise überlebt. Auch die Times Bar ist noch weitgehend im Originalzustand, und die Cocktails, die hier gemixt werden, sind exzellent. Bei Wodka-Martini und einer Cohiba Robusto kann man dem schönen Gefühl nachhängen, in einem Hotel zu wohnen, wo schon neben Thomas Mann, Maria Callas, Romy Schneider, Herbert von Karajan, Heinrich Böll, Helmut Newton und Peter Zadek genächtigt haben.

Preiskategorie: €€.
Zimmer: 125 Zimmer (21 Einzel-, 86 Doppelzimmer, 18 Suiten).
Restaurants: Weinrot (saisonale Küche), Times Bar (Klassiker mit Zigarrenlounge).
Geschichte: 1929 wurde das Savoy eröffnet und war damals das erste Berliner Hotel, in dem jedes Zimmer ein Bad hatte.
X-Faktor: Für Reflexzonenmassagen und Akupunktur kommt eine Heilpraktikerin ins Haus.

Thomas Mann a écrit : « Nous descendions au Savoy de la Fasanenstraße, qui nous était déjà familier. Un petit hôtel dont j'ignore s'il est connu de vous, mais si sympathique et confortable. » Le petit grand hôtel, qui a ouvert ses portes en 1929 dans une rue transversale tranquille du Kurfürstendamm, jouit de nos jours d'une renommée mondiale. Ses pièces les plus classiques ont subi une rénovation en 2005 – malheureusement pas toujours réussie. Les stucs, colonnes et lustres des années 1930 ont, Dieu merci, survécu aux travaux. Le Times Bar est encore en grande partie dans son état d'origine, et les cocktails qui y sont préparés sont excellents. Un vodka martini à la main et un Cohiba Robusto de l'autre, on peut songer délicieusement à ceux qui ont déjà passé la nuit ici comme Thomas Mann, Maria Callas, Romy Schneider, Herbert von Karajan, Heinrich Böll, Helmut Newton et Peter Zadek.

Catégorie de prix : €€.
Chambres : 125 chambres (21 simples, 86 doubles, 18 suites).
Restauration : Weinrot (cuisine de saison), Times Bar (un classique avec lounge pour les fumeurs de cigares).
Histoire : Ouvert en 1929. Premier hôtel berlinois dont les chambres avaient toutes une salle de bains.
Le « petit plus » : Réflexologie et acupuncture.

Hotels

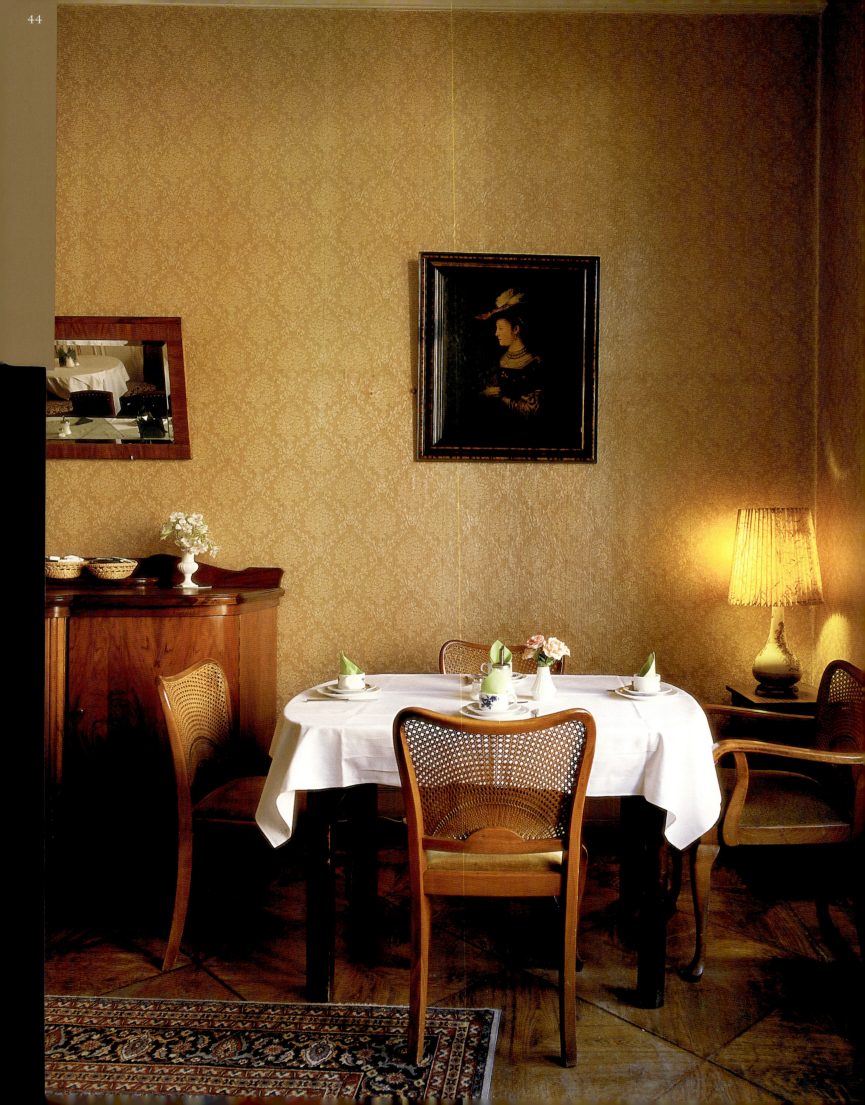

Pension Funk

Fasanenstraße 69, 10719 Berlin
☎ +49 30 8 82 71 93 📠 +49 30 8 83 33 29
berlin@hotel-pensionfunk.de
www.hotel-pensionfunk.de
Ⓤ Kurfürstendamm, Uhlandstraße

Would you like to live like a star from the silent-movie era? Between 1931 and 1937 Pension Funk was the apartment of Asta Nielsen, the cinema's first female international star, and one of its first sex symbols. The building, located in elegant Fasanenstraße near Kurfürstendamm, dates from 1895. In 1956 the Funk sisters converted the 14-room apartment into a guest house. Even today the establishment is reminiscent of a long-lost era. And, thankfully, the Gründerzeit (founding era) and Art Nouveau elements of the building are still in place. Pension Funk's high-ceilinged rooms are superior to the ones in any modern high-end hotel. The absence of luxurious bathrooms or televisions in the room is easily offset by the place's charm and atmosphere. Even better, the price is right. Especially for Fasanenstraße, one of the most distinguished districts in the city.

Price category: €.
Rooms: 3 single rooms, 11 double rooms.
Restaurant: Breakfast is served in the delightful parlour.
History: From 1931 to 1937 the silent-movie star Asta Nielsen lived here, and it still contains a lot of her memorabilia.
X-Factor: Authentic Berlin style, with high-corniced ceilings and Art Nouveau windows.

Wohnen wie eine Stummfilm-Berühmtheit? Die Pension Funk war von 1931 bis 1937 die Wohnung von Asta Nielsen, dem ersten weiblichen Weltstar in der Geschichte des Kinos und einem der ersten Sexsymbole des Films. Das Haus in der großbürgerlichen Fasanenstraße nahe des Kurfürstendamms wurde 1895 gebaut. 1956 machten die Schwestern Funk aus der 14-Zimmer-Wohnung eine Pension. Heute noch erinnert die Einrichtung an eine längst vergangene Epoche, und dankenswerterweise wurden die Gründerzeit- und Jugendstilelemente des Hauses erhalten. Die Größe der reich mit Stuck verzierten Zimmer und die mondänen Deckenhöhen schlagen jedes moderne Luxushotel. Auch wenn es keine Luxusbadezimmer und keinen Fernseher auf dem Zimmer gibt: Der Charme und die Atmosphäre der Pension wiegen das locker auf – vom Preis ganz zu schweigen. Hinzu kommt, dass die Fasanenstraße zu den feinsten Adressen der Stadt zählt.

Preiskategorie: €.
Zimmer: 3 Einzel-, 11 Doppelzimmer.
Restaurant: Das Frühstück wird im schönen Salon serviert.
Geschichte: In dem Haus anno 1895 wohnte von 1931–1937 der Stummfilmstar Asta Nielsen – an sie erinnern noch heute viele Memorabilia.
X-Faktor: Berliner Flair mit hohen Stuckdecken und Jugendstilfenstern.

Vous rêvez d'être logé comme une célébrité du cinéma muet ? De 1931 à 1937, la pension Funk était l'appartement d'Asta Nielsen, la première femme élevée au rang de star mondiale dans l'histoire du cinéma et un des premiers sex-symbols de l'écran. Cette maison de 1895 est située près du Kurfürstendamm, dans la Fasanenstraße aux belles villas bourgeoises. En 1956, les sœurs Funk transformaient l'appartement de 14 chambres en pension. Son aménagement rappelle, encore de nos jours, une époque révolue. Par chance, les éléments de l'ère wilhelminienne et Art Nouveau ont été conservés. La grandeur des pièces richement décorées de stuc et la hauteur des plafonds rivalisent avec n'importe quel hôtel de luxe moderne. Même s'il n'existe pas de salles de bains luxueuses ou de téléviseur dans les chambres, le charme et l'ambiance de la pension compensent cette absence, sans parler du prix. Un avantage non négligeable est que la Fasanenstraße est l'une des adresses les plus distinguées de la ville.

Catégorie de prix : €.
Chambres : 3 chambres simples, 11 doubles.
Restauration : Le petit déjeuner est servi dans un charmant salon.
Histoire : De nombreux souvenirs rappellent toujours la présence d'Asta Nielsen.
Le « petit plus » : Hauts plafonds ornés de stuc et fenêtres Art Nouveau.

Hotels

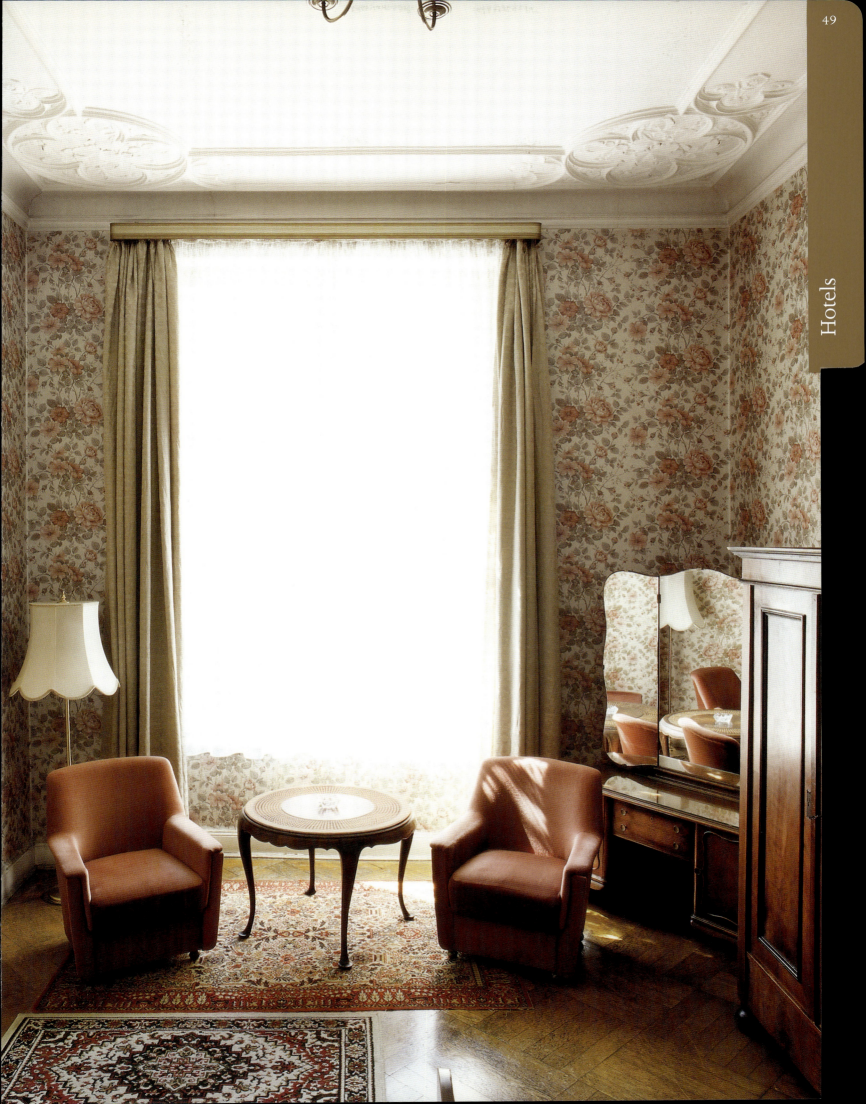

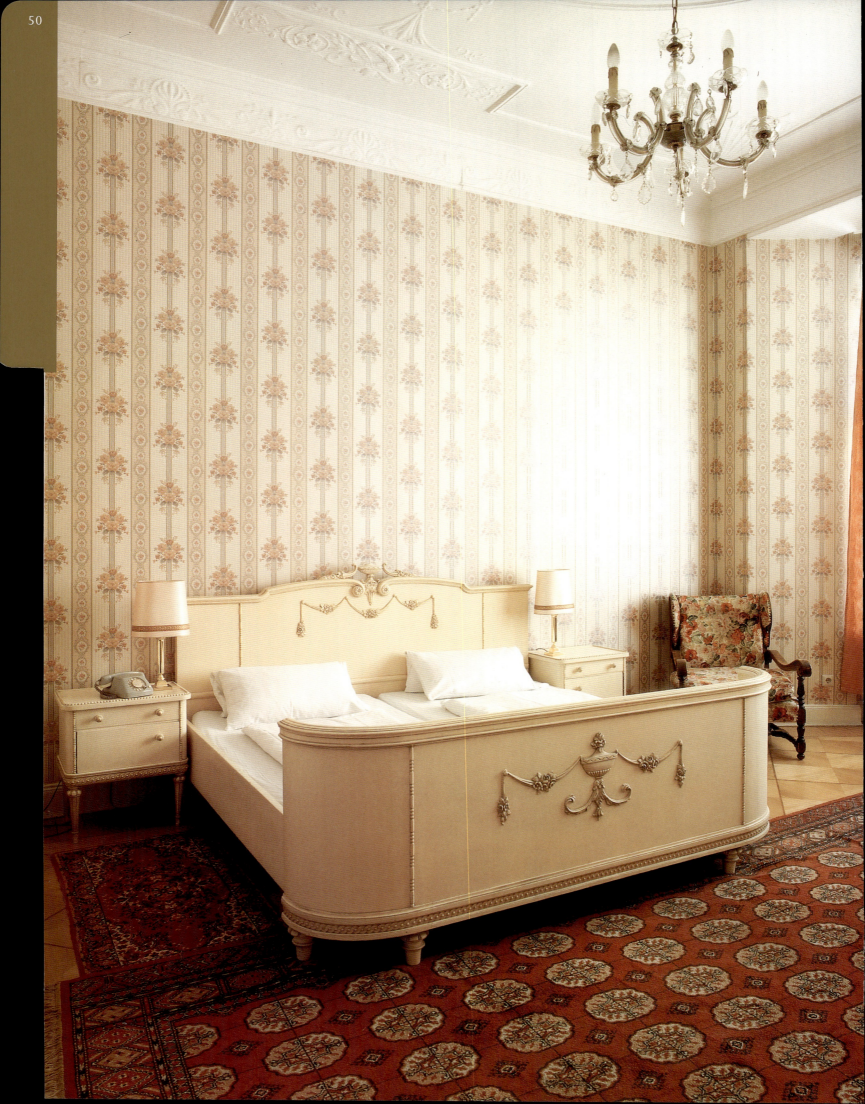

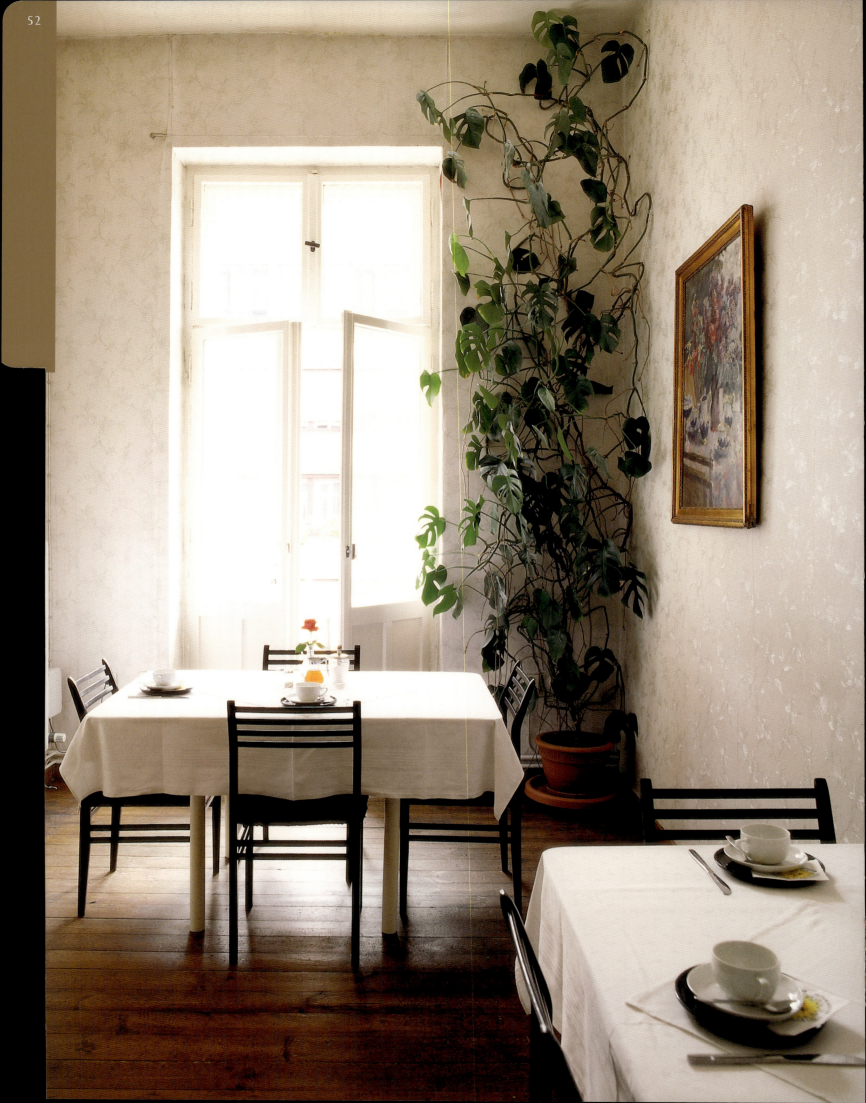

Nürnberger Eck

Nürnberger Straße 24a, 10789 Berlin
☎ +49 30 2 35 17 80 📠 +49 30 23 51 78 99
nuernberger-eck@t-online.de
www.nuernberger-eck.de
Ⓤ Augsburger Straße

The building on the corner of Nürnberger Straße in Charlottenburg-Wilmersdorf was erected over 100 years ago. Occupying a floor of the building, this guest house with eight rooms has been in the same location since the 1920s. Artists and creative souls will especially appreciate the atmosphere here: original tiled stoves from 1895, wallpaper from the 1950s and furniture from the 1920s make for an inimitable combination. Each of the large rooms has developed its own character over the years. One especially peaceful and romantic room is the "Wedding Room", with pink rose-covered wallpaper and white-varnished wooden furniture with carved patterns of flowers and birds. A Bakelite radio from the 1960s sits on the bedside table. The light and airy breakfast room with its flowered wallpaper and rubber plant is a fantastic place to start a day in Berlin. Another plus: many places of interest are within walking distance.

Price category: €.
Rooms: 2 single rooms, 6 double rooms. 5 rooms have a shower and WC, 2 rooms only a washbasin and share a bathroom in the hall.
Restaurant: Breakfast room, room service for drinks.
History: The first floor of the building has functioned as a charming Berlin guest house since the 1920s.
X-Factor: Family atmosphere, with a nostalgic ambience.

Das Eckhaus an der Nürnberger Straße in Charlottenburg-Wilmersdorf wurde vor mehr als 100 Jahren gebaut. Seit den 1920ern befindet sich hier eine Etagenpension mit acht Zimmern. Vor allem Künstler und Kreative wissen die Atmosphäre zu schätzen: originale Kachelöfen von 1895, Tapeten von 1950 und Möbel aus den 1920er Jahren in einem unvergleichlichen Mix. Jedes der großen Zimmer hat seinen eigenen, im Laufe der Jahre gewachsenen Charakter. Besonders ruhig und romantisch ist das „Hochzeitszimmer" mit rosa Rosentapete und weiß lackierten Holzmöbeln mit geschnitzten Blumen- und Vogelmotiven. Auf dem Nachtisch steht ein Bakelit-Radio aus den 1960ern. Der lichtdurchflutete Frühstücksraum mit Blümchentapete und Gummibaum ist ein wunderbarer Ort, um einen Tag in Berlin zu beginnen. Ein Plus: Viele Sehenswürdigkeiten liegen in Gehweite.

Preiskategorie: €.
Zimmer: 2 Einzel-, 6 Doppelzimmer. 5 Zimmer besitzen Dusche & WC, 2 Zimmer nur ein Waschbecken, sie teilen sich Etagenbäder.
Restaurant: Frühstücksraum, Getränkeservice aufs Zimmer.
Geschichte: Seit den 1920ern wird das Haus als Berliner Etagenpension genutzt.
X-Faktor: Familiär-nostalgisches Ambiente.

Vieille de plus d'un siècle, la maison qui fait l'angle de la Nürnberger Straße à Charlottenbourg-Wilmersdorf abrite une pension de huit chambres depuis les années 1920. Les artistes et les créateurs qui y descendent apprécient surtout l'ambiance du décor bigarré : authentiques poêles en faïence de 1895, papiers peints de 1950 et meubles des années 1920. Les grandes chambres ont toutes un caractère particulier qui s'est développé petit à petit au fil des années. La « chambre nuptiale » au papier peint décoré de roses roses et aux meubles laqués en blanc, ornés de fleurs et d'oiseaux, est calme et romantique. Une radio en bakélite des années 1960 est posée sur la table de chevet. La salle des petits déjeuners au papier peint fleuri et où trône un hévéa est baignée de lumière : un endroit fantastique pour bien commencer la journée. Un avantage supplémentaire : cet endroit charmant n'est qu'à deux pas de nombreuses curiosités.

Catégorie de prix : €.
Chambres : 2 chambres simples, 6 doubles. 5 chambres avec douche & WC, 2 chambres avec lavabo et salle de bains à l'étage.
Restauration : Salle pour les petits déjeuners, boissons servies dans les chambres.
Histoire : Cette maison abrite une pension charmante depuis les années 1920.
Le « petit plus » : Ambiance familiale et rétro.

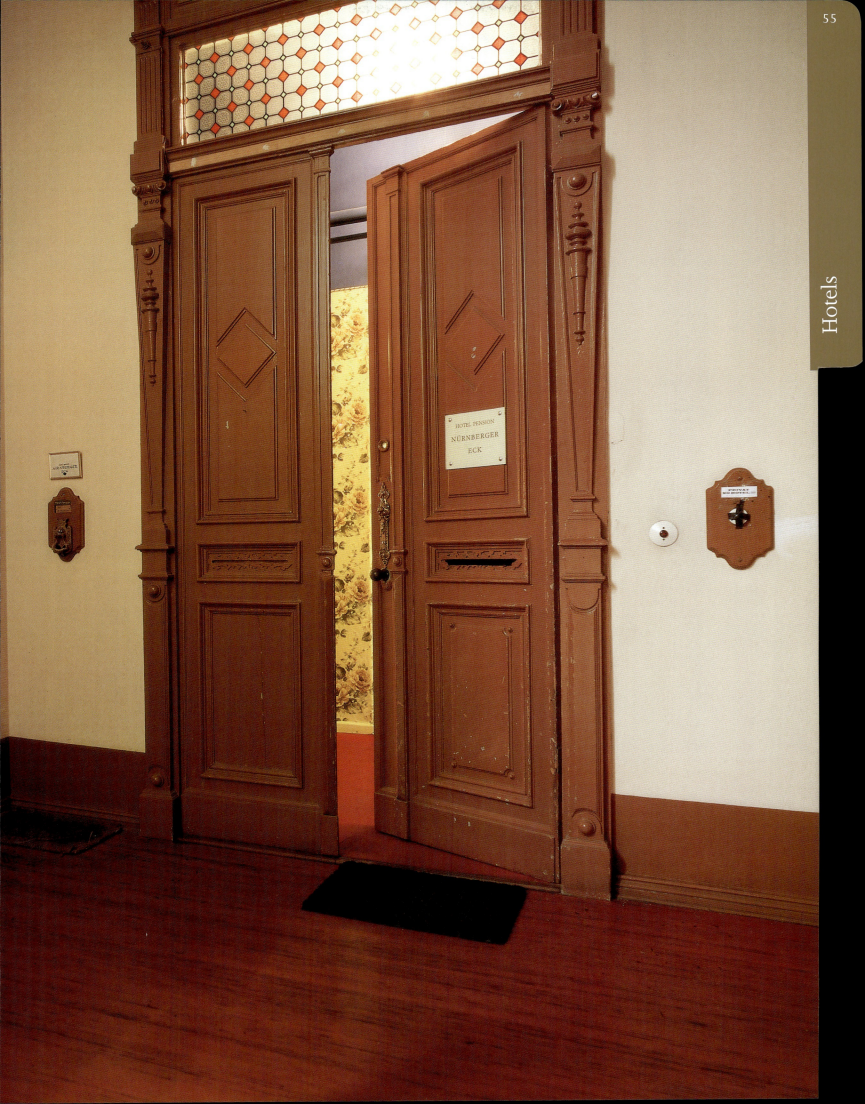

Hotels

Hotels

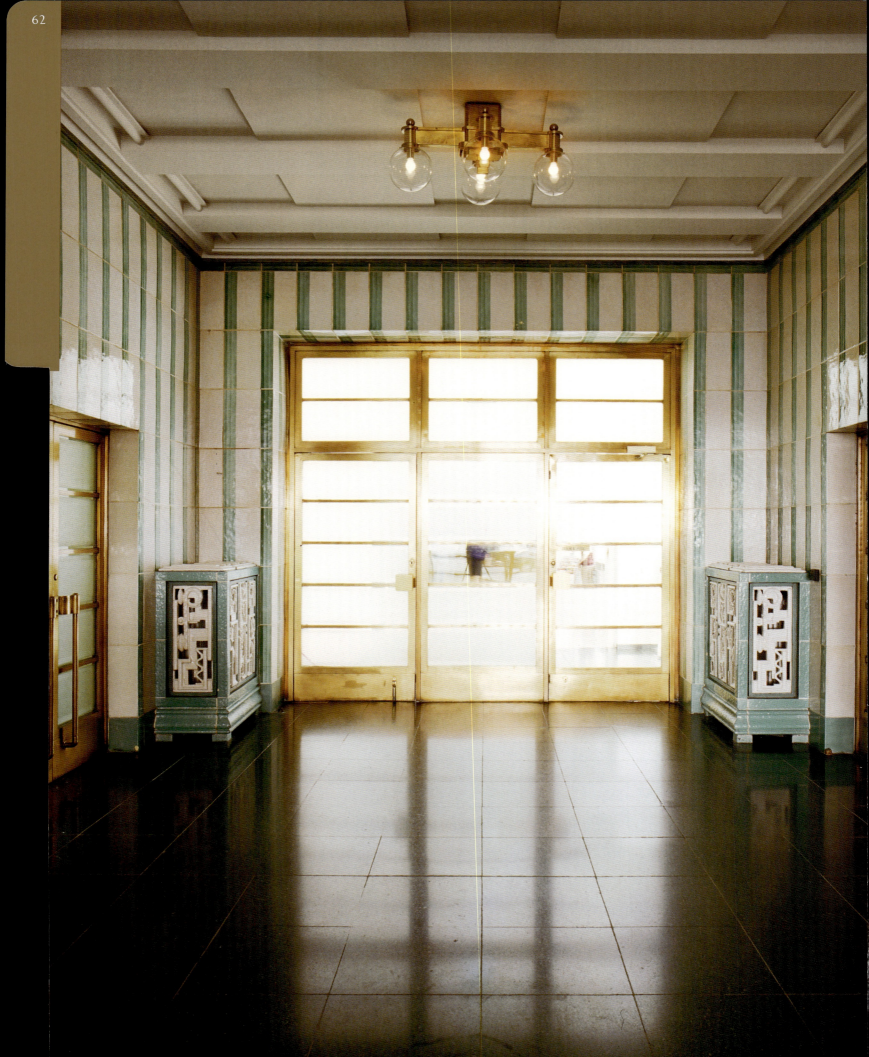

Ellington Hotel Berlin

Nürnberger Straße 50–55, 10789 Berlin
☎ +49 30 68 31 50 📠 +49 30 68 31 55 555
contact@ellington-hotel.com
www.ellington-hotel.com
Ⓤ Wittenbergplatz

In the 1930s Haus Nürnberg, as it was once called, housed Berlin's most famous ballroom, the Femina-Saal, which was equipped with table telephones and a letter chute. After the war, stars like Lionel Hampton performed for GIs in the cellar jazz club, and in the late 1970s Dschungel, the ultimate "in"disco, opened here. The building made less exciting headlines as the seat of the Berlin city finance office: this is where the senators held their press conferences. Today the Ellington Hotel lies behind the 185-metre-long façade of travertine stone – and it combines an eventful history with modern design. The rooms are completely new, in a plain and sober style; the tower suites have the finest view of the Gedächtniskirche. The foyer, by contrast, maintains the appearance of days gone by with brass doors and the original cream-white and green ceramic tiles. The Femina-Saal is now used for conferences, and the old strongroom of the finance office is a store for over 300 wines. Only the paternoster has unfortunately not been kept – the authorities thought it was too dangerous.

Price category: €€.
Rooms: 285 rooms.
Restaurants: Duke, with a bar and show kitchen; Mediterranean and Asian dishes. Exclusive tasting can be enjoyed in the wine safe.
History: What used to be called Haus Nürnberg was built between 1928 and 1931 by Richard Bielenberg and Josef Moser. The Ellington Hotel opened in the listed monument in March 2007.
X-Factor: Shopping gallery with lifestyle stores.

Das einstige Haus Nürnberg beherbergte in den 1930ern das berühmteste Ballhaus Berlins, den Femina-Saal, der mit Tischtelefonen und Saalrohrpost ausgestattet war. Nach dem Krieg eröffnete im Keller ein Jazzklub, in dem Stars wie Lionel Hampton vor GIs auftraten, und Ende der 1970er wurde hier der Dschungel, die Szenedisco schlechthin, eingerichtet. Etwas trockenere Schlagzeilen machte der Bau als Sitz der Berliner Finanzverwaltung: Hier gaben die Senatoren ihre Pressekonferenzen. Heute verbirgt sich hinter der 185 Meter langen Travertin-Fassade das Ellington Hotel, das spannende Geschichte mit modernem Design verbindet. Ganz neu, schnörkellos und sachlich sind die Zimmer gestaltet; den schönsten Blick auf die Gedächtniskirche bieten die Turmsuiten. Noch wie in vergangenen Tagen präsentiert sich dagegen das Foyer mit Messingtüren sowie originalen cremeweißen und grünen Keramikkacheln. Im Femina-Saal finden jetzt Konferenzen statt, und im ehemaligen Tresorraum der Finanzdirektion lagern mehr als 300 Weine. Nur den Paternoster gibt es leider nicht mehr – die Baubehörde befand ihn als zu gefährlich.

Preiskategorie: €€.
Zimmer: 285 Zimmer.
Restaurants: Duke, mit Bar und Showküche; mediterrane und asiatische Speisen. Im Weintresor sind exklusive Verkostungen möglich.
Geschichte: Das ehemalige Haus Nürnberg wurde 1928–1931 von Richard Bielenberg und Josef Moser errichtet. Das Ellington Hotel wurde in dem denkmalgeschützten Bau im März 2007 eröffnet.
X-Faktor: Die Ladengalerie mit Lifestyle-Shops.

Durant les années 1930, l'hôtel Haus Nürnberg abritait la plus célèbre salle de bal de Berlin, la Femina-Saal, équipée de tubes pneumatiques et de téléphones de table. Après la guerre, un club de jazz prit possession de la cave – des stars comme Lionel Hampton jouaient devant les GIs – et la fin des années 1970 vit naître la légendaire discothèque Dschungel. Les journalistes appréciérent – mais la présence en ces murs de l'administration berlinoise des Finances générait des articles moins amènes : c'est ici qu'avaient lieu les conférences de presse des sénateurs. Aujourd'hui, l'Ellington Hotel se cache derrière une façade de travertin de 185 mètres de long et marie un passé captivant au design moderne. Les chambres ont été totalement rénovées dans un style fonctionnel ; les suites de la tour offrent la meilleure vue sur la Gedächtniskirche. Toutefois, la réception avec ses portes de laiton et ses carreaux de céramique crème et vert est restée comme autrefois. La salle Femina abrite maintenant des conférences et plus de 300 vins sont entreposés dans l'ancienne chambre forte de la direction des Finances. Seul le paternoster a disparu, les autorités le jugeant trop dangereux.

Catégorie de prix : €€.
Chambres : 285 chambres.
Restauration : Duke, avec bar et cuisine ouverte ; cuisines méditerranéenne et asiatique. Dégustations exclusives dans la « chambre forte » à vin.
Histoire : L'ancien Haus Nürnberg a été construit de 1928 à 1931 par Richard Bielenberg et Josef Moser. L'Ellington Hotel a été ouvert en mars 2007 dans le bâtiment classé monument historique.
Le « petit plus » : La galerie marchande abritant des boutiques lifestyle.

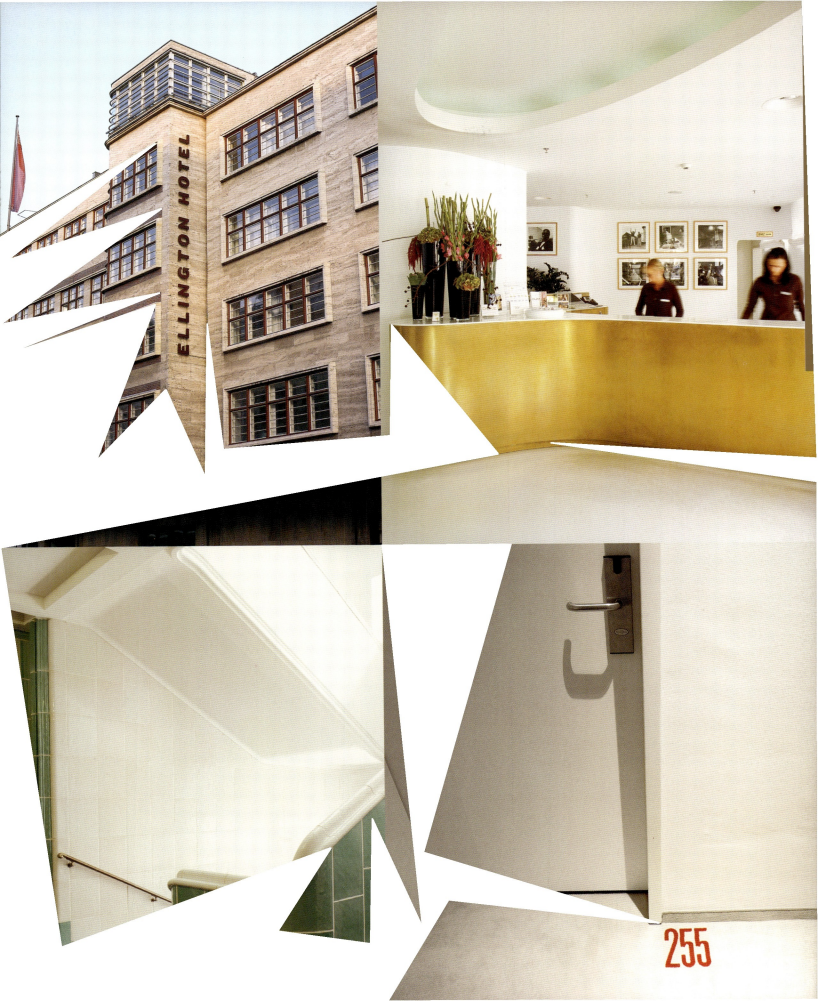

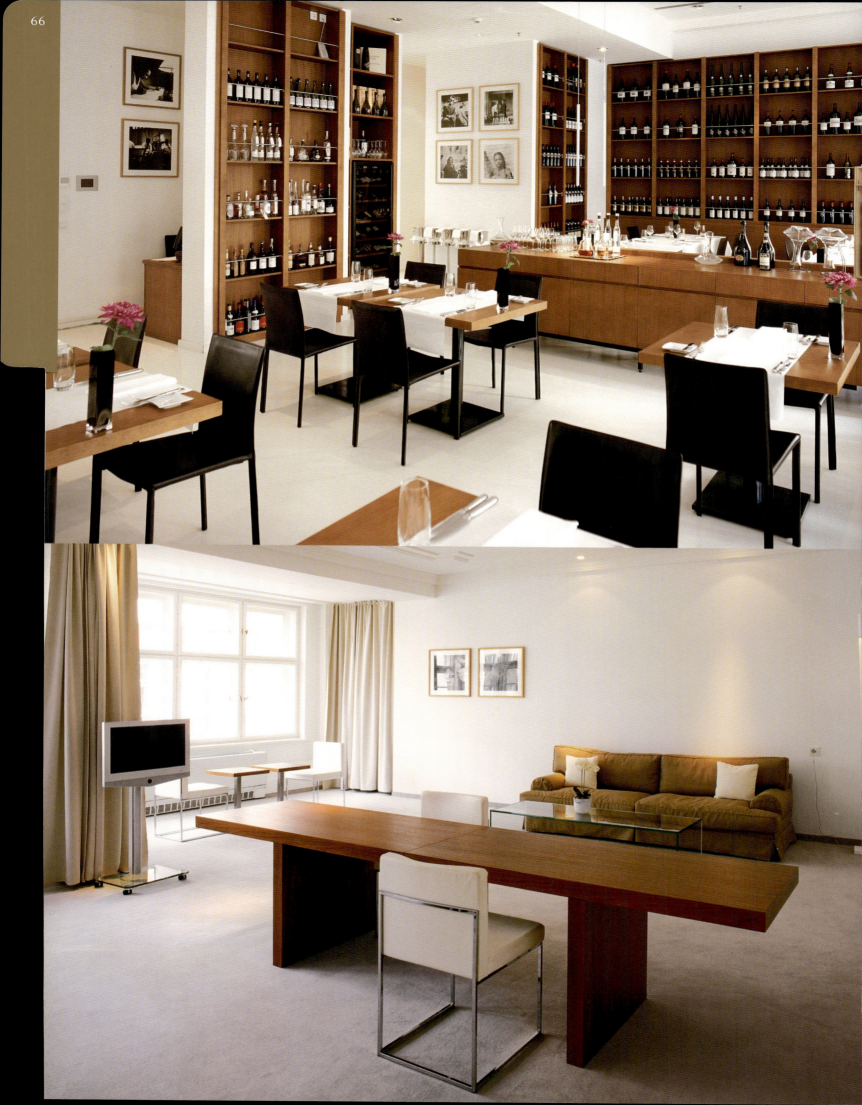

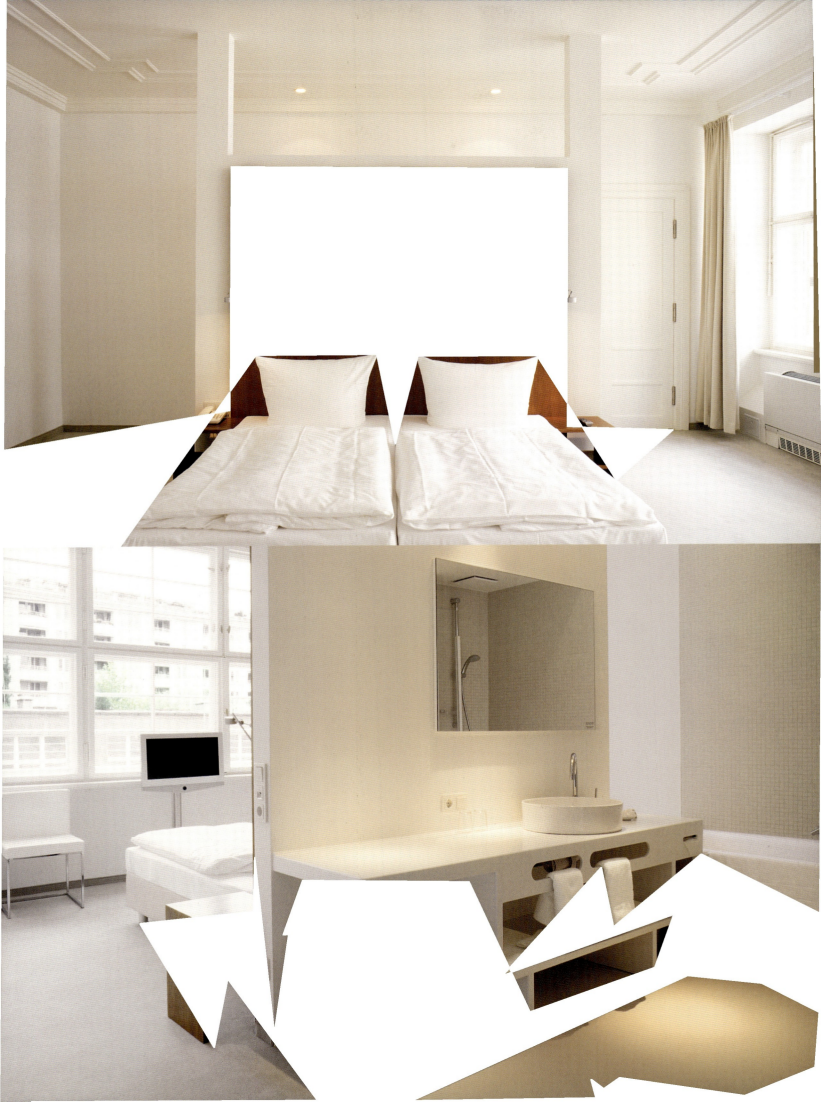

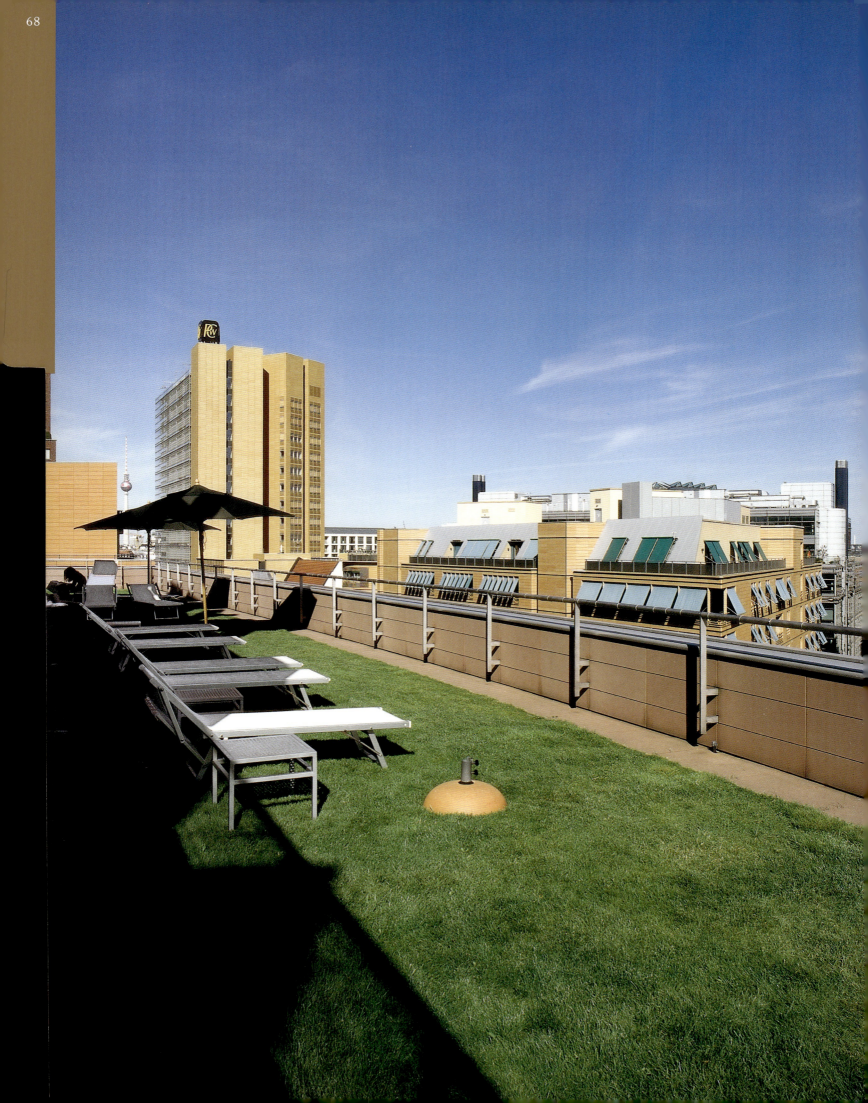

Grand Hyatt Berlin

Marlene-Dietrich-Platz 2, 10785 Berlin
☎ +49 30 25 53 12 34 +49 30 25 53 12 35
berlin.grand@hyatt.com
www.berlin.grand.hyatt.de
Ⓢ Ⓤ Potsdamer Platz

Potsdamer Platz was once the biggest building site in Europe. A galaxy of star architects were signed up for projects, and money flowed like water. And the result? A mediocre concrete jungle with chain stores and multiplex cinemas that has no appeal whatsoever. The notable exception is the Grand Hyatt, located at the edge of Potsdamer Platz. Opened in 1998, it was designed by the famous Spanish architect José Rafael Moneo. The hotel is within walking distance of the National Gallery, the Tiergarten, the Brandenburg Gate, the Holocaust Memorial and Friedrichstraße. Hannes Wettstein's interior design is modern, unfussy, Zen-like. The restaurants are good, and the bar is one of the finest in Berlin. Photos from the Bauhaus archives adorn the walls of the rooms, whose furnishings recall Gropius and Le Corbusier. One of the big reasons to stay here is the rooftop spa, which boasts a huge sauna, a lavishly appointed wellness area and a stunning view over the city.

Price category: €€€€.
Rooms: 326 rooms, 16 suites.
Restaurants: Vox Restaurant, Vox Bar, Tizian (classic), Mesa (international).
History: The building was opened in 1998 (architect: José Rafael Moneo, interior design: Hannes Wettstein).
X-Factor: Aveda and Ren treatments in the spa, and the roof terrace, with a lawn of 250 square metres.

Der Potsdamer Platz war die größte Baustelle Europas. Es durften zahllose große Architekten bauen, und das Geld floss in Strömen – aber das Ergebnis ist bloß eine mittelmäßige Steinwüste mit Kettenläden und Großkinos ohne jeden Charme. Das am Rande des Potsdamer Platzes gelegene Grand Hyatt wurde von dem berühmten spanischen Architekten José Rafael Moneo entworfen und 1998 eröffnet. Das Hotel liegt in Gehweite von Neuer Nationalgalerie, Tiergarten, Brandenburger Tor, Holocaust-Mahnmal und Friedrichstraße. Die Innengestaltung von Hannes Wettstein ist modern, schlicht und zenartig. Die Restaurants sind gut, die Bar ist eine der besten Berlins. In den Zimmern, deren Einrichtung an Gropius und Le Corbusier erinnert, hängen Fotos aus dem Bauhaus-Archiv. Einer der besten Gründe, hier abzusteigen, ist das Spa auf dem Dach mit riesiger Sauna und großzügigem Wellness-Bereich. Der Blick von dort über die Stadt ist überwältigend.

Preiskategorie: €€€€.
Zimmer: 326 Zimmer, 16 Suiten.
Restaurants: Vox Restaurant, Vox Bar, Tizian (Klassiker), Mesa (international).
Geschichte: Das Haus wurde im Oktober 1998 eröffnet (Architekt: José Rafael Moneo, Interior: Hannes Wettstein).
X-Faktor: Treatments mit Produkten von Aveda und Ren im Spa und die Dachterrasse mit 250 qm Rasen.

La Potsdamer Platz, le plus grand chantier d'Europe, a vu l'argent couler à flots et d'innombrables architectes de renom ont eu le privilège d'y ériger des bâtiments – mais le résultat est un médiocre désert de pierres avec des chaînes de magasins et de grands cinémas sans aucun charme. Inauguré en 1998, le Grand Hyatt situé au bord de la Potsdamer Platz a été conçu par le célèbre architecte espagnol José Rafael Moneo. L'hôtel jouit d'une situation exceptionnelle à quelques pas de la Nouvelle Galerie Nationale, du Tiergarten, de la porte de Brandebourg, du mémorial de l'Holocauste et de la Friedrichstraße. L'aménagement intérieur de l'hôtel, œuvre de Hannes Wettstein, est moderne, sobre et zen. Les restaurants sont de qualité, le bar est un des meilleurs de Berlin. Des photos provenant des archives du Bauhaus sont accrochées dans les chambres, dont l'ameublement rappelle Gropius et Le Corbusier. Une des meilleures raisons pour descendre dans cet hôtel est son spa sur le toit, doté d'un immense sauna et d'un grand espace wellness. La vue sur la ville y est grandiose.

Catégorie de prix : €€€€.
Chambres : 326 chambres, 16 suites.
Restauration : Vox Restaurant, Vox Bar, Tizian (classique), Mesa (international).
Histoire : Ouvert en 1998 (architecte : José Rafael Moneo, intérieur: Hannes Wettstein).
Le « petit plus » : Soins Aveda et Ren au spa et une terrasse sur le toit avec 250 mètres carrés de gazon.

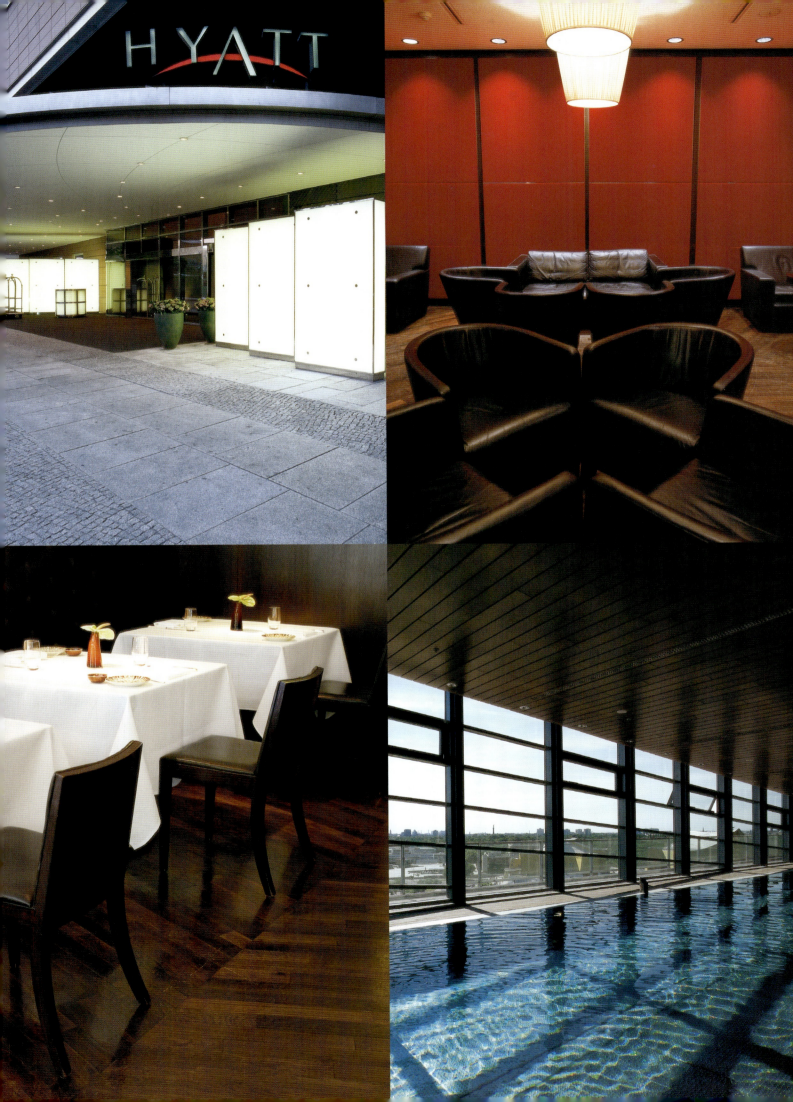

Hotels

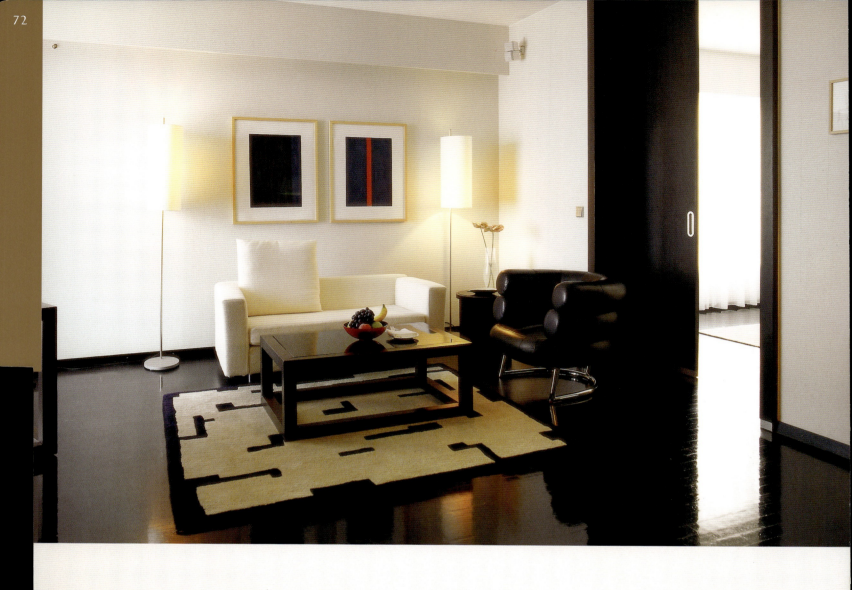

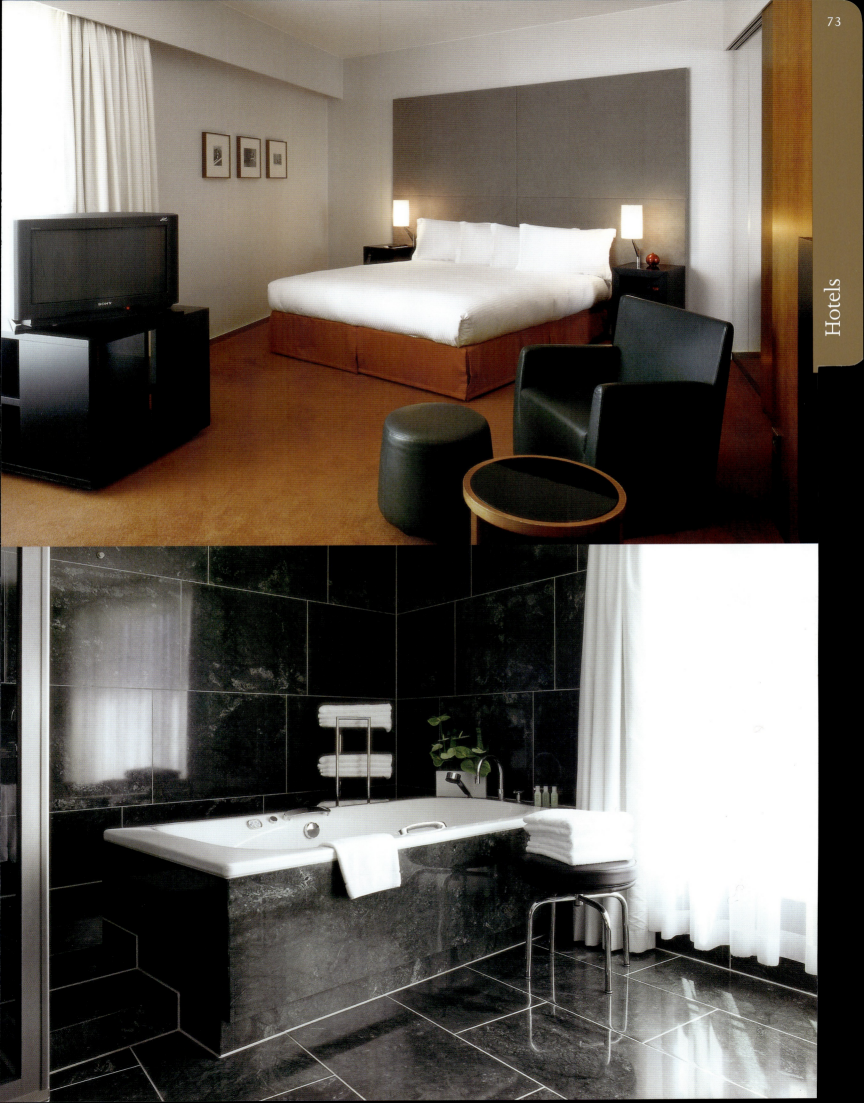

The Regent Berlin

Charlottenstraße 49, 10117 Berlin
☎ +49 30 2 03 38 📠 +49 30 20 33 61 19
www.regenthotels.com/hotels/berre
Ⓢ Friedrichstraße Ⓤ Französische Straße

The Regent Berlin is located at Gendarmenmarkt, the most beautiful square in Berlin. Josef Kleihues designed the hotel, which opened in 1996. American designer Frank Nicholson created the opulent interior. Guests are welcomed by gleaming marble floors, huge chandeliers, magnificent bouquets of flowers and the finest carpets and upholstery. The luxurious interior is matched by impeccable service – something you don't often encounter in Berlin. The rooms are furnished in shades of beige and cream, and the bathrooms are lush and huge. You can relax in the hotel's own spa, or in the nearby Holmes Place fitness club. If you would rather kick back without burning so many calories, the comfy sofas in the cosy hotel bar are just the ticket. My tip: make sure you ask for a room with a view of the Gendarmenmarkt. This, truly, is Berlin at its most beautiful.

Price category: €€€€.
Rooms: 156 rooms, 39 suites.
Restaurants: Fischers Fritz (fish and seafood specialities, chef Christian Lohse was awarded two Michelin stars), lobby lounge & bar.
History: The house was opened as a Four Seasons Hotel in 1996; since September 2004 it has been called The Regent Berlin.
X-Factor: There are experts on hand for every indulgence – even a tea master and a water sommelier.

The Regent Berlin liegt am Gendarmenmarkt, dem schönsten Platz Berlins. Konzipiert wurde das 1996 eröffnete Hotel von Josef Kleihues, für die opulenten Interiors ist der Amerikaner Frank Nicholson verantwortlich. Den Gast erwarten glänzende Marmorböden, riesige Kristallleuchter, prächtige Blumenbouquets, edle Teppiche und Polstermöbel mit Fransen, dazu ein tadelloser Service, der für Berlin wirklich außergewöhnlich ist. Die Zimmer sind in behaglichen Beige- und Cremetönen gehalten, die Badezimmer überzeugen durch ihre luxuriöse Größe. Entspannen kann man entweder im hauseigenen Spa oder im nahe gelegenen Fitnessklub Holmes Place. Wer sich beim Entspannen lieber nicht bewegen möchte, dem sei die gemütliche Hotelbar mit ihren weichen Sofas empfohlen. Tipp: Lassen Sie sich ein Zimmer mit Blick auf den Gendarmenmarkt geben. Schöner kann Berlin nicht sein.

Le Regent Berlin est situé sur la plus belle place de Berlin, le Gendarmenmarkt. Cet hôtel, conçu par Josef Kleihues et décoré avec opulence par l'Américain Frank Nicholson, a ouvert ses portes en 1996. Un dallage de marbre éclatant, de gigantesques lustres en cristal, d'énormes bouquets de fleurs, des tapis précieux et des meubles capitonnés garnis de franges, le tout assorti d'un service impeccable, chose plutôt rare à Berlin, attendent les clients. Des tons de beige et crème agréables dominent dans les chambres et les salles de bains sont immenses et luxueuses. Si vous désirez vous relaxer, la maison possède un spa tandis qu'une salle de remise en forme, le Fitnessclub Holmes Place, se trouve à proximité de l'hôtel. Si vous voulez vous détendre sans devoir faire de l'exercice, nous vous recommandons les canapés moelleux du bar de l'hôtel. Demandez une chambre avec vue sur le Gendarmenmarkt ! Berlin ne peut pas être plus belle.

Preiskategorie: €€€€.
Zimmer: 156 Zimmer, 39 Suiten.
Restaurants: Fischers Fritz (2 Michelin-Sterne für Chefkoch Christian Lohse, Fisch- und Meeresfrüchtekreationen), Lobby Lounge, Bar.
Geschichte: Das Haus wurde 1996 als Four Seasons Hotel eröffnet; seit September 2004 firmiert es als The Regent Berlin.
X-Faktor: Hier gibt es Experten für jeden Genuss – sogar einen Tea-Master und einen Wasser-Sommelier.

Catégorie de prix : €€€€.
Chambres : 156 chambres, 39 suites.
Restauration : Fischers Fritz (2 étoiles au Michelin pour le chef Christian Lohse, spécialités de poisson et fruits de mer), lobby lounge, bar.
Histoire : Ouvert en 1996 comme Four Seasons, l'hôtel opère sous le nom de The Regent Berlin depuis septembre 2004.
Le « petit plus » : Un expert en thé et un sommelier pour l'eau.

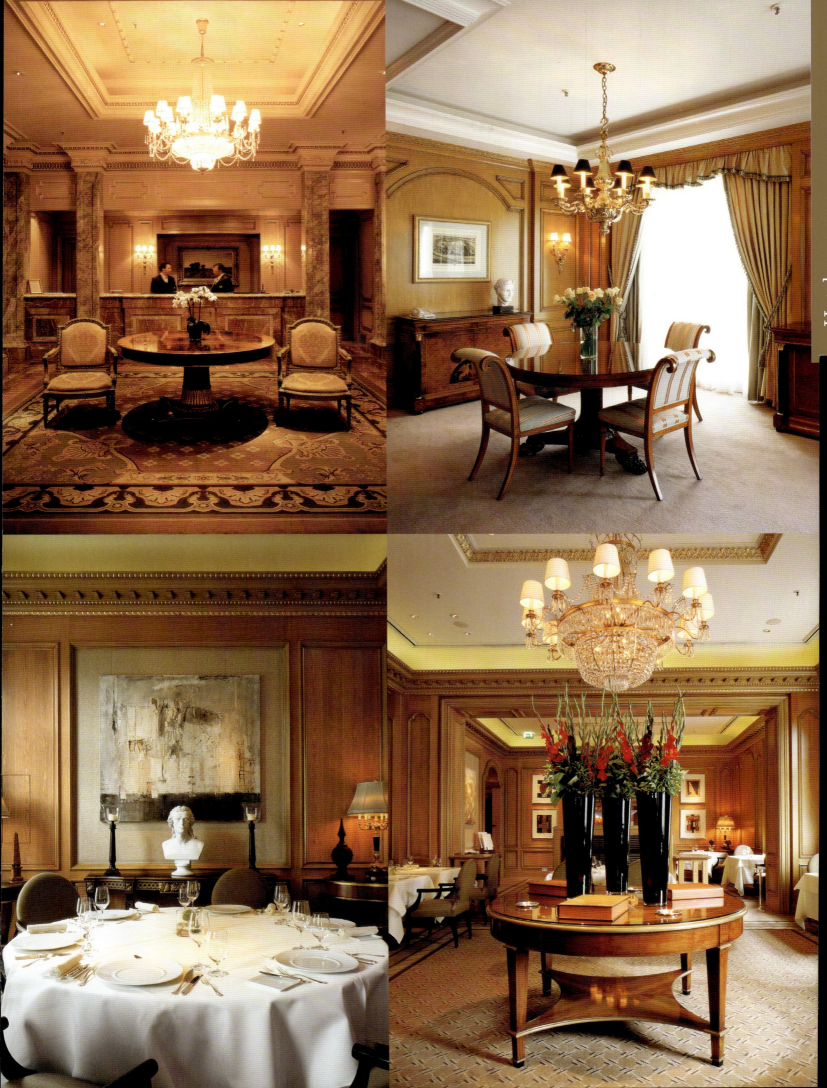

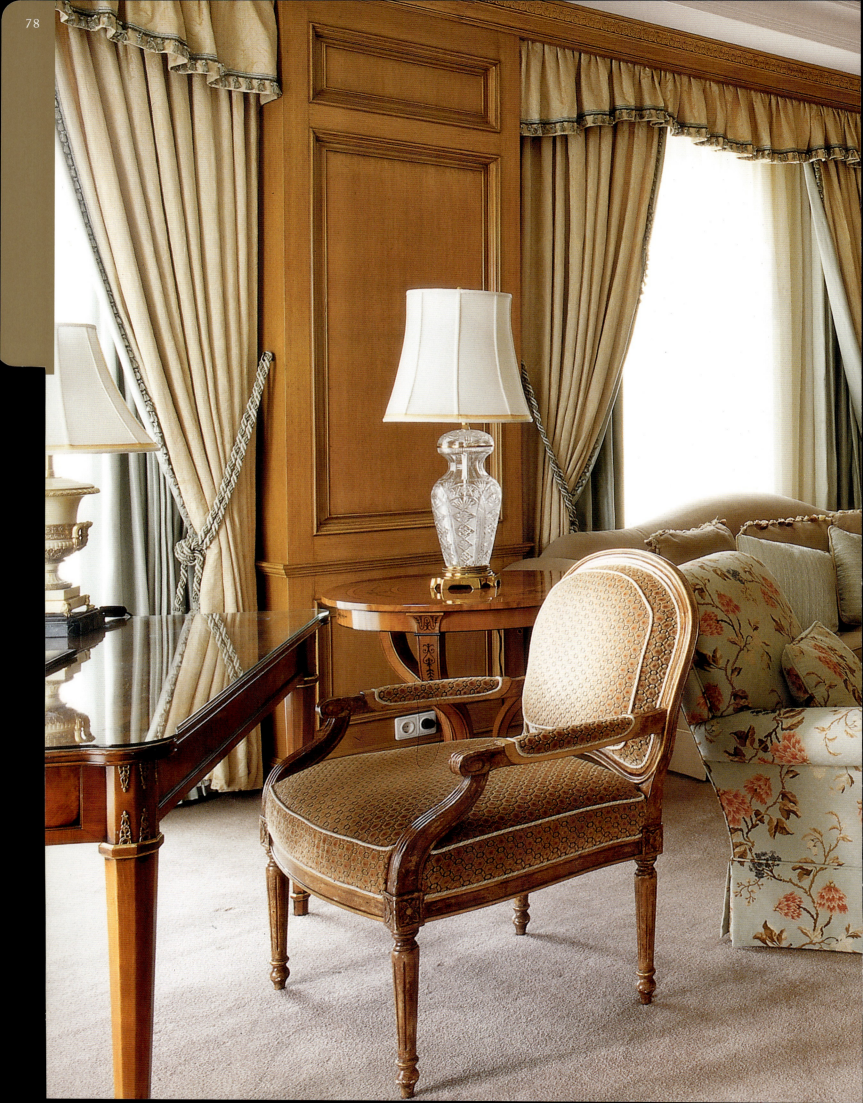

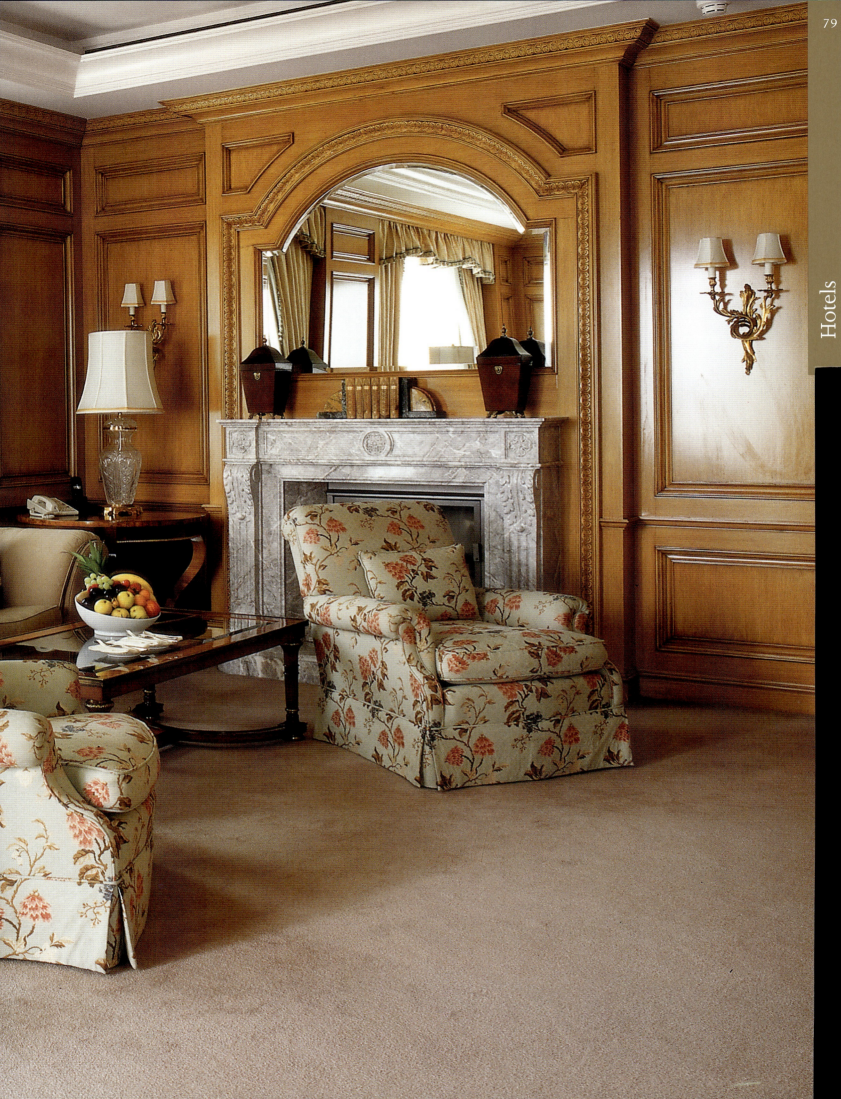
Hotels

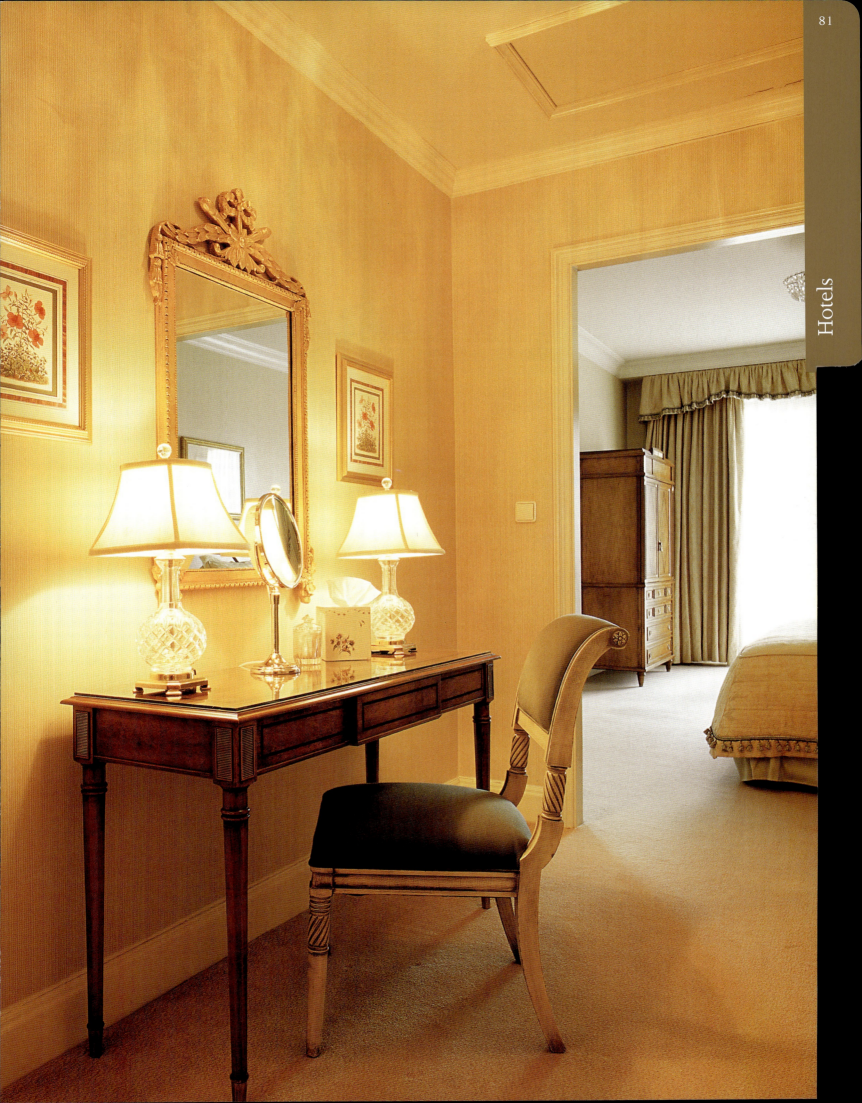

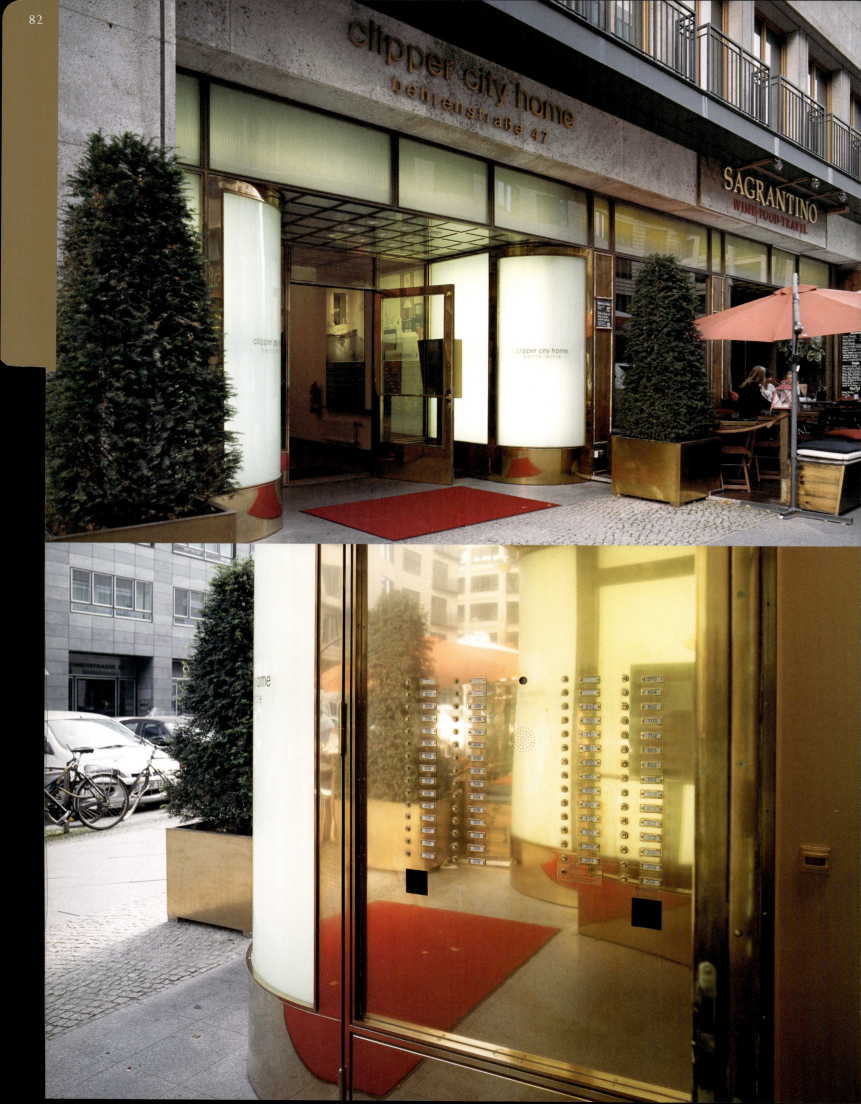

Clipper City Home

Behrenstraße 47, 10117 Berlin
☏ +49 30 2 06 37-0 📠 +49 30 20 63 54 00
www.clipper-boardinghouse.de
Ⓢ Friedrichstraße Ⓤ Französische Straße

Forget about calling room service in this hotel: there isn't any. Instead, each apartment has its own well-equipped little kitchen. And if you don't feel like cooking, there are great cafés and restaurants only a stone's throw away. Other things that may take some getting used to here: the reception is open until just 10pm, and the bed linen gets changed only every three days. On the other hand, a stay here is like having a home away from home, in a top location, between Gendarmenmarkt and Friedrichstraße, at a reasonable rate! The apartments have been tastefully furnished in a modern style, and have desks with a fax connection. You can stay here comfortably for more than three days. In the mornings, enjoy a delicious cup of coffee in Café Einstein in Friedrichstraße. Pick up a selection of delicacies from Butter Lindner for a cosy evening in front of the television in your room. Both places are right next door to the hotel. My tip: try to book the penthouse, which has its own roof terrace.

Price category: €€.
Rooms: 51 suites (47–74 square metres), underground car park.
Restaurant: The wine bar Sagrantino for breakfast, lunch and dinner.
History: Opened in 1999.
X-Factor: The Elixia fitness studio is right next door and there is a daily concierge shopping service.

Nach dem Roomservice sucht man hier vergebens, dafür hat jedes Apartment eine kleine Küche mit kompletter Kochausstattung (zudem sind sehr gute Cafés und Restaurants bloß einen Steinwurf entfernt). Ebenfalls gewöhnungsbedürftig: Die Rezeption ist nur bis 22 Uhr besetzt, und die Bettwäsche wird nur alle drei Tage gewechselt – aber dafür hat man ein Home away from Home in allerbester Lage zwischen Gendarmenmarkt und Friedrichstraße, und das zu einem günstigen Preis! Die Apartments sind modern und geschmackvoll eingerichtet und bieten einen Schreibtisch zum Arbeiten, mit eigenem Faxanschluss. Hier kann man sich auch länger als drei Tage wohlfühlen, denn morgens lockt ein köstlicher Kaffee im Café Einstein in der Friedrichstraße, abends kann man sich mit Delikatessen von Butter Lindner (beides vor der Tür) einen gemütlichen Fernsehabend auf dem Zimmer machen. Tipp: Versuchen Sie, das Penthouse mit eigener Dachterrasse zu bekommen.

Ne comptez pas sur le service en chambre, ici c'est chose vaine ! Mais chaque appartement est doté d'une petite cuisine totalement équipée, et de très bons cafés et restaurants se situent à deux pas. De même, il faut s'accoutumer au fait que la réception n'est occupée que jusqu'à 22 h et que les draps ne sont changés que tous les trois jours – en contrepartie, on a un Home away from Home très bien situé entre le Gendarmenmarkt et la Friedrichstraße, et ce pour un prix avantageux ! Les appartements sont modernes et aménagés avec goût et disposent d'un bureau avec fax. Si vous désirez prolonger votre séjour au-delà de trois jours, n'ayez crainte, vous vous sentirez toujours aussi bien car, le matin, vous pourrez prendre un délicieux café au Café Einstein dans la Friedrichstraße et, le soir, acheter de bons petits plats chez Butter Lindner (tous les deux à proximité). Vous n'aurez plus qu'à vous installer confortablement devant la télé. Le nec plus ultra : essayez de réserver le penthouse avec terrasse privée sur le toit !

Preiskategorie: €€.
Zimmer: 51 Suiten (47 bis 74 qm), Tiefgarage.
Restaurant: Die Weinbar Sagrantino für Frühstück, Mittagessen und Abendessen.
Geschichte: 1999 eröffnet.
X-Faktor: Nebenan das Fitness-Studio Elixia, und im Haus der tägliche Concierge-Einkaufsservice.

Catégorie de prix : €€.
Chambres : 51 suites (47 à 74 mètres carrés), parking souterrain.
Restauration : Le bar à vin Sagrantino pour les petits déjeuners, déjeuners et dîners.
Histoire : A ouvert ses portes en 1999.
Le « petit plus » : La salle voisine de remise en forme Elixia et un service de conciergerie quotidien.

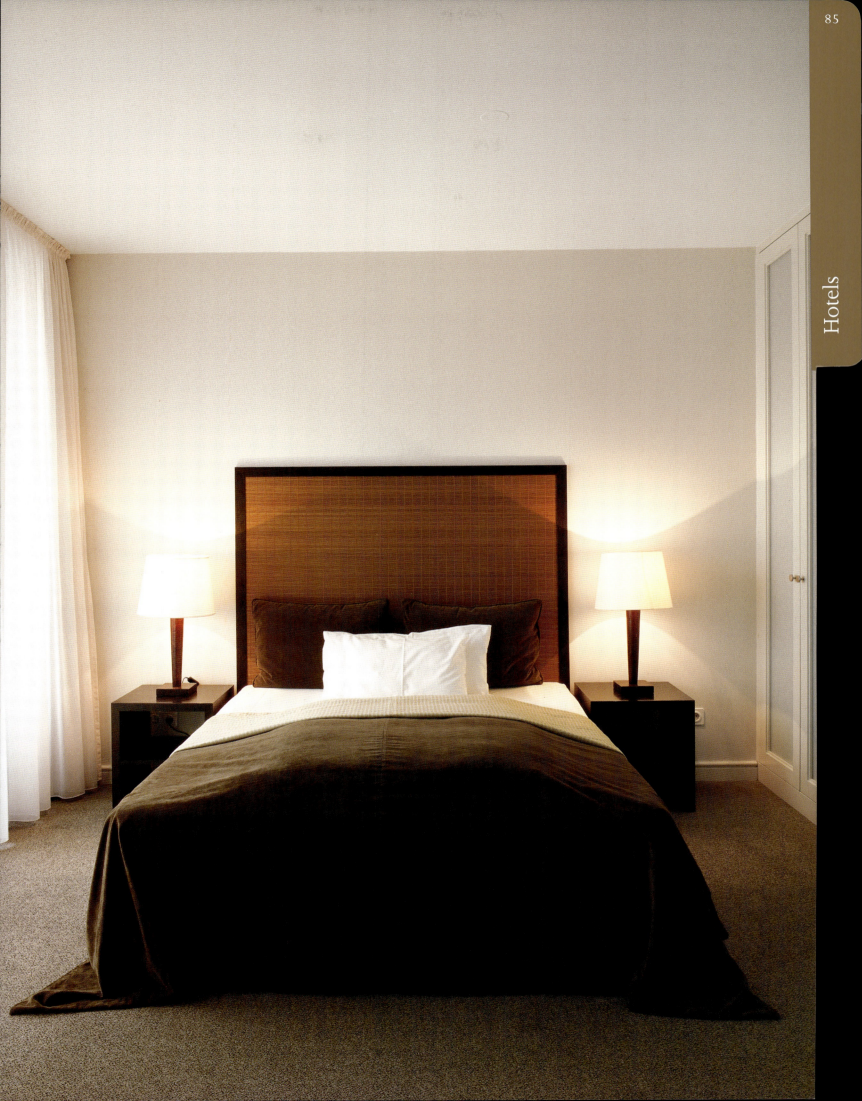

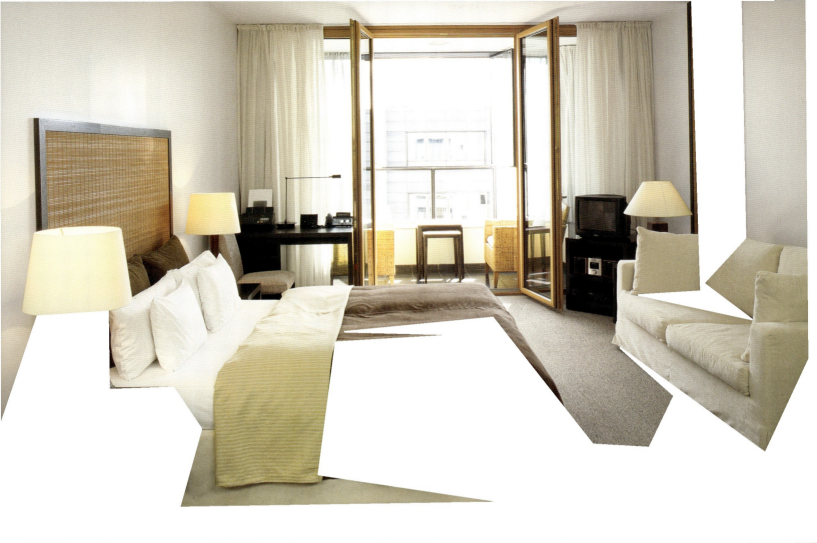
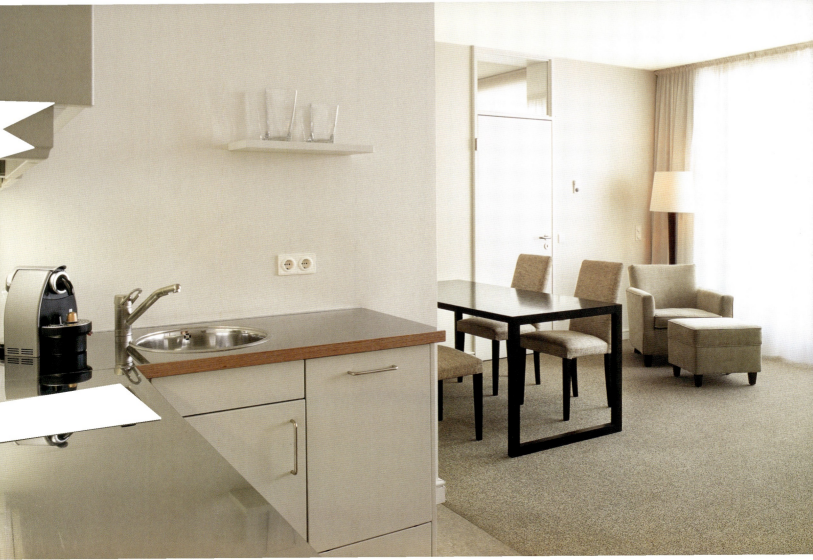

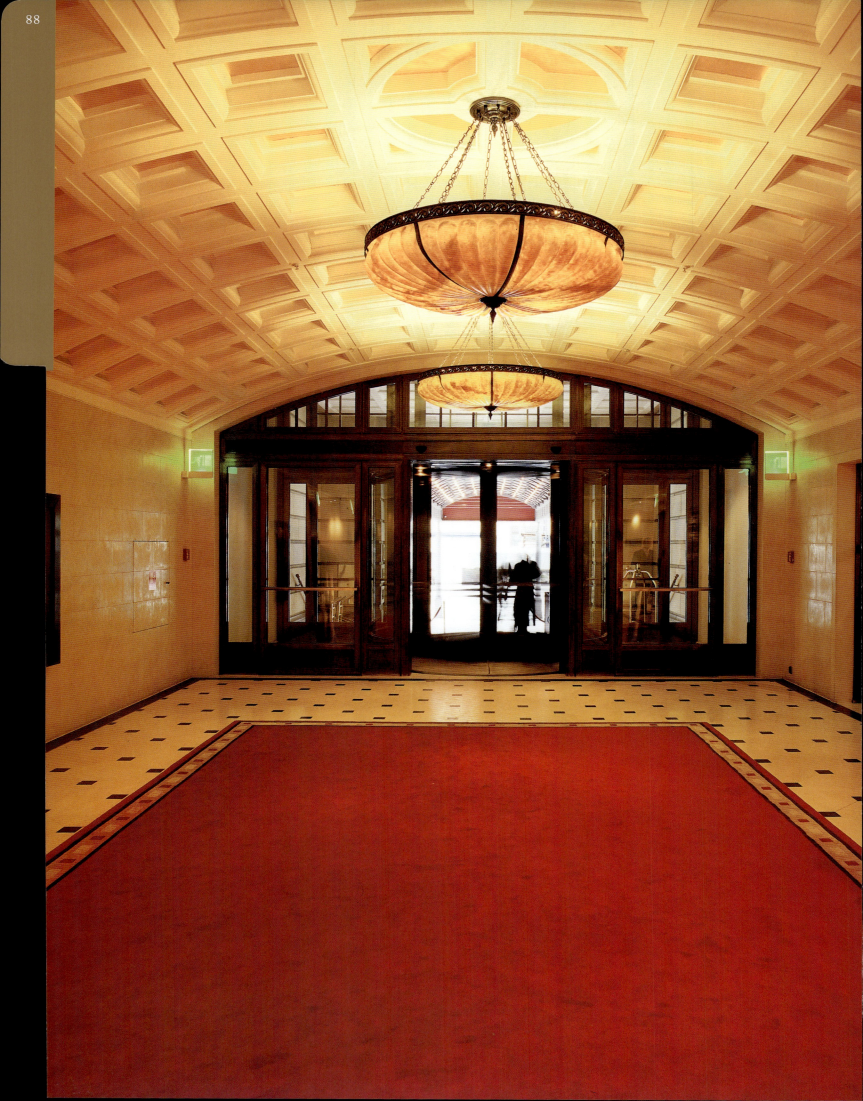

Hotel Adlon

Unter den Linden 77, 10117 Berlin
☎ +49 30 22 61-0 📠 +49 30 22 61-22 22
Adlon@Kempinski.com
www.hotel-adlon.de
Ⓢ Unter den Linden Ⓤ Mohrenstraße

Hotel Adlon is located very close to the Brandenburg Gate, and bears the distinguished address Unter den Linden. When Lorenz Adlon, the hotel's founder, opened his establishment in 1907 his dream was to give Berlin a luxury hotel that could compare with the best hostelries in London or Paris. And he succeeded. The celebrities of the era came to the Adlon to see and be seen: Edison, Ford, Rockefeller, Stresemann, Einstein, Karajan, Marlene Dietrich, Charlie Chaplin. Kaiser Wilhelm II loved the hotel for its luxurious features, like electricity and warm running water (his not so beloved and draughty town palace was a short walk away). The hotel inspired Vicki Baum's celebrated novel "Grand Hotel". The illustrious old building became a military hospital in the Second World War, and was burned down to its foundations in 1945. After the fall of the Wall in 1989, the Kempinski Group was awarded permission to rebuild. The building re-opened in 1997. There is no place to spend a night in Berlin that is more central, or more steeped in history.

Price category: €€€€.
Rooms: 306 rooms, 78 suites.
Restaurants: Quarré (international), Lorenz Adlon (gourmet), lobby, lounge & bar.
History: Founded in 1907 by Lorenz Adlon, later used as a military hospital and apprentices' hostel and then pulled down. Rebuilt by Kempinski and opened in 1997.
X-Factor: The luxurious spa.

Das 1907 eröffnete Hotel Adlon liegt direkt am Brandenburger Tor und schmückt sich mit der Adresse Unter den Linden. Der Gründer Lorenz Adlon wollte der Weltstadt Berlin ein Luxushotel geben, das den feinsten Häusern in Paris und London ebenbürtig sein sollte. Und alle kamen sie, um zu sehen und gesehen zu werden: Edison, Ford, Rockefeller, Stresemann, Einstein, Karajan, die Dietrich, Charlie Chaplin. Kaiser Wilhelm II. schätzte das Hotel wegen luxuriöser Errungenschaften wie Elektrizität und fließend Warmwasser (sein ungeliebtes zugiges Stadtschloss lag in Fußnähe), und für Vicki Baum war das Hotel die Inspiration für den legendären Roman „Menschen im Hotel". Im Zweiten Weltkrieg wurde die Luxusadresse zum Lazarett; 1945 zerstörte ein Brand das Haus bis auf die Grundmauern. Als 1989 die Mauer fiel, erwarb die Kempinski-Gruppe die Baugenehmigung zum Wiederaufbau. 1997 wurde das Haus neu eröffnet. Geschichtsträchtiger und zentraler kann man in Berlin nicht logieren.

L'hôtel Adlon, qui a inauguré ses murs en 1907, se situe directement à la porte de Brandebourg à l'adresse Unter den Linden. Son fondateur, Lorenz Adlon, voulait faire cadeau à la ville cosmopolite de Berlin d'un hôtel de luxe, comparable aux hôtels les plus raffinés de Paris et de Londres. Et tous sont venus, pour voir et être vus : Edison, Ford, Rockefeller, Stresemann, Einstein, Karajan, Marlene Dietrich, Charlie Chaplin. L'empereur Guillaume II appréciait l'hôtel en raison de ses acquisitions luxueuses comme l'électricité et l'eau chaude (son château mal aimé et mal chauffé se trouvait non loin de là), quant à Vicki Baum, l'hôtel a été la source d'inspiration de son roman légendaire « Grand hôtel ». Durant la Seconde Guerre mondiale, ce palace est devenu un lazaret, détruit en 1945 jusqu'aux murs de fondation par un incendie. À la chute du Mur en 1989, le groupe Kempinski a obtenu le permis de reconstruire. Le palace a donc réouvert ses portes en 1997. Vous ne trouverez pas de cadre plus empreint d'histoire ni plus central pour vous loger à Berlin.

Preiskategorie: €€€€.
Zimmer: 306 Zimmer, 78 Suiten.
Restaurants: Quarré (international), Lorenz Adlon (Gourmet), Lobby Lounge & Bar.
Geschichte: 1907 von Lorenz Adlon gegründet, später als Lazarett und Lehrlingsheim genutzt und abgerissen. Von Kempinski neu errichtet und 1997 eröffnet.
X-Faktor: Das luxuriöse Spa.

Catégorie de prix : €€€€.
Chambres : 306 chambres, 78 suites.
Restauration : Quarré (internationale), Lorenz Adlon (gastronomique), Lobby Lounge & Bar.
Histoire : Fondé en 1907 par Lorenz Adlon, utilisé plus tard comme lazaret et foyer pour apprentis puis détruit. Rebâti par Kempinski et ouvert en 1997.
Le « petit plus » : Le spa luxueux.

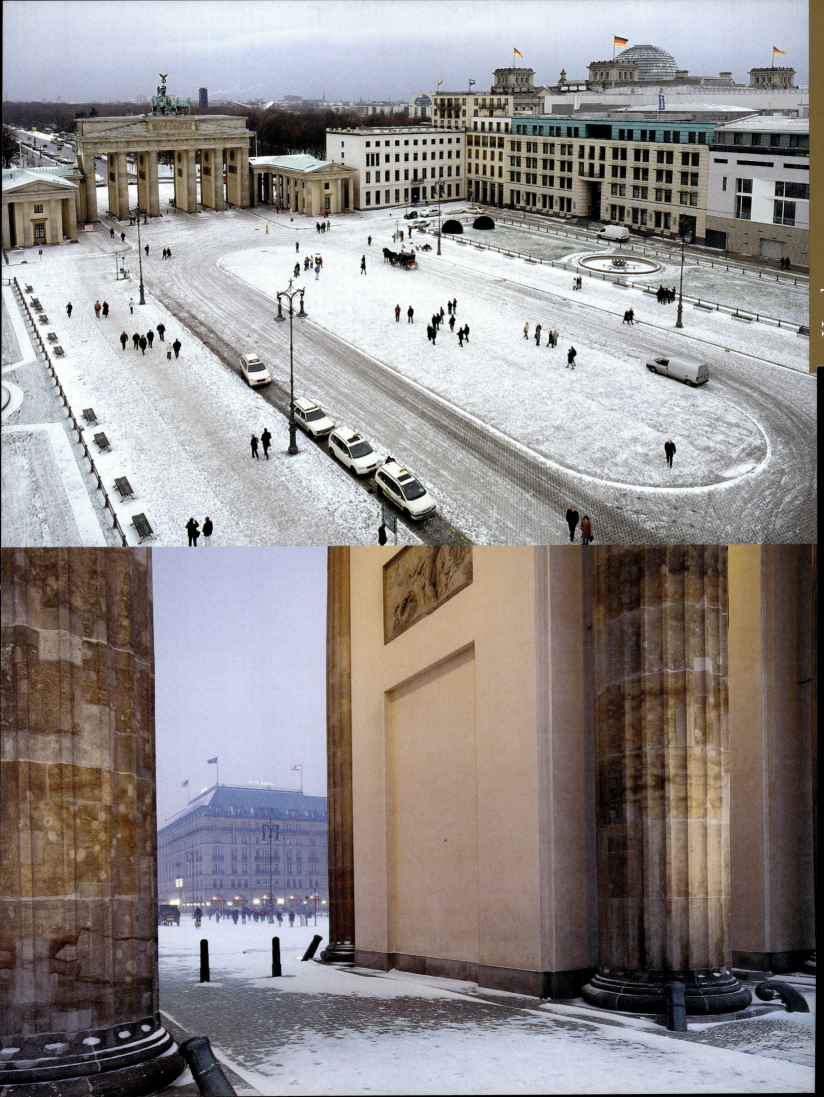

Hotels

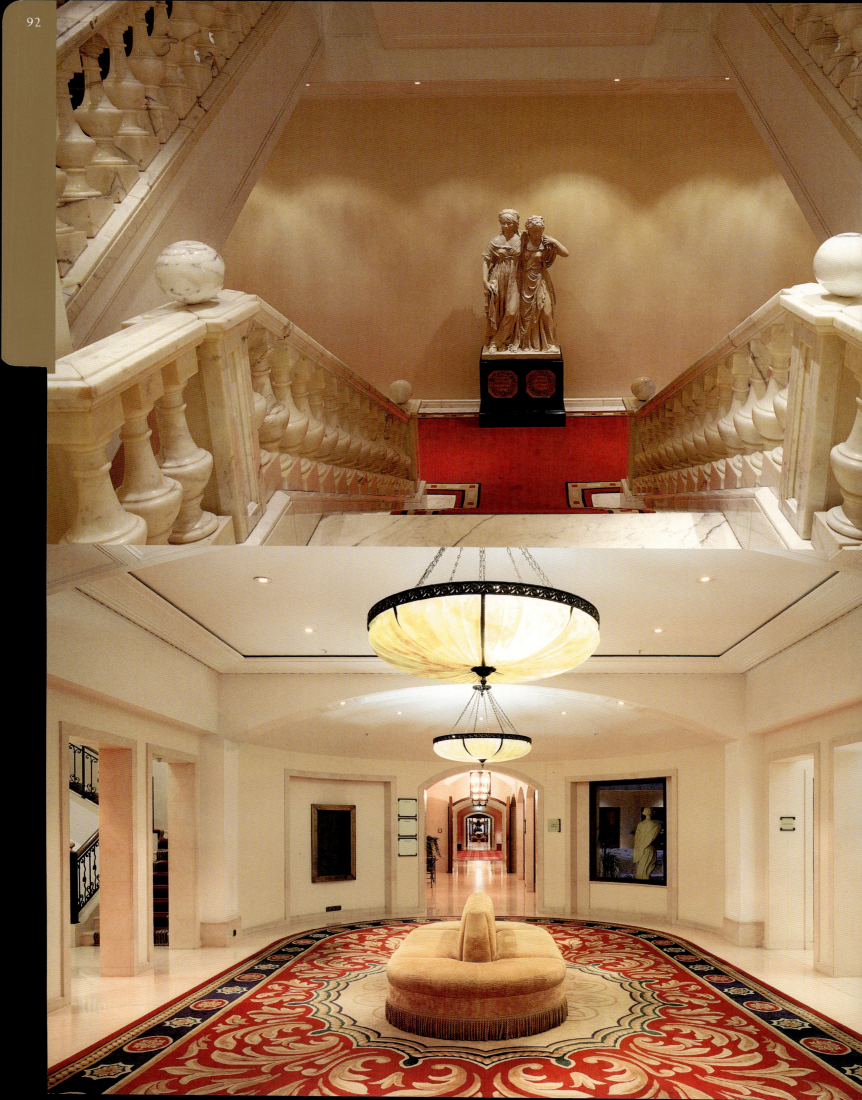

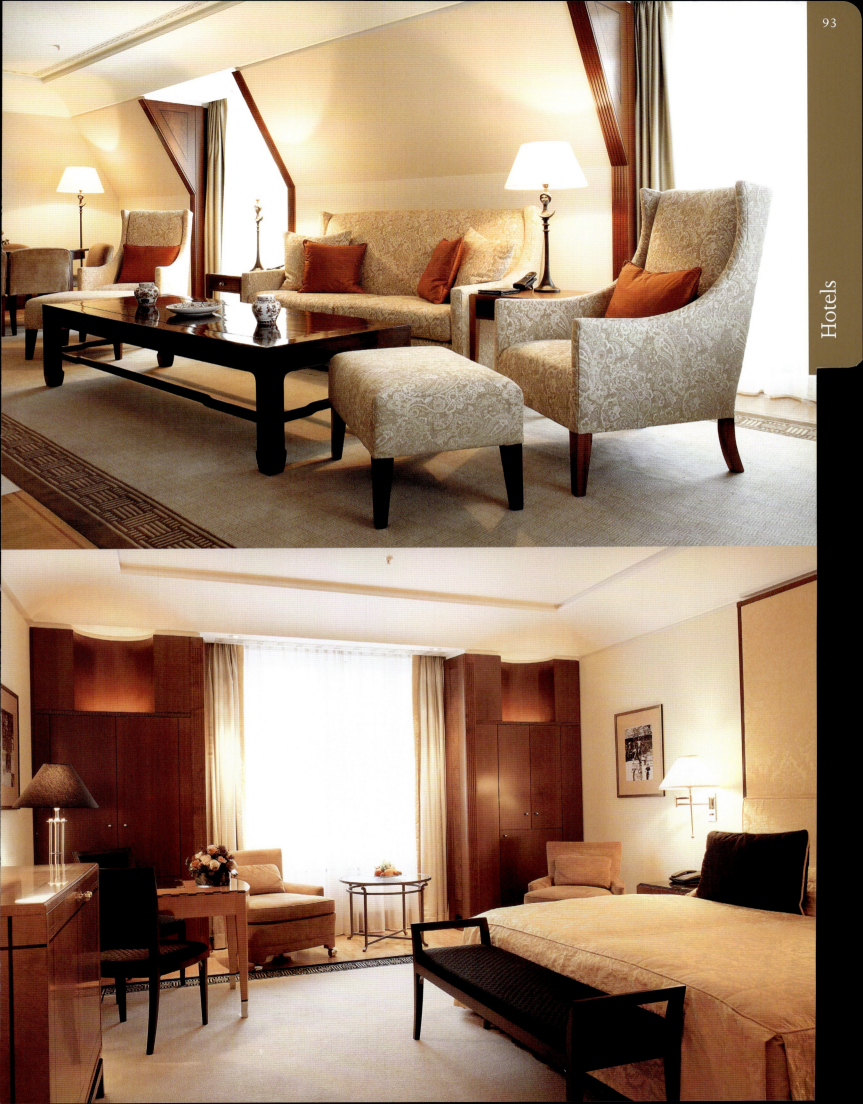

94

Hotel de Rome

Behrenstraße 37, 10117 Berlin
☎ +49 30 46 06 09-0 📠 +49 30 46 06 09-20 00
info.derome@roccofortecollection.com
www.roccofortecollection.com
www.hotelderome.com
Ⓢ Ⓤ Friedrichstraße

This 1889 building used to be a bank and was opened as a hotel in 2006. Its most attractive feature is its superb location, on Bebelplatz, opposite the Humboldt University and the State Opera. To the left is the former royal library, and St Hedwig's Cathedral is nearby. The square has a fantastic collection of landmarks – but also a dark history: it was the site of the Nazis' infamous book-burning in 1933. Tommaso Ziffer designed the building's interior, with guidance from Olga Polizzi, and together they have tried to connect the past with the present. The rooms are larger than average and the most attractive are the ones with a view of Bebelplatz, a Neoclassical square. The historical suites retain the original wooden panelling, and you can still see the holes made by shell splinters from the Second World War. The bathrooms have a Roman air, and feature mosaic flooring and limestone washbasins.

Price category: €€€€.
Rooms: 103 rooms, 43 suites.
Restaurants: Restaurant Parioli, Opera Court (tea & coffee), Bebel Bar & Velvet Room, roof terrace.
History: The Dresdner Bank was located in this complex, which was built in 1889, until 1945. Hotel de Rome opened in October 2006 (design: Tommaso Ziffer, Aukett + Heese, Olga Polizzi).
X-Factor: The spa in the former strongroom.

Das Gebäude wurde 1889 errichtet und war früher eine Bank. Der größte Pluspunkt des 2006 eröffneten Hotels ist die Lage am Bebelplatz: Gegenüber liegen Humboldt-Universität und Staatsoper, die Königliche Alte Bibliothek und die St.-Hedwigs-Kathedrale – ein Ensemble zum Dahinschmelzen. Man sollte allerdings nicht verschweigen, dass der Platz eine schreckliche Geschichte hat, denn hier fanden 1933 die Bücherverbrennungen der Nazis statt. Das Innere des Hotels wurde von Tommaso Ziffer unter der Leitung von Olga Polizzi entworfen. Man hat versucht, die Historie mit der Gegenwart zu verbinden. Die Zimmer sind überdurchschnittlich groß; die mit Blick auf den klassizistischen Bebelplatz sind am schönsten. In den historischen Suiten hat man die originalen Holzpaneelen erhalten – samt der Einschüsse von Granatsplittern aus dem Zweiten Weltkrieg. Die Badezimmer haben mit Mosaikböden und Kalksteinwaschtischen einen römischen Touch.

Preiskategorie: €€€€.
Zimmer: 103 Zimmer, 43 Suiten.
Restaurants: Restaurant Parioli, Opera Court (Tee & Kaffee), Bebel Bar & Velvet Room, Dachterrasse.
Geschichte: In dem 1889 erbauten Komplex residierte bis 1945 die Dresdner Bank. Das Hotel de Rome eröffnete im Oktober 2006 (Design: Tommaso Ziffer, Aukett + Heese, Olga Polizzi).
X-Faktor: Das Spa im einstigen Tresorraum.

Érigé en 1889, ce bâtiment abritait jadis une banque. Hôtel depuis 2006, il a pour avantage majeur d'être très bien situé sur la Bebelplatz, devant un ensemble harmonieux qui ne peut pas laisser indifférent : l'université Humboldt et l'Opéra national, l'ancienne bibliothèque royale et la cathédrale Sainte-Edwige. Malheureusement, cette magnifique place s'est également rendue tristement célèbre avec les autodafés de livres par les nazis en 1933. L'intérieur de l'hôtel a été conçu par Tommaso Ziffer sous la direction d'Olga Polizzi dans un désir d'allier l'histoire au présent. Les chambres sont plus grandes que la moyenne et celles avec vue sur la Bebelplatz sont les plus belles. On a conservé dans les suites historiques les lambris d'origine – avec les impacts des grenades de la Seconde Guerre mondiale. Les salles de bains ont un air romain avec leurs mosaïques au sol et leurs petites vasques en pierre calcaire.

Catégorie de prix : €€€€.
Chambres : 103 chambres, 43 suites.
Restauration : Restaurant Parioli, Opera Court (salon de thé et café), Bebel Bar & Velvet Room, toit-terrasse.
Histoire : La Dresdner Bank a résidé jusqu'en 1945 dans ce complexe bâti en 1889. L'Hotel de Rome a ouvert ses portes en octobre 2006 (design : Tommaso Ziffer, Aukett + Heese, Olga Polizzi).
Le « petit plus » : Le spa dans l'ancienne salle des coffres.

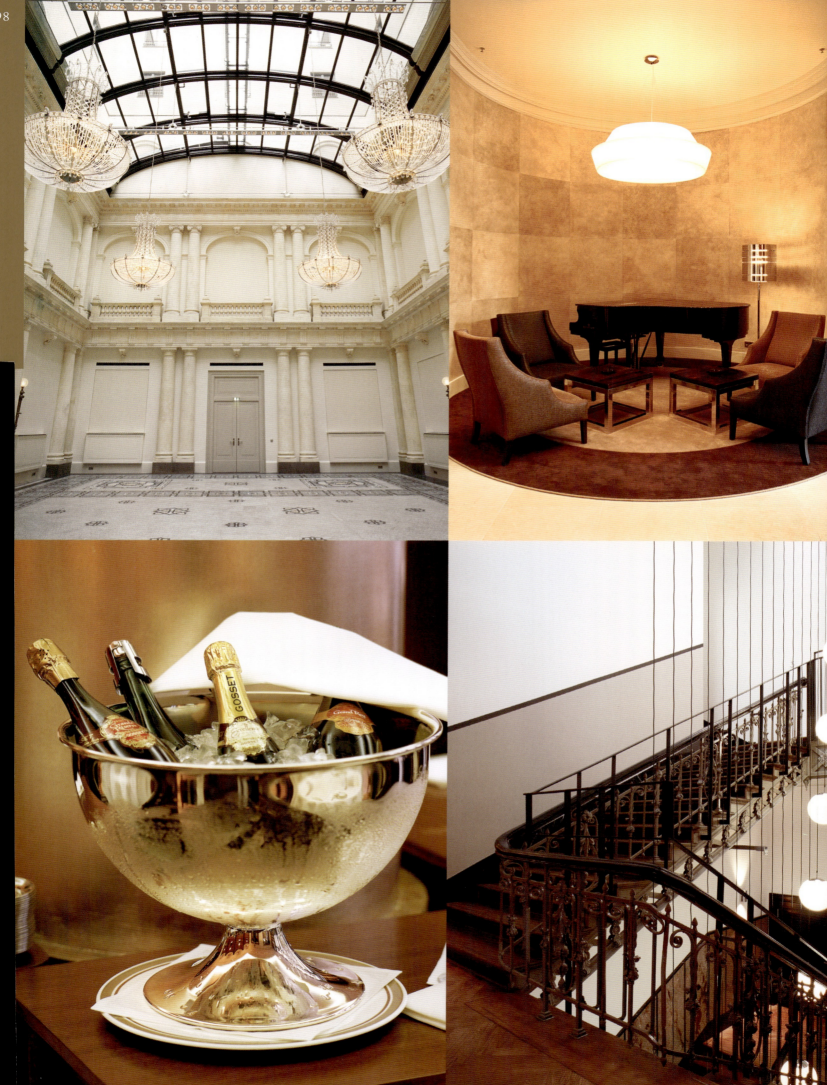

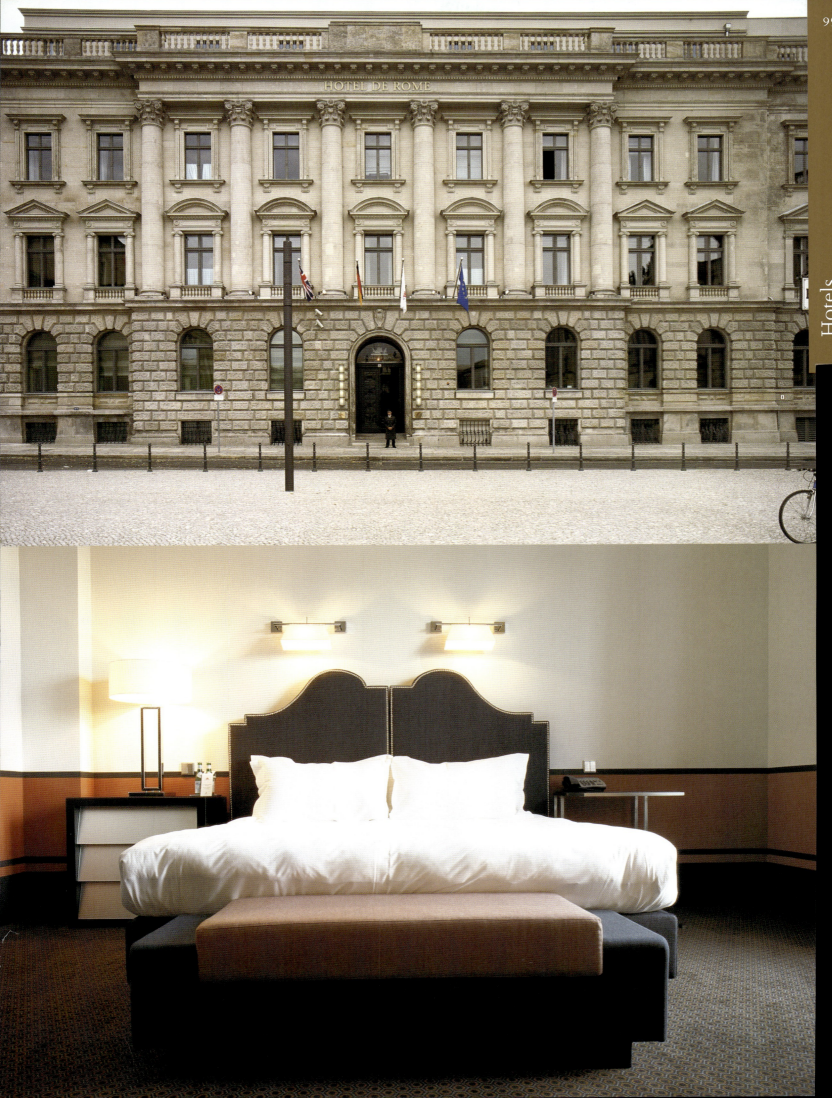

Park Inn Alexanderplatz

Alexanderplatz 7, 10178 Berlin
☎ +49 30 23 89-0 📠 +49 30 23 89-43 05
www.parkinn.com
Ⓢ Ⓤ Alexanderplatz

Park Inn is located on Alexanderplatz at the beginning of Karl-Marx-Allee, the monumental socialist boulevard. Across the street from the hotel is a long block of flats constructed from the large, prefab concrete sections so typical of East German socialist architecture. A quotation from Alfred Döblin's 1929 book "Berlin Alexanderplatz" stretches across the buildings. The Park Inn is the tallest hotel in Berlin, 150 metres high with 37 floors. It was an Interhotel of the Socialist Republic until 1989. "From the Party to the party," say Berliners, who rent rooms for festivities on the top floor, with its splendid panoramic view of Berlin. Be sure to reserve a room facing the television tower and below the 25th floor, as the rooms have so far been refurbished only up to this level. The new décor, with warm chocolate brown and beige hues, makes the rather small rooms appear more spacious, and the modern bathrooms are tiled with sand-coloured marble.

Price category: €€.
Rooms: 1012 rooms, 23 suites.
Restaurants: Humboldt's Restaurant, Zille-Stube, Zille-Garten, Spagos Bar & Lounge, Club & Bar 37 (in the Casino, on the 37th floor).
History: The Interhotel Stadt Berlin opened in 1970, and after reunification it was renamed the Forum Hotel. It has been known as Park Inn since 2003.
X-Factor: The hotel is the second-tallest building in the city, after the television tower.

Das Park Inn liegt am Alexanderplatz und zu Beginn der Karl-Marx-Allee, der Prunkmeile des Sozialismus. Gegenüber vom Hoteleingang, über einen ganzen Plattenbaublock geschrieben, liest man ein Zitat aus Alfred Döblins Buch „Berlin Alexanderplatz" von 1929. Das Haus ist mit über 150 Metern auf 37 Etagen verteilt das höchste Hotel in Berlin. Bis 1989 war das Park Inn ein Interhotel der sozialistischen Republik. Unter dem Motto „von der Partei zur Party" mieten hier Berliner heute gern Zimmer in den oberen Etagen für Feste, da man von hier eine gigantische Aussicht über Berlin hat, vor allem bei Nacht. Man sollte aber unbedingt ein Zimmer bis zur 25. Etage Richtung Fernsehturm nehmen, da bisher nur bis zu dieser Etage die Zimmer renoviert wurden. Durch die Neugestaltung wirken die sonst eher kleinen Zimmer großzügiger, alles ist in harmonischen, warmen Tönen von Schokobraun bis Hellbeige gehalten, die modernen Bäder sind mit sandfarbenem Marmor gefliest.

Le Park Inn est situé sur l'Alexanderplatz, au début de la Karl-Marx-Allee, la somptueuse artère socialiste. En face du hall d'entrée de l'hôtel, on peut lire sur une dalle de béton une citation d'Alfred Döblin, extraite de son livre « Berlin Alexanderplatz » de 1929. Ancien Interhotel de la République socialiste jusqu'en 1989, le Park Inn est avec ses 150 m et 37 étages l'hôtel le plus haut de Berlin. Fidèles à la devise « du parti à la (surprise)-partie », les Berlinois d'aujourd'hui aiment réserver des chambres dans les derniers étages pour y faire la fête, car on a de là-haut une vue absolument extraordinaire sur Berlin, surtout la nuit. Mais il faut absolument prendre une chambre entre le premier et le 25e étage, face à la Tour de télévision, car les chambres au-delà du 25e étage ne sont pas encore rénovées. Grâce au réaménagement, les chambres plutôt petites paraissent plus grandes, tout a été décoré harmonieusement dans des tons chauds de chocolat et beige clair, les salles de bains sont modernes et recouvertes de marbre couleur sable.

Preiskategorie: €€.
Zimmer: 1012 Zimmer, 23 Suiten.
Restaurants: Humboldt's Restaurant, Zille-Stube, Zille-Garten, Spagos Bar & Lounge, Club & Bar 37 (im Casino im 37. Stock).
Geschichte: 1970 wurde das Haus als Interhotel Stadt Berlin eröffnet, nach der Wende hieß es Forum Hotel. Seit 2003 ist es ein Park Inn.
X-Faktor: Das Hotel ist nach dem Fernsehturm das zweithöchste Gebäude der Stadt, atemberaubender Ausblick garantiert.

Catégorie de prix : €€.
Chambres : 1012 chambres, 23 suites.
Restauration : Humboldt's Restaurant, Zille-Stube, Zille-Garten, Spagos Bar & Lounge, Club & Bar 37 (au Casino au 37e étage).
Histoire : Baptisé Stadt Berlin en 1970, puis Forum Hotel après 1989. Park Inn depuis 2003.
Le « petit plus » : Cet hôtel est le bâtiment le plus haut de Berlin après la Tour de télévision.

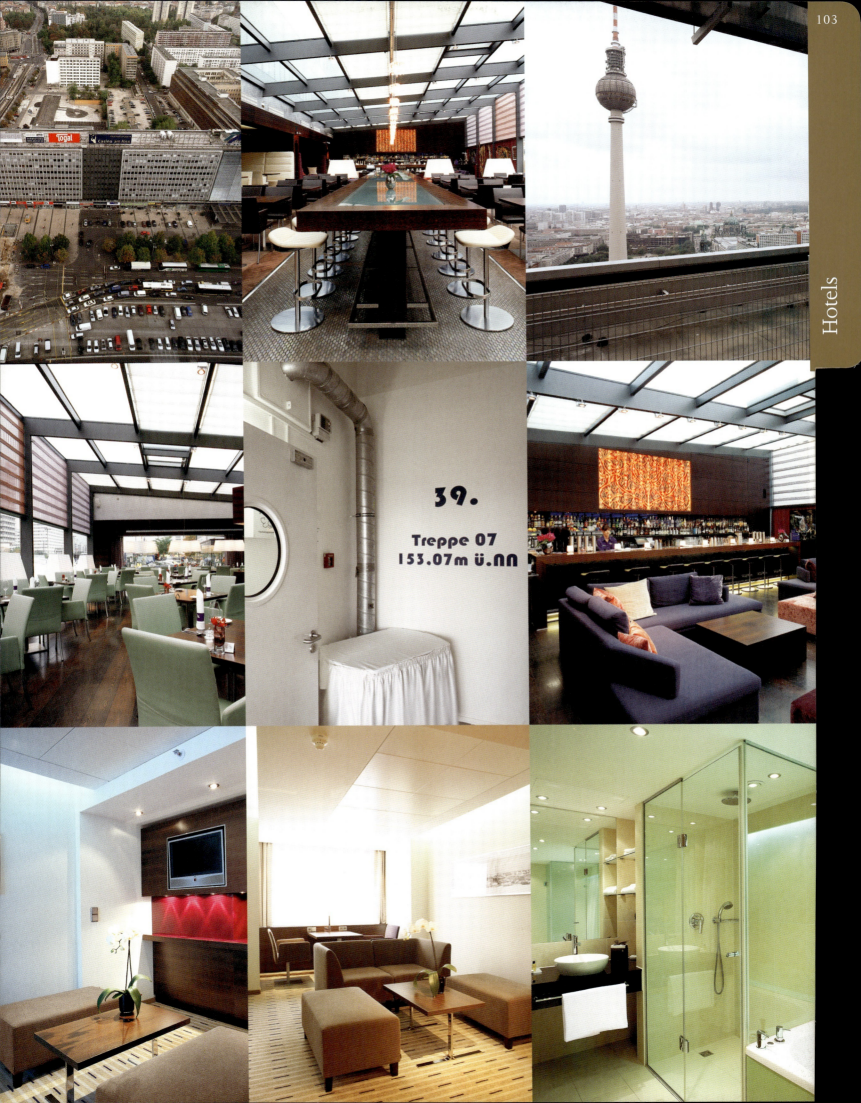

Hotels

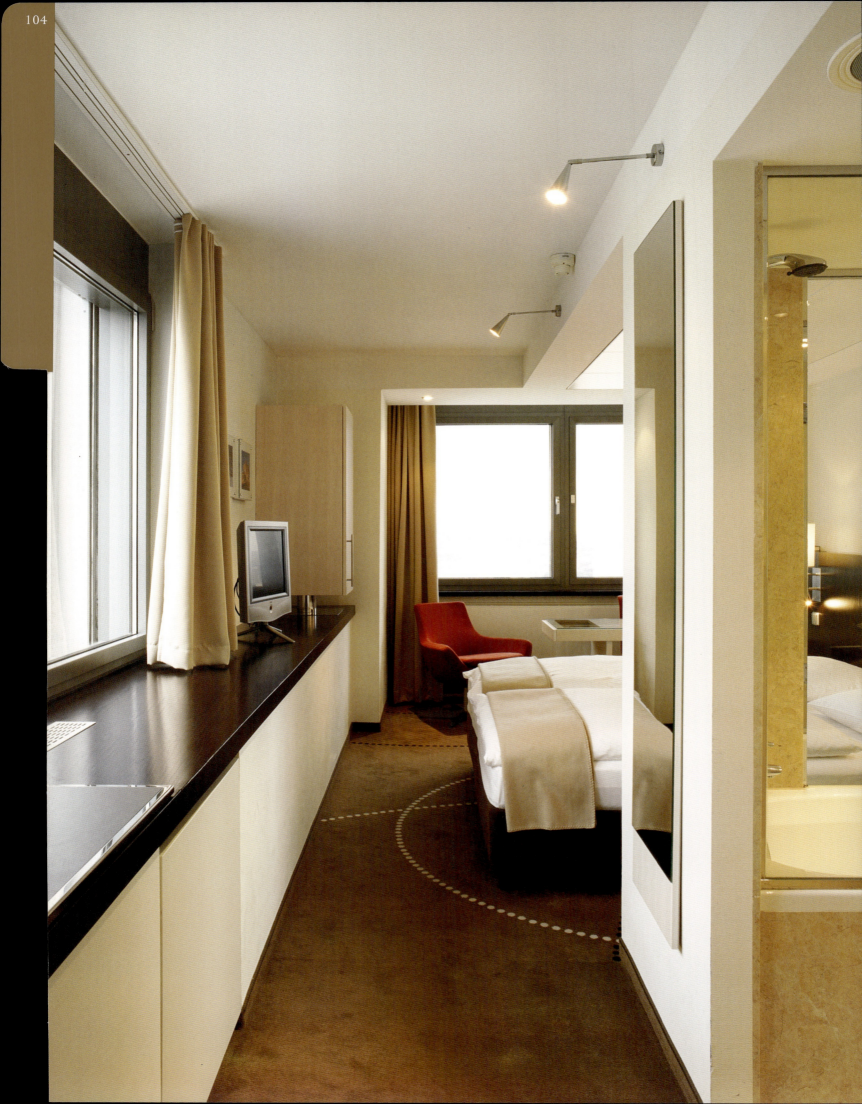

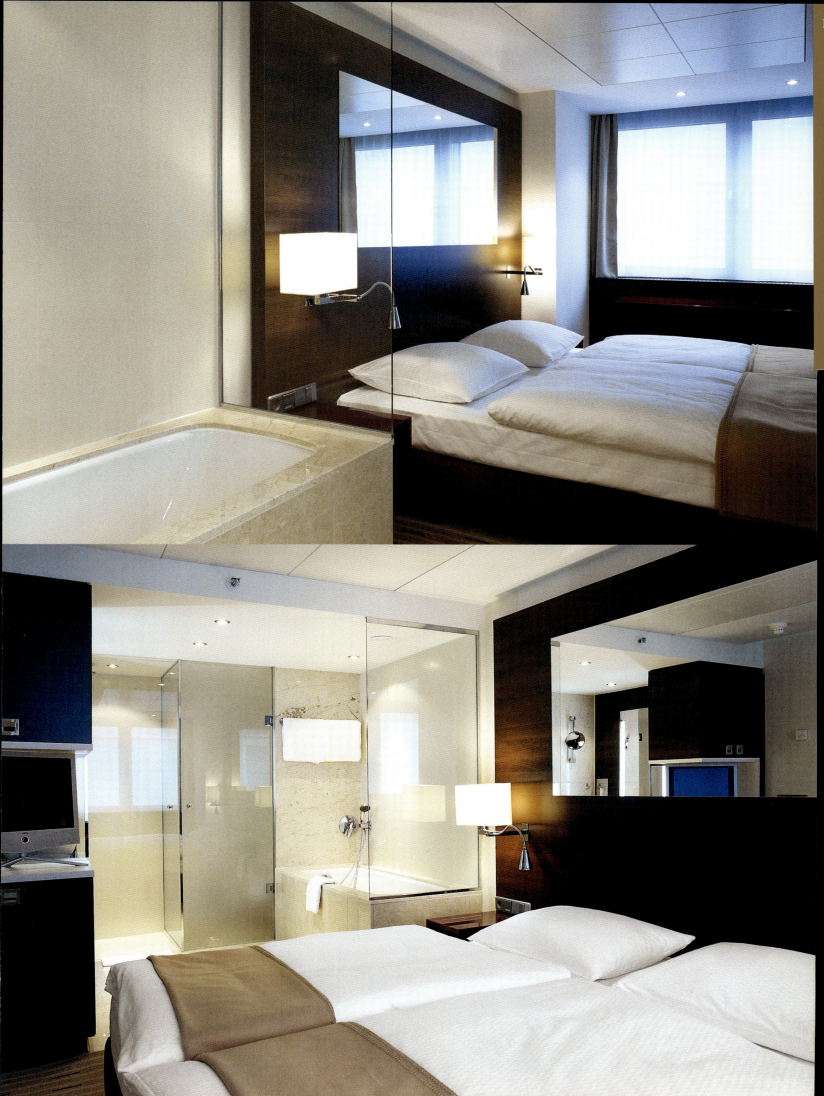

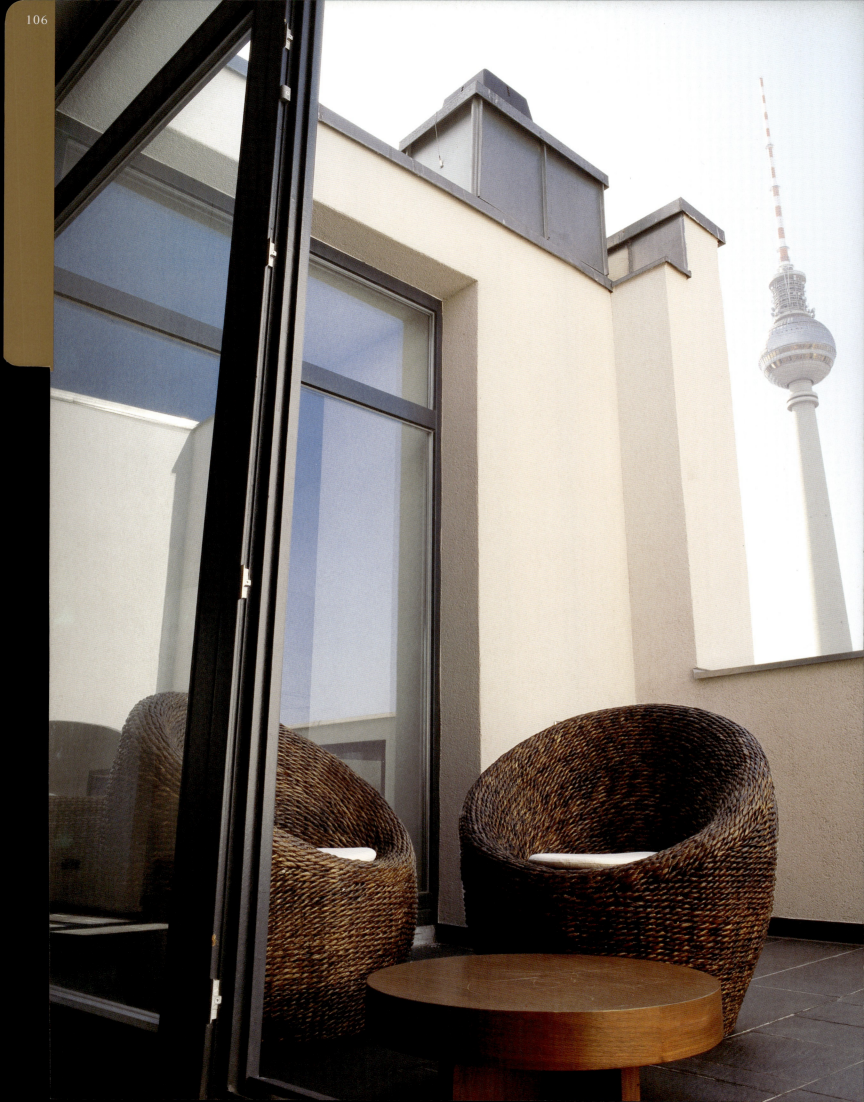

Lux 11

Rosa-Luxemburg-Straße 9–13, 10178 Berlin
☎ +49 30 9 36 28 00 📠 +49 30 93 62 80 80
info@lux-eleven.de
www.lux-eleven.de
Ⓢ Alexanderplatz Ⓤ Alexanderplatz, Rosa-Luxemburg-Platz

The Lux 11 is located in Rosa-Luxemburg-Straße, which is turning into one of the trendiest streets in Berlin. This is the new hip face of Berlin-Mitte, and you'll find a lot of reasons to linger. There are new and interesting restaurants, fashion shops and designer stores, plus the fine architecture of the Volksbühne (one of the most progressive theatres in Germany), and the legendary Babylon cinema. The Lux 11 is an apartment hotel; there is no room service but there are kitchenettes and a laundry room with a washing machine and dryer for guests' use. The rooms are light and spacious, with up-to-date furnishings. Fortunately, the designers chose to install neutral flooring instead of unhygienic carpeting. The Lux 11 has a super-convenient location; from here you can walk to many of Berlin's most attractive sights, restaurants and bars.

Price category: €€€.
Rooms: 72 apartments (25–55 square metres).
Restaurant: Shiro i Shiro (fusion cuisine).
History: The building dates from 1897 and the KGB used to have offices here. Lux 11 opened in July 2005 (design: Claudio Silvestrin, Giuliana Salmaso).
X-Factor: The Aveda spa.

Das Lux 11 liegt in der Rosa-Luxemburg-Straße, die sich gerade zu einer der hippen Straßen von Berlin-Mitte entwickelt. Der Grund: neue, interessante Restaurants, Modeläden und Designerstores, dazu der imposante Bau der Volksbühne und das legendäre Babylon-Kino. Das Lux 11 ist ein Apartmenthaus ohne Roomservice, bietet aber Kitchenettes, einen Raum mit Waschmaschine und Trockner, sodass man sich selbst versorgen kann. Die Zimmer sind hell, geräumig und modern eingerichtet. Dankenswerterweise hat man auf großflächige, unhygienische Teppichböden verzichtet und neutrale Böden verlegt. Vom Lux 11 aus kann man unzählige Berliner Sehenswürdigkeiten zu Fuß besichtigen.

Le Lux 11 est situé dans la Rosa-Luxemburg-Straße, une des rues les plus branchées du moment à Berlin-Mitte. La raison: de nouveaux restaurants intéressants, des boutiques de mode et de design, l'imposante construction de la Volksbühne et le légendaire cinéma Babylon. Le Lux 11 est un hôtel comprenant des mini-appartements sans service dans les chambres, mais proposant des cuisines toutes équipées, une pièce avec machine à laver et sèche-linge, si bien que cette formule requiert une certaine indépendance de votre part. Les chambres sont claires, spacieuses et modernes. Dieu soit loué, on a renoncé à la moquette antihygiénique sur la majeure partie des grandes surfaces et posé un revêtement neutre. Du Lux 11, il est possible d'accéder à pied à de nombreuses curiosités de la ville.

Preiskategorie: €€€.
Zimmer: 72 Apartments (25–55 qm).
Restaurant: Shiro i Shiro (Fusion Cuisine).
Geschichte: In dem Bau aus dem Jahr 1897 war einst der KGB tätig. Das Lux 11 eröffnete im Juli 2005 (Design: Claudio Silvestrin, Giuliana Salmaso).
X-Faktor: Das Aveda-Spa.

Catégorie de prix : €€€.
Chambres : 72 appartements (25–55 mètres carrés).
Restauration : Shiro i Shiro (cuisine fusion).
Histoire : Construit en 1897 et occupé autrefois par le KGB. Le Lux 11 a ouvert ses portes en juillet 2005 (design : Claudio Silvestrin, Giuliana Salmaso).
Le « petit plus » : Le spa Aveda.

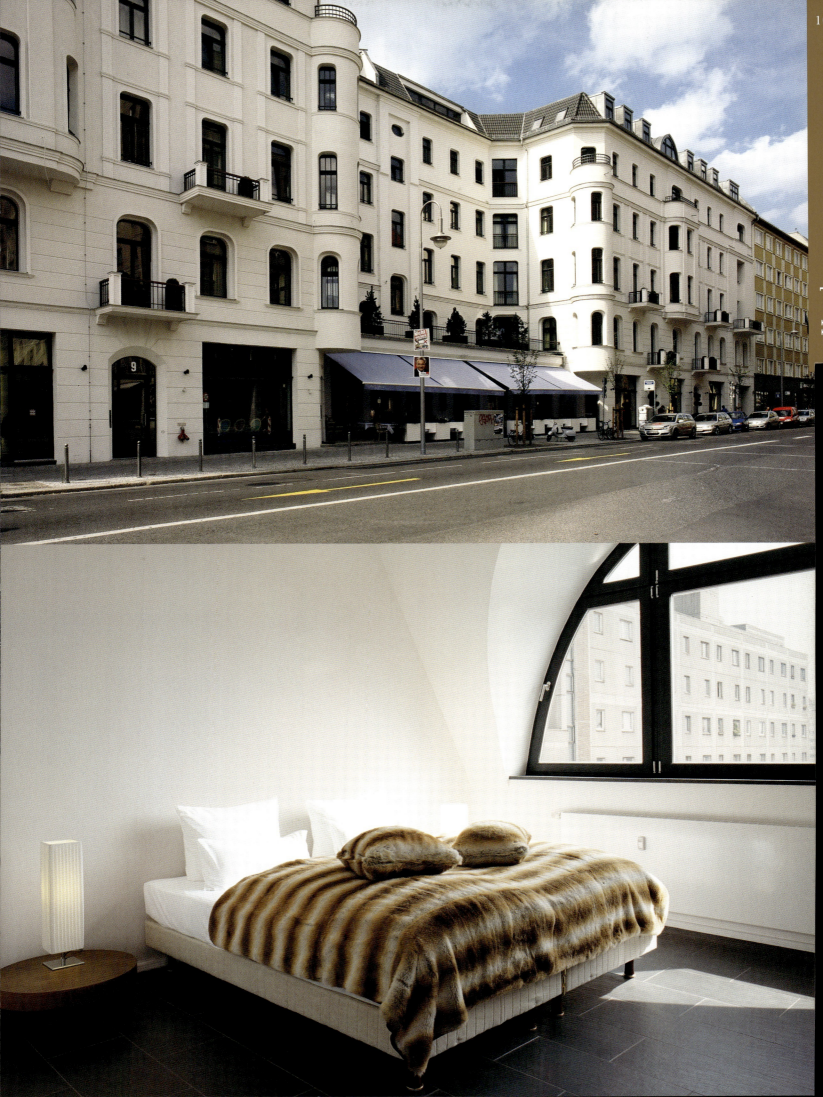

Hotels

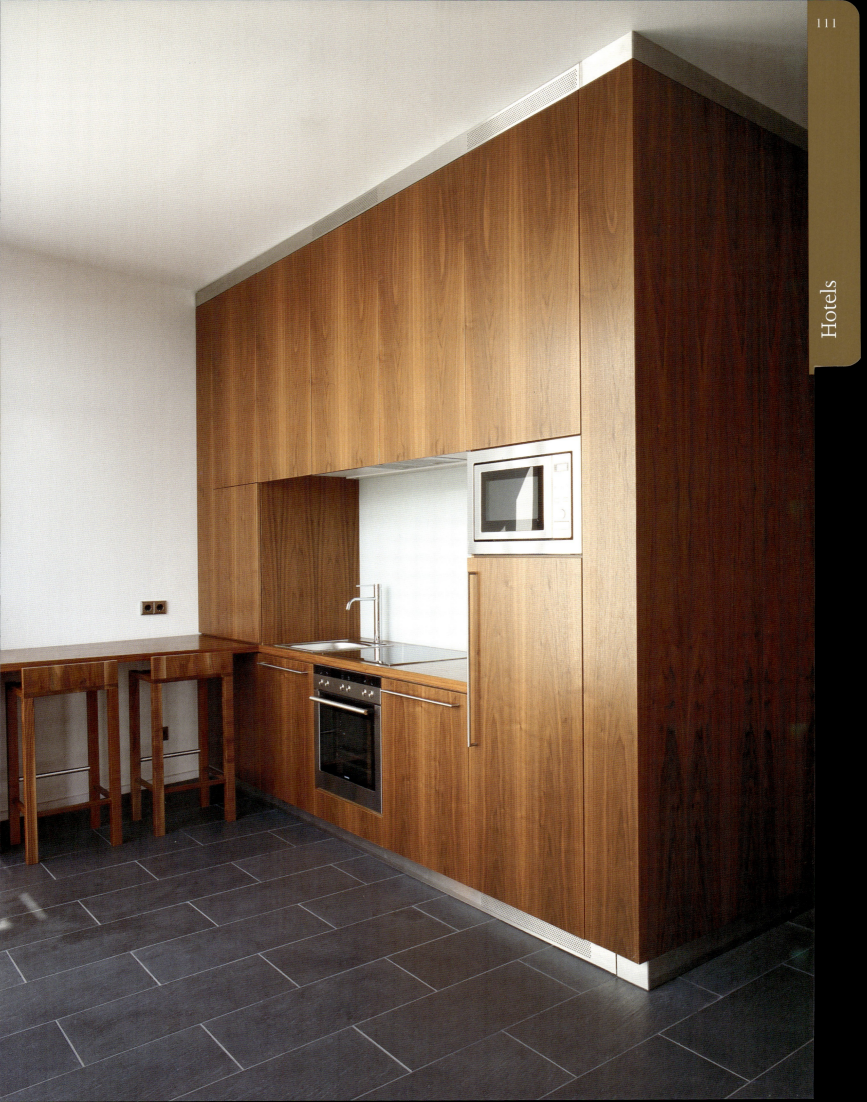

Honigmond

Tieckstraße 11, 10115 Berlin
☎ +49 30 28 44 55-0 ✉ +49 30 28 44 55-11
info@honigmond.de
www.honigmond.de
Ⓢ Nordbahnhof Ⓤ Oranienburger Tor

This corner building dates from 1899 and was lovingly refurbished a few years ago. It's steeped in history: one of the favourite meeting places of the GDR opposition, the pub Borsig-Eck, used to be here. Songwriter Wolf Biermann was a regular, and so were Eva-Maria and Nina Hagen, not to mention the former President of the German Bundestag, Wolfgang Thierse. The Stasi shut the Borsig-Eck down in the mid-1980s, to squash the dissidents' forum. Today, the hotel's wooden floors, original stuccoed ceilings, chandeliers and heavy leather and wooden furniture combine to create a cosy atmosphere. The rooms are decorated with kitschy oil paintings in heavy gold frames (unfortunately, not genuine). Most of the rooms are en suite, but if you want to save some money, you can opt for one with just a washbasin.

Price category: €€.
Rooms: 14 single rooms, 20 double rooms.
Restaurant: Honigmond (hearty food). This is where dissidents like Wolf Biermann would meet in the days of the GDR.
History: In 1998 the hotel was opened on the first floor of a building dating from 1899.
X-Factor: Family-run establishment near Berlin's main train station. Homemade bread at breakfast.

Das Eckgebäude wurde 1899 gebaut und vor ein paar Jahren liebevoll renoviert. Man befindet sich hier auf geschichtsträchtigem Terrain, denn früher gab es an dieser Stelle die Kneipe Borsig-Eck, einen der bevorzugten Treffpunkte der DDR-Opposition. Der Liedermacher Wolf Biermann stand hier ebenso am Tresen wie Eva-Maria und Nina Hagen sowie der ehemalige Bundestagspräsident Wolfgang Thierse. Mitte der 1980er wurde das Borsig-Eck von der Stasi geschlossen, um den Systemkritikern ihr Forum zu entziehen. Im heutigen Hotel schaffen Holzdielenböden, der größtenteils originale Stuck, die großen Kronleuchter und die schweren Möbel aus Leder und Holz eine gemütliche Atmosphäre. Die Räume zieren dicht an dicht gehängte Ölschinken in schweren Goldrahmen (leider nicht echt). Die meisten Zimmer haben ein eigenes Bad. Wer besonders preiswert wohnen möchte, kann mit einem Waschbecken vorliebnehmen.

Rénové avec beaucoup de goût il y a quelques années, ce bâtiment, situé à l'angle de la rue, date de 1899. Les lieux sont chargés d'histoire. En effet, cet hôtel se trouve à l'emplacement de l'ancien bistrot Borsig-Eck, un des rendez-vous favoris des opposants au régime est-allemand. L'auteur-compositeur Wolf Biermann y était souvent accoudé au comptoir, tout comme Eva-Maria et Nina Hagen ainsi que Wolfgang Thierse, ex-président du Bundestag. La Stasi a fermé le Borsig Eck au milieu des années 1980 pour priver les opposants au système de leur forum. Dans l'hôtel actuel, les parquets, la majeure partie des stucs d'origine, les grands lustres et les meubles massifs en bois ou en cuir créent une atmosphère plaisante. Les pièces sont ornées de tableaux (des faux malheureusement) aux lourds cadres dorés et accrochés les uns contre les autres. La plupart des chambres ont une salle de bains. Si vous voulez faire des économies, il faudra vous contenter d'un lavabo.

Preiskategorie: €€.
Zimmer: 14 Einzel-, 20 Doppelzimmer.
Restaurant: Restaurant Honigmond (deftige Küche) – hier trafen sich zu DDR-Zeiten die Oppositionellen wie Wolf Biermann.
Geschichte: Das Hotel wurde 1998 in der Beletage eines Hauses von 1899 eröffnet.
X-Faktor: Familiär geführtes Haus unweit des Berliner Hauptbahnhofes. Selbst gebackenes Brot zum Frühstück.

Catégorie de prix : €€.
Chambres : 14 simples, 20 doubles.
Restauration : Restaurant Honigmond (cuisine rustique) – au temps de la RDA, lieu de rencontre d'opposants au régime.
Histoire : L'hôtel a ouvert ses portes en 1998 au premier étage d'une maison datant de 1899.
Le « petit plus » : Hôtel familial à proximité de la gare centrale de Berlin. Pain fait maison au petit déjeuner.

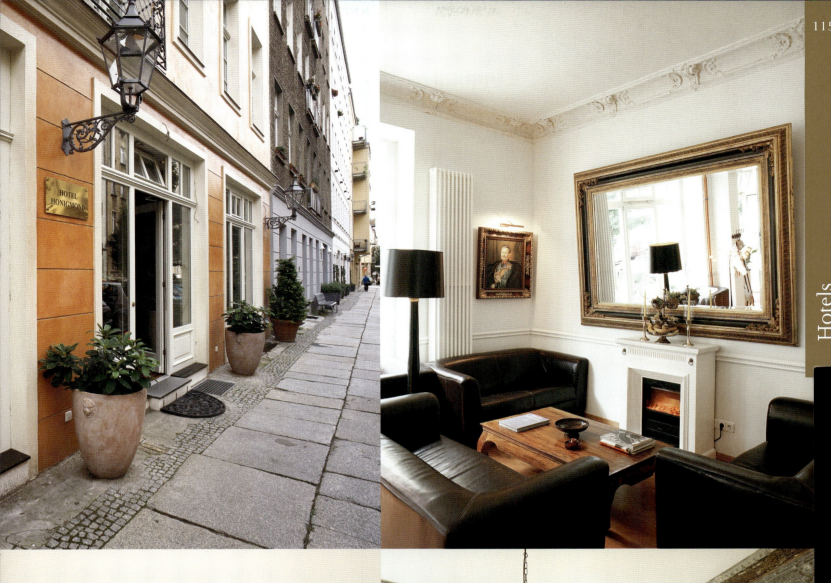

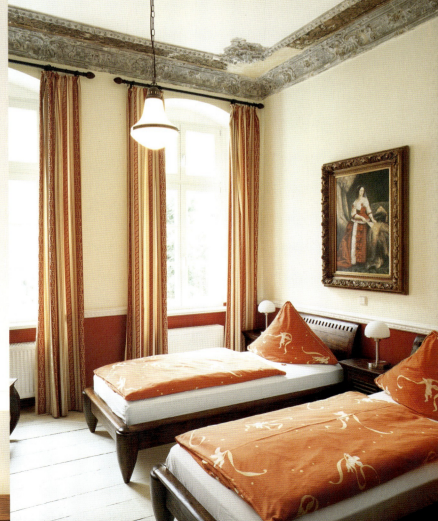

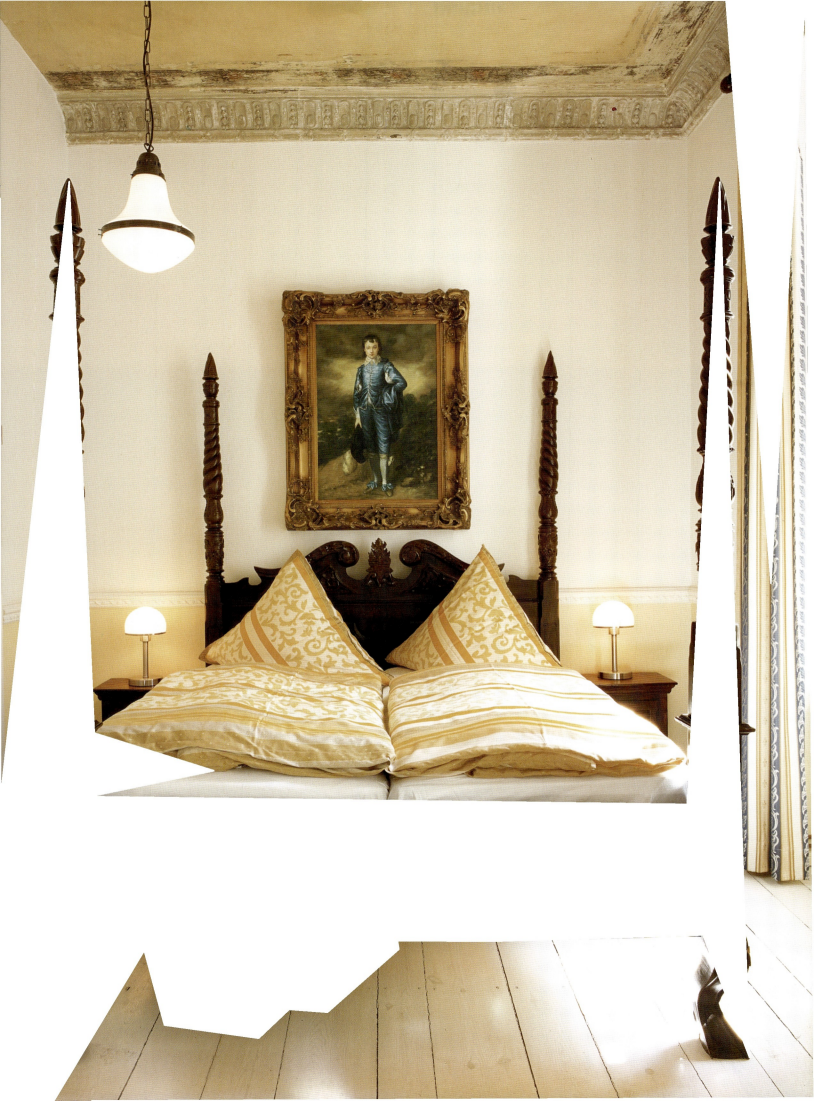

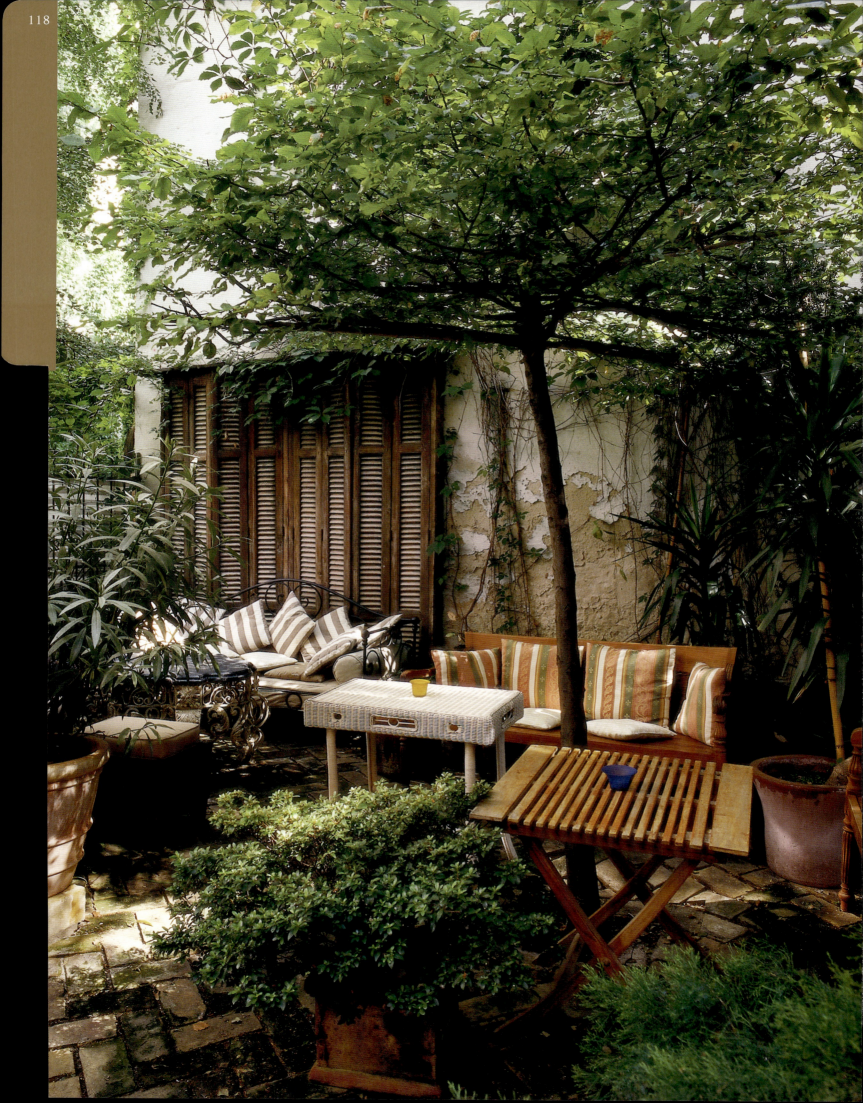

Ackselhaus

Belforter Straße 21, 10405 Berlin
☎ +49 30 44 33 76 33 📠 +49 30 4 41 61 16
info@ackselhaus.de
www.ackselhaus.de
Ⓤ Senefelder Platz

Opened in 2000, Ulf Acksel's boarding house is just a stone's throw from Kollwitzplatz, in one of the most dynamic neighbourhoods in town, only a step away from Berlin-Mitte. The rooms and the idyllic garden have an Italian motif. In 2006 a second guest house was opened with a sea motif. The courtyard of this building has a soothing and peaceful reflecting pool. Next door, the attractive Club del Mar with its wooden furniture and crystal chandeliers serves breakfast for guests. The rooms in the new building are unfussy, modern, not over-designed. Hand-finished teak furniture from Bali, old wooden floors, chandeliers and, in most cases, a kitchenette, make for a comfortable ambience. The bathrooms feature mosaics in different colours, and elegant fittings with rain shower heads by Citterio for Axor. This little oasis in a street lined with old plane trees is a real Berlin gem for travellers who want to relax in a home away from home.

Price category: €€.
Rooms: 35 apartments, some with kitchenettes.
Restaurant: The café Club del Mar with outside tables and a fireplace (only breakfast).
History: The boarding house occupies two buildings from the Gründerzeit (founding era).
X-Factor: Mediterranean flair in Prenzlauer Berg, including an idyllic garden and courtyard with pond.

Das 2000 eröffnete Boarding House von Ulf Acksel liegt einen Steinwurf vom Kollwitzplatz entfernt in einem der beliebtesten Viertel der Stadt mit gleichzeitiger Fußnähe zu Berlin-Mitte. Die Zimmer und der verwunschene Garten kreisen um das Thema Italien. 2006 kam ein zweites Haus hinzu, das das Thema Meer hat. Im Innenhof gibt es einen beruhigend wirkenden Reflecting Pool. Der mit Holzmöbeln und Kristallleuchtern eingerichtete Club del Mar ist wunderschön und dient als Frühstücksraum. Die Zimmer in dem neuen Haus sind äußerst geschmackvoll eingerichtet: schlicht, modern, aber nicht allzu designt. Den Gast erwarten handgefertigte Teakholzmöbel aus Bali, alte Dielenböden, Kristallleuchter, dazu meist eine kleine Kitchenette. Jedes Bad hat Mosaiksteine in einer anderen Farbe mit eleganten Armaturen und Regenduschen von Citterio, die er für Axor entwarf. Diese Oase in einer mit alten Platanen bestandenen Straße ist ein Geheimtipp in Berlin, wenn man entspannen oder sich länger einquartieren möchte.

La pension de Ulf Acksel a ouvert ses portes en 2000. Elle est située près de Berlin-Mitte, à deux pas de la Kollwitzplatz, dans un des quartiers les plus prisés de la ville. Le thème de l'agencement des chambres et du ravissant jardin est l'Italie. À cette maison s'en est ajoutée une deuxième, en 2006, dont le décor est consacré à la mer. Vous trouverez dans la cour intérieure un bassin aux reflets chatoyants et apaisants. Le Club del Mar aménagé de meubles en bois et de lustres en cristal est magnifique et sert de salle pour les petits déjeuners. Les chambres de la nouvelle maison sont décorées avec beaucoup de goût. Des meubles en teck en provenance de Bali, de vieux parquets, des lustres en cristal et, pour la plupart des chambres, un coin cuisine, vous y attendent. Toutes les salles de bains ont des mosaïques au sol dans une couleur différente, des armatures élégantes et des douches pluies dessinées par Citterio pour Axor. Cette oasis placée dans une rue bordée de bananiers est une bonne adresse en dehors des sentiers battus.

Preiskategorie: €€.
Zimmer: 35 Apartments, z.T. mit Küche.
Restaurants: Das Café Club del Mar mit Outdoor-Bereich und Kamin (nur Frühstück).
Geschichte: Aus zwei Gründerzeithäusern wurde ein Boarding House.
X-Faktor: Mediterranes Flair in Prenzlauer Berg – inklusive verwunschenem Garten und Innenhof mit Wasserbassin.

Catégorie de prix : €€.
Chambres : 35 appartements, avec cuisine pour la majeure partie.
Restauration : Le café Club del Mar avec terrasse et cheminée (seulement petit-déjeuner).
Histoire : Une pension est née de deux maisons Gründerzeit.
Le « petit plus » : Ambiance méditerranéenne à Prenzlauer Berg – jardin ravissant et cour intérieure avec bassin.

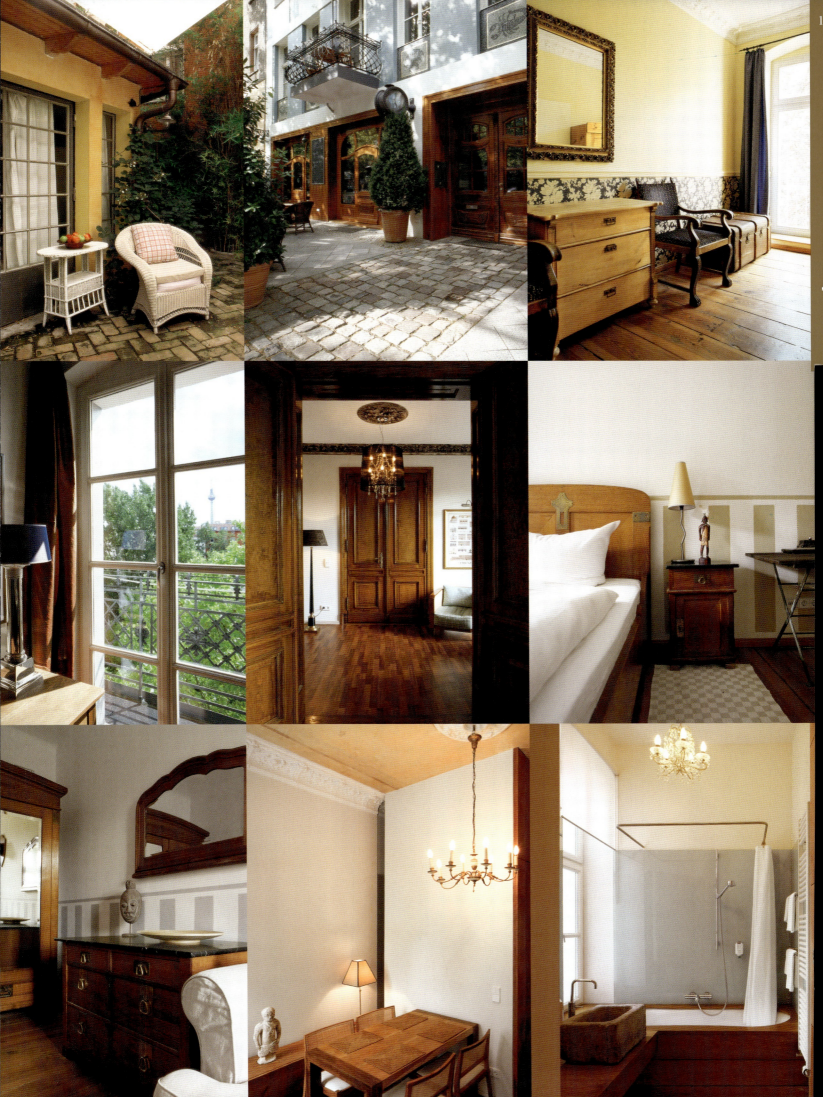

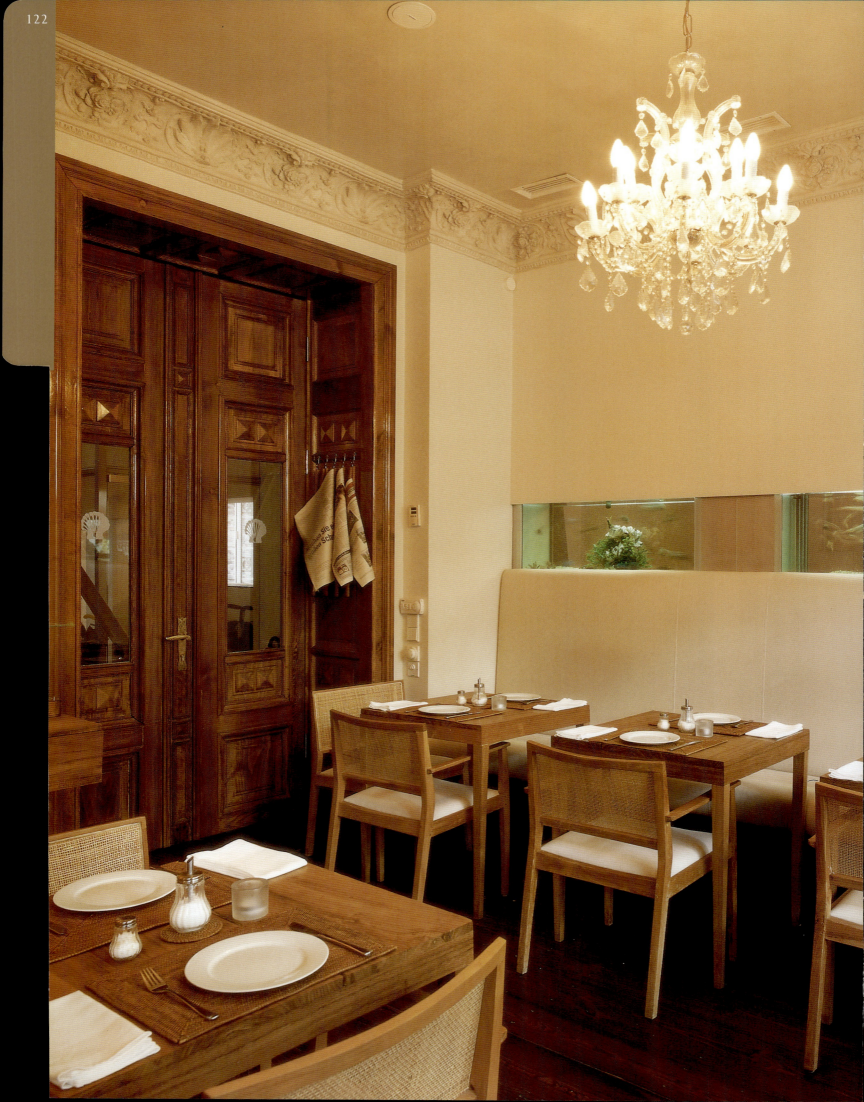

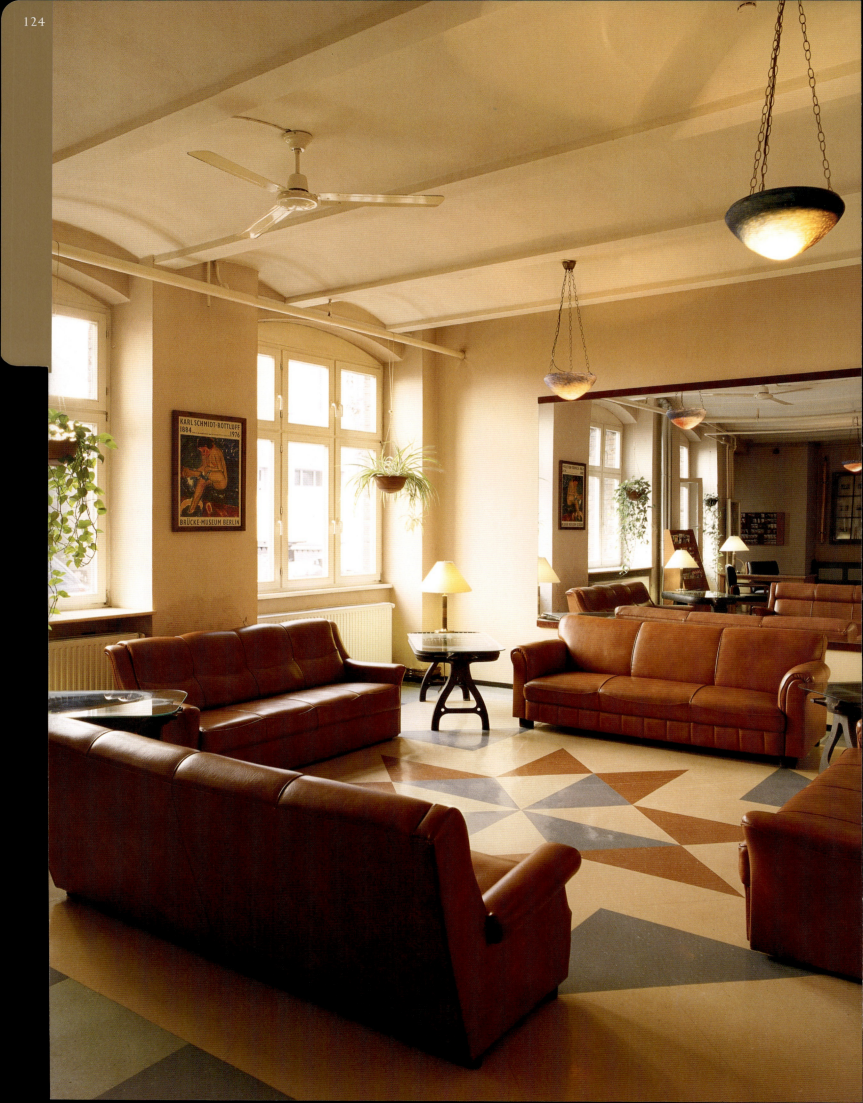

Die Fabrik

Schlesische Straße 18, 10997 Berlin
☎ +49 30 6 11 71 16/6 17 51 04 📠 +49 30 6 18 29 74
info@diefabrik.com
www.diefabrik.com
Ⓤ Schlesisches Tor

Die Fabrik ("The factory") in Schlesische Straße, located between Kreuzberg and Friedrichshain, is one of the most pleasant hostels in Berlin. Schlesische Straße was once a busy high street, but in 1961 it became a dead-end, closed off by the grey concrete of the Berlin Wall. With the Wall gone, Schlesische Straße has had a revival and it's now one of the trendiest streets in Berlin. Here you can find international galleries from Los Angeles and London, new cafés and fashion shops – an exciting, fast-changing scene. Die Fabrik opened in 1995, in an old five-floor factory building. The architects who redesigned it preserved the turn-of-the-century charm and industrial character of the original brick building. Young adventurers from all over the world hang out and swap travellers' tales in the spacious lobby. The hostel, with its colourful linoleum floors and bulky sofas, has a laid-back, international atmosphere. It's convenient, too: Fabrikcafé is right next door.

Price category: €.
Rooms: 14 single rooms, 28 double rooms, 7 three-bed rooms, 3 four-bed rooms, 2 dormitories. No television, telephone or minibar in the rooms.
Restaurant: Breakfast, lunch and dinner in the Fabrikcafé.
History: In 1995 the turn-of-the-century factory building was opened as a hotel with typical Kreuzberg charm.
X-Factor: Frequent concerts and readings.

Eines der angenehmsten Hostels in Berlin ist Die Fabrik in der Schlesischen Straße zwischen Kreuzberg und Friedrichshain. Früher eine belebte Einkaufsstraße, verödete die Schlesische Straße nach dem Mauerbau 1961 zu einer Sackgasse mit Blick auf grauen Beton. Seit einiger Zeit entwickelt sie sich zu einer der trendigsten Straßen Berlins. Man findet hier internationale Galerien aus Los Angeles und London, und es entstehen immer mehr neue Cafés und Modeläden. Die Fabrik wurde 1995 in einem fünfgeschossigen ehemaligen Fabrikgebäude eröffnet. Bei der Umgestaltung des urigen Backsteinbaus bewahrte man den Charme der Jahrhundertwende und den Industriecharakter. In der großzügigen Lobby mit buntem Linoleumboden und wuchtigen Sofas versammeln sich junge Abenteurer aus aller Welt und verleihen dem Ort eine friedliche, polyglotte Atmosphäre. Praktisch: Angegliedert an das Hotel ist das Fabrikcafé.

Die Fabrik est l'un des hôtels les plus agréables de Berlin, situé dans la Schlesische Straße entre Kreuzberg et Friedrichshain. Jadis rue commerçante animée, la Schlesische Straße s'est peu à peu dépeuplée après la construction du Mur en 1961, n'étant plus qu'une impasse avec vue sur le béton. Depuis quelque temps, elle est devenue l'une des rues les plus tendance de la ville. On y trouve des galeries internationales de Los Angeles et Londres, et les cafés et boutiques de mode y poussent comme des champignons. Die Fabrik a ouvert ses portes en 1995 dans une ancienne fabrique de cinq étages. Lors de la rénovation de cette authentique construction en briques, on a préservé son charme fin de siècle et son caractère industriel. De jeunes aventuriers du monde entier se rassemblent dans le grand hall au linoléum de couleur et aux canapés imposants. Ils confèrent à l'endroit une atmosphère paisible et cosmopolite. Pratique : le Fabrikcafé est rattaché à l'hôtel.

Preiskategorie: €.
Zimmer: 14 Einzel-, 28 Doppel-, 7 Dreier-, 3 Viererzimmer, 2 Schlafsäle. Alle ohne Fernseher, Telefon und Minibar.
Restaurant: Im Fabrikcafé gibt es Frühstück, Mittag- und Abendessen.
Geschichte: Das Fabrikgebäude aus der Zeit der Jahrhundertwende wurde 1995 als Hotel mit Kreuzberger Charme eröffnet.
X-Faktor: Regelmäßig finden Konzerte und Lesungen statt.

Catégorie de prix : €.
Chambres : 14 chambres simples, 28 chambres doubles, 7 à trois lits, 3 à quatre lits, 2 dortoirs. Toutes sans téléviseur, téléphone ou minibar.
Restauration : Au Fabrikcafé, on sert les petits déjeuners, déjeuners et dîners.
Histoire : Cet hôtel au charme typique de Kreuzberg a ouvert ses portes en 1995.
Le « petit plus » : Des concerts et des lectures y ont lieu régulièrement.

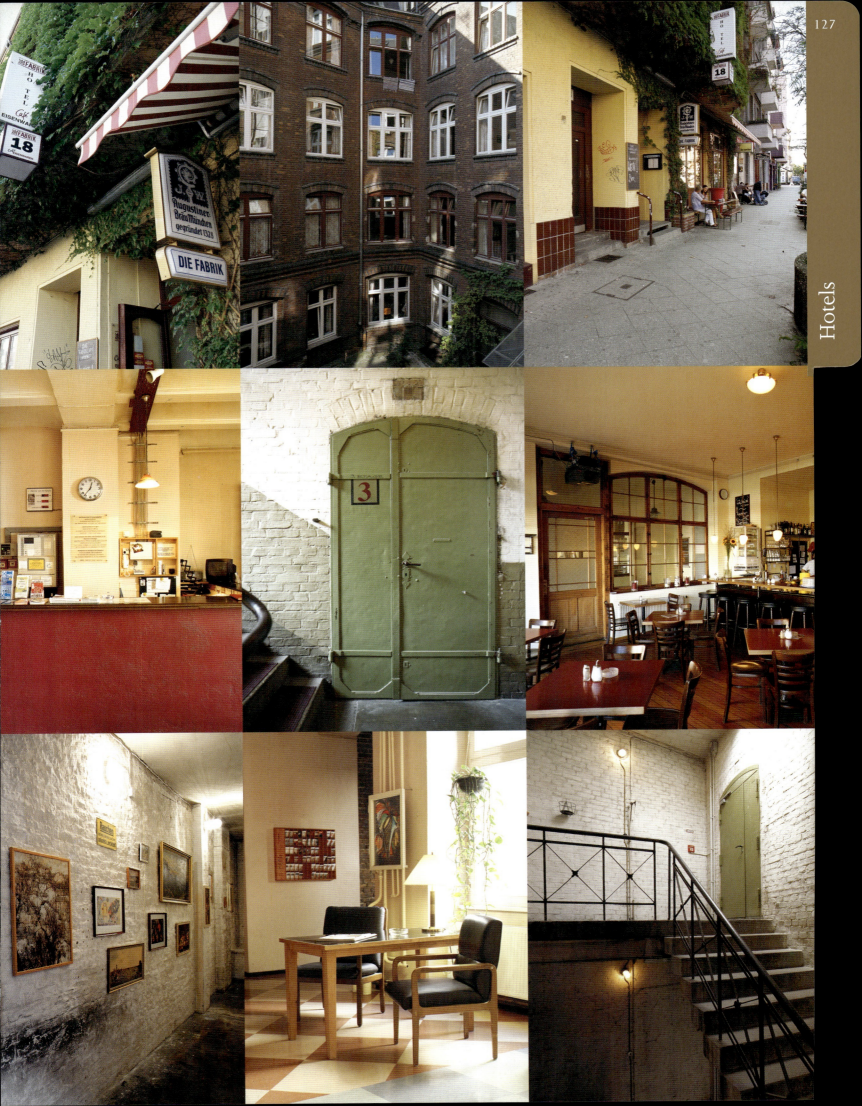

Hotels

Hotels

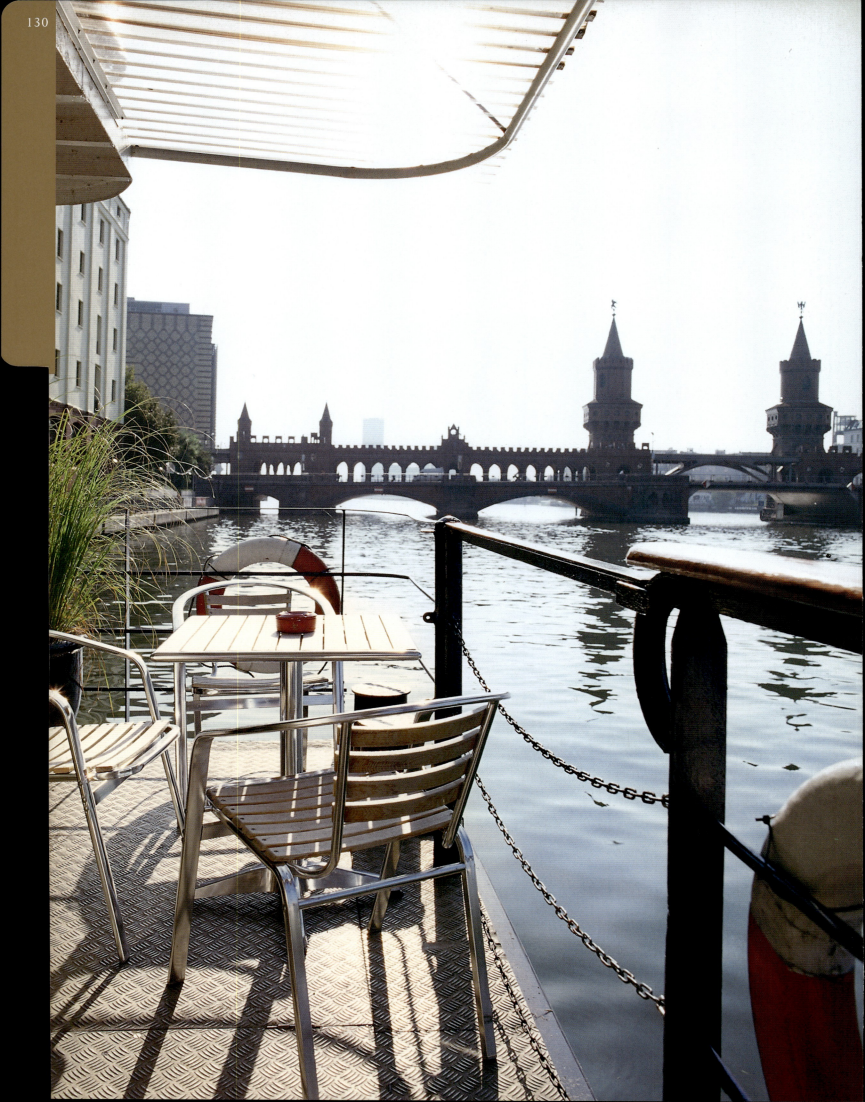

Eastern Comfort Hostelboat

Mühlenstraße 73–77, 10243 Berlin
☎ +49 30 66 76 38 06 📠 +49 30 66 76 38 05
www.eastern-comfort.com
Ⓢ Ⓤ Warschauer Straße

Looking for a romantic experience in Berlin? Why not spend the night on a boat? The hostel boat Eastern Comfort is located on the River Spree between Kreuzberg and Friedrichshain, just ten metres from the East Side Gallery, the longest piece of the Berlin Wall still standing. The guest cabins are cosy. Through the portholes you can see the opposite riverbank lined with weeping willows, and the monumental Oberbaumbrücke. The gentle rocking has a soothing effect and lulls you into a wonderfully deep sleep. In the winter season there is a crackling open fire. If you'd rather sit outside, you can have a blanket to bundle up in. Enjoy the fantastic view, drink a grog to keep you warm, revel in these unforgettable moments. The choice of accommodation ranges from a single cabin on the top deck to a four-bed crew cabin. Be forewarned: non-swimmers won't be accepted as guests.

Price category: €.
Rooms: 8 first-class cabins on the top deck, including bedding; 16 second-class cabins, 1 third-class cabin (bring your own bedding, or hire it).
Restaurant: The lounge on deck.
History: The former Expo-hotel-boat has been anchored on the Spree since 2005.
X-Factor: In summer you can sleep outside on the deck. Room for 2–3 tents.

Sie suchen in Berlin eine romantische Erfahrung? Dann übernachten Sie doch mal auf einem Boot! Seit 2005 liegt das Hostelboat Eastern Comfort auf der Spree zwischen Kreuzberg und Friedrichshain, zehn Meter neben der East Side Gallery, dem längsten erhaltenen Mauerabschnitt der Stadt. Die Kajüten, in denen der Gast übernachtet, sind urgemütlich. Man blickt durch Bullaugen auf das gegenüberliegende, von Trauerweiden bestandene Ufer oder auf die monumentale Oberbaumbrücke. Das leichte Schaukeln hat eine beruhigende Wirkung und verhilft zu besonders tiefem Schlaf. In der kalten Jahreszeit gibt es in der Café-Lounge ein prasselndes Kaminfeuer. Wer sich lieber draußen an Deck einmummeln möchte, bekommt Decken gestellt. Bei einem wärmenden Grog die fantastische Aussicht zu genießen, ist ein unvergessliches Erlebnis. Zur Wahl stehen Einzelkojen im Oberdeck und bis zu Vierbett-Mannschaftskabinen. Wichtig zu wissen: Nichtschwimmer werden als Gäste nicht akzeptiert.

Vous cherchez une expérience romantique à vivre à Berlin ? Alors, passez donc la nuit sur un bateau ! Depuis 2005, le Hostelboat Eastern Comfort se trouve sur la Spree entre Kreuzberg et Friedrichshain, à dix mètres de la East Side Gallery, le plus long vestige du Mur encore conservé. Les cabines réservées aux clients sont très confortables. En regardant par le hublot, vous aurez une vue sur les saules pleureurs de l'autre rive ou sur le pont monumental Oberbaumbrücke. Le léger bercement de l'eau a un effet apaisant et facilite un sommeil profond. En hiver, un feu est allumé dans la cheminée du café lounge. Mais si vous préférez admirer cette vue formidable sur le pont, en buvant un bon grog chaud, vous recevrez des couvertures pour vous emmitoufler. Vous verrez, c'est une expérience inoubliable. Pour la réservation, vous avez un grand choix qui va des couchettes simples sur le pont supérieur aux cabines d'équipage à quatre lits. Important à savoir : les clients ne sachant pas nager ne sont pas acceptés.

Preiskategorie: €.
Zimmer: 8 Kabinen 1. Klasse im Oberdeck inkl. Bettzeug, 16 Kabinen 2. Klasse, 1 Kabine 3. Klasse, dort muss Bettzeug mitgebracht oder geliehen werden.
Restaurant: Lounge am Deck.
Geschichte: Das ehemalige Expo-Hotelboot ankert seit April 2005 auf der Spree.
X-Faktor: Im Sommer kann man auch auf dem Außendeck unter freiem Himmel schlafen. Platz für 2 bis 3 Zelte.

Catégorie de prix : €.
Chambres : 8 cabines de 1ère classe sur le pont supérieur (draps inclus), 16 cabines de 2e classe, 1 cabine de 3e classe (apporter ses draps ou les louer sur place).
Restauration : Lounge sur le pont.
Histoire : Depuis avril 2005 sur la Spree.
Le « petit plus » : Possibilité de dormir sur le pont.

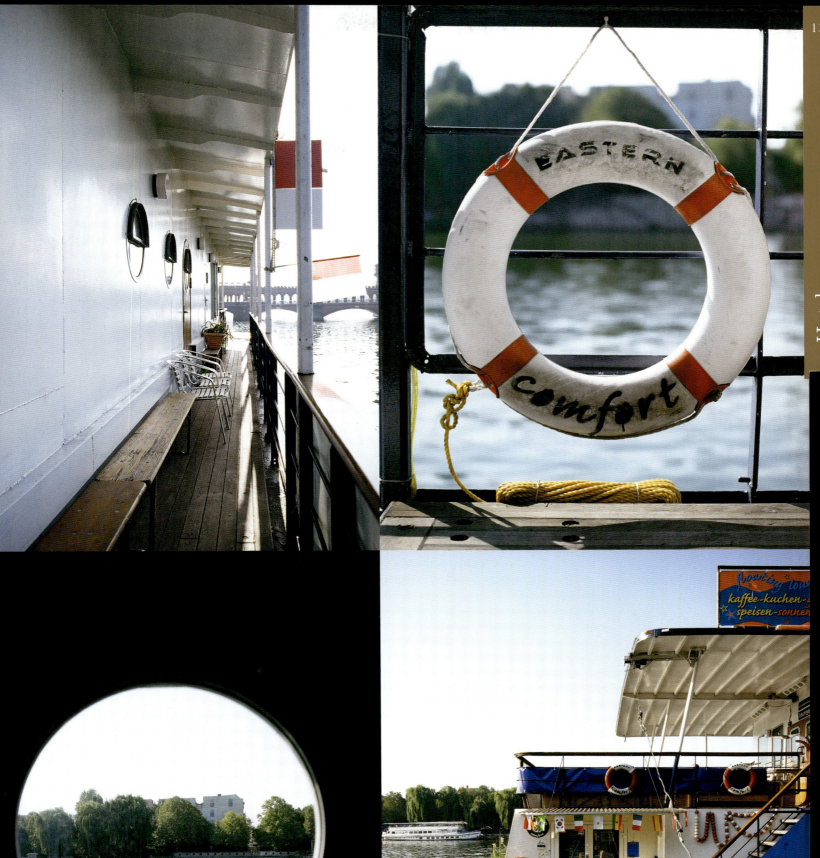

Hotels

Hotels

Hotels

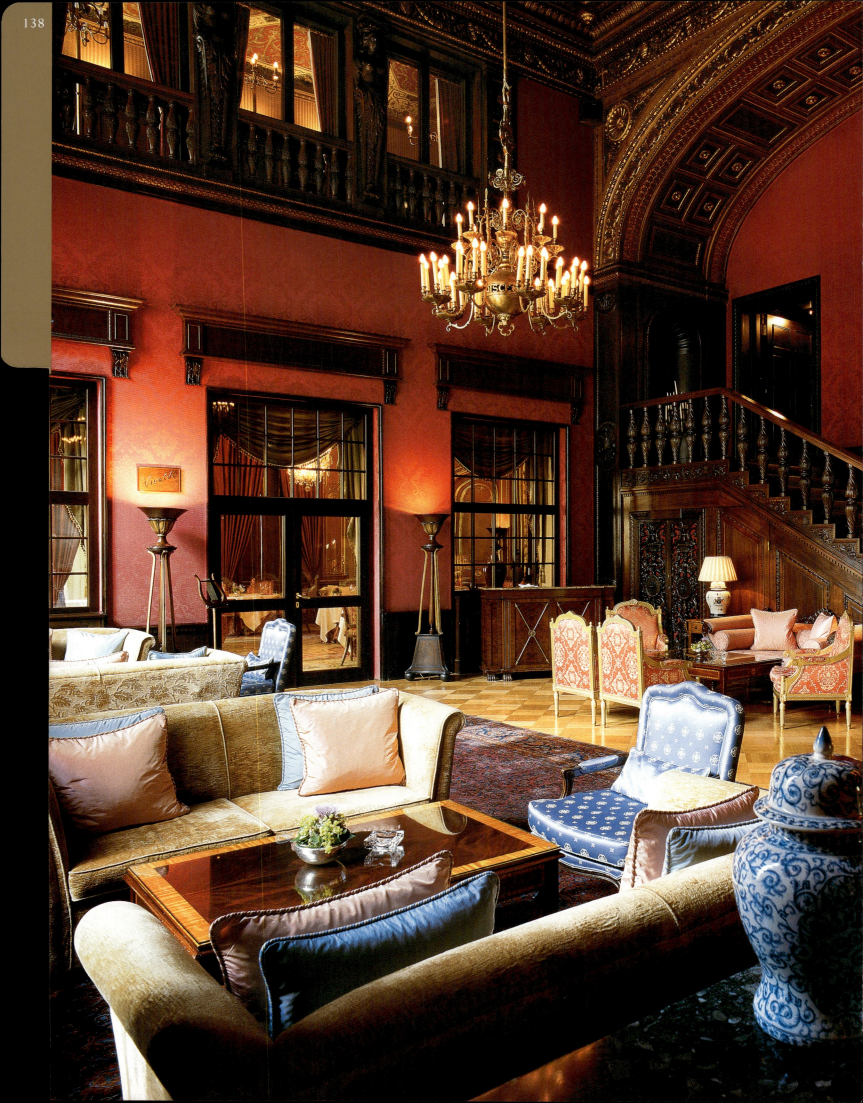

Schlosshotel im Grunewald

Brahmsstraße 10, 14193 Berlin
☎ +49 30 89 58 40 📠 +49 30 89 58 48 00
info@schlosshotelberlin.com
www.schlosshotelberlin.com
Ⓢ Ⓤ Grunewald

This is the best place to stay in Berlin if you are looking for a quiet, pastoral setting. You can walk along the banks of beautiful lakes yet still be close to the bustle of Kurfürstendamm. The mansion was built for Walter von Pannwitz and his art collection in 1912, and it was converted into a hotel in 1951. It has since hosted a panoply of famous guests, from Robert Kennedy and Errol Flynn to Josephine Baker. Romy Schneider got married here – twice. In 1991 the building was closed for renovation, and Karl Lagerfeld signed on to do the interior design. Polish craftsmen restored the antique wooden panelling, bronzes and gilded stucco. The hotel has frequently changed hands since its 1994 reopening. In 2006 it was once again comprehensively refurbished. The simply magnificent Renaissance-style hall is dominated by the Lion Staircase, and it feels just like a museum. Red silk wallpaper adorns the walls and the rooms are all individually furnished in the style of the 18th century.

Price category: €€€€.
Rooms: 42 rooms, 12 suites.
Restaurants: Vivaldi (gourmet), Le Jardin (breakfast), Le Tire Bouchon (bar with open fireplace), Catalina Bar, terrace, garden (only in summer), lobby lounge.
History: In 1994 the former Palais Pannwitz was converted into the Schlosshotel (with interior design by Karl Lagerfeld).
X-Factor: The hot-chocolate treatment in the spa.

Wer sich nach Natur und Ruhe sehnt, kann in Berlin nicht schöner nächtigen. Man kann entlang wunderschöner Seen spazieren gehen und ist trotzdem nicht weit vom quirligen Kurfürstendamm entfernt. Das Schlösschen wurde 1912 für Walter von Pannwitz und seine Gemäldesammlung erbaut; 1951 wurde es zum Hotel umfunktioniert – mit Gästen wie Robert Kennedy, Errol Flynn und Josephine Baker. Romy Schneider heiratete hier gleich zweimal. 1991 wurde das Gebäude zwecks Renovierung geschlossen, und Karl Lagerfeld mit dem neuen Interieur beauftragt. Polnische Handwerker restaurierten die alten Holzvertäfelungen, die Bronzen und den vergoldeten Stuck. Seit der Wiedereröffnung 1994 haben die Besitzer mehrfach gewechselt. 2006 wurde das Hotel erneut umfangreichen Renovierungsarbeiten unterzogen. Grandios ist die museumsartige Halle im Renaissancestil, die von der „Löwentreppe" dominiert wird. Die Wände sind mit roten Seidentapeten aus Lyon bespannt. Die Zimmer sind alle individuell im Stil des 18. Jahrhunderts eingerichtet.

Preiskategorie: €€€€.
Zimmer: 42 Zimmer, 12 Suiten.
Restaurants: Vivaldi (Gourmet), Le Jardin (Frühstück), Le Tire Bouchon (Kaminbar), Catalina Bar, Terrasse und Schlossgarten (nur im Sommer), Lobby Lounge.
Geschichte: Aus dem ehemaligen Palais Pannwitz im Grunewald wurde 1994 das Schlosshotel (Interiordesign: Karl Lagerfeld).
X-Faktor: Die Hot-Chocolate-Behandlungen im Spa.

Si vous aspirez au calme et à la verdure, vous ne pourrez pas passer de plus belle nuit à Berlin. Vous pourrez vous promener le long de lacs magnifiques sans être loin de la vie trépidante du Kurfürstendamm. Cette résidence château a été construite en 1912 pour Walter von Pannwitz et sa collection de tableaux. En 1951, elle est devenue un hôtel qui a accueilli des clients comme Robert Kennedy, Errol Flynn et Josephine Baker. Romy Schneider s'y est même mariée deux fois. En 1991, l'hôtel a été fermé pour travaux de rénovation et Karl Lagerfeld a été chargé du design d'intérieur. Des artisans polonais ont restauré les anciens lambris, les bronzes et les stucs dorés. Depuis sa réouverture en 1994, il a vu défiler de nombreux propriétaires. En 2006, l'hôtel a fait à nouveau l'objet d'importants travaux de rénovation. Dans un style Renaissance et digne d'un musée, le hall dominé par « l'escalier des lions » est grandiose. Les murs sont recouverts de soieries rouges de Lyon. Toutes les chambres sont décorées individuellement dans un style XVIIIe.

Catégorie de prix : €€€€.
Chambres : 42 chambres, 12 suites.
Restauration : Vivaldi (gastronomique), Le Jardin (petit déjeuner), Le Tire Bouchon (bar avec cheminée), Catalina Bar, terrasse et jardin (en été), Lobby Lounge.
Histoire : L'ancien palais Pannwitz à Grunewald est devenu en 1994 le Schlosshotel (décoration intérieure : Karl Lagerfeld).
Le « petit plus » : Soins au chocolat chaud dans le spa.

Hotels

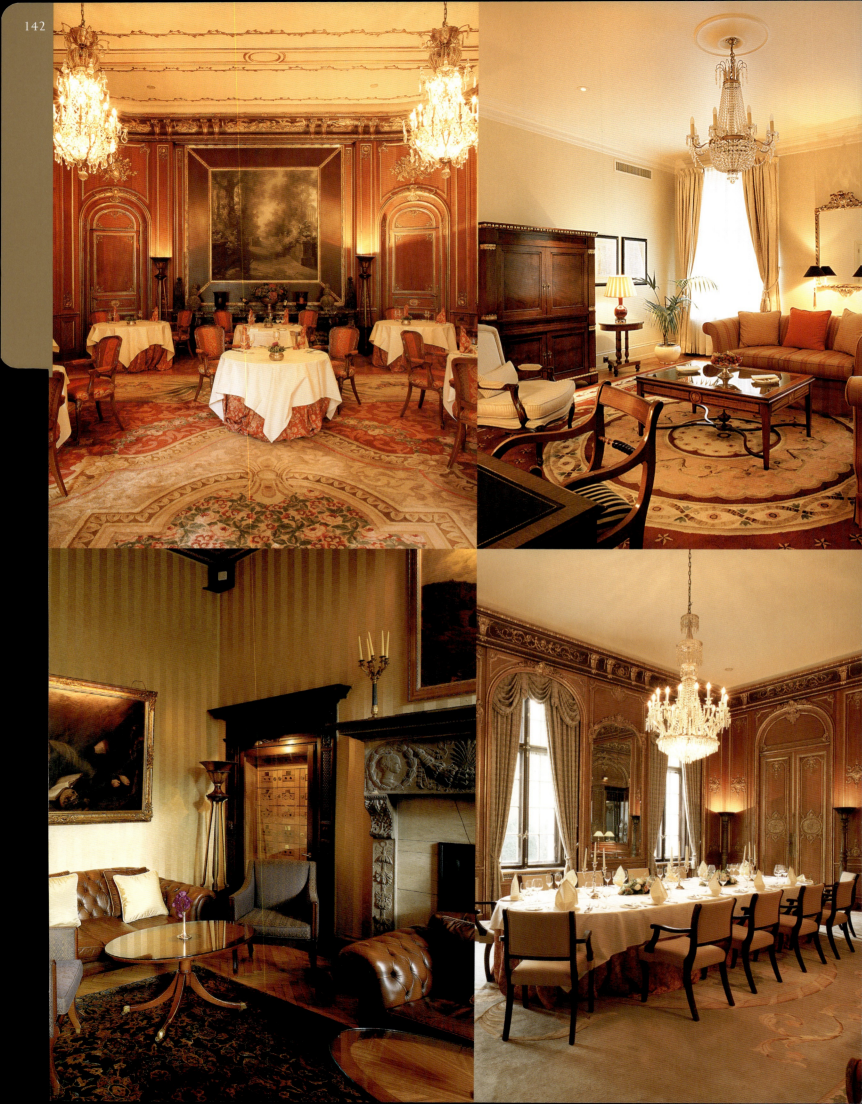

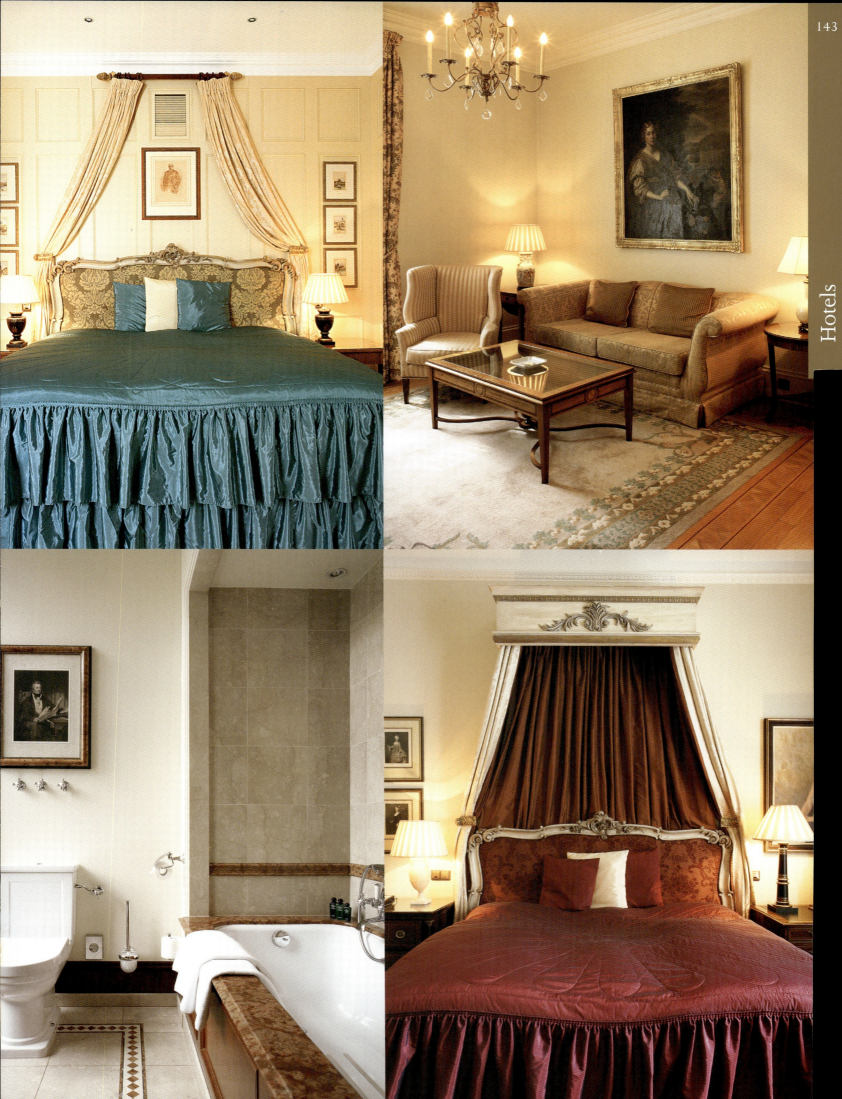

Restaurants

Charlottenburg | Wilmersdorf Schöneberg
- 150 **Times Bar**
- 152 **Paris Bar**
- 156 **Diener Tattersall**
- 160 **Adnan**
- 162 **Café im Literaturhaus**
- 166 **Rum Trader**
- 170 **Galerie Bremer**
- 172 **Manzini**
- 176 **Big Window**
- 180 **Green Door**
- 184 **Café Einstein**

Kreuzberg
- 192 **Henne**
- 198 **Hasir**
- 202 **Ankerklause**

Tiergarten | Mitte
- 208 **Victoria Bar**
- 212 **Edd's**
- 216 **Kumpelnest 3000**
- 220 **Vox Bar**
- 222 **Zur letzten Instanz**
- 224 **Borchardt**
- 228 **Grill Royal**
- 232 **Dolores**
- 236 **Barcomi's Deli**
- 240 **Greenwich**
- 244 **Clärchens Ballhaus**

Prenzlauer Berg
- 250 **Galão A Pastelaria**
- 252 **Der Imbiss W**
- 256 **Prater Garten**
- 262 **Konnopke's Imbiß**
- 264 **Si An**
- 266 **Wohnzimmer**

Friedrichshain
- 272 **Restaurant Schönbrunn**
- 276 **CSA Bar**
- 280 **Miseria e Nobiltà**
- 284 **Schneeweiß**

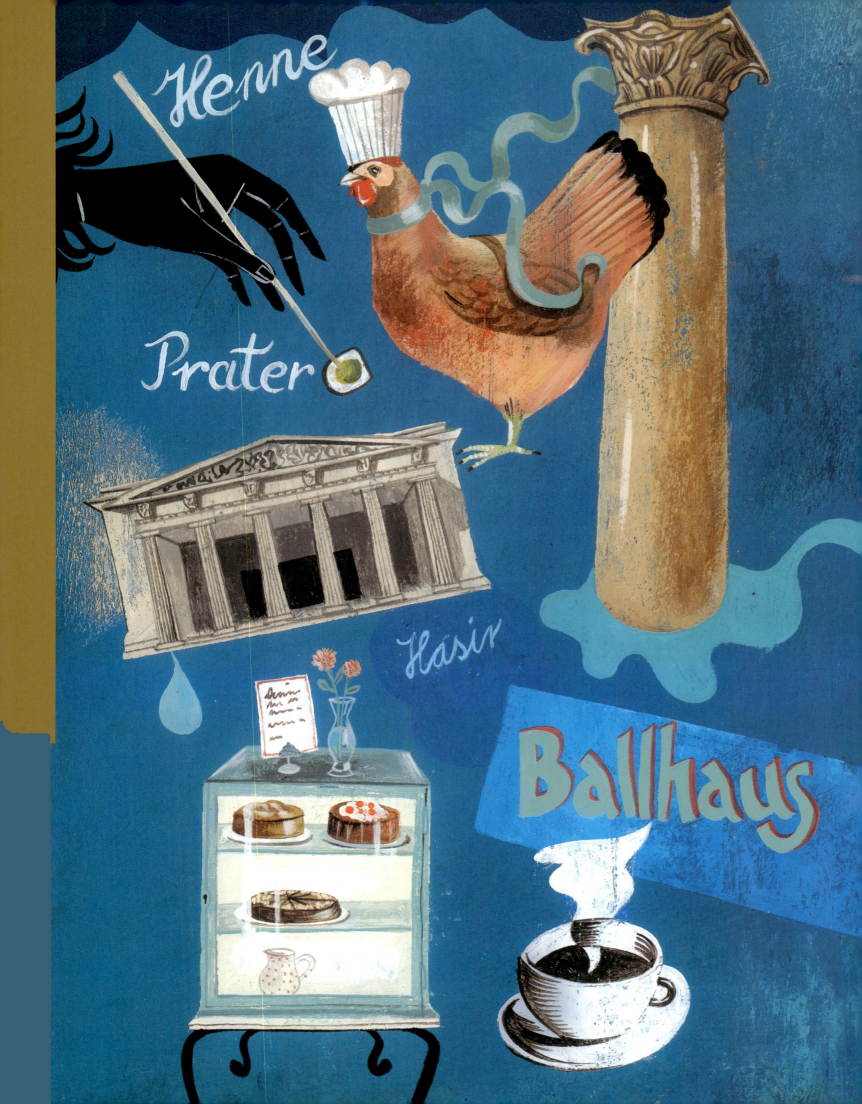

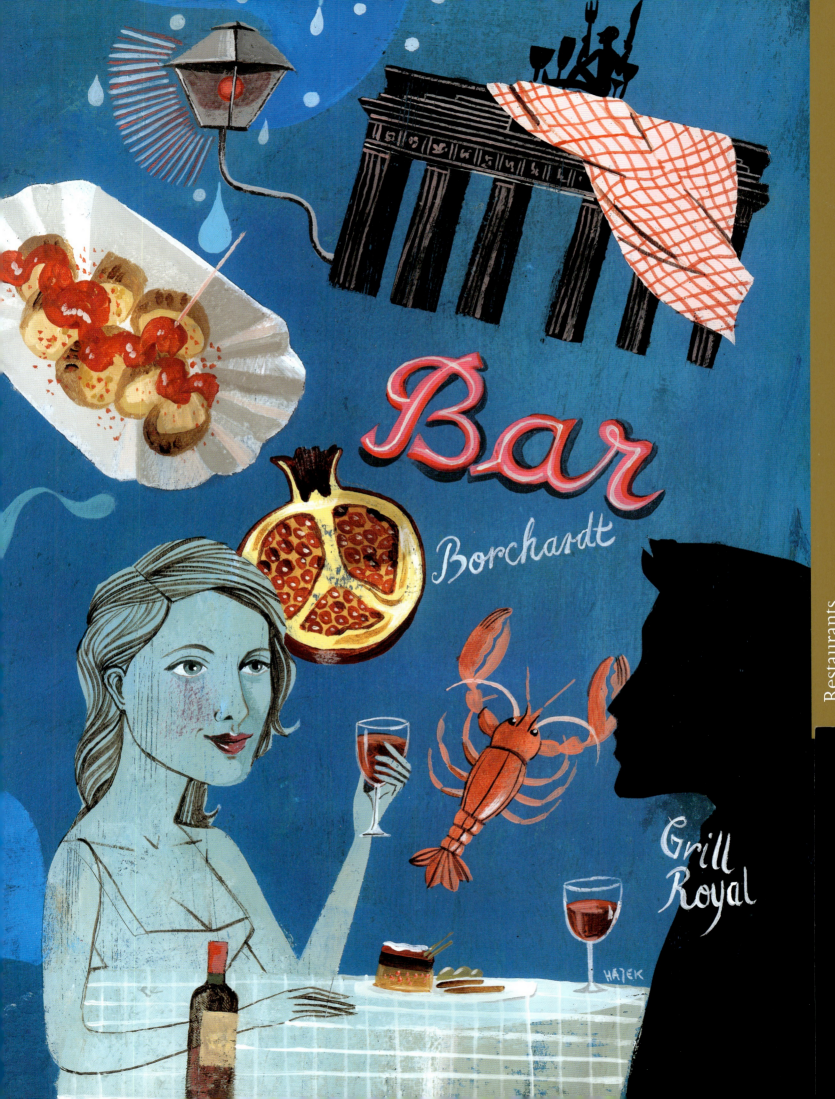

Restaurants

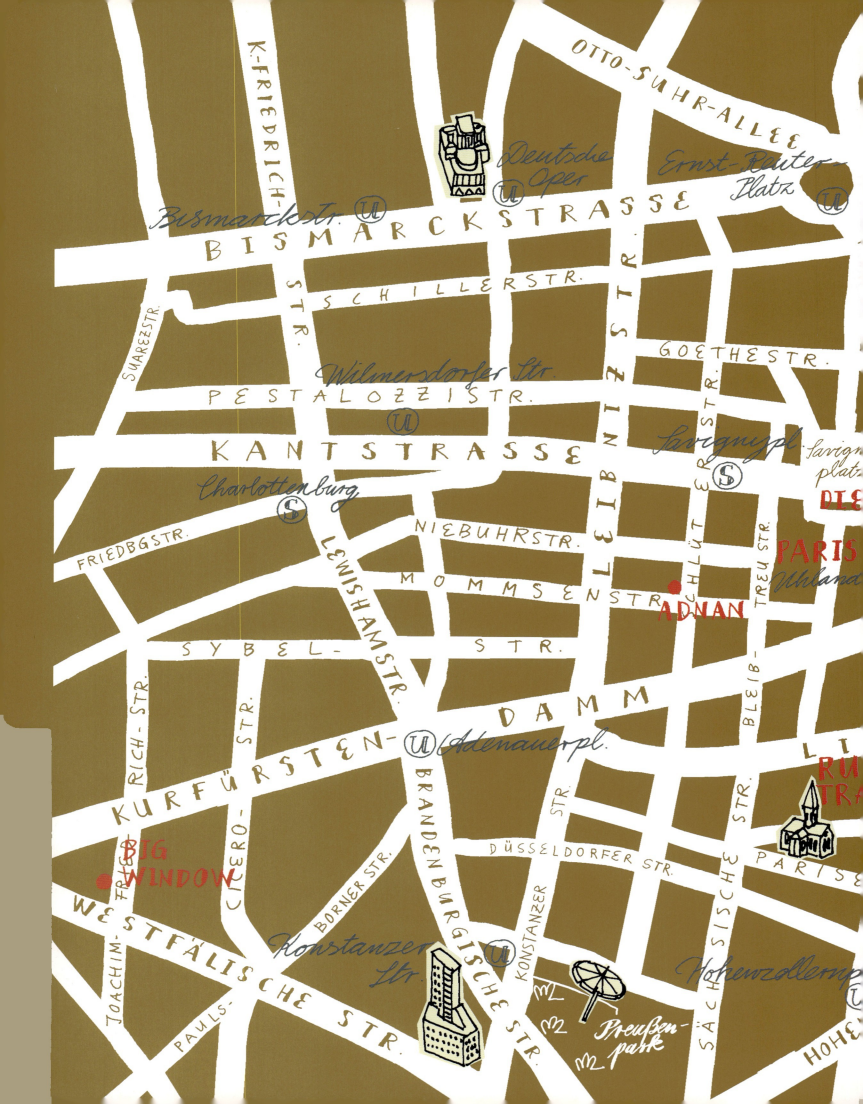

Restaurants

Times Bar

Savoy
Fasanenstraße 9–10, 10623 Berlin
☏ +49 30 31 10 30
www.hotel-savoy.com
Ⓢ Savignyplatz, Zoologischer Garten
Ⓤ Uhlandstraße, Zoologischer Garten

The Times Bar in the Savoy Hotel in Fasanenstraße is one of the very few classics in the Berlin bar scene. Leather easy chairs await guests, not to mention excellent service, skilfully prepared drinks and muted, tasteful music. To complete the picture: an unparalleled selection of first-class Cuban cigars.

Die Times Bar im Savoy Hotel in der Fasanenstraße zählt zu den wenigen Klassikern der Berliner Barszene. Den Gast erwarten gemütliche Ledersessel, ein exzellenter Service, mit souveränem Know-how gemixte Drinks und gedämpfte, geschmackvolle Musik. Dazu gibt es ein einmaliges Angebot hochklassiger kubanischer Zigarren.

Le Times Bar de l'hôtel Savoy dans la Fasanenstraße est une adresse incontournable puisqu'il est encore l'un des rares classiques du genre à Berlin. Venez vous prélasser sur fond de musique de choix dans de confortables fauteuils en cuir, un long drink à la main : un service impeccable vous attend ! Vous y découvrirez également un choix exceptionnel d'excellents cigares cubains.

Open: Daily from 11am.
Interior: A classic since 1957. The bar got its name from the pillar in the centre, which shows the time of day in all the international metropolises.
X-Factor: The Casa del Habano, where cigar aficionados can buy and smoke, where permitted, the best Cuban brands.

Öffnungszeiten: Täglich ab 11 Uhr.
Interieur: Seit 1957 ein Klassiker. Die zentrale Säule, an der die Uhrzeiten von Metropolen in aller Welt angezeigt werden, gab der Bar ihren Namen.
X-Faktor: Die Casa del Habano – dort können Zigarren-Aficionados die besten kubanischen Marken kaufen und im Raucherbereich rauchen.

Horaires d'ouverture : Tous les jours à partir de 11h.
Décoration intérieure : Un classique depuis 1957 : sièges en cuir foncé, excellents long drinks et cigares. Les colonnes centrales indiquent l'heure des grandes métropoles dans le monde, d'où le nom du bar.
Le « petit plus » : La Casa del Habano – où les amateurs de cigares peuvent acheter et fumer les meilleures marques cubaines.

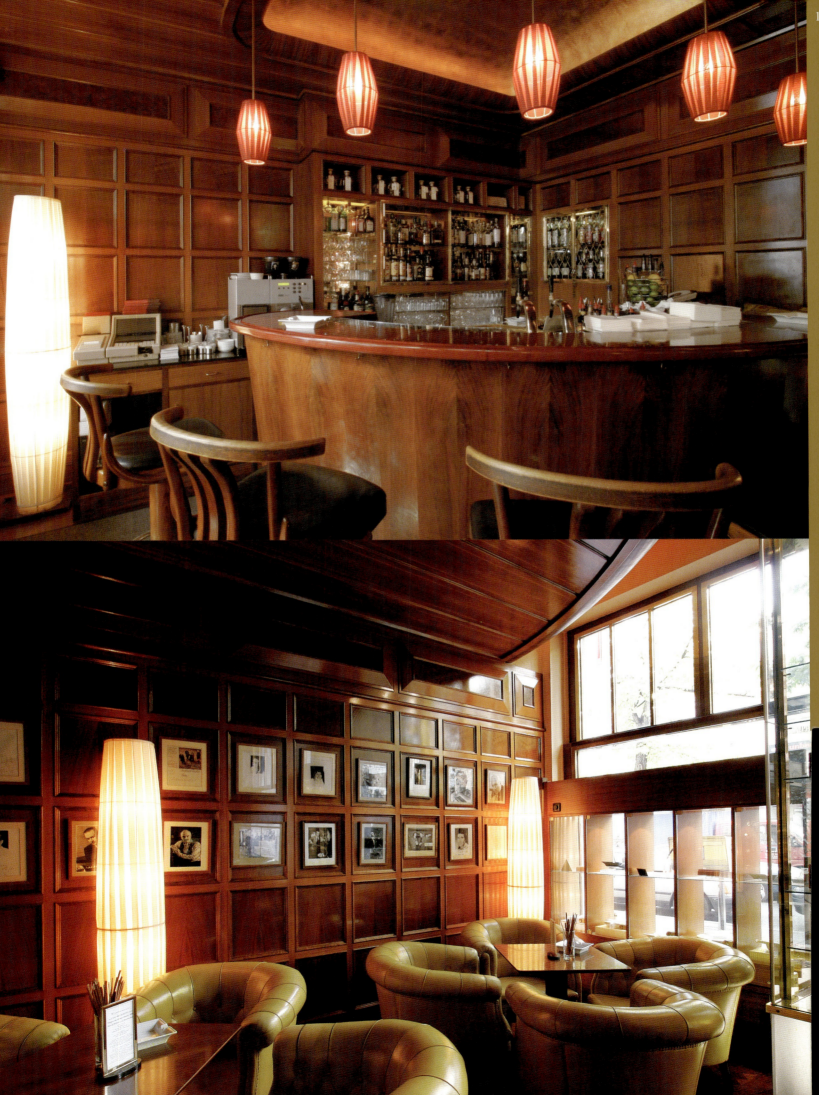

Paris Bar

Kantstraße 152, 10623 Berlin
☎ +49 30 3 13 80 52
www.parisbar.de
Ⓢ Savignyplatz Ⓤ Uhlandstraße

So much has already been said about the Paris Bar, it's hard to know where to begin. The minute you step inside you can feel the history, the stories. The cuisine is typical Parisian brasserie fare, but nobody comes to this fascinating place for the food. The list of artists, actors, directors and politicians who have spent enchanted nights here is endless.

Die Paris Bar ist eine Institution, über die schon alles gesagt wurde. Bereits beim Betreten spürt man Geschichte und Geschichten. Man kommt nicht unbedingt wegen des Essens hierher, sonst wäre dieser Ort auch nur halb so spannend. Endlos die Liste von Künstlern, Schauspielern, Regisseuren und Politikern, die hier Nächte voller Zauber verbracht haben.

Le Paris Bar est une institution sur laquelle tout a déjà été dit. Rien qu'en pénétrant ici, on perçoit l'histoire, les histoires. La cuisine – de style brasserie parisienne, mais on ne se rend pas au Paris Bar pour sa table. La liste des artistes, acteurs, metteurs en scène et politiciens qui ont fréquenté ce lieu magique en nocturne est longue.

Open: Daily midday–2am.
Interior: Classic French brasserie look: with red leather-covered benches, white tablecloths and chess-board patterned floors.
X-Factor: The countless pictures on the walls, including originals by Martin Kippenberger, Sarah Lucas and Jürgen Teller.

Öffnungszeiten: Täglich 12–2 Uhr.
Interieur: Klassisch, französischen Brasserien nachempfunden: mit rot gepolsterten Lederbänken, weiß eingedeckten Tischen und Fußboden im Schachbrettmuster.
X-Faktor: Die ungezählten Bilder an den Wänden – darunter Originale von Martin Kippenberger, Sarah Lucas und Jürgen Teller.

Horaires d'ouverture : Tous les jours 12h–2h du matin.
Décoration intérieure : Un style classique de brasserie francaise : banquettes en cuir rouge, tables aux nappes blanches et sol à carreaux noir et blanc.
Le « petit plus » : D'innombrables tableaux sur les murs, dont des originaux de Martin Kippenberger, Sarah Lucas et Jürgen Teller.

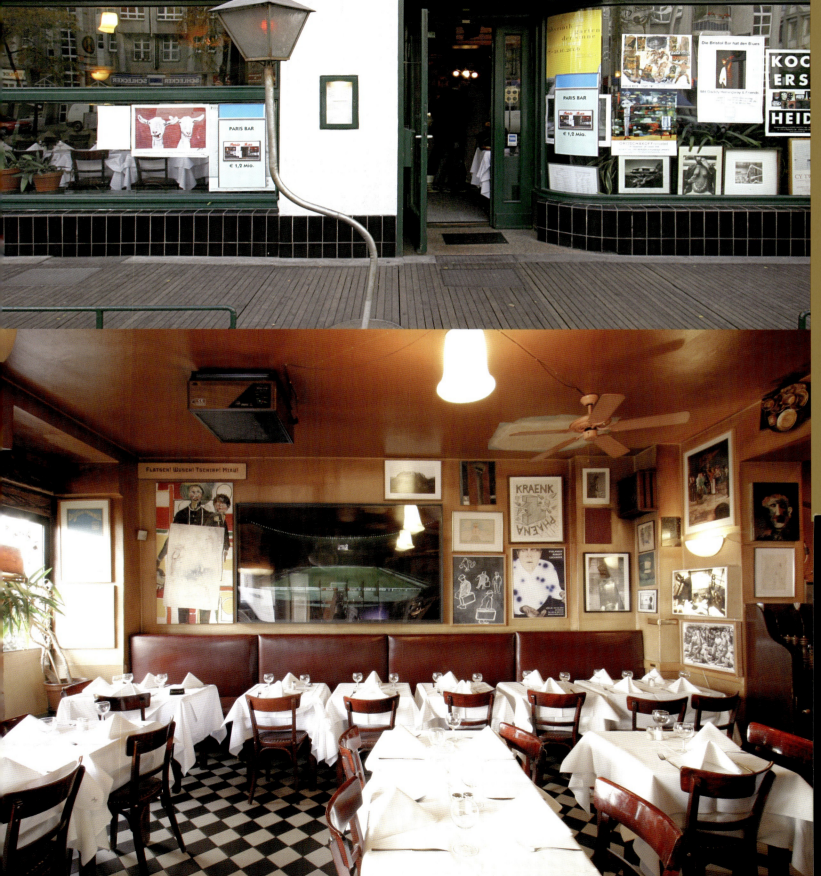

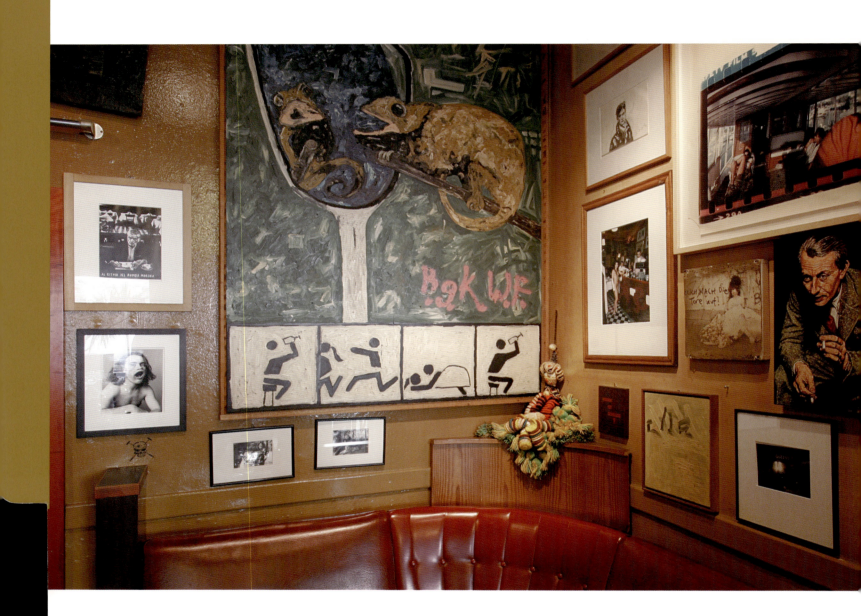

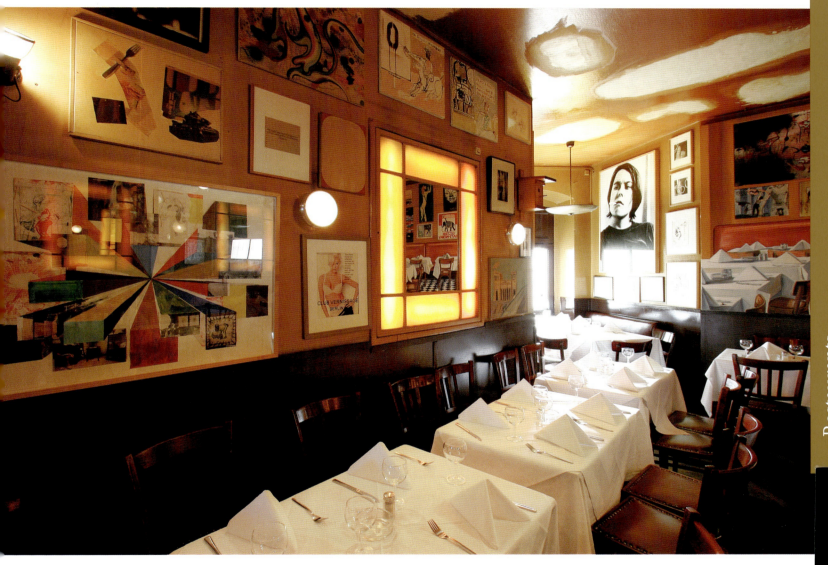

Diener Tattersall

Grolmanstraße 47, 10623 Berlin
☎ +49 30 8 81 53 29
www.diener-tattersall.de
Ⓢ Savignyplatz

The walls in this rustic tavern tell stories: they're covered with photo portraits of illustrious former patrons like Billy Wilder, Manfred Krug and Harry Belafonte. The pub was established by the English Tattersall family, then taken over by Franz Diener, the heavyweight boxer who defeated the world champion Max Schmeling in a knockout victory. Tattersall has been a meeting point for artists, actors and all sorts of bizarre characters since the 1920s. Even after the death of Franz Diener in 1969, the furnishings and the clientele remained unchanged. There is draught beer on tap, pickled gherkins and fried eggs – this place is simply glorious!

Die Wände sprechen Bände: In dieser urigen Kneipe hängen Porträtfotos von so illustren Gästen wie Billy Wilder, Manfred Krug und Harry Belafonte. Ursprünglich von der englischen Familie Tattersall gegründet, wurde das Lokal von dem Schwergewichtsboxer Franz Diener übernommen, der den Weltmeister Max Schmeling mit einem Knock-out besiegte. Die Kneipe war seit den 1920ern Treffpunkt von Künstlern, Schauspielern und allerlei skurrilen Gestalten. Auch nach dem Tod Franz Dieners 1969 hat sich weder die Einrichtung noch das Publikum verändert. Es gibt Bier vom Fass, Buletten, saure Gurken und Spiegelei – einfach herrlich!

Les murs de cet authentique bistrot en disent long : ils sont tapissés de photos d'aussi illustres clients que Billy Wilder, Manfred Krug et Harry Belafonte. Appartenant à l'origine à la famille Tattersall d'origine anglaise, ce bistrot a été repris par le boxeur poids lourd Franz Diener, qui a vaincu le champion du monde Max Schmeling par KO. Ce bistrot était, depuis les années 1920, l'antre des artistes, acteurs et autres personnages insolites. Même après le décès de Franz Diener en 1969, le décor et le public n'ont pas changé. Bière pression, boulettes de viande, gros cornichons et œufs sur le plat – à la bonne franquette !

Open: Daily from 6pm.
Interior: The building was erected in 1896 as a casino for a riding arena. The rustic pub interior dates from 1954.
X-Factor: The liver sausage is legendary and has been served here since the time of Franz Diener, who was a qualified butcher.

Öffnungszeiten: Täglich ab 18 Uhr.
Interieur: Das Gebäude wurde 1896 als Casino einer Reithalle erbaut. Das urige Kneipeninterieur entstand ab 1954.
X-Faktor: Die Leberwurst ist legendär – wie schon zu Zeiten Franz Dieners, der gelernter Fleischer war.

Horaires d'ouverture : Tous les jours à partir de 18h.
Décoration intérieure : Ce bâtiment a été construit en 1896 pour abriter le casino d'un manège. L'intérieur du local date de 1954.
Le « petit plus » : La saucisse de pâté de foie est légendaire comme au temps de Franz Diener, boucher de métier.

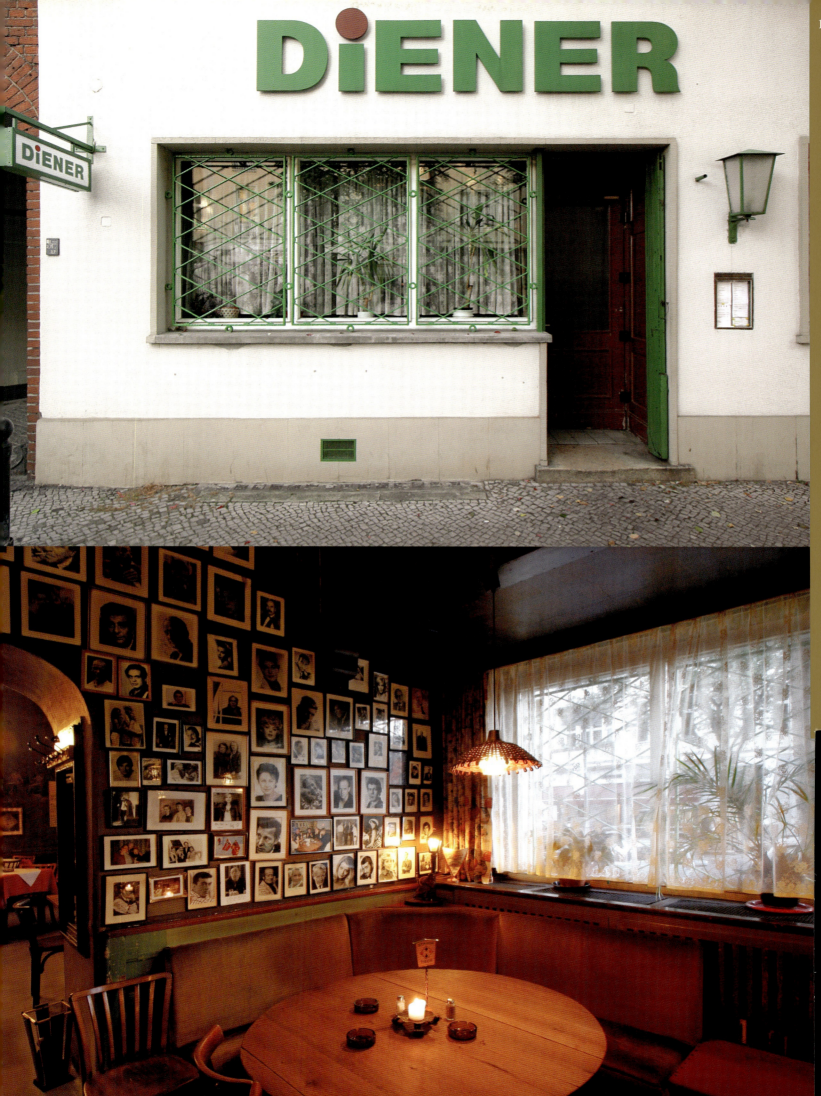

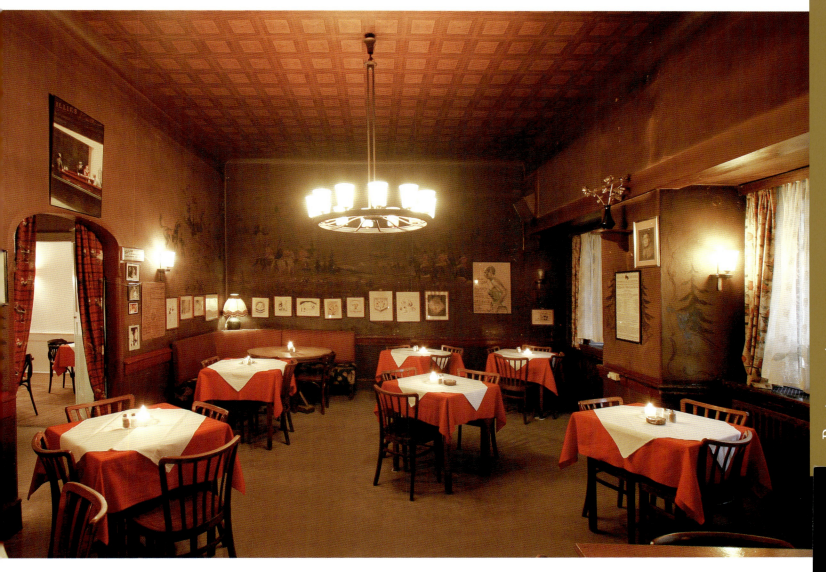

Adnan

Schlüterstraße 33, 10629 Berlin
☎ +49 30 54 71 05 90
Ⓢ Savignyplatz Ⓤ Uhlandstraße

This elegant restaurant is the perfect place to watch Charlottenburgers going about their daily business with their usual panache. In summer there are sidewalk tables under the plane trees. Adnan, the proprietor, was born in Turkey and offers his guests warm hospitality, making them feel that they are in the right place at the right time. The dishes are simple, tasty Mediterranean fare prepared with the best ingredients. No foodie snobbery here.

Open: Mon–Sat midday–midnight.
Interior: Straight-forward design. The window seats are best. From there you can admire the corner of Schlüter and Mommsenstraße with their splendid old Berlin façades.
X-Factor: Not only very important Berliners but also Hollywood stars like Tom Cruise and Katie Holmes have been known to reserve a table here.

In diesem schlicht-eleganten Restaurant (im Sommer kann man draußen unter Platanen essen) lässt sich vortrefflich der typische Charlottenburger beobachten, der etwas vom Savoir-vivre versteht. Der in der Türkei geborene Restaurantbesitzer Adnan weiß die Gäste charmant zu begrüßen und ihnen das Gefühl zu geben, zur richtigen Zeit am richtigen Ort zu sein. Es gibt einfache, schmackhafte mediterrane Gerichte aus erstklassigen Produkten, und das alles ohne Gourmettempel-Theater.

Öffnungszeiten: Mo–Sa 12–24.
Interieur: Geradlinig und schlicht. Am schönsten sind die Fensterplätze, von denen man auf die Ecke Schlüter-/Mommsenstraße mit ihren prächtigen Berliner Altbauten schaut.
X-Faktor: Neben Berliner Prominenten reservieren hier sogar Hollywood-Stars wie Tom Cruise und Katie Holmes.

Il fait bon observer le savoir-vivre des habitants de Charlottenbourg dans ce petit restaurant au décor simple et élégant, qui sort ses tables en été sous les platanes. Le propriétaire du restaurant Adnan, d'origine turque, sait recevoir ses clients avec le sourire et leur donner l'impression d'être au bon endroit au bon moment. Au menu, des plats simples et goûteux d'influence méditerranéenne, réalisés avec des produits de première qualité et sans cérémonies.

Horaires d'ouverture : Lun–Sam 12h–24h.
Décoration intérieure : Simple et sans chichi. Les meilleures places sont près des fenêtres avec vue sur les magnifiques immeubles berlinois au coin de la Schlüter-/Mommsenstraße.
Le « petit plus » : Outre des célébrités berlinoises, on y voit des stars hollywoodiennes comme Tom Cruise et Katie Holmes.

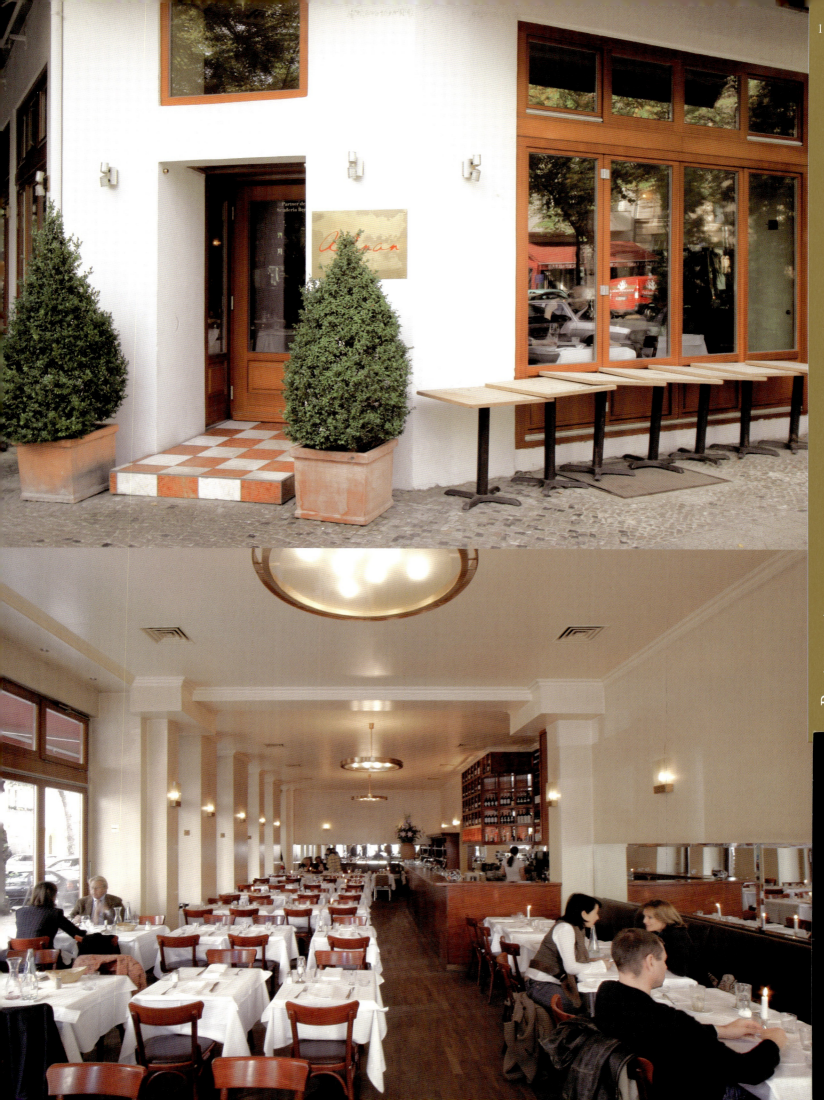

Café im Literaturhaus

Fasanenstraße 23, 10719 Berlin
☎ +49 30 8 82 54 14
www.literaturhaus-berlin.de
🄄 Uhlandstraße

The noble apartment mansions of the haute bourgeoise, and the Gründerzeit (founding era) villas in this stretch of Fasanenstraße are a great attraction. Two highlights are the Griesebach Villa and the Wintergarten Ensemble, which houses one of the prettiest coffee houses in Berlin. The idyllic garden is considered to be one of the most pleasant spots in the city in summer. The basement-level bookshop, Kohlhaas & Company, has an excellent selection of literature.

Open: Daily 9.30am–1am.
Interior: The renovated classical rooms of this Gründerzeit villa dating from 1889 contain modern furniture.
X-Factor: The bookshop in the basement. New acquisitions can be read right away in the garden, which looks onto the bourgeois façades of Fasanenstraße.

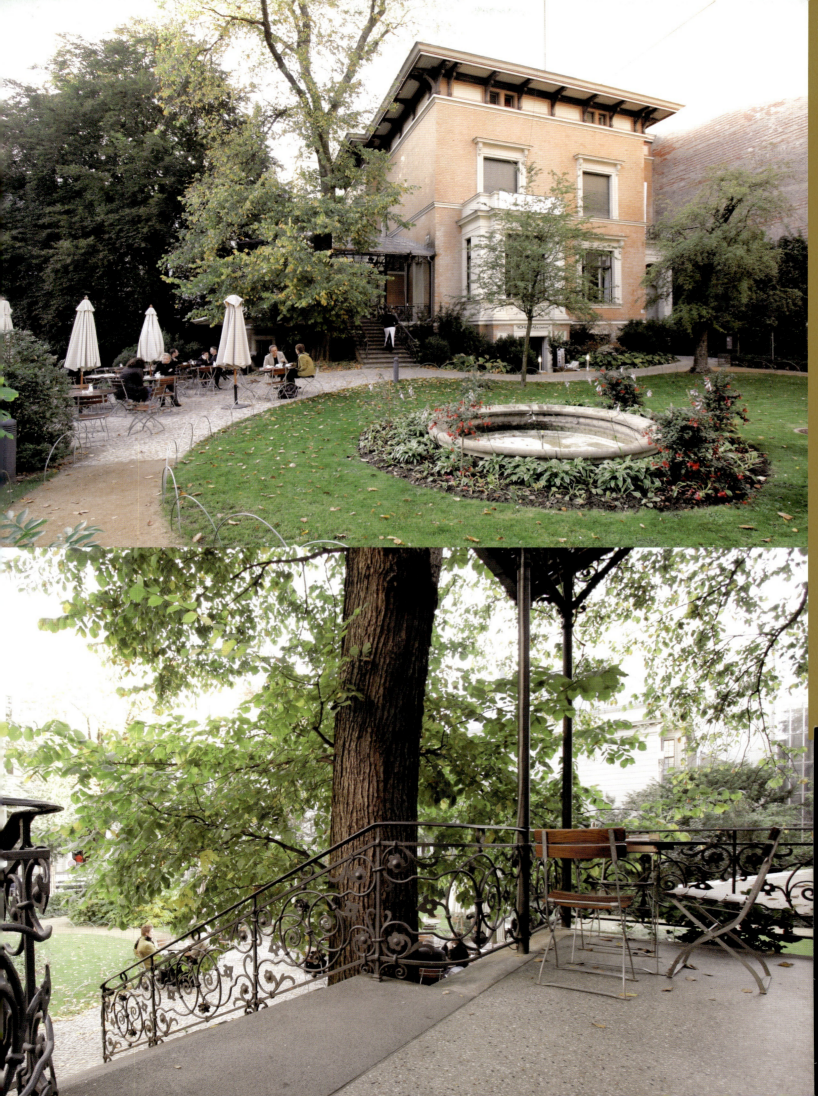

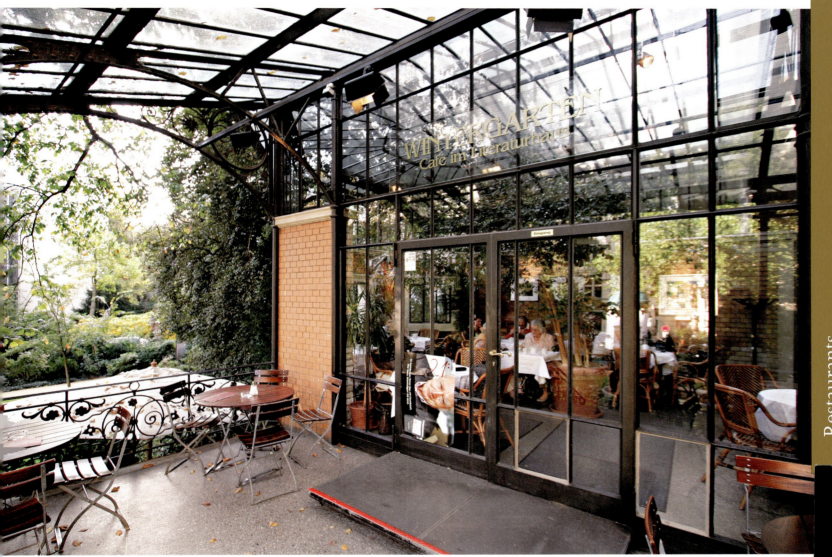

Restaurants

Rum Trader

Fasanenstraße 40, 10719 Berlin
☎ +49 30 8 81 14 28
Ⓤ Spichernstraße

This tiny bar with 15 seats is smaller than some hotel bathrooms. Yet it has more style than any other pub in Berlin. The bar was opened in 1976 by the well-travelled hotelier Hans Schröder, and the management was taken over a few years ago by Gregor Scholl, who remains true to the spirit of his predecessor. Each drink is unique, created by the bartender to harmonise with your mood.

Diese winzige Bar ist mit 15 Plätzen kleiner als die Badezimmer in manchen Hotels – dennoch hat dieser Ort mehr Stil als jedes andere Lokal in Berlin. Eröffnet wurde die Bar 1976 vom weit gereisten Hotelier Hans Schröder; vor ein paar Jahren hat Gregor Scholl die Leitung übernommen. Er bleibt dem Geist seines Vorgängers treu: Jeder Drink ist ein Unikat, genau auf die Stimmung des Gastes abgestimmt.

Ce bar minuscule de 15 places est plus petit que les salles de bains de certains hôtels – toutefois, cet endroit est plus stylé que bon nombre de bars de Berlin. Ouvert en 1976 par l'hôtelier et globe-trotter Hans Schröder, il a été repris il y a quelques années par Gregor Scholl, qui reste fidèle au concept de son prédécesseur : chaque boisson est unique et s'adapte à l'humeur du client.

Open: Mon–Fri 8pm–1am, Sat 9.30pm–2am.
Interior: James Bond atmosphere. Appropriately, the Rum Trader turns up in Ian Fleming's "Thrilling Cities" – the author knew the bar's founder, Hans Schröder.
X-Factor: A bar with only 15 seats, but the largest selection of rums in Berlin.

Öffnungszeiten: Mo–Fr 20–1, Sa 21.30–2 Uhr.
Interieur: James-Bond-Flair. Passenderweise taucht das Rum Trader in „Thrilling Cities" von Ian Fleming auf – er kannte den Bargründer Hans Schröder.
X-Faktor: Eine Bar mit nur 15 Plätzen, aber der größten Rumauswahl Berlins.

Horaires d'ouverture : Lun–Ven 20h–1h du matin, Sam 21h30–2h.
Décoration intérieure : Ambiance James Bond. Le Rum Trader apparaît dans « Thrilling Cities » de Ian Fleming qui connaissait le patron du bar Hans Schröder.
Le « petit plus » : Un bar de 15 places ayant le plus grand choix en rhum de Berlin.

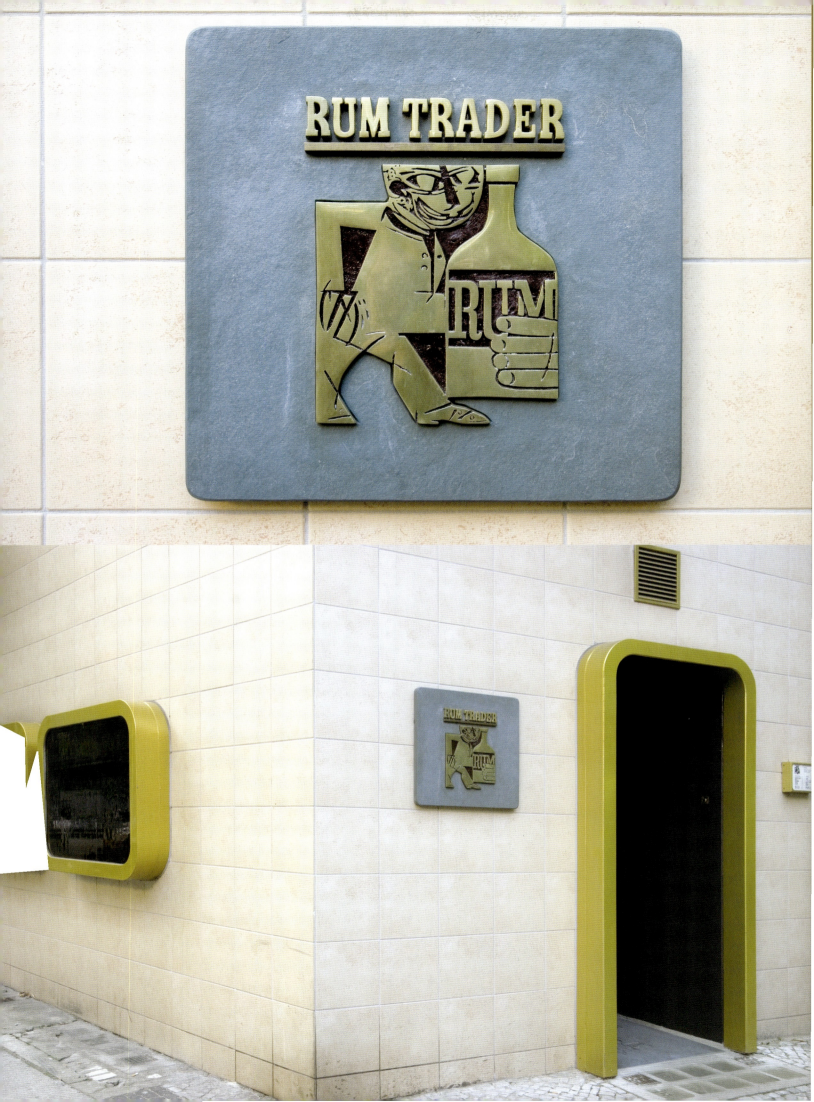

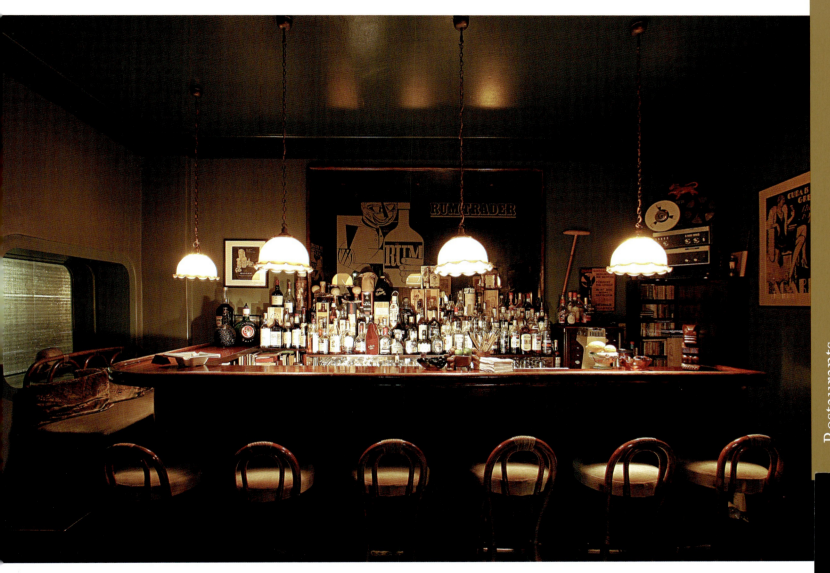

Galerie Bremer

Fasanenstraße 37, 10623 Berlin
☎ +49 30 8 81 49 08
www.galerie-bremer.de
Ⓤ Spichernstraße

The atmosphere and history of this cosy bar are what attract customers. In 1955 Anja Bremer had a club room put in behind her gallery to serve as a salon for intellectuals. The salon later became a bar. The architect she hired was her friend Hans Scharoun, who eight years later built Berlin's world-famous Philharmonie.

Diese Bar besucht man vor allem wegen ihrer Atmosphäre und ihrer Geschichte. 1955 ließ Anja Bremer hinter ihrer Galerie einen Clubraum einbauen, der als Salon für Intellektuelle diente und später zur Bar wurde. Als Architekten gewann sie ihren Freund Hans Scharoun. Der baute acht Jahre später die weltberühmte Philharmonie.

[...] et qui est devenue, par la suite, un bar. C'est l'architecte Hans Scharoun, ami de la galeriste, qui a effectué les travaux. Huit ans plus tard, il construisait la célèbre philharmonie.

Open: Mon–Sat from 8pm.
Interior: The club ambience in green and red has not changed since it was founded in 1955. Also, Romy Schneider and Billy Wilder once ordered drinks here.
X-Factor: The art gallery and the "Berlin Salon Evenings" with literary and musical performances.

Öffnungszeiten: Mo–Sa ab 20 Uhr.
Interieur: Das Klubambiente in Grün und Rot ist seit der Gründung 1955 unverändert schön geblieben. Hier bestellten schon Romy Schneider und Billy Wilder einen Drink.
X-Faktor: Die „Berliner Salon-Abende" mit literarischen und musikalischen Darbietungen (69 Sitzplätze im Galeriebereich).

Horaires d'ouverture : Lun–Sam à partir de 20h.
Décoration intérieure : L'atmosphère de club en rouge et vert n'est pas changé depuis sa fondation en 1955. Romy Schneider et Billy Wilder y ont déjà pris un verre.
Le « petit plus » : Les « soirées salon berlinoises » aux représentations littéraires et musicales (69 places assises dans la galerie).

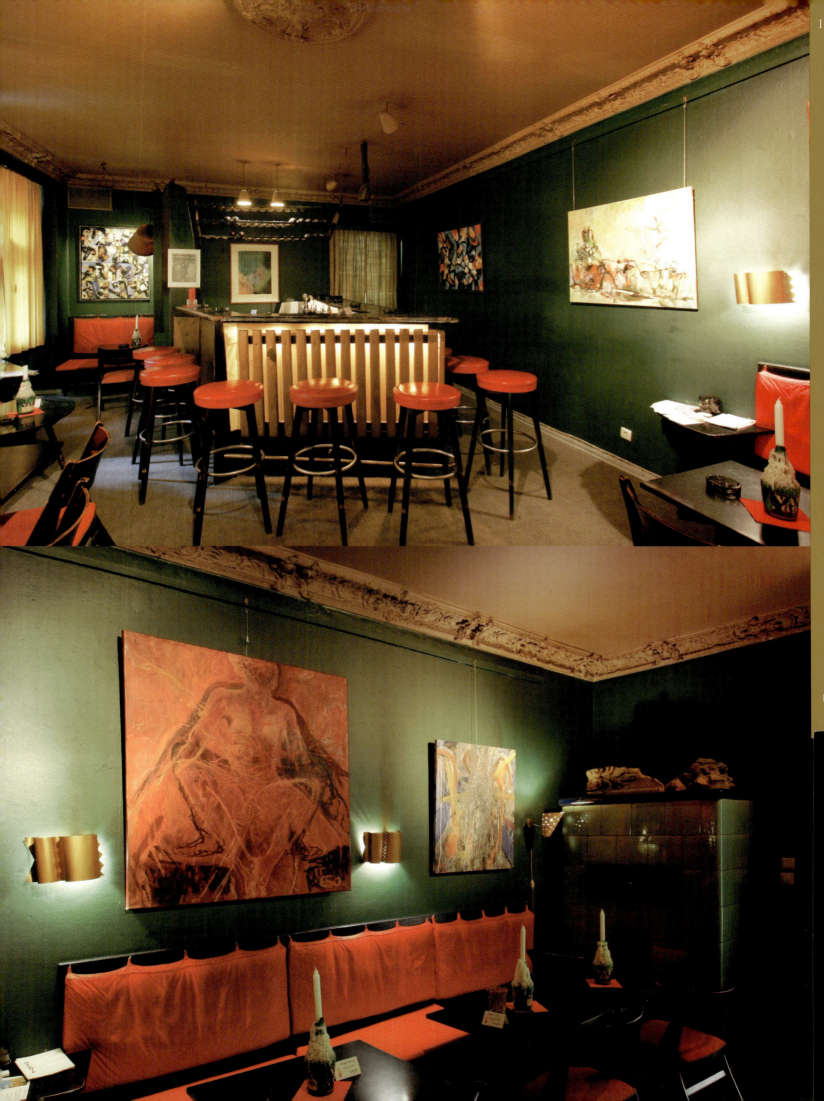

Restaurants

Manzini

Ludwigkirchstraße 11, 10719 Berlin
☎ +49 30 8 85 78 20
www.manzini.de
🚇 Spichernstraße

Manzini is located in picturesque Ludwigkirchstraße, a delightful place to sit outside in summer. The restaurant has a classic and tasteful ambiance, serves an excellent breakfast, and offers a lunch menu full of traditional fare, such as Wiener schnitzel, risotto and Kaiserschmarrn, a sweet Austrian dish also eaten for lunch. The coffee and the Bellini cocktails served here are just as delicious.

Das Manzini liegt in der malerischen Ludwigkirchstraße, wo man im Sommer wunderschön draußen sitzen kann. Das klassisch und geschmackssicher gestaltete Restaurant bietet ausgezeichnetes Frühstück, außerdem Klassiker wie Wiener Schnitzel, Risotto und Kaiserschmarrn. Der Kaffee schmeckt hier ebenso ausgezeichnet wie die Bellinis.

Le Manzini est situé dans la pittoresque Ludwigkirchstraße où il est possible de s'asseoir à la terrasse en été. Ce restaurant au décor sobre mais de bon goût propose un excellent petit déjeuner ainsi que des plats classiques comme la Wiener Schnitzel (escalope viennoise), le risotto et la Kaiserschmarrn (crêpe de l'Empereur). Le café y est aussi divin que les cocktails Bellini.

Open: Daily 8am–2am.
Interior: A classically elegant interior with dark wood, mirrors and chandeliers.
X-Factor: Berlin's best Bellinis are available here and even Berliners queue for the risotto.

Öffnungszeiten: Täglich 8–2 Uhr.
Interieur: Klassisch-elegantes Interieur mit dunklem Holz, Spiegeln und Kronleuchtern.
X-Faktor: Hier gibt es Berlins besten Bellini, und für das Risotto stehen selbst die Berliner Schlange.

Horaires d'ouverture : Tous les jours 8h–2h du matin.
Décoration intérieure : Intérieur avec boisé sombre, classique et élégant, avec de grandes glaces et des lustres.
Le « petit plus » : Les meilleurs Bellinis de Berlin et on s'y presse pour savourer le risotto.

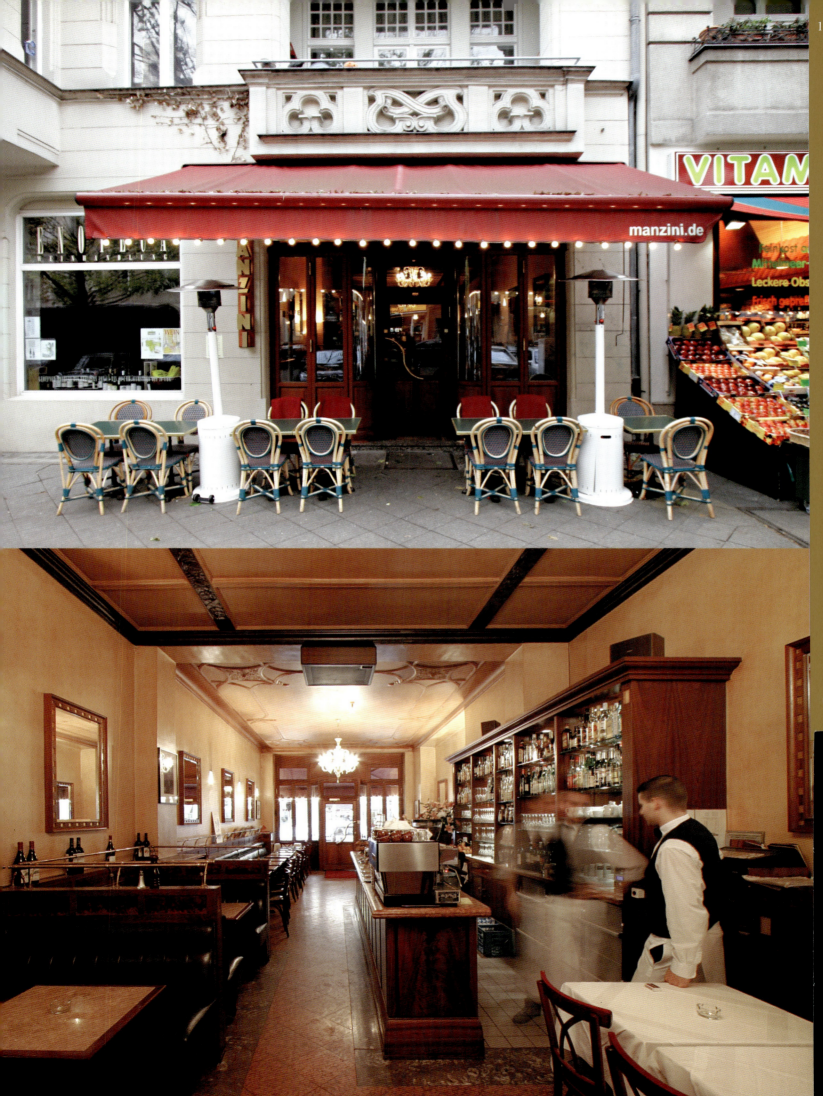

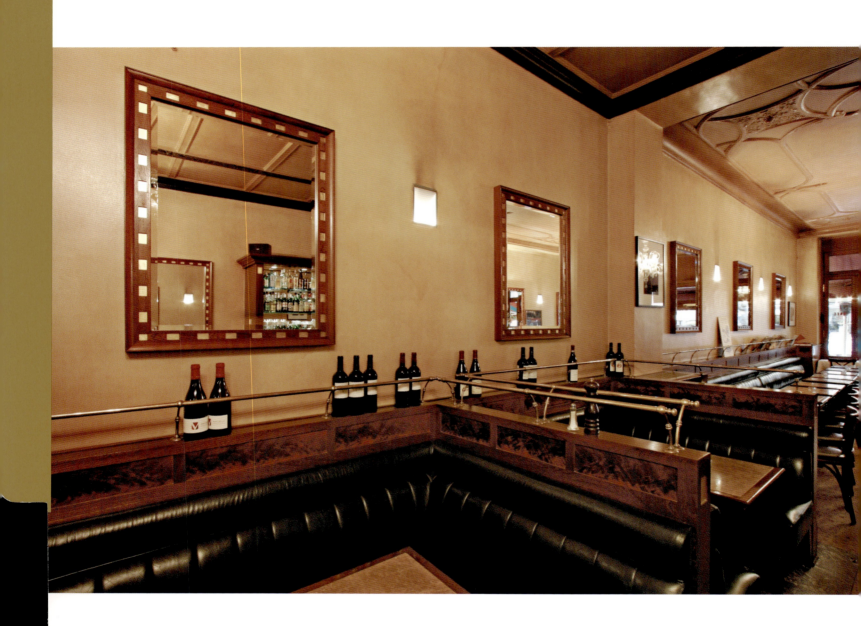

Big Window

Joachim-Friedrich-Straße 49, 10711 Berlin
☎ +49 30 8 92 58 36
www.big-window.de
Ⓢ Halensee

You can order grilled meat here: lamb, beef, veal and pork. It is sublime to the taste and as tender as butter, because it has been soaking for days in a secret Armenian marinade. The atmosphere and guests are just as delicious. There are a lot of very attractive young women, flamboyantly dressed, with extremely large bosoms – most are in the company of grey-haired sugar daddies. A great people-watching place for those who love the unusual and the louche (like me).

Hier gibt es Fleisch vom Grill: Lamm, Rind, Kalb und Schwein. Der Trick ist, dass das Fleisch nach geheimen armenischen Rezepten tagelang mariniert wird. So ist es einmalig schmackhaft und zart wie Butter. Ambiente und Besucher sind ebenfalls einmalig. Man sieht sehr viele bildhübsche junge Frauen, die auffallend gekleidet sind und über eine prächtige Oberweite verfügen. Die meisten von ihnen werden von ergrauten Sugardaddys begleitet. Ein schöner Geheimtipp für alle, die das Besondere und Halbseidene lieben (wie ich).

Viandes grillées à volonté : agneau, bœuf, veau et porc. Le secret de ces viandes goûteuses et fondantes réside dans les marinades aux recettes arméniennes bien gardées. Une expérience gustative unique ! L'ambiance et les clients sont également hors du commun. On y croise un grand nombre de très belles filles aux atours voyants et aux décolletés généreux. Elles sont en général accompagnées par des messieurs aux tempes grisonnantes. Une bonne adresse pour tous ceux qui aiment fréquenter des milieux un peu louches (comme moi).

Open: Mon–Sat from 7pm.
Interior: Rustic and cosy, this restaurant is only 58 square metres in size.
X-Factor: The Armenian-Indian marinades, before the meat is grilled over charcoal.

Öffnungszeiten: Mo–Sa ab 19 Uhr.
Interieur: Rustikal und intim – das Restaurant ist nur 58 qm groß.
X-Faktor: Die armenisch-indischen Marinaden, bevor die Fleischgerichte über Holzkohle gegrillt werden.

Horaires d'ouverture : Lun–Sam à partir de 19h.
Décoration intérieure : Rustique et intime – le restaurant fait 58 mètres carrés.
Le « petit plus » : Les marinades arméniennes et indiennes avant que la viande ne soit grillée au feu de bois.

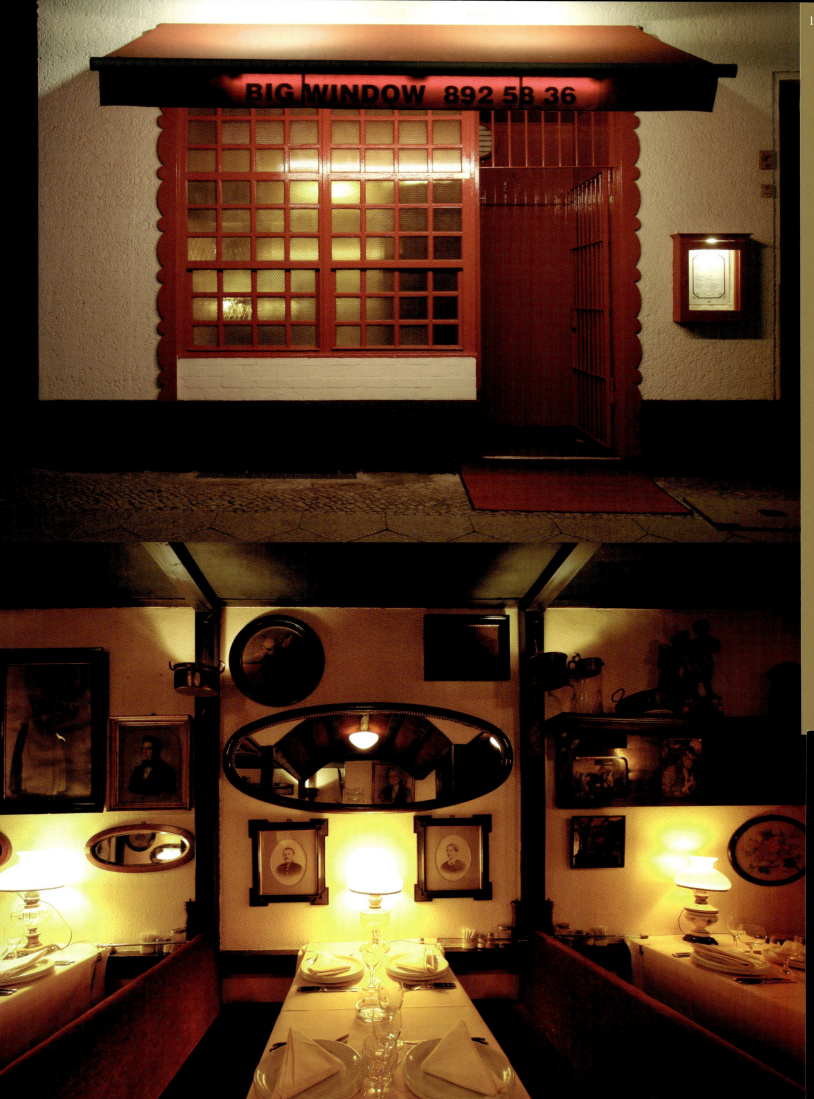

Restaurants

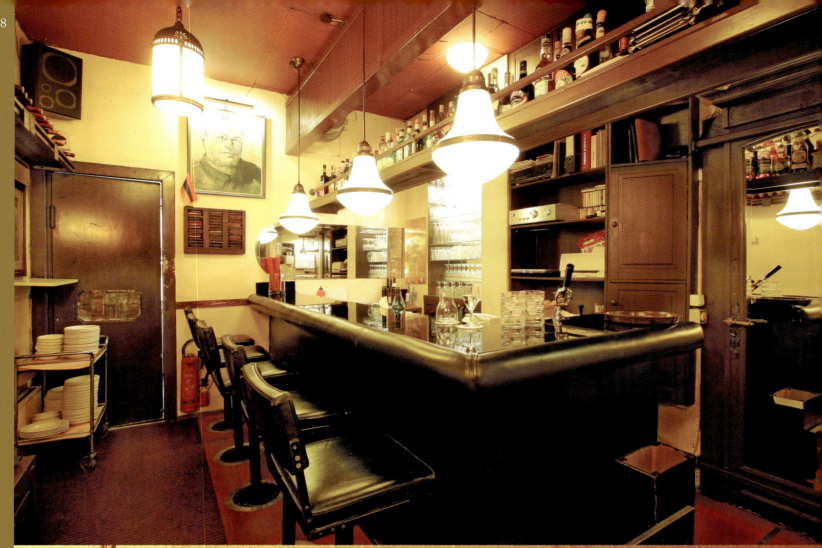

Restaurants

Green Door

Winterfeldtstraße 50, 10781 Berlin
☏ +49 30 2 15 25 15
www.greendoor.de
Ⓤ Nollendorfplatz

Berlin doesn't have many new bars with style, but the Green Door in Schöneberg is one. Their slogan is: "The Power of Positive Drinking." Excellent cocktails are mixed and served in a dimly lit retro ambience. Frank Jansen, Berlin's high priest of elegant drinking, writes: "The Green Door is a paradise for the professional drinker, who can dedicate himself to the serious business of enjoying his cocktail with little diversion."

Es gibt wenige neue Bars in Berlin, die Stil haben – aber das Green Door in Schöneberg zählt dazu. Der Haus-Slogan lautet: „The Power of Positive Drinking". Im schummrigen Retro-ambiente werden exzellente Drinks gemischt. Frank Jansen, Berlins „Großinquisitor für elegantes Trinken", schrieb: „Das Green Door ist das Utopia für Berliner Profitrinker, die hier mit wenig Allüren und großer Ernsthaftigkeit dem Cocktail frönen."

Open: Sun–Thu 6pm–3am, Fri/Sat 6pm–4am.
Interior: Retro-look. The wavy counter with its intimate, indirect lighting is particularly attractive.
X-Factor: Once you have rung the bell and gained entrance through the green door, you should order a mai tai.

Öffnungszeiten: So–Do 18–3, Fr/Sa 18–4 Uhr.
Interieur: Im Retrolook: Besonders gelungen ist der wellenförmig geschwungene Tresen mit intimer, indirekter Beleuchtung.
X-Faktor: Wer nach dem Klingelzeichen durch die grüne Tür darf, bestellt am besten einen Mai Tai.

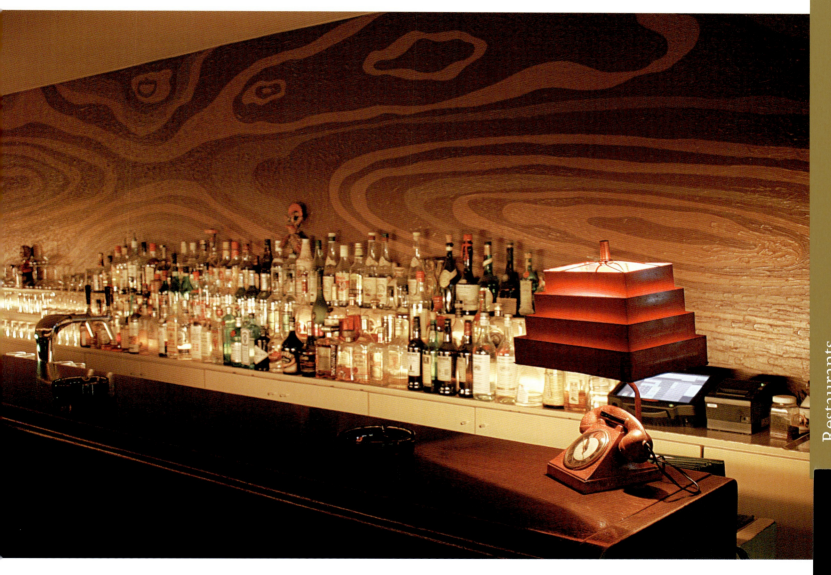

Café Einstein

Kurfürstenstraße 58, 10785 Berlin
☎ +49 30 2 61 50 96
www.cafeeinstein.com
Ⓤ Nollendorfplatz

A Berlin institution. It is worth a visit just to sit in the spacious Berlin rooms in this 1920s villa. The coffee and apple strudel here are also delightful. The waiters are clad, fittingly, in black and white, and the guests have stepped right out of the Who's Who of the cultural avant-garde. The garden in summer is one of the most secluded spots in Berlin.

Eine Berliner Institution. Allein die großen Berliner Räume in der Villa aus den 1920er-Jahren sind einen Besuch wert. Aber auch Kaffee und Apfelstrudel sind hier ein Genuss. Die Kellner bedienen formvollendet in schwarzweißer Garderobe, und die Besucher gehören zum Who's who der Kulturszene. Im Sommer zählt der Garten zu den lauschigsten Plätzen Berlins.

Une institution berlinoise. Rien que les grandes pièces 1920 de la villa valent le détour. Le café et le strudel aux pommes sont aussi divins. Le service des garçons de café est impeccable et les clients font partie du Bottin mondain de la culture. En été, son jardin est l'un des endroits les plus agréables de Berlin.

Open: Daily 8am–1am.
Interior: The silent-movie star Henny Porten once lived in this palace, dating from 1898. Today it is a picture-book café, with high-ceilinged rooms, creaking parquet floors and waiters in black and white.
X-Factor: The delightful garden in the back and the Lebensstern bar on the first floor.

Öffnungszeiten: Täglich 8–1 Uhr.
Interieur: In diesem Palais von 1898 lebte früher der Stummfilmstar Henny Porten. Heute ist es ein Kaffeehaus wie im Bilderbuch: mit hohen Räumen, knarzendem Parkett und Kellnern in Schwarz-Weiß.
X-Faktor: Der lauschige Garten und die Bar Lebensstern in der ersten Etage.

Horaires d'ouverture : Tous les jours 8h–1h du matin.
Décoration intérieure : Henny Porten, une star du film muet, vivait autrefois dans ce palais construit en 1898. De nos jours, c'est une maison du café typique : hauts plafonds, parquet qui craque et serveurs en livrée.
Le « petit plus » : Le charmant petit jardin et le bar Lebensstern au premier étage.

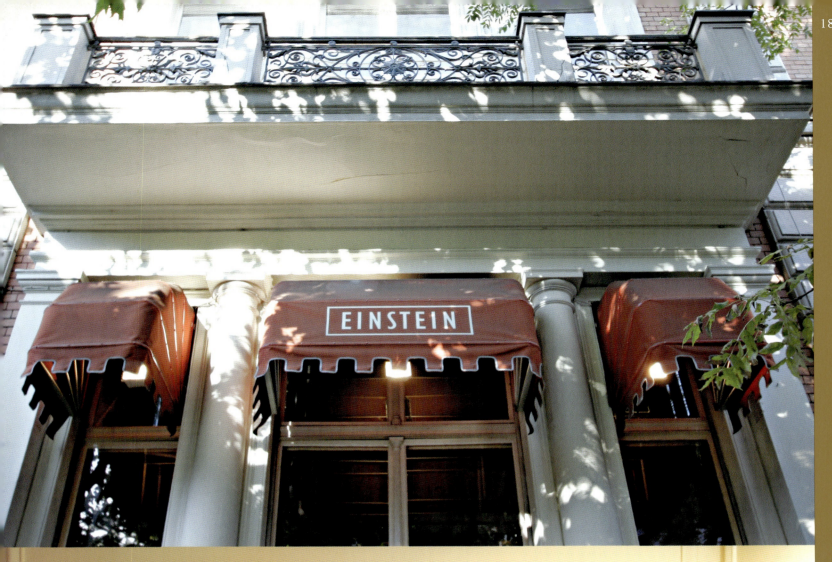

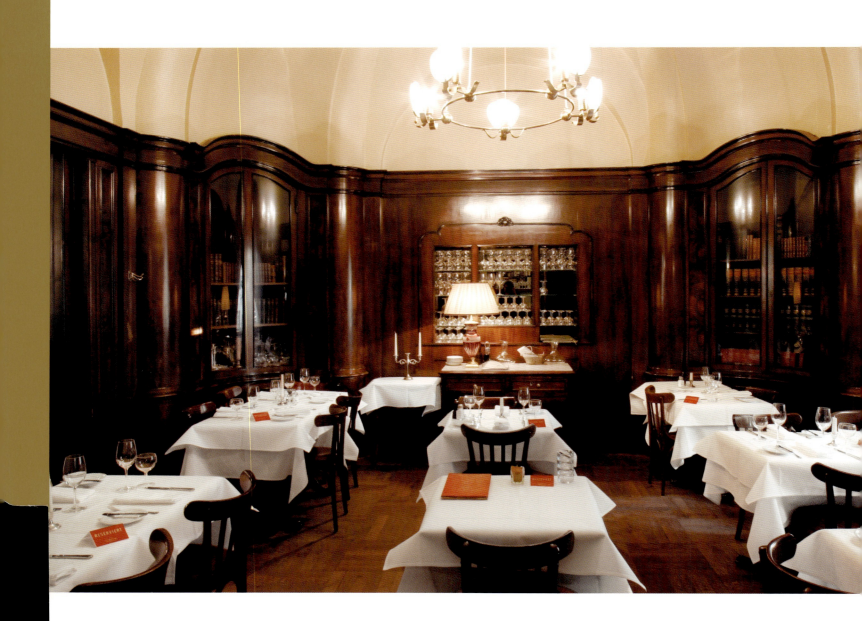

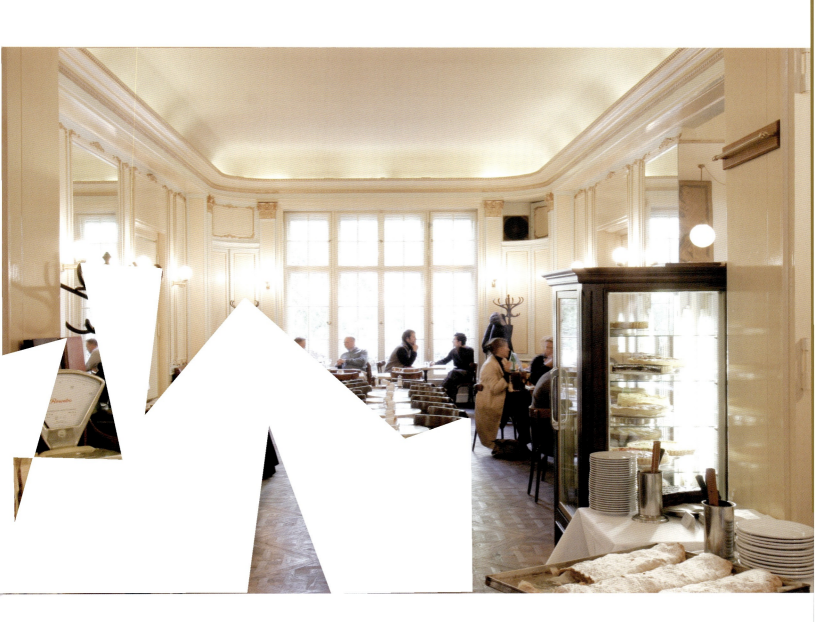

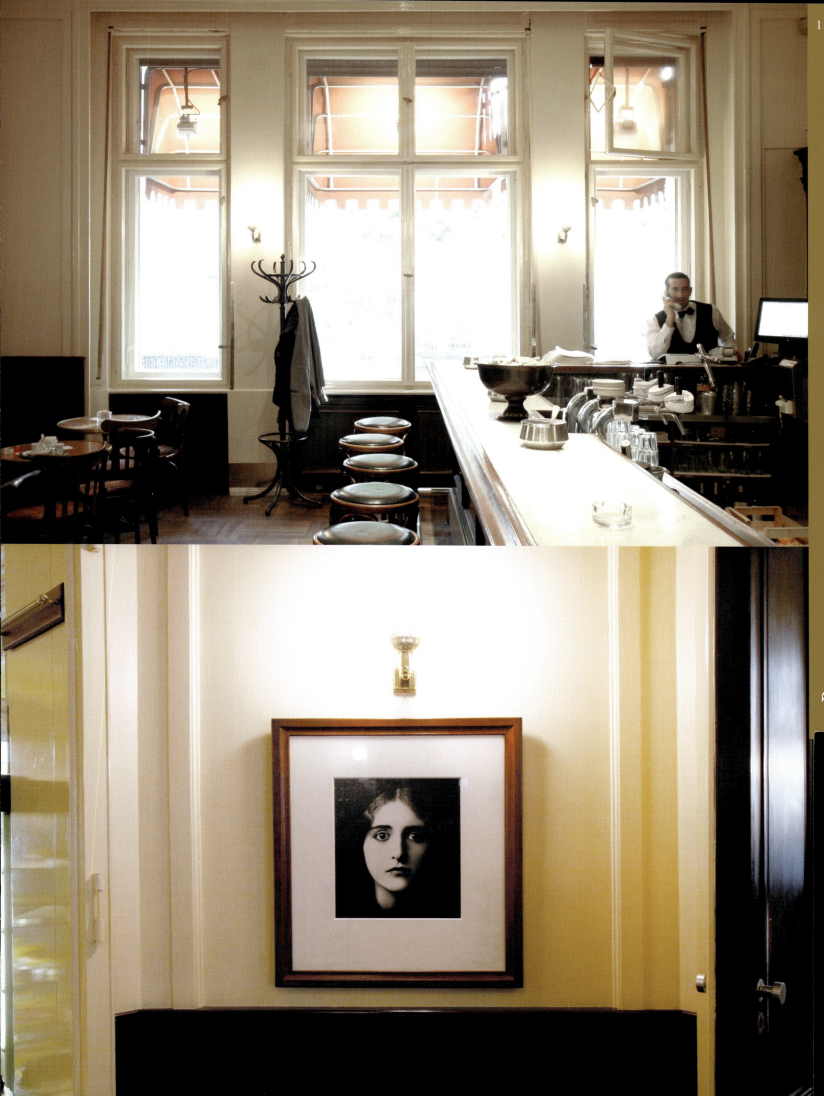

Restaurants

191

Henne

Leuschnerdamm 25, 10999 Berlin
☏ +49 30 6 14 77 30
www.henne-berlin.de
Ⓤ Moritzplatz

This is it: the most traditional of all the old Berlin taverns. The idyllic beer garden was shuttered after the Berlin Wall was built in 1961 – the Wall was only five metres away, and the Volkspolizei (People's Police) were on patrol just behind it. Nowadays, you can enjoy a Berliner Weiße with a shot of syrup while sitting under the linden trees in the beer garden. Or take a seat inside, in a wood-panelled room with red-and-green checked tablecloths. Photographs on the wall document the absurdity of the Cold War.

Eindeutig das urigste Altberliner Wirtshaus. Nach dem Mauerbau 1961 wurde der idyllische Biergarten enteignet, weil die Mauer nur fünf Meter entfernt war. Dahinter patrouillierte die Volkspolizei der DDR. Heute sitzt man wieder unter Linden im Biergarten oder im holzvertäfelten Gastraum mit grün-rot karierten Tischdecken und trinkt Berliner Weiße mit Schuss. Fotos an den Wänden dokumentieren die Absurditäten des Kalten Krieges.

Sans conteste l'auberge la plus authentique du vieux Berlin. À la construction du Mur en 1961, le Biergarten idyllique a été fermé parce que le mur derrière lequel patrouillait la police populaire de RDA n'était qu'à cinq mètres. De nos jours, on peut de nouveau s'asseoir sous les tilleuls dans le Biergarten ou dans les salles aux murs lambrissés, un verre de Berliner Weiße mit Schuss posé sur la nappe rouge et verte à carreaux. Des photos sur les murs témoignent de l'absurdité de la Guerre froide.

Open: Tue–Sat from 7pm, Sun from 5pm.
Interior: The antique taps, tiled stoves and hunting trophies are original to the 1900s.
X-Factor: The roasted half-chicken on the menu and the signed photograph of John F. Kennedy.

Öffnungszeiten: Di–Sa ab 19, So ab 17 Uhr.
Interieur: Original von 1900; mit antiken Zapfhähnen, Kachelöfen und Jagdtrophäen.
X-Faktor: Die halben Milchhähnchen und das signierte Foto von John F. Kennedy.

Horaires d'ouverture : Mar–Sam à partir de 19h, Dim à partir de 17h.
Décoration intérieure : Authentique de 1900 avec d'anciens robinets de faïence et trophées de chasse.
Le « petit plus » : Le demi-poulet rôti et la photo signée de John F. Kennedy.

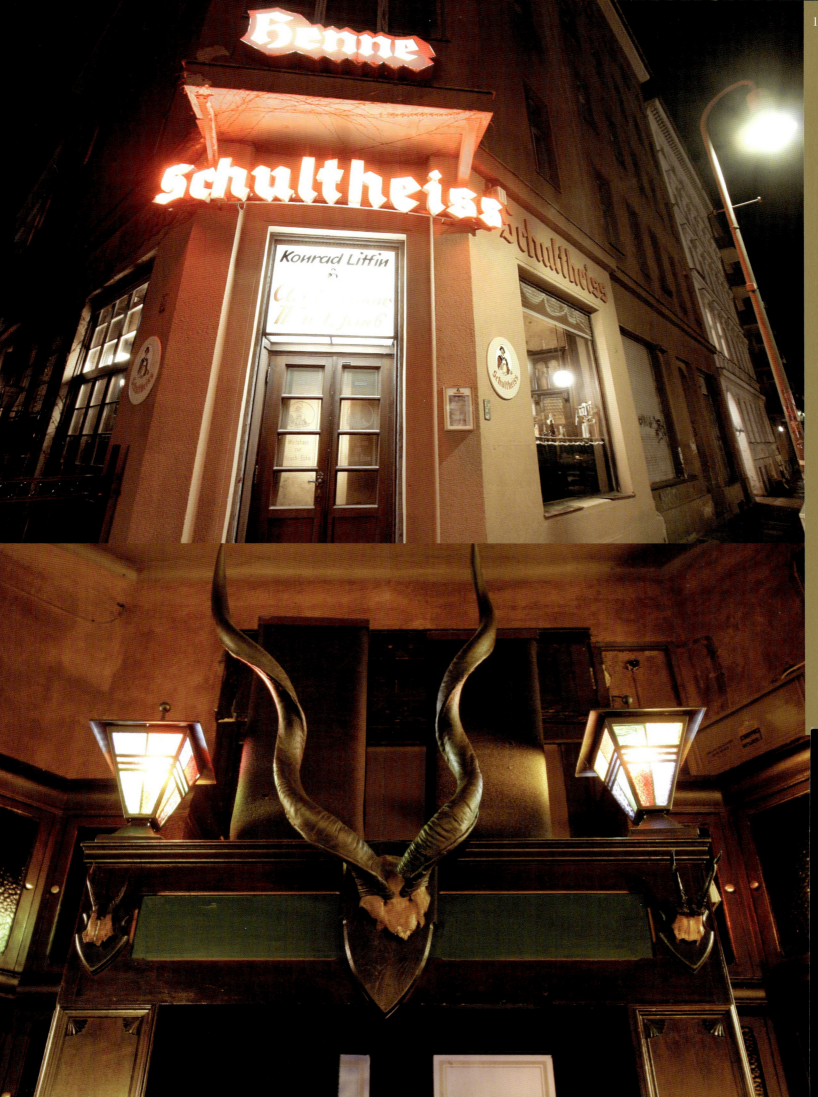

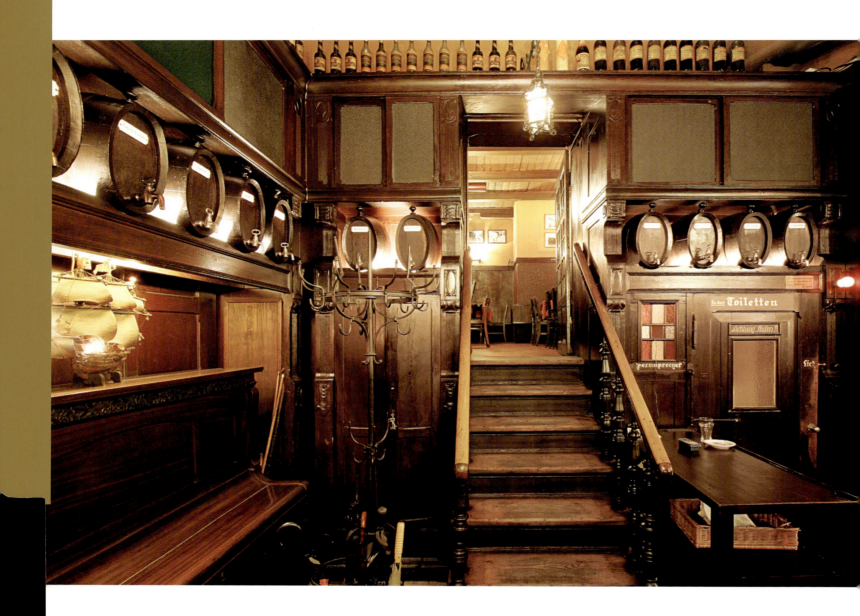

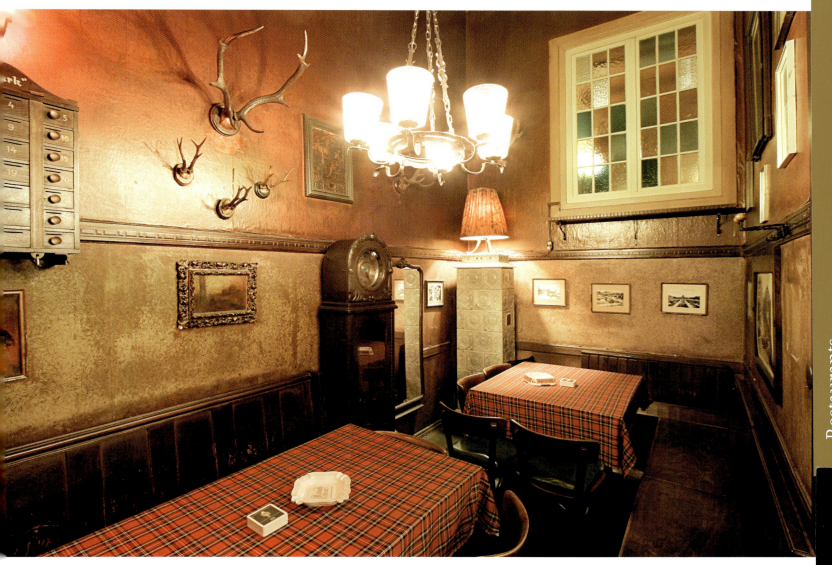

"Die letzte Mark"

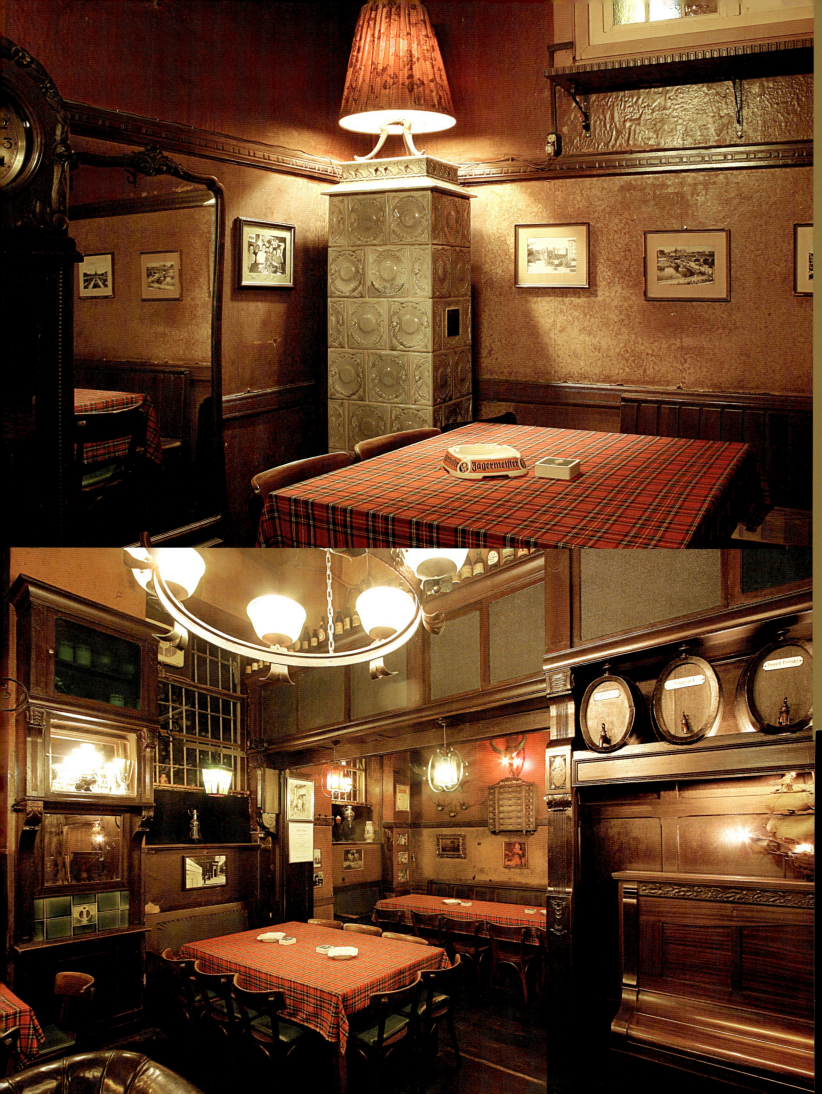

Hasir

Adalbertstraße 10, 10999 Berlin
☎ +49 30 6 14 23 73
www.hasir.de
Ⓤ Kottbusser Tor

Kreuzberg boasts the largest Turkish population outside of Turkey. The best Turkish food in the district is served at Hasir, which also has branches in Wilmersdorf and Mitte.

Nirgendwo außerhalb der Türkei leben so viele Türken wie in Kreuzberg. Das leckerste türkische Restaurant in diesem Bezirk ist das Hasir, das weitere Zweigstellen in Wilmersdorf und Mitte unterhält.

Nulle part ailleurs, si ce n'est en Turquie, ne vivent autant de Turcs qu'à Kreuzberg. Le meilleur restaurant turc dans ce district est le Hasir qui possède deux succursales à Wilmersdorf et Mitte.

Open: Daily around the clock.
Interior: Both practical and cosy, thanks to oriental tiles, oil paintings and photographs showing the owner Mehmet Aygün and his team with famous guests.
X-Factor: The fresh-baked flat bread and the tasty Turkish "Mezeler", hot and cold hors d'oeuvres.

Öffnungszeiten: Täglich 24 Stunden.
Interieur: Praktisch und gemütlich zugleich – dank orientalischer Kacheln, Ölgemälden und Fotos, die Besitzer Mehmet Aygün und sein Team mit berühmten Gästen zeigen.
X-Faktor: Das frische Fladenbrot und die köstlichen „Mezeler", kalte und warme türkische Vorspeisen.

Horaires d'ouverture : Tous les jours 24 heures sur 24.
Décoration intérieure : Pratique et de plus agréable – grâce aux céramiques orientales, aux tableaux et photos montrant le propriétaire des lieux Mehmet Aygün et son équipe avec des hôtes célèbres.
Le « petit plus » : Le pain frais et les succulents « Mezeler », hors-d'œuvre turcs froids et chauds.

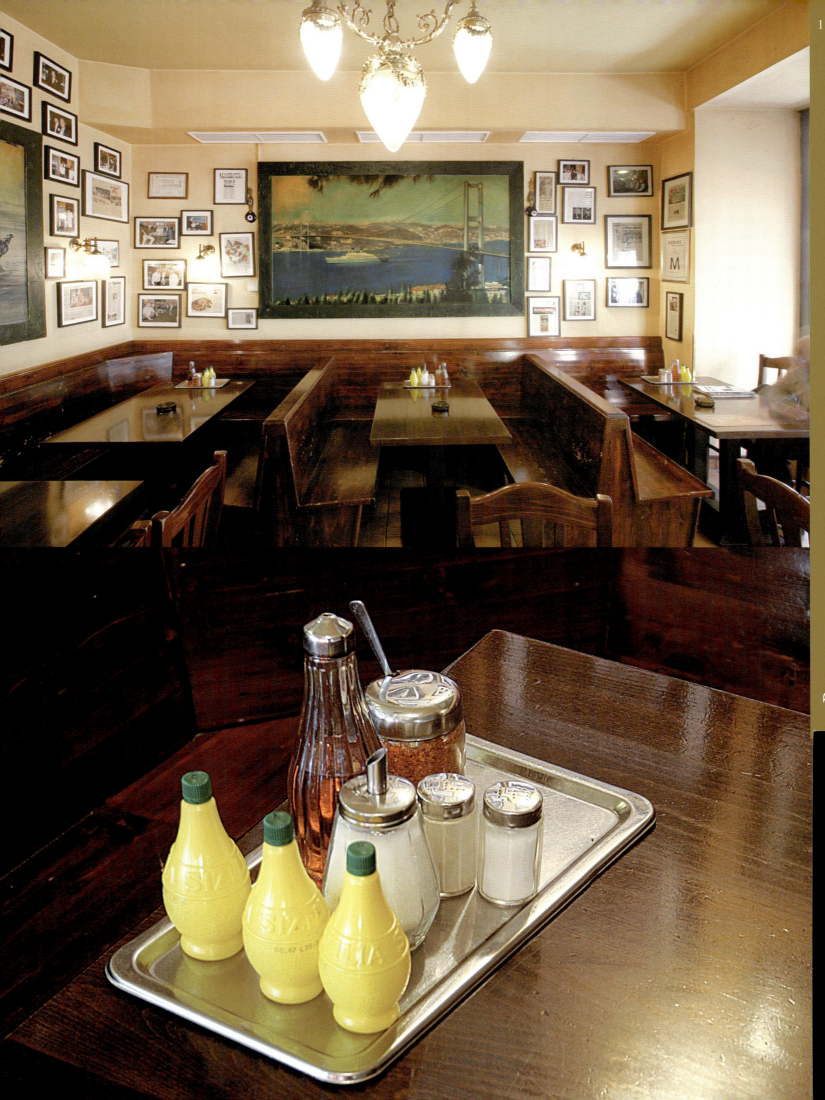

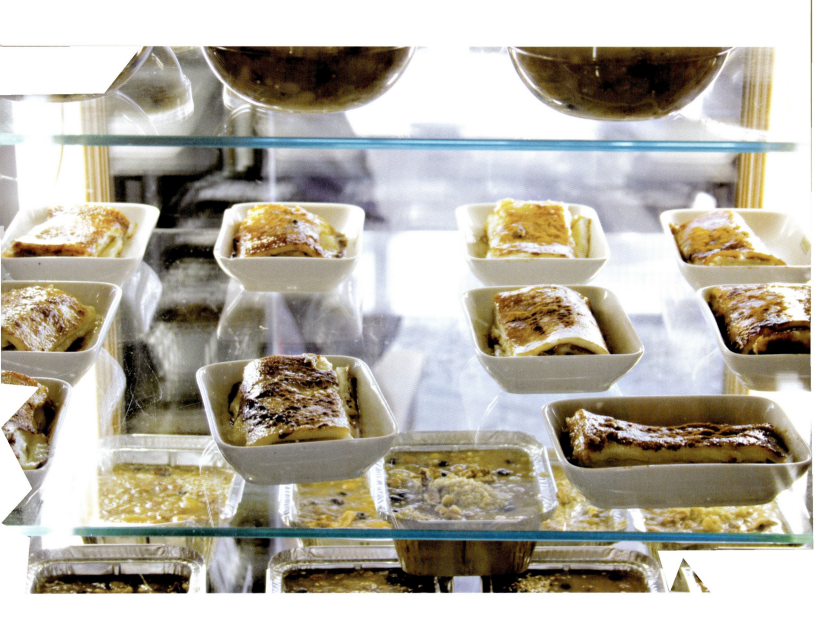

Ankerklause

Kottbusser Damm 104, 10967 Berlin
☎ +49 30 6 93 56 49
www.ankerklause.de
U Schönleinstraße

A great dive on the Landwehrkanal that has a balcony and a conservatory directly over the water – the perfect backdrop for the naval-themed décor. Something is always going on here, from breakfast to the late-night mini-disco with the jukebox or a DJ.

Eine wunderbare Spelunke am Landwehrkanal mit Balkon und Wintergarten direkt über dem Wasser. Die maritime Deko ist daher durchaus stimmig. Vom Frühstück bis zur nächtlichen Minidisco mit Jukebox oder DJ ist immer was los.

Un formidable [...] Landwehrkanal avec ba[...] d'hiver directement au-des[...] Le décor marin convient d[...] tout à fait. Du petit déjeune[...] mini-discothèque en soirée[...] box et DJ, il y a toujours de [...]

Open: Mon from 4pm, Tue–Sun from 10am.
Interior: Maritime interior with life belts and fishing nets, directly above the Landwehrkanal so you feel like you are on board a floating pub. Careful not to fall in!
X-Factor: The Club Night (Thurs from 9pm). Quentin Tarantino and his film crew came here after shooting "Inglourious Basterds" in Babelsberg.

Öffnungszeiten: Mo ab 16, Di–So ab 10 Uhr.
Interieur: Maritimes Interieur mit Rettungsringen und Fischernetzen: Man fühlt sich wie an Bord einer schwimmenden Spelunke. Absturzgefahr!
X-Faktor: Die Club-Night (Do ab 21 Uhr). Hier ließen schon Quentin Tarantino und seine Filmcrew die Drehtage zu „Inglourious Basterds" in Babelsberg ausklingen.

Horaires d'ouverture : Lun à parti[...] Mar–Dim à partir de 10h.
Décoration intérieure : [...] avec bouées de sauvetag[...] directement au-dessus du [...] on se sent comme dans un b[...] Attention, risque de chute accid[...]
Le « petit plus » : Le Club-Night (Je[...] 21h). Fréquenté par Quentin Tarantin[...] équipe, après quelques journées de tou[...] pour « Inglourious Basterds » à Babelsbe[...]

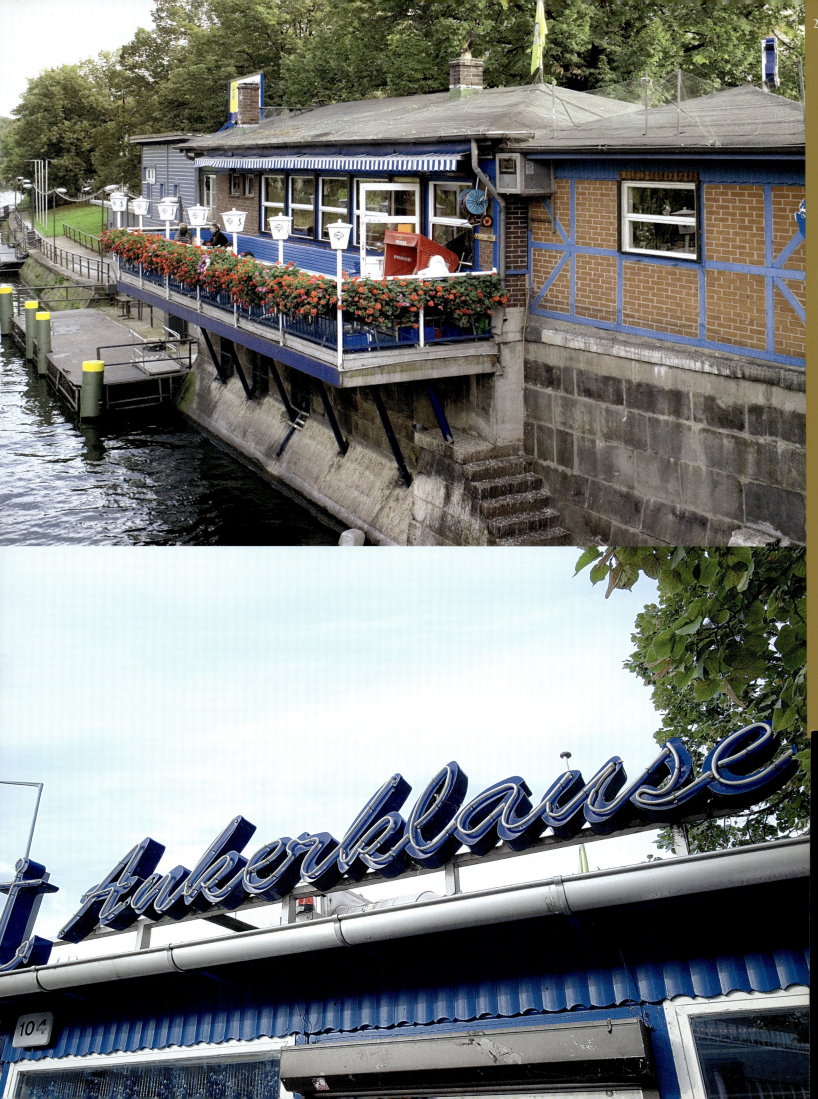

Restaurants

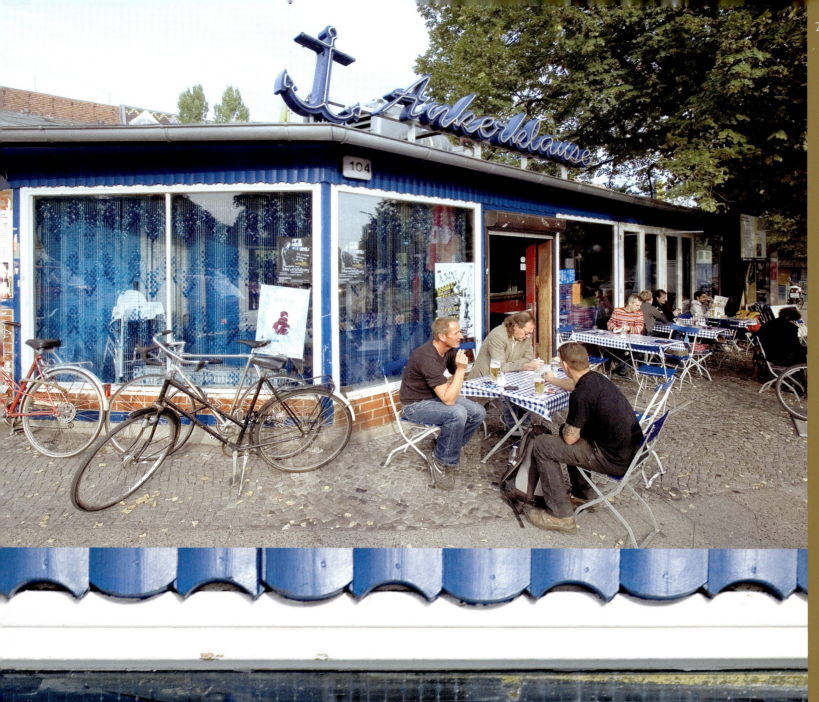

Restaurants

Berlin Map

Parks & Areas:
- Fritz-Schloss-Park
- Tiergarten
- M. Bartholdy Park

Streets:
- Invaliden Str.
- Alt-Moabit
- Paulstr.
- John-Foster-Dulles-Allee
- Strasse des 17. Juni
- Luisenstr.
- Reinhardtstr.
- Dorotheenstr.
- Unter den Linden
- Behrenstr.
- Ebert Str.
- Vossstr.
- Tiergartenstrasse
- Potsdamer Str.
- A. Potsdamer Str.
- Leipziger
- Wilhelmstr.
- Stresemannstr.
- Zimmerstr.
- Anhalter Str.
- Schöneberger Str.
- Lützowstr.
- Einemstr.
- Kurfürstenstr.
- Pohlstr.
- Mohrenstr.
- Friedrichstr.
- Oranienstr.

Landmarks (grey):
- Hauptbahnhof (S)
- Oranienburger Tor
- Friedrichstr.
- Unter den Linden
- Pariser Platz
- Holocaust Mahnmal
- Philharmonie
- Neue National-Galerie
- Potsdamer Platz
- Mohrenstr. Stadt
- Anhalter Bhf.
- Kurfürstenstr.

Highlighted (red):
- GRILL ROYAL
- DEUTSCHE GUGGENHEIM
- BORCHARDT
- VOX BAR
- KUMPELNEST 3000
- EDD'S
- VICTORIA BAR

206

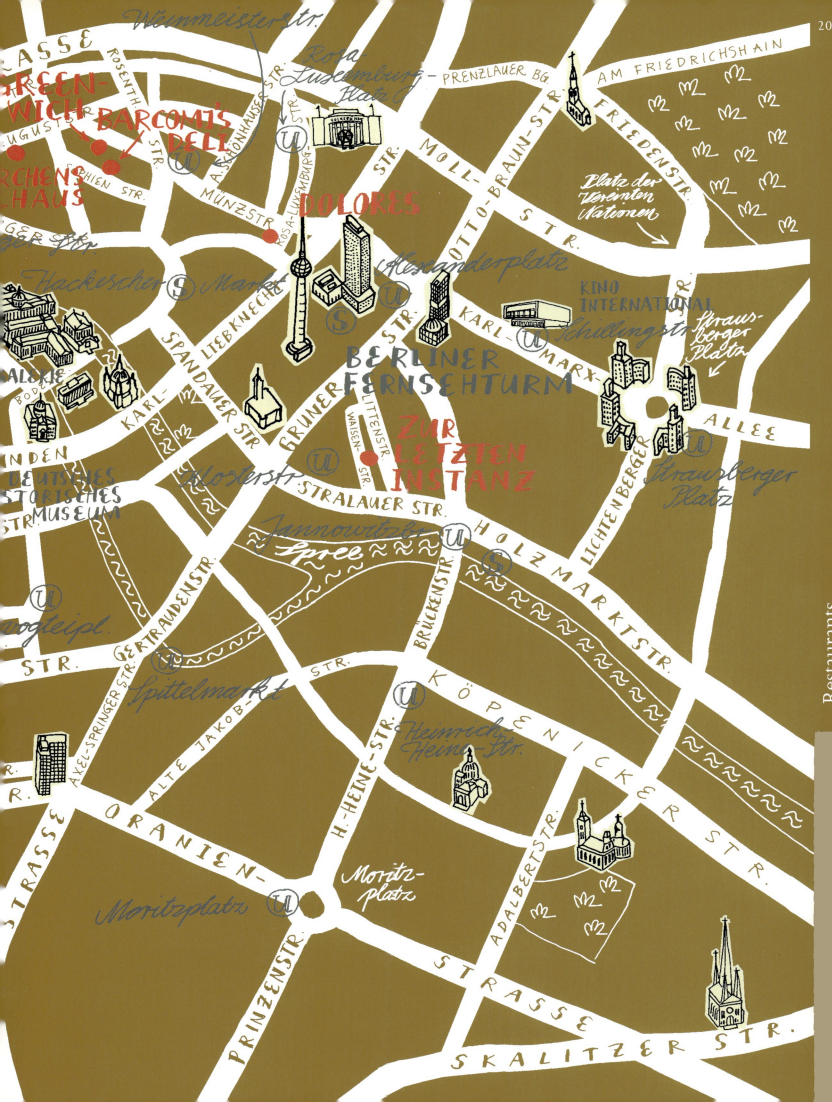

Viktoria Bar

Potsdamer Straße 102, 10785 Berlin
☎ +49 30 25 75 99 77
www.victoriabar.de
Ⓤ Kurfürstenstraße, Bülowstraße

With its wooden panelling, leather upholstery and soft, low lighting, the bar has the distinguished atmosphere of a modern British club. The service is perfect and the cocktails first class. On selected Sundays, there is a "School of Inebriation", where the art of elegant drinking is taught. The proprietor, Stefan Weber, was nominated Barkeeper of the Year by the Gault Millau guide in 2001.

Die Bar hat mit holzvertäfelten Wänden, Lederpolstern und angenehm dämmrigem Licht die distinguierte Atmosphäre eines modernen britischen Klubs. Der Service ist perfekt, die Drinks werden auf höchstem Niveau zelebriert. An ausgewählten Sonntagen wird eine „Schule der Trunkenheit" angeboten, wo man das gepflegte Trinken lernen kann. Besitzer Stefan Weber wurde 2001 vom Gault Millau zum Barkeeper des Jahres gekürt.

Il se dégage de ce bar – murs lambrissés, coussins en cuir et lumière agréablement tamisée – l'atmosphère distinguée d'un club moderne britannique. Le service est parfait, les cocktails font l'objet d'un rite de haut niveau. Lors de dimanches choisis, une « École de l'ivresse » est proposée pour apprendre à bien boire. Le propriétaire Stefan Weber a été élu barman de l'année au Gault Millau 2001.

Open: Sun–Thu 6.30pm–3am, Fri/Sat 6.30pm–4am.
Interior: The elegant retro style was designed by C+M architects Ingo Strobel (Motorberlin) and Thomas Hauser.
X-Factor: The excellent classic American bar food, including Caesar salads and club sandwiches.

Öffnungszeiten: So–Do 18.30–3, Fr/Sa 18.30–4 Uhr.
Interieur: Den edlen Retrostil gestalteten C+M Architekten, Ingo Strobel (Motorberlin) und Thomas Hauser.
X-Faktor: Die sehr gute und klassisch amerikanische Barküche inklusive Caesar Salad und Clubsandwich.

Horaires d'ouverture : Dim–Jeu 18h30–3h, Ven/Sam 18h30–4h du matin.
Décoration intérieure : Le style rétro et élégant est l'oeuvre de C+M Architekten, Ingo Strobel (Motorberlin) et Thomas Hauser.
Le « petit plus » : Une très bonne cuisine américaine de bistrot, salade César et club sandwich inclus.

Restaurants

Edd's

Lützowstraße 81, 10785 Berlin
☎ +49 30 2 15 52 94
www.edds-thairestaurant.de
Ⓤ Kurfürstenstraße

The best Thai restaurant in Berlin, tastefully designed with just the right amount of ethnic decoration. Even King Bhumibol has paid a visit. The banana flower salad is out of this world.

Das beste thailändische Restaurant in Berlin. Dazu noch geschmackvoll und mit der richtigen Dosis Folklore eingerichtet. Selbst König Bhumibol ist hier eingekehrt. Der Bananenblütensalat ist einmalig gut.

Le meilleur restaurant thaï de Berlin. Aménagé avec goût et une bonne dose de folklore. Même le roi Bhumibol s'est arrêté ici. La salade de fleurs de bananier est exceptionnelle.

Open: Tue–Fri 11.30am–3pm, 6pm–midnight; Sat 5pm–midnight, Sun 2pm–midnight.
Interior: The minimalist interior has a Thai atmosphere thanks to the sparsely hung carvings, the Buddha figures and the house altar.
X-Factor: Edd's grandmother was a cook at the Royal Palace in Bangkok – he is the Thai King of Berlin.

Öffnungszeiten: Di–Fr 11.30–15, 18–24, Sa 17–24, So 14–24 Uhr.
Interieur: Das minimalistische Interieur bekommt durch sparsam eingesetztes Schnitzwerk, Buddha-Figuren und einem Hausaltar thailändisches Flair.
X-Faktor: Edds Großmutter war Köchin im Palast von Bangkok – er ist der Thai-König von Berlin.

Horaires d'ouverture : Mar–Ven 11h30–15h, 18h–24h, Sam 17h–24h, Dim 14h–24h.
Décoration intérieure : L'intérieur minimaliste respire l'ambiance thaïlandaise : sculpture sur bois, bouddhas et autel.
Le « petit plus » : La grand-mère de Edd était cuisinière au Palais de Bangkok – Edd est le roi de la cuisine thaïlandaise à Berlin.

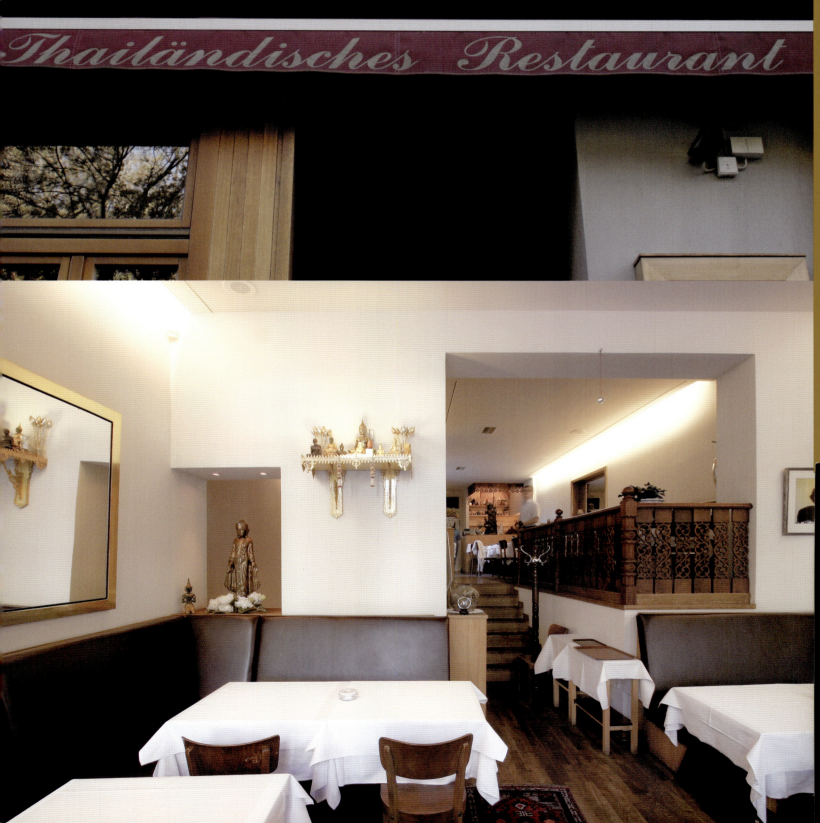

Restaurants

Kumpelnest 3000

Lützowstraße 23, 10785 Berlin
☏ +49 30 2 61 69 18
www.kumpelnest3000.com
Ⓤ Kurfürstenstraße

The later the hour, the wilder the mood in this former brothel. It doesn't fill up until about 5 o'clock in the morning. The flashy-trashy interior from the 1960s is crazy kitsch and appeals to the bad boys and girls, from competition boozers to young Bohemians. A legend!

Je später der Abend, desto wilder geht es zu in diesem ehemaligen Bordell. So richtig voll wird es erst um 5 Uhr morgens. Das Trash-Interieur aus den 1960ern ist schräg kitschig und zieht verruchte Gäste an, von Kampftrinkern bis zu jungen Bohemiens. Eine Legende!

Plus il est tard, plus l'ambiance est sauvage dans cet ancien bordel. Ce bar n'atteint toutefois son maximum de fréquentation qu'à partir de cinq heures du matin. L'intérieur toc des années 1960 est extrêmement kitsch et attire les fêtards, des buveurs invétérés aux jeunes bohèmes. Un mythe !

Open: Daily from 7pm.
Interior: A former brothel with cult status, lavishly patterned fabric wallpapers, gold-framed photographs and vintage paintings.
X-Factor: The theme parties, for example at Halloween. But the real parties actually begin around 5 o'clock in the morning.

Öffnungszeiten: Täglich ab 19 Uhr.
Interieur: Ein ehemaliges Bordell mit Kultstatus, opulent gemusterten Stofftapeten und goldgerahmten Fotos und Vintage-Gemälden.
X-Faktor: Die Themen-Partys – zum Beispiel zu Halloween. Die echten Partys beginnen aber erst gegen 5 Uhr morgens.

Horaires d'ouverture : Tous les jours à partir de 19h.
Décoration intérieure : Un ancien bordel culte, de somptueuses tapisseries, des photos dans des cadres dorés et des tableaux vintage.
Le « petit plus » : Les soirées à thème – par exemple Halloween. Les soirées en temps normal débutent en général vers 5h du matin.

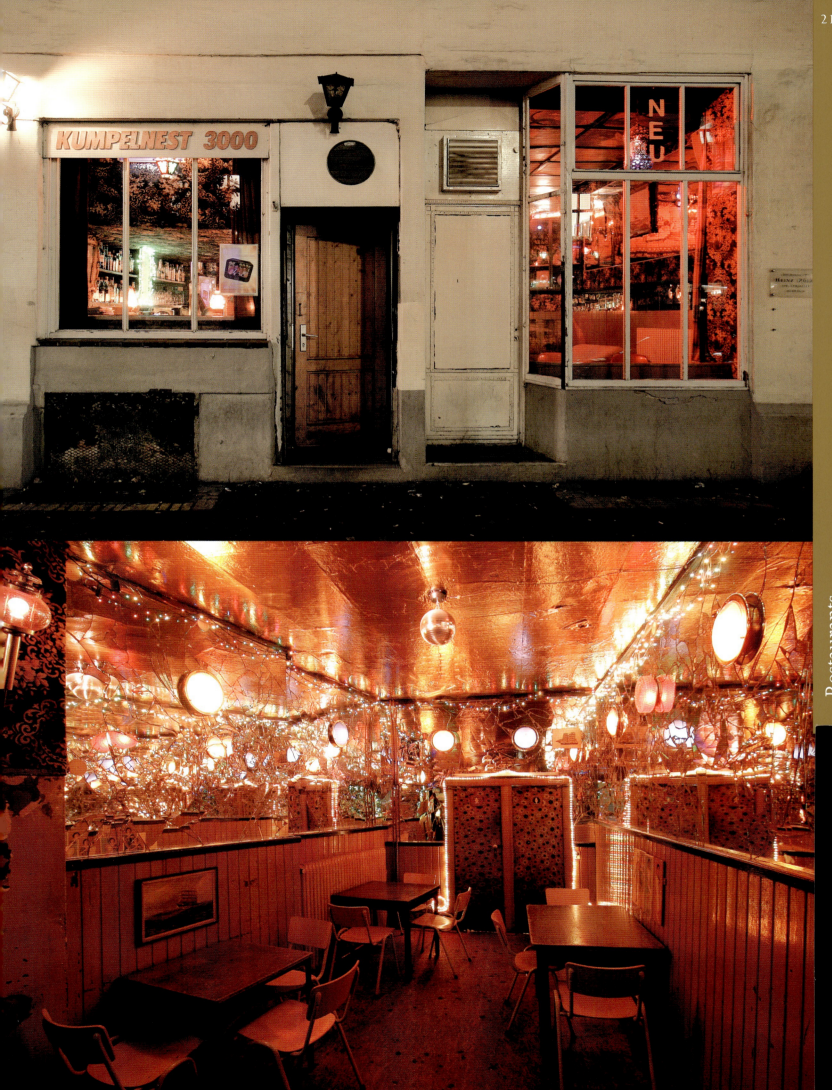

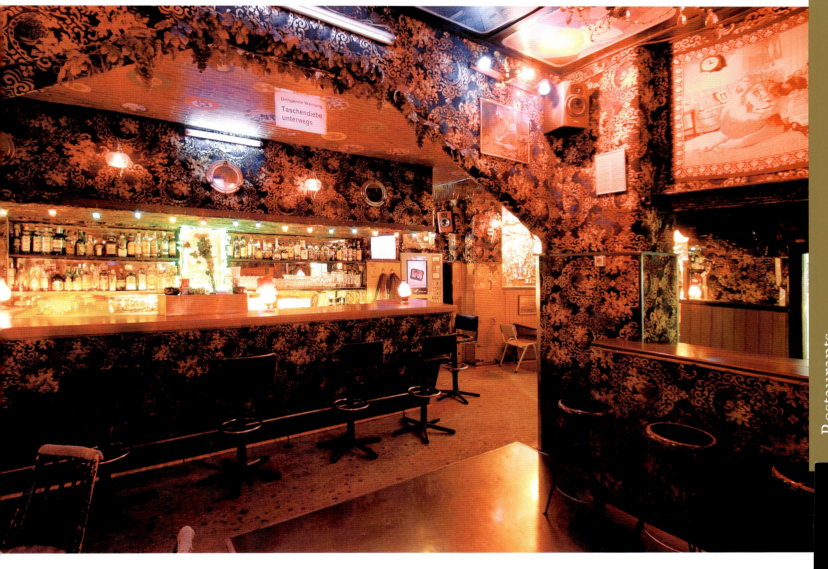

Vox Bar

Grand Hyatt Berlin
Marlene-Dietrich-Platz 2, 10785 Berlin
☎ +49 30 25 53 17 72
www.vox-restaurant.de
Ⓢ Ⓤ Potsdamer Platz

This bar deserves the highest praise and it is one of my favourite hang-outs. Comfortable leather easy chairs, flattering dim lighting, the best bartender in Berlin. What more do you need? The Vox Bar is perfect.

Diese Bar verdient höchstes Lob und ist einer meiner immer wieder gern frequentierten Hang-outs. Bequeme Ledersessel, vorteilhaft schummriges Licht, die besten Barkeeper Berlins: Ich wüsste nicht, was man an der Vox Bar verbessern könnte.

Ce bar ne mérite que des éloges et est un de mes favoris. Les fauteuils en cuir y sont confortables, la lumière est avantageusement tamisée et les meilleurs barmen de Berlin se trouvent derrière le comptoir. Je ne vois vraiment pas ce qu'on pourrait apporter comme amélioration au Vox Bar.

Open: Daily from 6pm.
Interior: The elegantly reduced design is by Swiss designer Hannes Wettstein.
X-Factor: The drinks menu features more than 240 kinds of whisky.

Öffnungszeiten: Täglich ab 18 Uhr.
Interieur: Das elegante, reduzierte Interior-Design stammt vom Schweizer Hannes Wettstein.
X-Faktor: Die Karte umfasst mehr als 240 Whiskysorten.

Horaires d'ouverture : Tous les jours à partir de 18h.
Décoration intérieure : L'élégante et simple design était réalisé par le Suisse Hannes Wettstein.
Le « petit plus » : La carte comprend plus de 240 sortes de whisky.

Restaurants

Zur letzten Instanz

Waisenstraße 14–16, 10179 Berlin
☎ +49 30 2 42 55 28
www.zurletzteninstanz.de
Ⓢ Jannowitzbrücke Ⓤ Klosterstraße

This typical Berlin tavern has been around since 1621, with its romantic beer garden in the shade of linden trees. The finest item in the traditional interior is the 200-year-old tiled stove, where Napoleon himself warmed his hands. Dishes like "The lawyer's breakfast" (chicory stuffed with nuts and mushrooms) or "Clerk's aspic" are menu highlights.

Seit 1621 gibt es dieses typische Berliner Wirtshaus mit einem romantischen Biergarten, in dem im Sommer Linden Schatten spenden. Prachtstück des urigen Interieurs ist der 200 Jahre alte Kachelofen, an dem schon Napoleon sich wärmte. Auf der Speisekarte stehen Gerichte wie „Anwaltsfrühstück" (mit Pilzen und Nüssen gefüllter Chicorée) oder „Gerichtsschreiber-Sülze".

Cette taverne typiquement berlinoise existe depuis 1621. Elle est dotée d'un Biergarten romantique où il fait bon s'asseoir sous les tilleuls en été. À l'intérieur, vous pouvez y admirer un splendide poêle en faïence bicentenaire auprès duquel Napoléon venait se réchauffer. À la carte figurent des plats tels que le « Anwaltsfrühstück » (petit déjeuner de l'avocat), des endives farcies aux champignons et aux noix ou le « Gerichtsschreiber-Sülze » (fromage de tête du greffier).

Open: Mon–Sat midday–1am.
Interior: Berlin's oldest pub has been able to withstand the passing of more than four centuries completely intact.
X-Factor: Many prominent guests such as Heinrich Zille, Wilhelm Raabe, Maxim Gorky and others were inspired by the atmosphere here.

Öffnungszeiten: Mo–Sa 12–1 Uhr.
Interieur: Die älteste Schankstube Berlins konnte bis heute, den Einflüssen von mehr als vier Jahrhunderten zum Trotz, vollständig erhalten bleiben.
X-Faktor: Viele prominente Gäste wie Heinrich Zille, Wilhelm Raabe, Maxim Gorky und viele andere ließen sich von der Atmosphäre der Gaststätte inspirieren.

Horaires d'ouverture : Lun–Sam 12h–1h.
Décoration intérieure : Le plus vieux restaurant de Berlin a pu être complètement conservé jusqu'à nos jours malgré les influences de plus de quatre siècles.
Le « petit plus » : De nombreux hôtes célèbres comme Heinrich Zille, Wilhelm Raabe, Maxim Gorky, entre autres, ont trouvé l'inspiration en ces lieux.

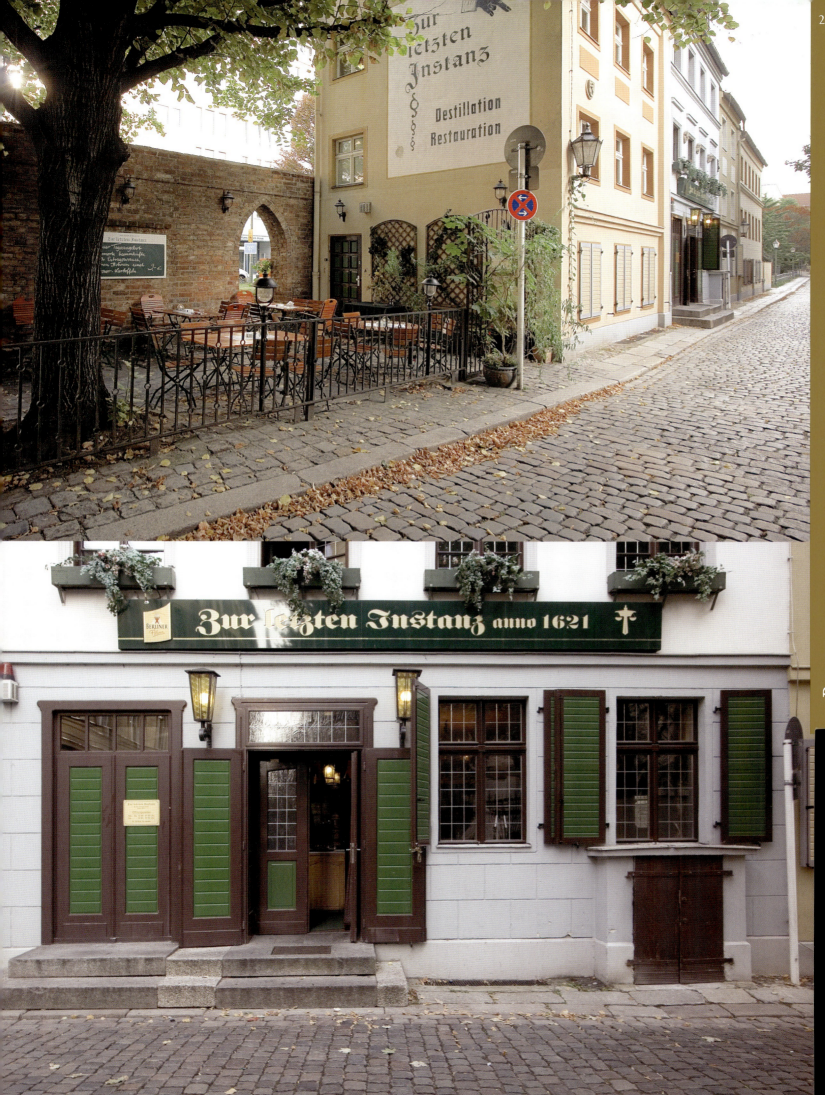

Restaurants

Borchardt

Französische Straße 47, 10117 Berlin
☎ +49 30 81 88 62 62
Ⓤ Französische Straße

The restaurant to go to in Berlin: a place to see and be seen. There's an endless coming and going of local, national and international celebrities – the politicans, film stars, media celebrities, etc. Yet everything here still has a down-to-earth, family ambience. Friendly, professional and discreet table service, with a classic menu. In summer one can eat al fresco in the garden courtyard. This is one place that deserves superlatives: it is absolutely world class!

Das Restaurant, in das „man" in Berlin geht. Hier geht es um das Sehen und Gesehenwerden, die lokale, nationale und internationale Prominenz gibt sich die Klinke in die Hand, Kanzler, Filmstars, Medienfürsten, und dabei fühlt sich alles familiär an. Freundlicher, professioneller und diskreter Service, klassisches Menü. Im Sommer kann man im Hofgarten unter freiem Himmel speisen. Dieser Superlativ muss sein: Weltklasse!

Le restaurant où il faut aller à Berlin. Il s'agit ici de voir et d'être vu ; les célébrités locales, nationales ou internationales défilent, chancelier, vedettes de cinéma, pontifes des médias, et ce dans une ambiance familiale. Service aimable, professionnel et discret, menu classique. Il est possible de manger en plein air dans la cour en été. Le superlatif est de rigueur : ultraclasse !

Open: Daily 11.30am–1am.
Interior: Right on the famous Gendarmenmarkt. The restaurant makes a striking impression on account of its high ceilings, mosaics and the four imposing pillars.
X-Factor: August F. W. Borchardt was the Kaiser's personal and court caterer in the Wilhelminian era. Tom Hanks, Goldie Hawn and Gerhard Schröder have eaten Wiener schnitzel here.

Öffnungszeiten: Täglich 11.30–1 Uhr.
Interieur: Direkt am berühmten Gendarmenmarkt. Das Restaurant wirkt mit seinen hohen Decken, den Mosaiken und den vier markanten Säulen äußerst beeindruckend.
X-Faktor: August F. W. Borchardt war in der wilhelminischen Ära der Haus- und Hofcaterer des Kaisers. Tom Hanks, Goldie Hawn und Gerhard Schröder haben hier schon das Wiener Schnitzel bestellt.

Horaires d'ouverture : Tous les jours 11h30–1h du matin.
Décoration intérieure : Directement sur le célèbre Gendarmenmarkt. Le restaurant est impressionnant avec ses hauts plafonds et ses quatre colonnes imposantes.
Le « petit plus » : August F. W. Borchardt était le traiteur de la Cour durant l'ère wilhelmienne. Tom Hanks, Goldie Hawn et Gerhard Schröder y ont savouré l'escalope viennoise.

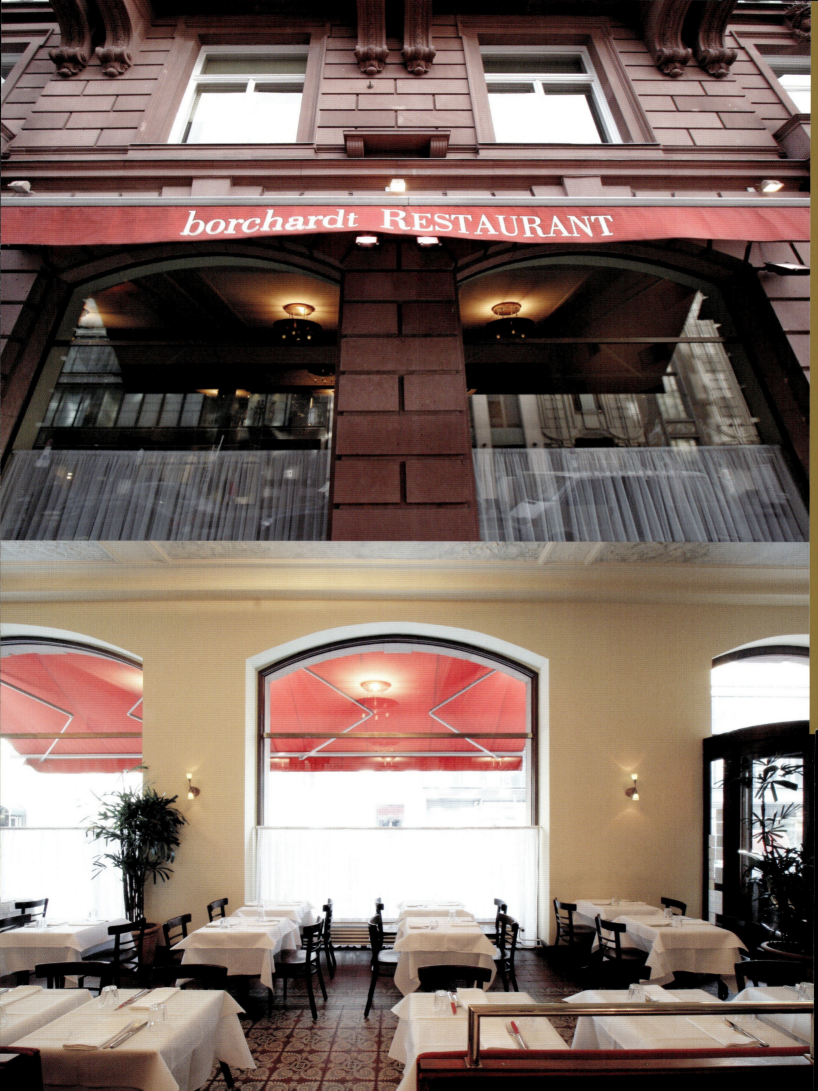

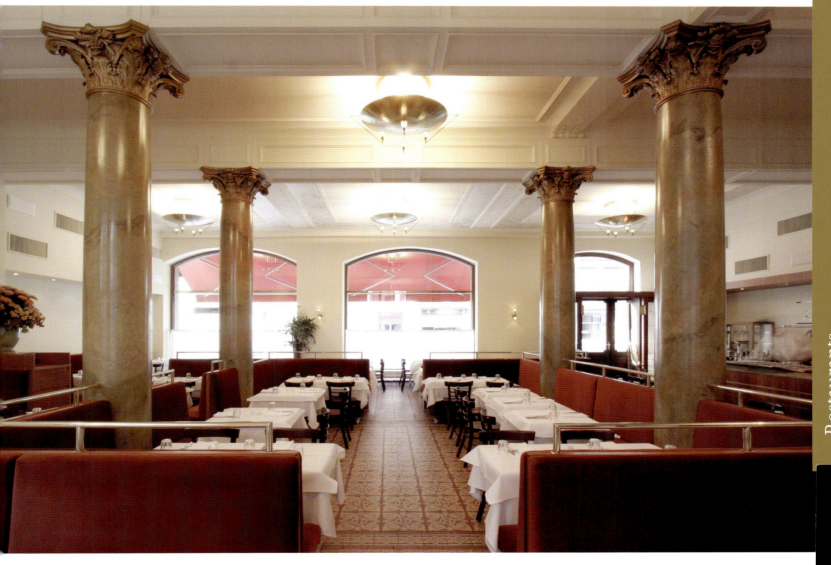

Restaurants

Grill Royal

Friedrichstraße 105b, 10117 Berlin
☎ +49 30 28 87 92 88
Ⓢ Friedrichstraße, Oranienburger Straße Ⓤ Oranienburger Tor

When Boris Radczun and Stephan Landwehr opened the Grill Royal early in 2007, it became a classic from the very first day. Since then Berlin's celebrities and the media and art scene have met here for oysters and steaks from the show kitchen – with Australian Wagyu as the crowning glory of the menu. The service is professional, the interior design sophisticated. In summer the best place to sit is on the terrace, to enjoy the fabulous view of the river Spree.

Als Boris Radczun und Stephan Landwehr das Grill Royal im Frühjahr 2007 eröffneten, wurde es gleichsam mit dem ersten Tag zum Klassiker. Seitdem trifft sich hier Berlins Prominenz, Medien- und Kunstszene zu Austern und Steaks aus der Showküche – das australische Wagyu krönt die Karte. Der Service ist professionell, das Interieur mondän. Im Sommer sitzt man am schönsten auf der Terrasse und genießt einen Traumblick auf die Spree.

Dès son ouverture au printemps 2007 par Boris Radczun et Stephan Landwehr, le Grill Royal est quasiment devenu un classique de la gastronomie. Depuis ce jour, la fine fleur du milieu médiatique et artistique de Berlin s'attable ici devant des huîtres et des steaks préparés dans la cuisine ouverte – le wagyu australien domine le menu. Le service est très professionnel, le design intérieur mondain. L'été, les places en terrasse avec superbe vue sur la Spree sont très convoitées.

Open: Daily from 6am.
Interior: A pleasantly spacious room with Hollywood glamour. James Bond would surely feel at home here.
X-Factor: Jonathan Meese not only designed some of the artwork, he is also a regular guest here.

Öffnungszeiten: Täglich ab 18 Uhr.
Interieur: Ein angenehm weitläufiger Raum mit Hollywood-Glamour, hier würde auch James Bond gerne sitzen.
X-Faktor: Jonathan Meese gestaltete nicht nur einige der Kunstwerke, sondern ist auch privat Stammgast.

Horaires d'ouverture : Tous les jours à partir de 18h.
Décoration intérieure : Un endroit agréable et spacieux avec un petit côté hollywoodien qui plairait aussi à James Bond.
Le « petit plus » : Jonathan Meese est non seulement l'auteur de quelques-uns des chefs-d'œuvre, mais est aussi un habitué.

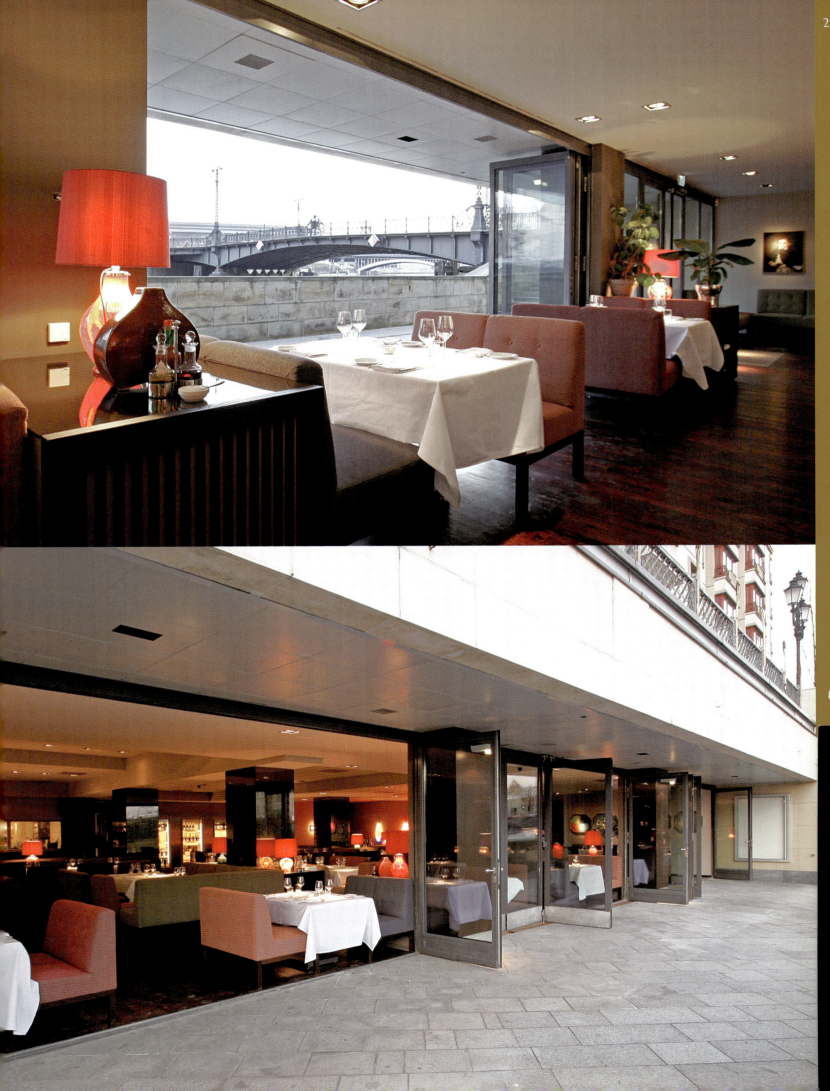

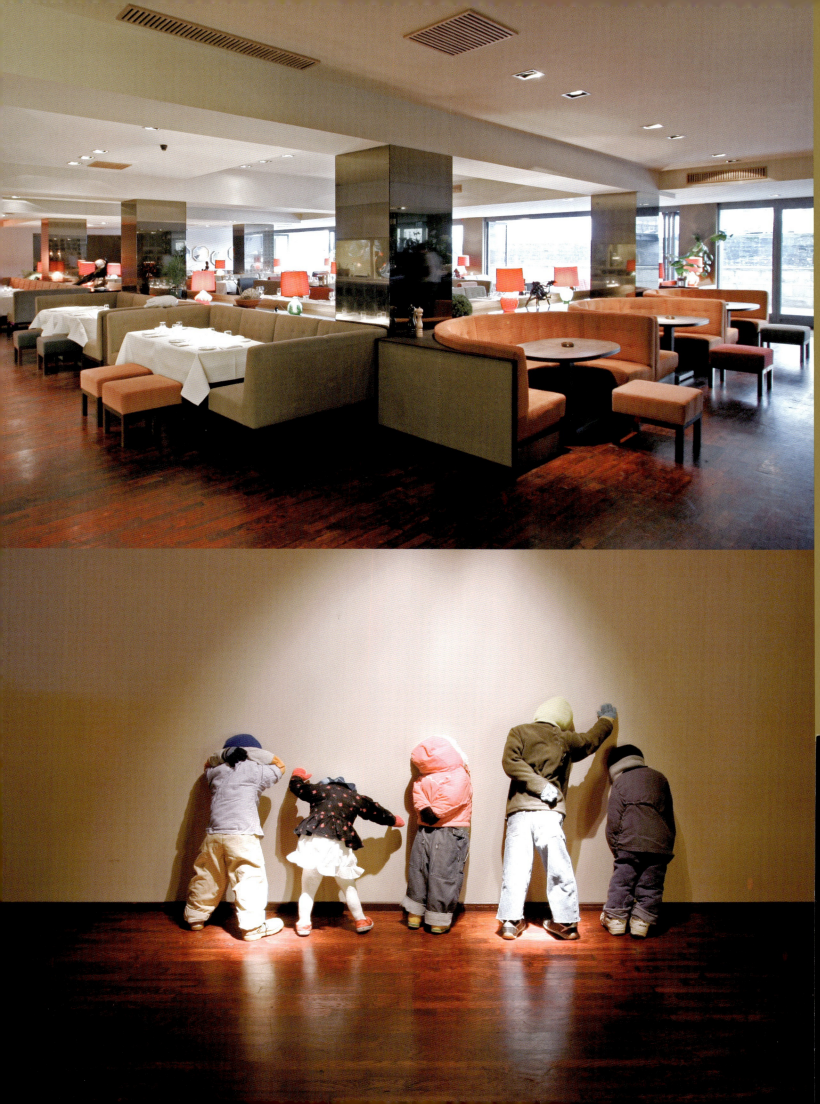

Dolores

Rosa-Luxemburg-Straße 7, 10178 Berlin
☎ +49 30 28 09 95 97
www.dolores-online.de
Ⓢ Alexanderplatz Ⓤ Rosa-Luxemburg-Platz

It is Dolores's mission to bring California sun into the German fast-food landscape. Preprocessed foods, preservatives and flavour enhancers are all verboten in her kitchen. That is why she has the best California-style burritos in all Berlin — if not outside of California! Then there are the quesadillas, the salads, the soups — all so fresh, delicious and inexpensive that it is a real pleasure to eat here.

Das erklärte Ziel von Dolores ist, kalifornische Sonne in die deutsche Fast-Food-Landschaft zu bringen. Verboten sind Fertigprodukte, Konservierungsstoffe oder Geschmacksverstärker. Das Resultat sind die besten California-style-Burritos in ganz Berlin — man könnte sogar sagen: außerhalb Kaliforniens! Auch die Quesadillas, Salate und Suppen sind so frisch, lecker und preiswert, dass es eine wahre Freude ist.

Le but déclaré de Dolores est de faire entrer le soleil californien dans le paysage du fast-food allemand. Sont interdits les plats préparés, les conservateurs et les exhausteurs de goût. Le résultat : les meilleurs burritos de style californien dans tout Berlin. On pourrait même ajouter : du monde entier en dehors de la Californie ! Les quesadillas, salades et soupes sont tellement fraîches, délicieuses et bon marché que c'est un véritable plaisir.

Open: Mon–Sat 11.30am–10pm, Sun 1–10pm.
Interior: The walls are decorated with out-sized street maps of the eponymous Dolores Heights and Mission District of San Francisco.
X-Factor: The home-made lemonades and the fudge brownies.

Öffnungszeiten: Mo–Sa 11.30–22, So 13–22 Uhr.
Interieur: Die Wände zieren überdimensionale Straßenkarten von den namensgebenden Dolores Heights und dem Mission District in San Francisco.
X-Faktor: Die hausgemachten Limonaden und Fudge Brownies.

Horaires d'ouverture : Lun–Sam 11h30–22h, Dim 13h–22h.
Décoration intérieure : Les murs sont parés de cartes routières immenses des Dolores Heights et de Mission District à San Francisco.
Le « petit plus » : Les limonades et les Fudge brownies faits maison.

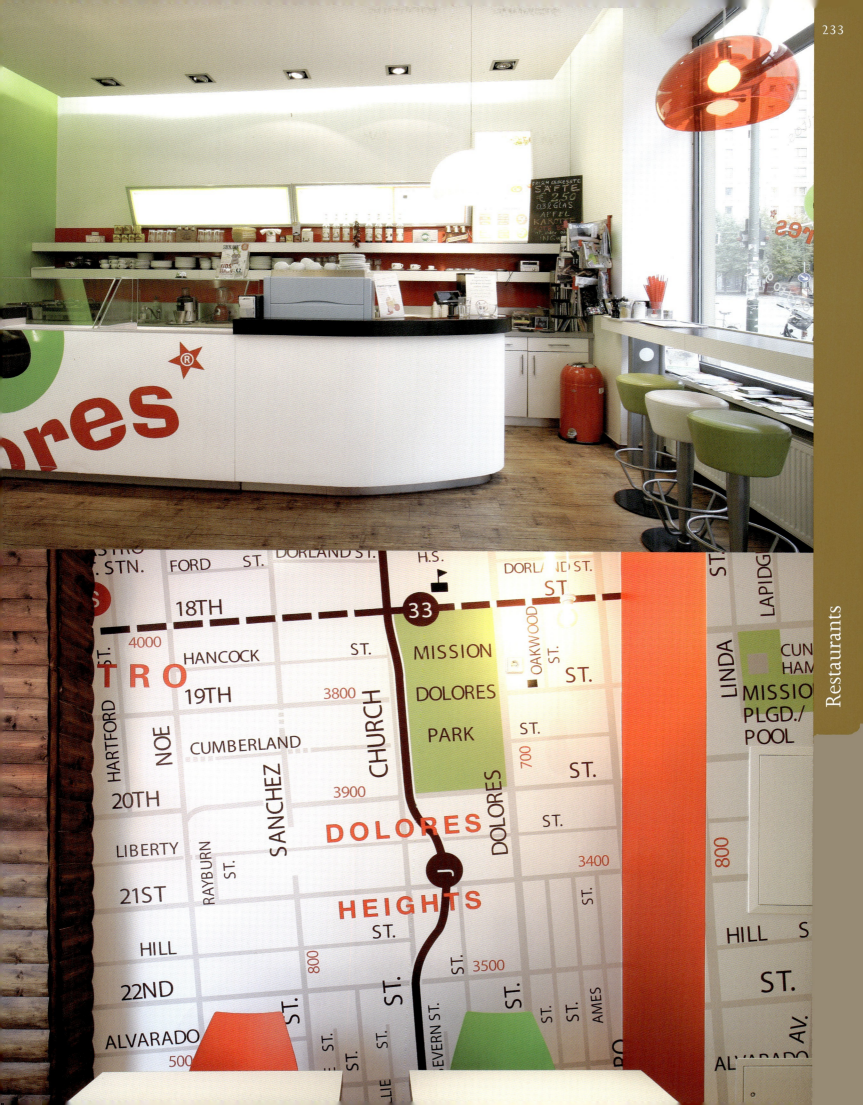

Barcomi's Deli

Sophienstraße 21, 10178 Berlin
☎ +49 30 28 59 83 63
www.barcomis.de
Ⓢ Hackescher Markt Ⓤ Weinmeisterstraße

Located in the idyllic Sophie-Gips courtyards, Barcomi's will remind you of cafés in Soho or on the Lower East Side of Manhattan. In the summer, they set up tables in the outside courtyard. All the specialities, such as muffins, scones, brownies, carrot cake and New York cheesecake, are homemade. The 13 different coffees on the menu are roasted in-house. The smaller flagship branch is at Bergmannstraße 21, in Kreuzberg.

In den idyllischen Sophie-Gips-Höfen gelegen, erinnert das Barcomi's an die Cafés in Soho oder der Lower East Side. Im Sommer werden im Innenhof Tische aufgestellt. Spezialitäten wie Muffins, Scones, Brownies, Carrot Cake und New York Cheese Cake sind allesamt hausgemacht. Die 13 angebotenen Kaffeesorten werden im Haus geröstet. Das kleinere Mutterhaus befindet sich in Kreuzberg in der Bergmannstraße 21.

Situé dans les jolies cours intérieures Sophie-Gips, le Barcomi's rappelle les cafés de Soho ou du Lower East Side de Manhattan. En été, les tables sont sorties dans la cour. Les spécialités maison sont les muffins, scones, brownies, carrot cake et New York cheese cake. Les 13 variétés de café proposées sont torréfiées sur place. La maison mère, plus petite, se trouve à Kreuzberg dans la Bergmannstraße 21.

Open: Mon–Sat 9am–9pm, Sun 10am–9pm.
Interior: An Oasis. Opened in 1998 at the heart of Berlin, this café has a good 50 seats both inside and out in the idyllic courtyard.
X-Factor: Berlin's "Miss American Pie" Cynthia Barcomi publicises her favourite recipes in two cookery books.

Öffnungszeiten: Mo–Sa 9–21, So 10–21 Uhr.
Interieur: Eine Oase: 1998 im Herzen Berlins eröffnet, ist das Café mit jeweils gut 50 Sitzplätzen drinnen und im idyllischen Innenhof konzipiert.
X-Faktor: Berlins „Miss American Pie" Cynthia Barcomi verrät ihre Lieblingsrezepte in zwei Backbüchern.

Horaires d'ouverture : Lun–Sam 9h–21h, Dim 10h–21h.
Décoration intérieure : Un oasis. Ouvert en 1998 au cœur de Berlin, ce café comprend 50 places assises à l'intérieur et autant dans la jolie cour extérieure.
Le « petit plus » : La « Miss American Pie » de Berlin, Cynthia Barcomi, dévoile ses recettes préférées dans deux ouvrages.

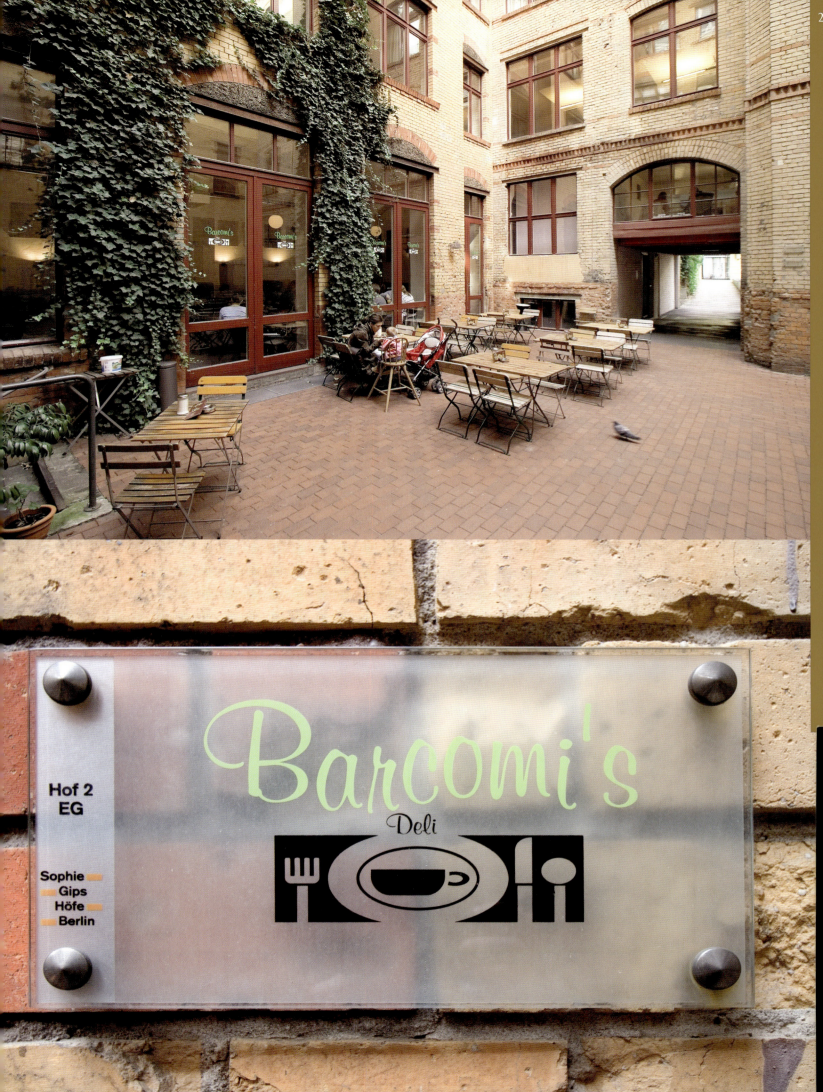

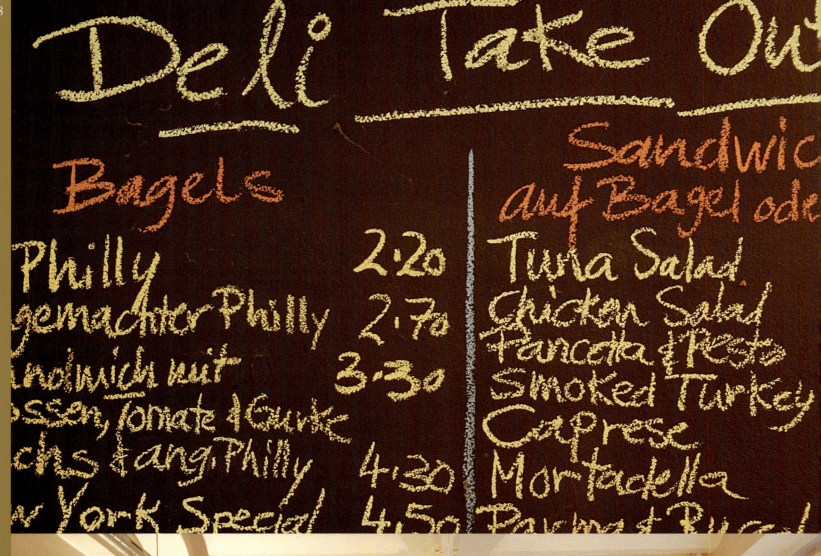
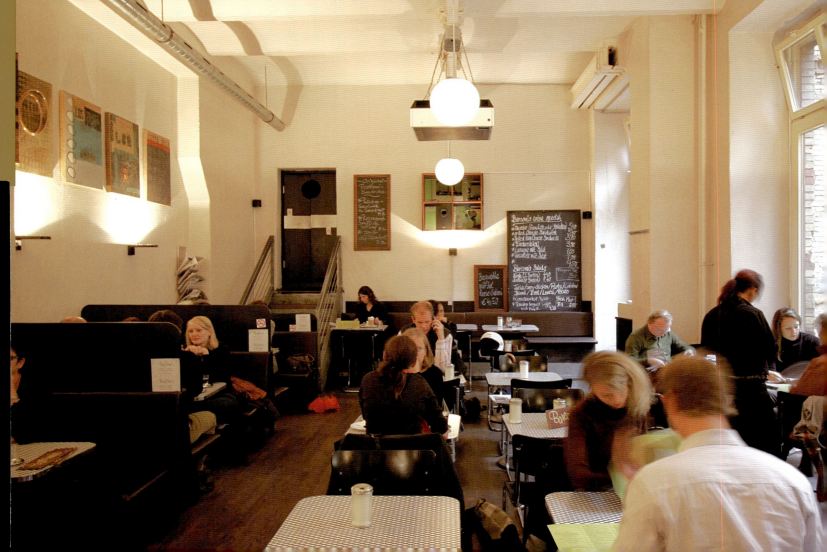

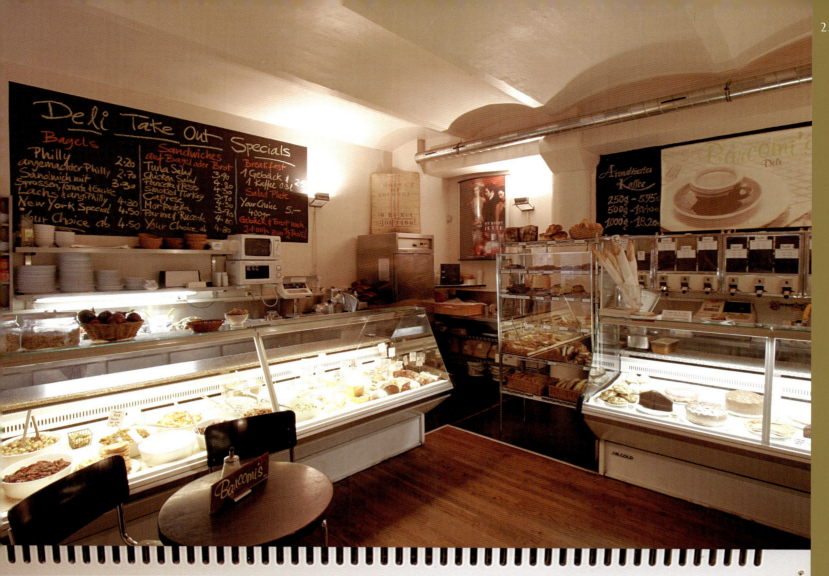

Greenwich

Gipsstraße 5, 10119 Berlin
☎ +49 30 28 09 55 66
Ⓢ Hackescher Markt Ⓤ Weinmeisterstraße

The pleasantly designed Greenwich bar is the last stop for many Berlin-Mitte nighthawks. The flirt factor is pretty high – and the fish in the large aquarium have certainly seen a lot …

Die angenehm designte Greenwich Bar ist für viele Nachtschwärmer von Berlin-Mitte die Endstation. Trotzdem ist der Flirt-Faktor hoch. Die Fische in den großen Aquarien haben schon vieles gesehen …

Agréable et design, le bar Greenwich est le terminus de nombreux noctambules de Berlin-Mitte. Toutefois, le facteur drague est élevé. Les poissons des grands aquariums ont vu bien des choses …

Open: Daily from 8pm.
Interior: Owner Heiko Martinez and Berlin's club guru Cookie gave the bar a futuristic, spaceship look with lime green, puffed leather walls and sofas.
X-Factor: Some guests even queue outside at minus temperatures for a drink.

Öffnungszeiten: Täglich ab 20 Uhr.
Interieur: Besitzer Heiko Martinez und Berlins Club-Guru Cookie verliehen der Bar ein futuristisches Raumschiff-Flair in limettengrünen, wulstigen Lederwänden und -sofas.
X-Faktor: Für einen Drink stehen die Gäste selbst bei Minusgraden draußen Schlange.

Horaires d'ouverture : Tous les jours à partir de 20h.
Décoration intérieure : Le propriétaire Heiko Martinez confère à ce bar un côté vaisseau spatial du futur avec ses murs et ses canapés renflés en cuir vert acidulé.
Le « petit plus » : On y fait la queue pour y boire un verre même par moins zéro.

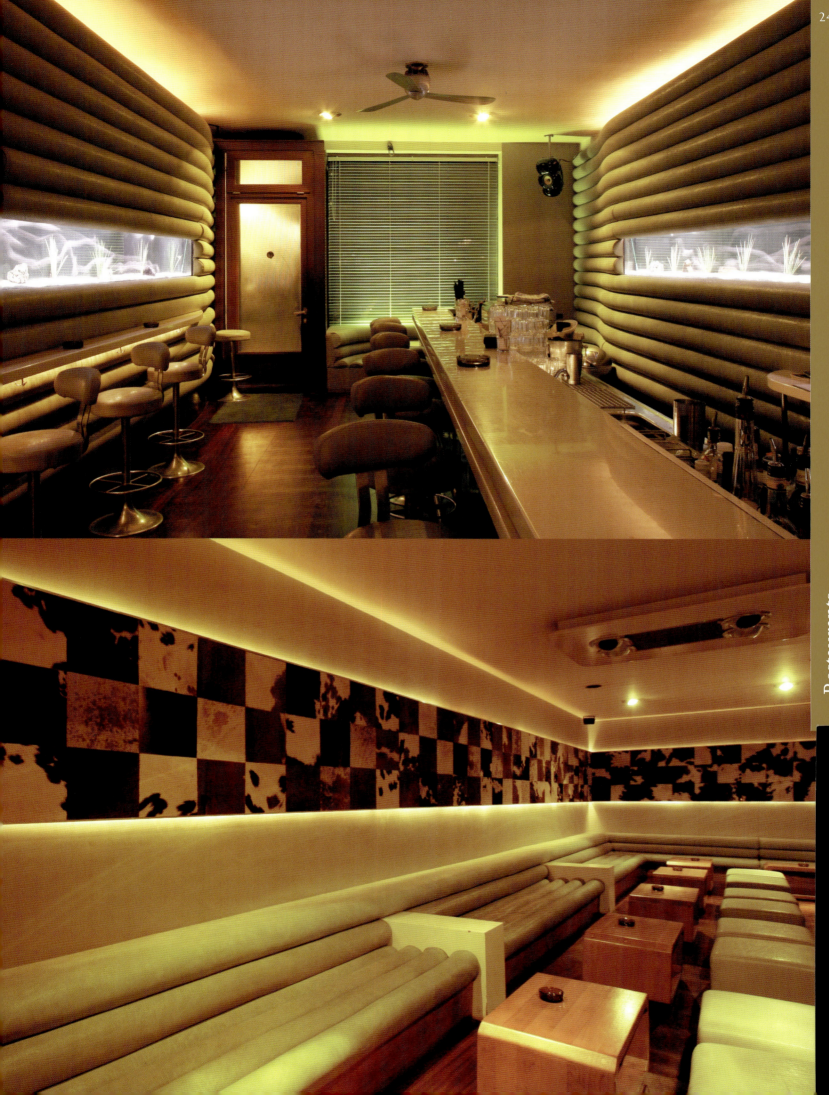

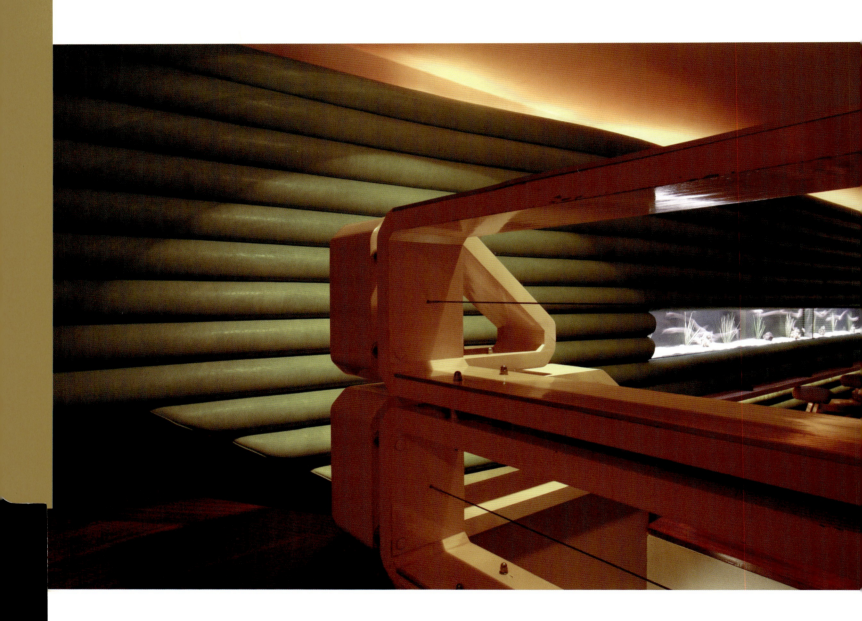

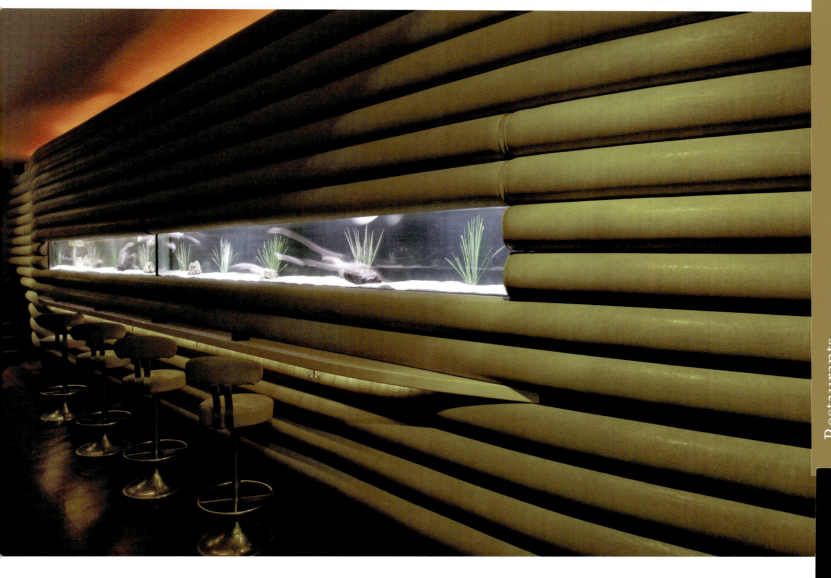

Clärchens Ballhaus

Auguststraße 24, 10119 Berlin
☎ +49 30 2 82 92 95
www.ballhaus.de
Ⓢ Hackescher Markt, Oranienburger Straße
Ⓤ Weinmeisterstraße, Oranienburger Tor

Clärchens Ballhaus (Little Claire's Ballroom) has been a legendary establishment in Berlin since 1913 – the city had more than 900 dance establishments in the 1920s. The new owners took over the building in 2004 and were clever enough to retain the original style of the premises. They hope to continue the ballroom tradition. This is where old and young go for a spin on a crowded dance floor with live music or a DJ. In summer you can sit outside in the delightful garden on old wooden chairs and eat stone-baked pizza and typical Berlin meatballs.

Seit 1913 war das Ballhaus ein legendäres Etablissement in Berlin (die Stadt hatte in den 1920er-Jahren mehr als 900 Tanzlokale). An diese Tradition wollen die neuen Betreiber anknüpfen, die das Haus 2004 übernommen haben und so klug waren, die Räumlichkeiten im Originalzustand zu belassen. Hier schwofen Alt und Jung dicht gedrängt zu Live- oder DJ-Musik. Im Sommer kann man im zauberhaften Garten auf alten Holzmöbeln Steinofenpizza und Berliner Buletten essen.

Le Ballhaus est depuis 1913 un établissement légendaire à Berlin (la ville abritait, dans les années 1920, plus de 900 dancings). Les nouveaux propriétaires qui l'ont repris en 2004 veulent renouer avec la tradition et ont eu la bonne idée de laisser les locaux en leur état d'origine. Jeunes et vieux guinchent sur de la musique live ou de DJ. L'été, on peut s'installer dans le joli jardin devant de vieilles tables en bois pour manger de la pizza cuite au feu de bois ou des boulettes berlinoises.

Open: Daily from 10am.
Interior: A homage to the 1920s: a classic ballroom, which even has its own coat-check ladies.
X-Factor: Between tradition and the present day. You can dance the night away here, but if you can no longer master the swing, cha cha cha or tango combinations, you can also take a dancing course.

Öffnungszeiten: Täglich ab 10 Uhr.
Interieur: Eine Hommage an die 1920er: Klassischer Ballsaal wie wie aus dem Bilderbuch; sogar mit eigenen Garderobieren.
X-Faktor: Ein Klassiker zwischen Tradition und Gegenwart – hier schwingt man das Tanzbein, und wer Cha-Cha-Cha oder Tango nicht (mehr) beherrscht, kann hier auch an Tanzkursen teilnehmen.

Horaires d'ouverture : Tous les jours à partir de 10h.
Décoration intérieure : Un hommage aux années 1920 : salle de bal typique avec dames aux vestiaires.
Le « petit plus » : Un classique entre tradition et présent – ici on danse, et si vous ne vous maîtrisez pas (ou plus) les pas du swing, cha-cha-cha ou du tango, vous pouvez participer aux cours.

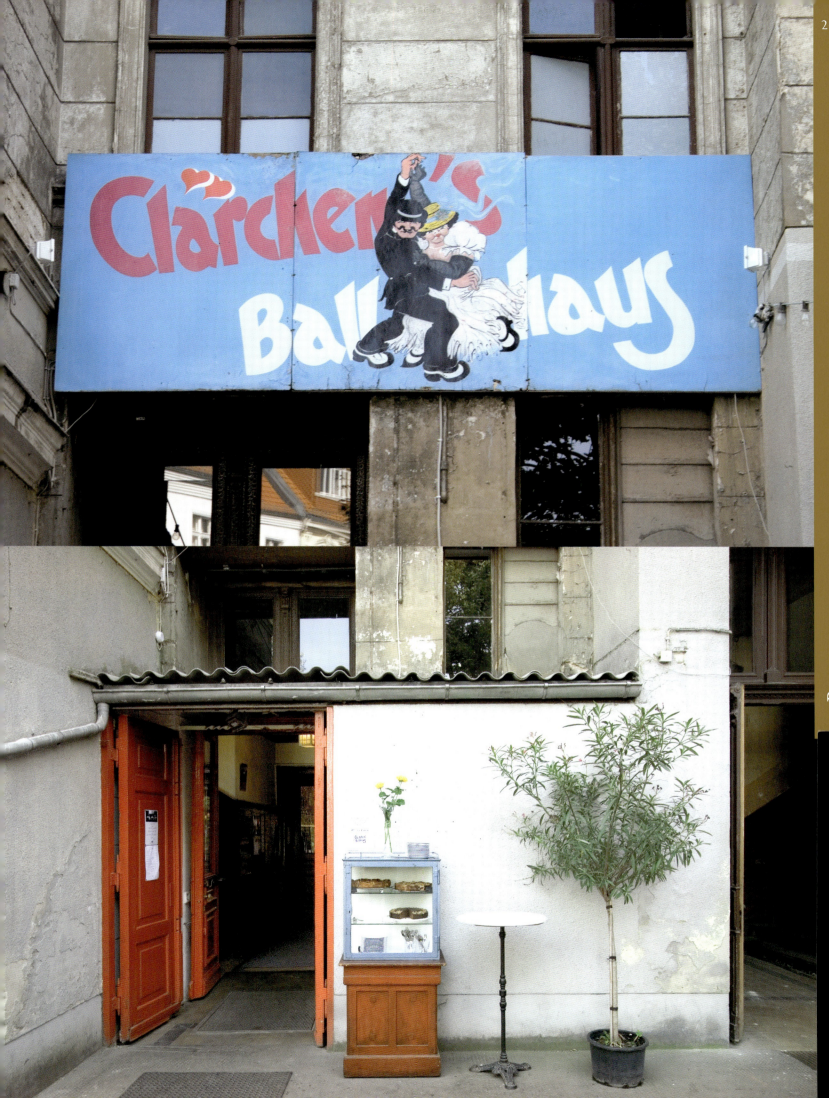

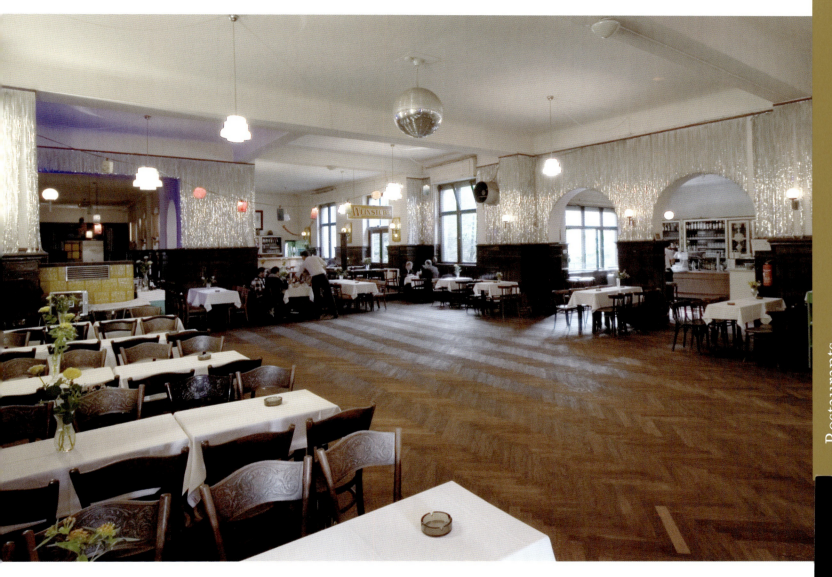

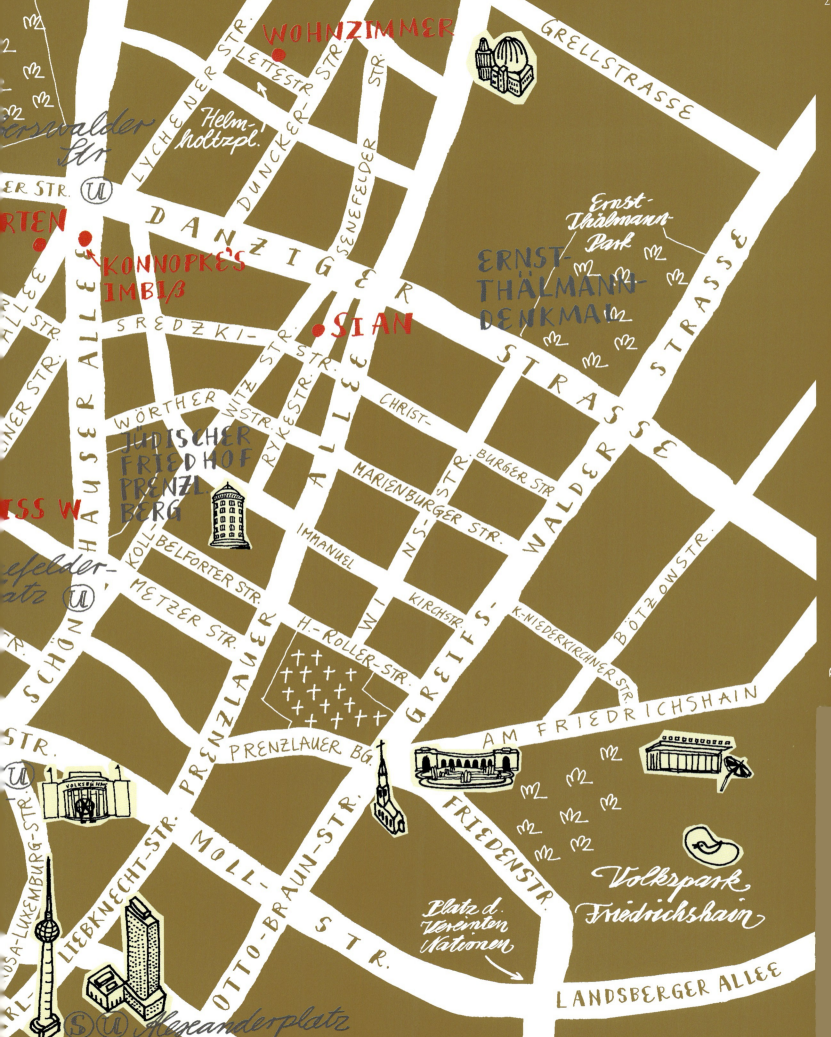

Galão A Pastelaria

Weinbergsweg 8, 10119 Berlin
☏ +49 30 44 04 68 82
www.galao-berlin.de
🇺 Rosenthaler Platz

Galão A Pastelaria in Weinbergsweg has developed into a popular meeting place in Berlin-Mitte since 2000. In summer you can sit outside on plastic chairs and watch Berlin life go by.

Seit 2000 hat sich das Galão A Pastelaria am Weinbergsweg zu einem beliebten Treffpunkt in Berlin-Mitte entwickelt. Im Sommer sitzt man entspannt vor der Tür auf Plastikstühlen und lässt das Berliner Leben an sich vorbeiziehen.

Depuis 2000, la Galão A Pastelaria au Weinbergsweg est devenu un des lieux de rencontre favoris de Berlin-Mitte. En été, on peut s'asseoir en toute insouciance à l'extérieur devant la porte sur des chaises en plastique et regarder passer la vie berlinoise.

Open: Mon–Sat 7.30am–8pm, Sun from 9am.
Interior: Inside it is like a bar in southern Europe; outside on the terrace, with a view of the park, you can loll about.
X-Factor: Their Galão (Portuguese caffe latte) and Pastel de Nata (pudding tart) put you in a holiday mood.

Öffnungszeiten: Mo–Sa 7.30–20, So ab 9 Uhr.
Interieur: Innen fühlt man sich wie in einer Bar im Süden Europas, draußen wird mit Parkblick gelümmelt.
X-Faktor: Bei einem Galão (portugiesischer Caffè Latte) und einer Pastel de Nata (Puddingtörtchen) kommt Ferienflair auf.

Horaires d'ouverture : Lun–Sam 7h30–20h, Dim à partir de 9h.
Décoration intérieure : À l'intérieur, on a l'impression d'être dans un bar dans le sud de l'Europe, à l'extérieur on se prélasse en terrasse avec vue sur un parc.
Le « petit plus » : Avoir l'impression d'être en vacances en buvant un Galão (café au lait portugais) et en dégustant un Pastel de nata (tartelette au flan).

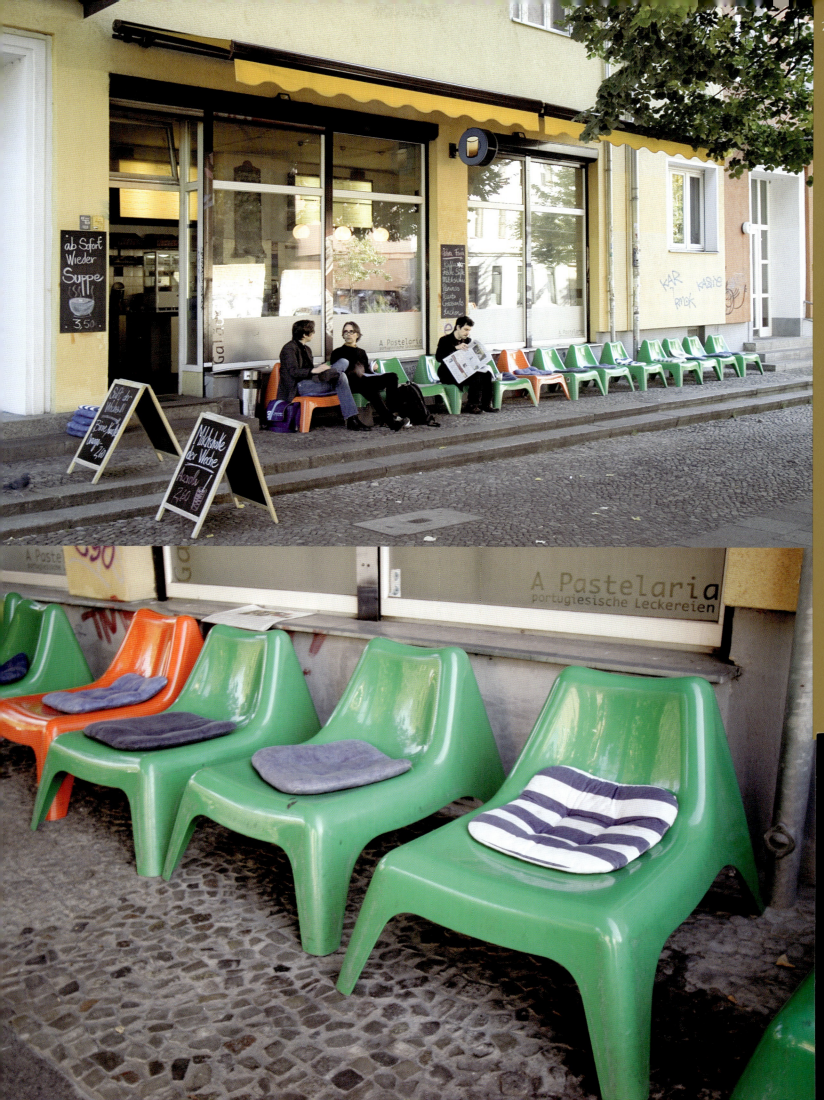

Der Imbiss W

Kastanienallee 49, 10119 Berlin
☎ +49 30 48 49 26 57
www.w-derimbiss.de
Ⓤ Eberswalder Straße

The Canadian cook Gordon W. always has a funny English comment to make while serving his delicious and healthy fusion-fast-food dishes like naan pizza, teriyaki tofu and vegetarian wraps. The drinks include mango lassi and Tannenzäpfle beer. In summer you can sit outside on the pavement and watch life drift by on Kastanienallee.

Der Kanadier Gordon W. serviert mit einem lustigen englischen Spruch auf den Lippen köstliche und gesunde Fusion-Fast-Food-Gerichte wie Naan-Pizza, Teriyaki-Tofu und vegetarische Wraps. Dazu gibt es Mango-Lassi oder Tannenzäpfle-Bier. Im Sommer gibt es Sitzplätze auf dem Trottoir, und man kann wunderbar das Treiben auf der Kastanienallee beobachten.

Le Canadien Gordon W. a toujours un mot d'esprit en anglais pour commenter avec humour ses plats de fusion-fast-food, délicieux et bons pour la santé, tels que la pizza naan, le tofu teriyaki et les wraps végétariens. Avec cela il y a du mango lassi ou de la bière Tannenzäpfle. En été, on peut s'installer sur le trottoir et merveilleusement bien observer les allées et venues sur la Kastanienallee.

Open: Daily from 12.30pm.
Interior: Simple Tiki style with a bamboo covered counter and South Seas accessories.
X-Factor: Everything is prepared fresh, even the dressings, like the hot chipotle-chilli or wild ginger sauces.

Öffnungszeiten: Täglich ab 12.30 Uhr.
Interieur: Einfacher Tiki-Stil mit bambusverkleidetem Tresen und Südsee-Accessoires.
X-Faktor: Alles wird ganz frisch zubereitet, auch die Dressings wie die scharfe Chipotle-Chili-Sauce oder die mit wildem Ingwer.

Horaires d'ouverture : Tous les jours à partir de 12h30.
Décoration intérieure : Style tiki simple avec comptoir habillé de bambou et accessoires des mers du Sud.
Le « petit plus » : Tout est frais, y compris les sauces comme la sauce épicée au piment Chipotle ou celle au gingembre sauvage.

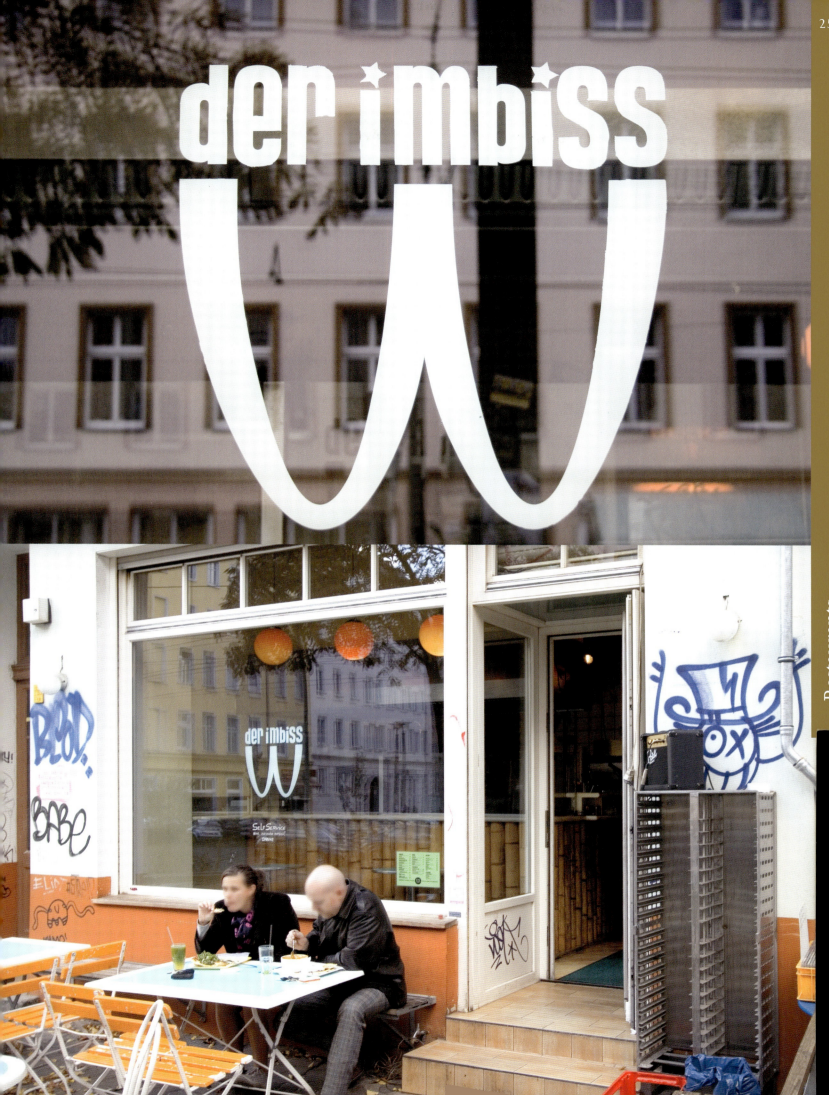

Restaurants

Prater Garten

Kastanienallee 7–9, 10435 Berlin
☎ +49 30 4 48 56 88
www.pratergarten.de
Ⓤ Eberswalder Straße

It all began with a beer counter in 1837, then it blossomed into a beer garden with an amusement tavern in 1852. The legendary actor Hans Albers was a regular customer, and the Paul Lincke orchestra played in the garden. In the wooden shack, which is a listed building, you can enjoy typical Berlin food like Königsberger Klopse (meat balls in a white sauce with capers) or Falscher Hase (meatloaf), accompanied by a tasty Prater Pils beer.

1837 wurde mit einem Bierausschank begonnen, 1852 kam der Aufstieg zum Biergarten mit Vergnügungsgaststätte. Der legendäre Schauspieler Hans Albers verkehrte hier, und Paul Lincke spielte mit seinem großen Orchester im Garten. In der denkmalgeschützten Bretterbude gibt es Berliner Küche wie Königsberger Klopse oder Falscher Hase, dazu leckeres Prater Pils.

Simple buvette en 1837, l'essor suivit en 1852 avec le Biergarten et la taverne. L'acteur légendaire Hans Albers fréquentait l'endroit, et Paul Lincke jouait avec son grand orchestre dans le jardin. Dans la baraque, classée monument historique, on propose de la cuisine berlinoise comme les Königsberger Klopse (boulettes de Königsberg) ou le Falscher Hase (rôti de viande hachée) et, pour arroser le tout, une bonne bière Prater Pils.

Open: Mon–Sat from 6pm, Sun from midday.
Interior: A traditional but contemporary venue for food and drink, with simple wooden furniture, floors and wall panelling.
X-Factor: In November and December they serve great roasted goose straight from the oven.

Öffnungszeiten: Mo–Sa ab 18, So ab 12 Uhr.
Interieur: Eine traditionelle, aber zeitgenössische Trink- und Speisewirtschaft; mit schlichten Holzmöbeln, -böden und -vertäfelungen.
X-Faktor: Zur Saison im November und Dezember wird hier bester Gänsebraten frisch aus dem Ofen serviert.

Horaires d'ouverture : Lun–Sam à partir de 18h, Dim à partir de 12h.
Décoration intérieure : Un bar et restaurant traditionnel, mais aussi moderne, avec des meubles en bois simples, des parquets et des lambris.
Le « petit plus » : En novembre et décembre, on y mange l'oie rôtie.

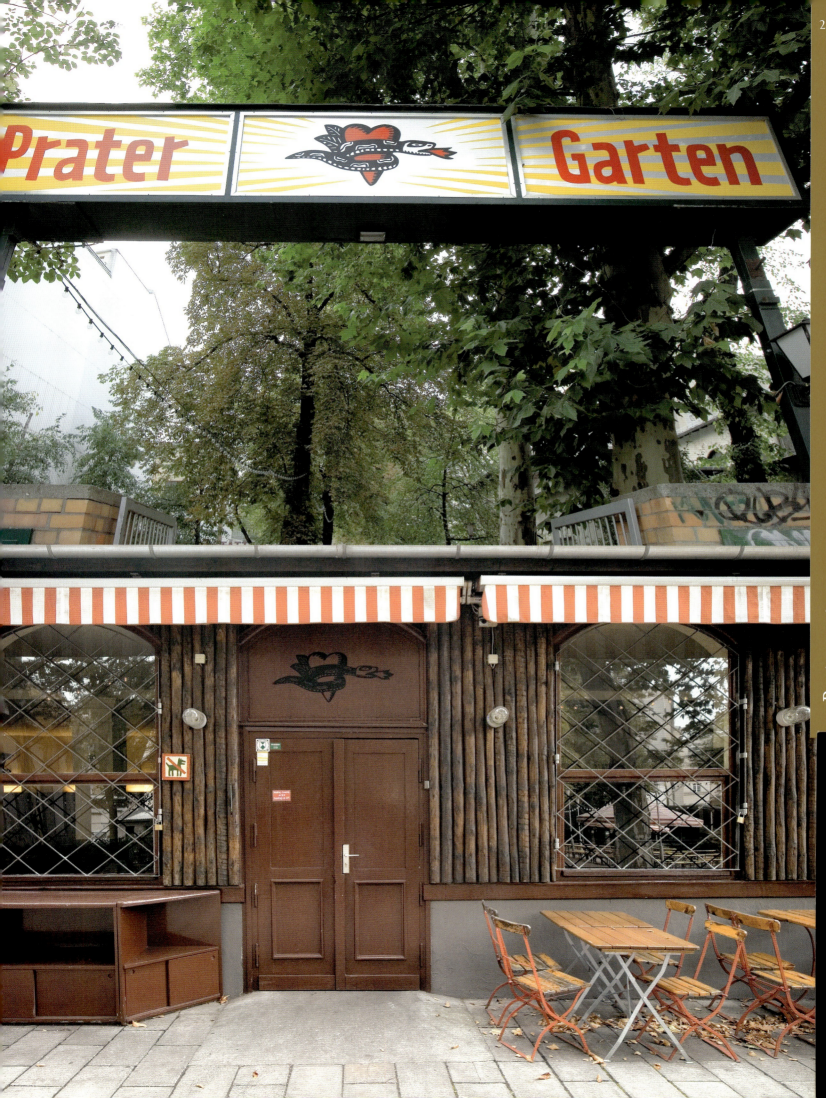

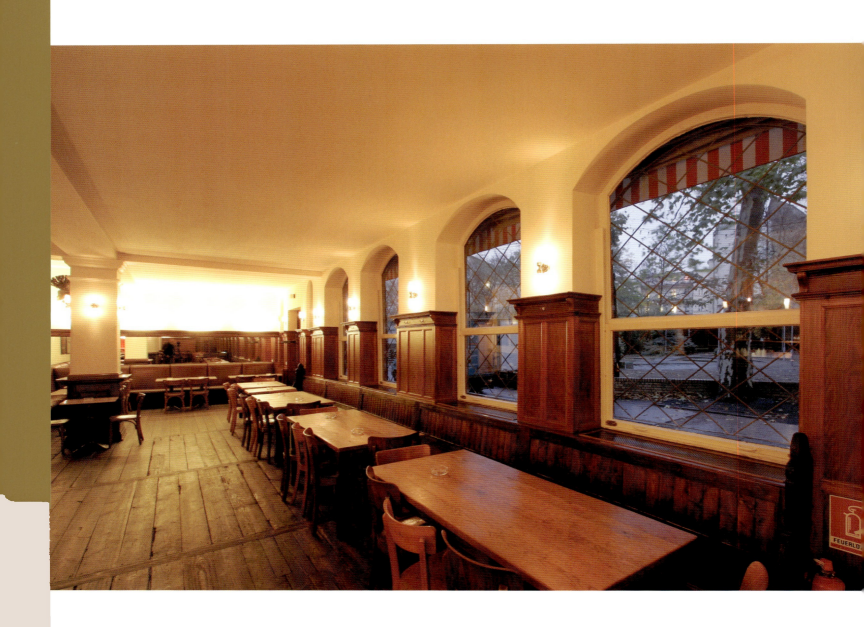

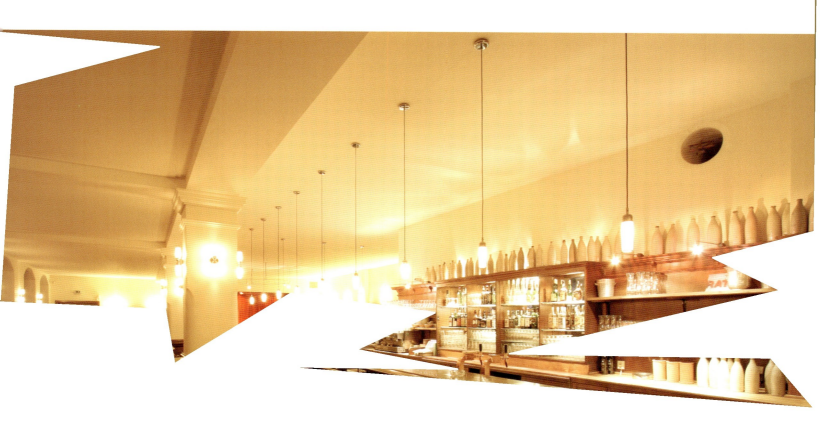

Konnopke's Imbiss

Schönhauser Allee 44a, 10435 Berlin
☎ +49 30 4 42 77 65
🆄 Eberswalder Straße

Here the most important Berlin speciality is served: currywurst (sausage with curry sauce). Since 1930 people have queued up here under the S-Bahn bridge to buy currywurst, with or without skin. The people in red-and-white striped aprons who serve you are real Berliners. This is one of the most traditional and quaint experiences you will find in Berlin – it's right out of a movie.

Hier gibt es die wichtigste Berliner Spezialität: die Currywurst. Seit 1930 steht man hier unter einer S-Bahn-Brücke Schlange, um eine Currywurst mit oder ohne Darm zu essen. Bedient wird man von Berliner Charakteren in rot-weiß gestreiften Kitteln. Eines der urigsten Erlebnisse, die man in Berlin haben kann. Filmreif.

La plus importante spécialité berlinoise : la saucisse au curry. Depuis 1930, on fait la queue ici sous un pont de la S-Bahn pour en manger une, avec ou sans boyau. Vous serez servi par des Berlinois typiques, vêtus de tabliers rayés rouge et blanc. Une des expériences les plus authentiques que l'on puisse vivre à Berlin. Digne d'être filmé.

Open: Mon–Fri 6am–8pm, Sat midday–7pm.
Interior: Sausage-and-chips stand. The pillars beside it are painted with graffiti – like images of famous Berlin buildings and figures, like Marlene Dietrich.
X-Factor: If you haven't been to Konnopke's, you don't really know Berlin.

Öffnungszeiten: Mo–Fr 6–20, Sa 12–19 Uhr.
Interieur: Die großen Pfeiler neben der Imbissbude sind mit grafittiähnlichen Bildern von bekannten Berliner Bauten und Berühmtheiten wie Marlene Dietrich bemalt.
X-Faktor: Wer nicht bei Konnopke war, hat Berlin nicht im Original kennengelernt.

Horaires d'ouverture : Lun–Ven 6h–20h, Sam 12h–19h.
Décoration intérieure : Les piliers de soutien du métro à côté du snack arborent des sortes de graffitis de constructions célèbres de Berlin et de personnalités comme Marlene Dietrich.
Le « petit plus » : Qui n'est pas allé chez Konnopke ne connaît pas Berlin.

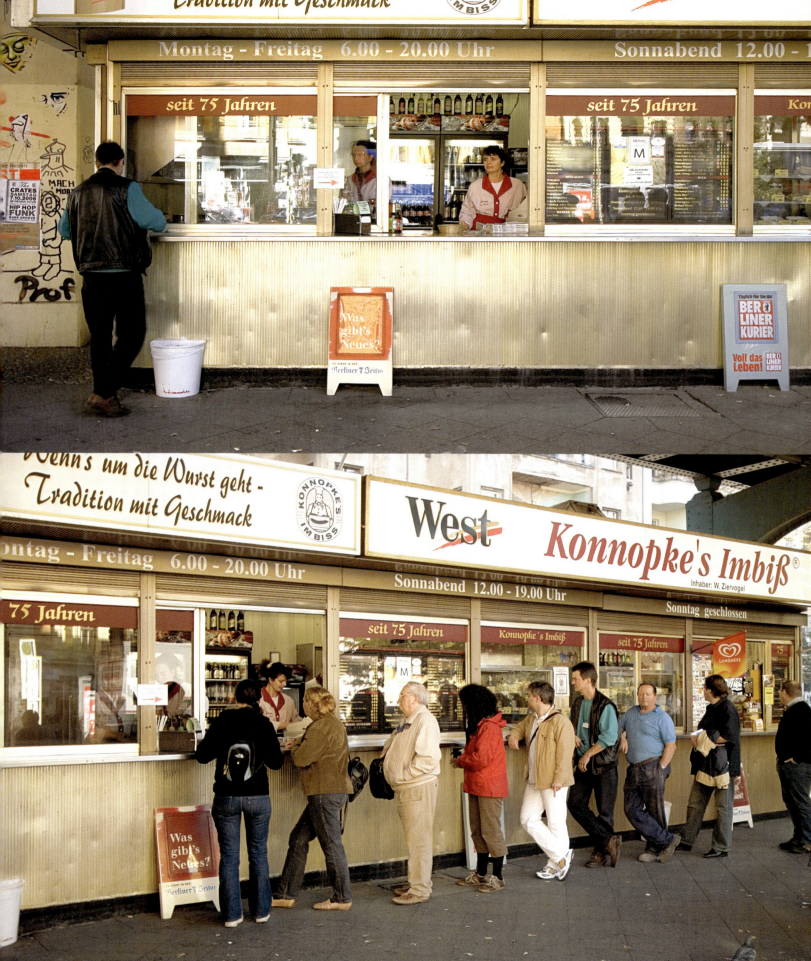

Restaurants

Si An

Rykestraße 36, 10405 Berlin
☎ +49 30 40 50 57 75
www.sian-berlin.de
Ⓢ Prenzlauer Allee Ⓤ Eberswalder Straße

Those who couldn't get a table at Monsieur Vuong in Alten Schönhauser Straße, or who found the food there just too boring, should try the Si An or its sister restaurant Chi Sing. The menu is similar, but the food much better prepared. The combination of spices in the dishes is out of this world, the teas and shakes quite unique and the desserts — to die for! Highly recommended!

Wer bei Monsieur Vuong in der Alten Schönhauser Straße keinen Platz findet oder das Essen allzu lieblos zubereitet findet, sollte unbedingt das Si An oder das Schwesterlokal Chi Sing ausprobieren. Hier gibt es ein ähnliches Menü – nur um Welten wohlschmeckender zubereitet. Die Gewürzmischungen der Speisen sind umwerfend, die Tees und Shakes einzigartig und die Nachtische eine Sünde wert. Unbedingt empfehlenswert!

Si vous ne trouvez pas de place chez Monsieur Vuong dans la Alte Schönhauserstraße ou si les plats vous semblent manquer d'exotisme, vous devez alors absolument essayer le Si An ou sa dépendance, Chi Sing. On y sert un menu semblable, mais les mets y sont bien meilleurs. Les mélanges d'épices dans ces plats sont prodigieux, les thés et shakes uniques et les desserts à vous damner. À tester absolument !

Open: Daily midday–midnight.
Interior: The minimalist Asian ambience was blessed by monks from the Buddhist monastery Phat Hue in Frankfurt am Main.
X-Factor: Si An and its sister restaurant Chi Sing, in Berlin-Mitte (Rosenthaler Straße 62), prepare the dishes without monosodium glutamate according to original recipes from Vietnamese monasteries.

Öffnungszeiten: Täglich 12–24 Uhr.
Interieur: Das kunstvoll minimale Asia-Ambiente wurde von Mönchen aus dem buddhistischen Kloster Phat Hue in Frankfurt am Main geweiht.
X-Faktor: Im Si An und im Schwesterlokal Chi Sing in Berlin-Mitte (Rosenthaler Straße 62) werden die Gerichte ausschließlich ohne Glutamat nach Originalrezepten aus vietnamesischen Klöstern zubereitet.

Horaires d'ouverture : Tous les jours 12–24h.
Décoration intérieure : L'ambiance asiatique, minimale réalisée avec art, a été bénie par les moines bouddhistes du monastère Phat Hue de Francfort-sur-le-Main.
Le « petit plus » : À Si An et à sa dépendance, Chi Sing, dans Berlin-Mitte (Rosenthaler Straße 62) les plats, sans glutamate, sont préparés selon des recettes originales de monastères vietnamiens.

Restaurants

Wohnzimmer

Lettestraße 6, 10437 Berlin
☎ +49 30 4 45 54 58
www.wohnzimmer-bar.de
Ⓢ Prenzlauer Allee Ⓤ Eberswalder Straße

The café is unusual and interestingly appointed, with all sorts of old living-room furniture (at last – a design-free space!). It's like sitting with Grandma in her parlour – except the guests are 50 years younger.

Das Café ist originell und gekonnt mit alten Wohnzimmermöbeln aller Art eingerichtet (endlich mal kein Design!). Man könnte meinen, man sitzt bei Oma auf dem Sofa – aber die Besucher sind 50 Jahre jünger.

Le café est original et parfaitement aménagé avec des meubles de salon de toutes sortes (enfin pas de design en vue!). On se croirait assis dans le canapé de sa grand-mère – mais les visiteurs ont 50 ans de moins.

Open: Daily from 9am.
Interior: Nostalgic vintage style: a mix of colourful wallpapers, old sofas and upholstered armchairs, little nostalgic lamps and assorted crockery – all very cosy.
X-Factor: Bionade with Prosecco!

Öffnungszeiten: Täglich ab 9 Uhr.
Interieur: Nostalgischer Vintage-Stil: Kunterbunt zusammengewürfelte Tapeten, alte Sofas, Omas Polstersessel, kleine nostalgische Lämpchen, bunt gemischtes Geschirr, – alles sehr gemütlich.
X-Faktor: Bionade mit Prosecco!

Horaires d'ouverture : Tous les jours à partir de 9 h.
Décoration intérieure : Style vintage nostalgique : pêle-mêle de papiers peints, vieux canapés, fauteuil capitonné de grand-mère, petites lampes nostalgiques, vaisselle colorée et mélangée – très chaleureux.
Le « petit plus » : Bionade avec Prosecco !

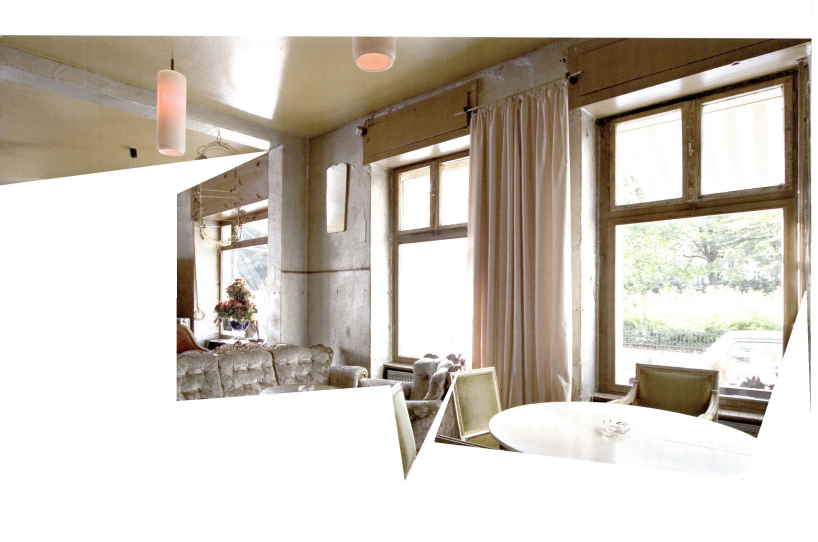

RESTAURANT SCHÖNBRUNN

ČSA BAR

MISERIA E NOBILTÀ

SCHNEEWEIß

Restaurants

Restaurant Schönbrunn

Am Schwanenteich im Volkspark Friedrichshain, 10249 Berlin
☏ +49 30 45 30 56 50
Bus: Am Friedrichshain

Restaurant Schönbrunn has an idyllic location, on Swan Pond in Friedrichshain Park, and consists of several pavilions with a restaurant, kiosk, terrace and beer garden. The pavilions were built in 1972 for the Weltfestspiele der Jugend (World Youth Festival) and were based on a design by the Weißensee Art School. The buildings were supposed to be demolished in 1999, but the present operator managed to prevent this and keep the pavilions as evidence of East German building history. The location is terrific, and the Wiener schnitzel is also excellent.

Idyllisch am Schwanenteich im Volkspark Friedrichshain gelegen, besteht das Restaurant Schönbrunn aus mehreren Pavillons mit Restaurant, Kiosk, Terrasse und Biergarten. Die Pavillons wurden anlässlich der Weltfestspiele der Jugend 1972 nach einem Entwurf der Kunsthochschule Weißensee gebaut. 1999 sollten die Gebäude abgerissen werden, doch die heutigen Betreiber erreichten den Erhalt der Pavillons als Dokument ostdeutscher Baugeschichte. Nicht nur die Location ist unschlagbar – auch das Wiener Schnitzel schmeckt hervorragend.

Situé de manière idyllique au bord d'un lac peuplé de cygnes dans le parc Friedrichshain, le Restaurant Schönbrunn est constitué de plusieurs pavillons avec restaurant, kiosque, terrasse et Biergarten. Ces pavillons ont été construits à l'occasion de la Fête mondiale de la jeunesse en 1972, conformément au projet de la Kunsthochschule Weißensee. Les bâtiments devaient être détruits en 1999, mais les propriétaires actuels ont réussi à sauvegarder ces pavillons, témoignages de l'histoire de l'architecture est-allemande. Cependant, il n'y a pas que l'endroit qui est irrésistible, la Wiener Schnitzel (l'escalope viennoise) y est excellente.

Open: Summer: Mon–Sun 10–1am, winter: Fri–Sun 10am–8pm.
Interior: Friedrichshain dates from 1840 and was Berlin's first public park designed according to an idea by Peter Joseph Lenné; the pavilions are still 1970s GDR.
X-Factor: A walk in the historical and varied park will give you an appetite for the substantial Austrian or Mediterranean cuisine.

Öffnungszeiten: Sommer: Mo–So 10–1 Uhr, Winter: Fr–S
Interieur: D... 1840 ist die erste ... und wur... Lenné... der D...
X-F...

Horaires d'ouverture : Été : Lun–Dim 10h–1h du matin, hiver : Ven–Dim 10h–20h.
Décoration intérieure : Le Friedrichshain de 1840 est le premier parc communal de Berlin, aménagé d'après une idée de Peter Joseph Lenné. Les pavillons sont restés dans le style RDA des années 1970.
Le « petit plus » : Il est possible de se restaurer dans ce parc chargé d'histoire : copieuses cuisines autrichienne ou méditerranéenne.

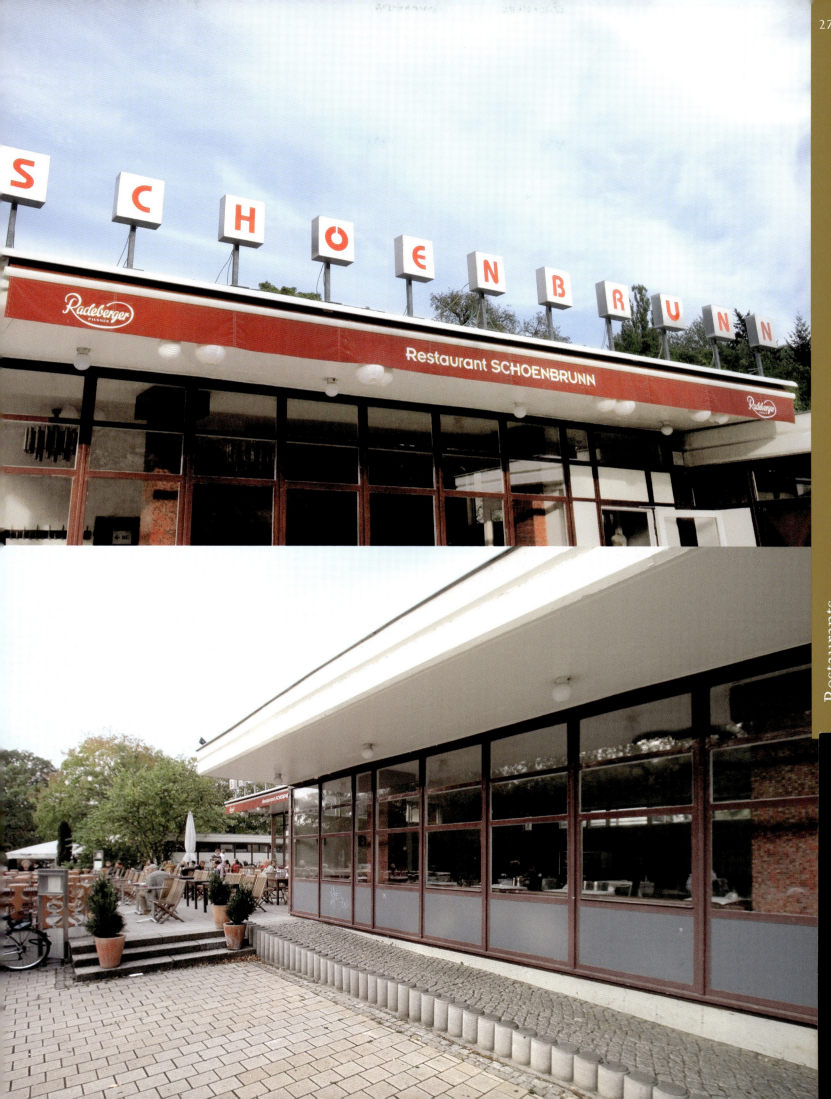

Restaurants

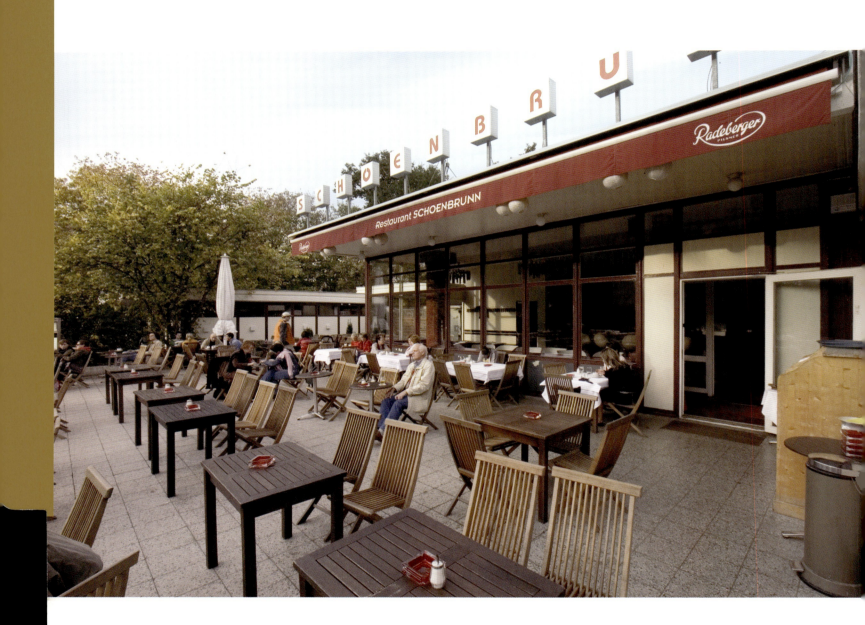

ČSA Bar

Karl-Marx-Allee 96, 10243 Berlin
☎ +49 30 29 04 47 41
www.csa-bar.de
Ⓤ Weberwiese

The most attractive bar in Berlin is inconspicuously located on the former showpiece boulevard of socialism, Karl-Marx-Allee, just beyond splendid Strausberger Platz. The rooms were renovated according to a scheme by owner and designer René Flatau that concentrates on essentials. The bar is completely tourist-free and you can drink an excellent cocktail in peace and quiet here. The bar occupies the former headquarters of the Československé Aerolinie, and is still haunted by socialists longing to fly up, up and away. I can recommend the Brandy Alexander or the White Russian, to name just two of the house specialties. Top class.

Open: Daily from 7pm (May–Oct from 8pm).
Interior: A successful homage to the 1960s: the aerodynamic reliefs behind the bar are relics from the ČSA airline.
X-Factor: The socialist atmosphere and the discreetly attentive service.

Die schönste Bar in Berlin liegt eher unscheinbar an der Karl-Marx-Allee, der ehemaligen Renommiermeile des Sozialismus, jenseits des grandiosen Strausberger Platzes. Die Räumlichkeiten wurden nach dem Konzept des Inhabers und Designers René Flatau, das sich auf das Wesentliche beschränkt, renoviert. Hierher verirren sich so gut wie keine Touristen, sodass man in Ruhe in dem ehemaligen Hauptbüro der Československé Aerolinie, das immer noch vom sozialistischen Fernweh zeugt, einen exzellent gemixten Cocktail trinken kann. Empfehlenswert z. B. ein Brandy Alexander oder White Russian. Weltklasse.

Öffnungszeiten: Täglich ab 19 Uhr (Mai–Okt ab 20 Uhr).
Interieur: Eine gelungene Hommage an die 1960er. Die aerodynamisch wirkenden Reliefs hinter der Bar sind Relikte der ČSA Fluglinie.
X-Faktor: Das sozialistische Flair und der aufmerksame und diskrete Service.

Le plus beau bar de Berlin se cache sur l'ancienne allée prestigieuse du socialisme, la Karl-Marx-Allee, de l'autre côté de la grandiose Strausberger Platz. Les espaces ont été restaurés selon le concept du propriétaire et designer René Flatau : se limiter à l'essentiel. Les touristes ne s'y perdent pas, si bien que vous pourrez boire tranquillement un excellent cocktail dans l'ancien siège de la Československé Aerolinie (compagnie aérienne tchèque), qui témoigne toujours de la nostalgie socialiste. Essayez par exemple le Brandy Alexander ou le White Russian. La classe !

Horaires d'ouverture : Tous les jours à partir de 19h (mai–oct. à partir de 20h).
Décoration intérieure : Un hommage réussi aux années 1960. Les reliefs aérodynamiques derrière le bar sont des vestiges de la compagnie aérienne ČSA.
Le « petit plus » : L'ambiance socialiste et le service attentif et discret.

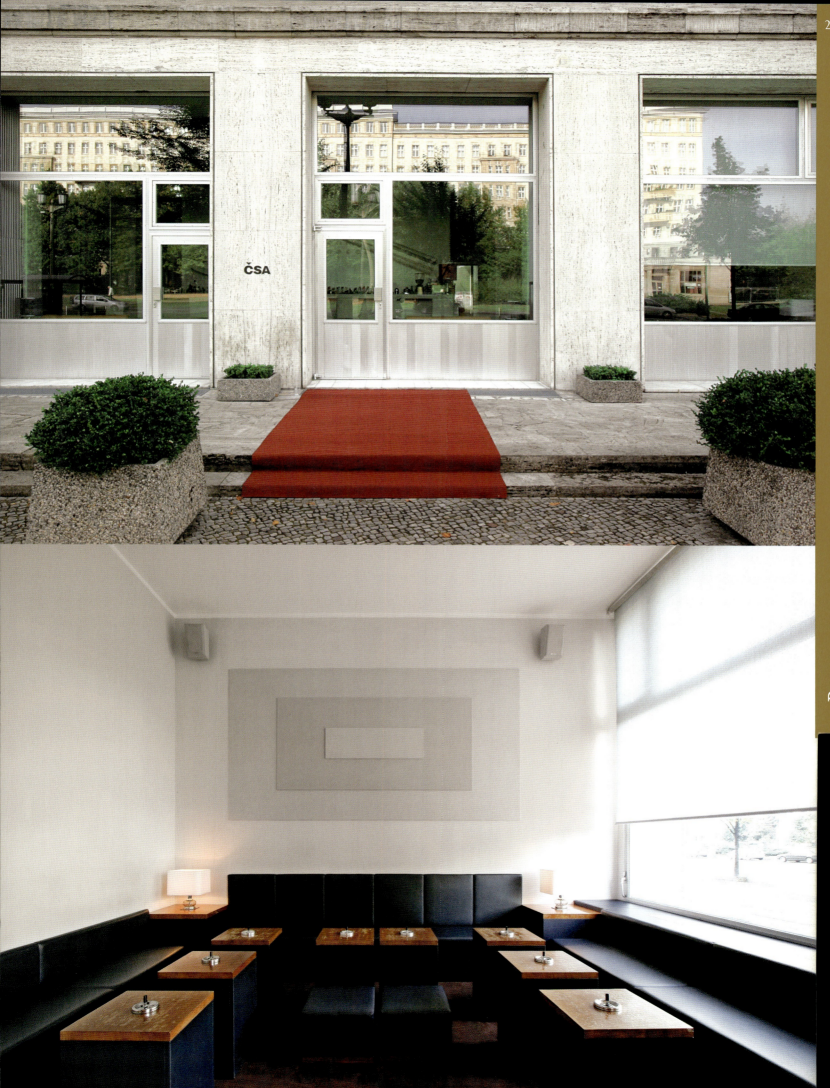

Restaurants

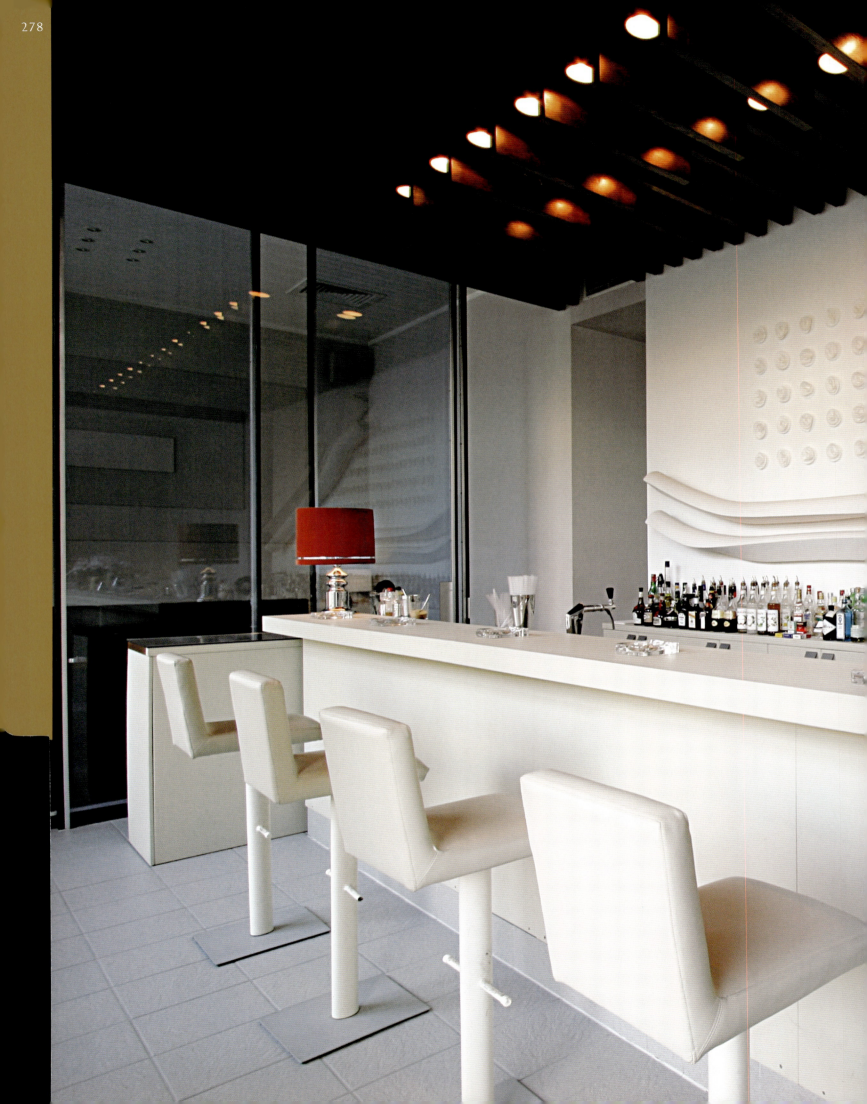

Miseria e Nobiltà

Kopernikusstraße 16, 10245 Berlin
☏ +49 30 29 04 92 49
🆂 Warschauer Straße 🆄 Samariterstraße

A small and refreshingly lively Italian restaurant named after the 1954 Italian film comedy starring a youthful and ravishing Sophia Loren. The food is prepared (no microwave here!) with real passion, a passion that's as warm as the welcome given to each guest. The menu is printed in Italian and is translated for you at your table by the chef.

Ein kleiner, erfrischend lebendiger Italiener, benannt nach der italienischen Filmkomödie von 1954 mit der blutjungen Sophia Loren in der Hauptrolle. Die Zubereitung der Speisen (nichts kommt aus der Mikrowelle!) wird genauso leidenschaftlich betrieben wie die Betreuung der Gäste. Die Speisekarte ist auf Italienisch verfasst und wird vom Chef am Tisch übersetzt.

Un petit restaurant italien, à l'ambiance joviale, dont le nom rappelle une comédie italienne de 1954 avec la toute jeune Sophia Loren dans le rôle principal. La préparation des plats (le micro-onde est banni !) fait autant l'objet de passion que l'accueil des clients. La carte est en italien, mais elle est traduite par le chef en personne à votre table.

Open: Tue–Thu 5.30pm–midnight, Fri–Sat 5.30pm–1am.
Interior: Dark wooden furniture and brick arches create a simple Italian atmosphere. The walls are decorated with photographs of film scenes with the young Sophia Loren.
X-Factor: Cooking and serving here are matters of passion. The fantastic pasta sauces are irresistible.

Öffnungszeiten: Di–Do 17.30–24, Fr–Sa 17.30–1 Uhr.
Interieur: Dunkle Holzmöbel und Backsteinbögen sorgen für schlichtes italienisches Flair. Die Wände schmücken Fotografien aus Filmszenen mit der jungen Sophia Loren.
X-Faktor: Hier kocht und serviert man mit Leidenschaft. Die fantastischen Pasta-Saucen sind unwiderstehlich.

Horaires d'ouverture : Mar–Jeu 17h30–24h, Ven–Sam 17h30–1h.
Décoration intérieure : Les meubles foncés et les voûtes en briques rouges confèrent une ambiance italienne simple. Les murs sont ornés de photos de scènes de tournage avec la jeune Sophia Loren.
Le « petit plus » : Ici, on cuisine et on sert avec passion. Les sauces accompagnant les pâtes sont succulentes.

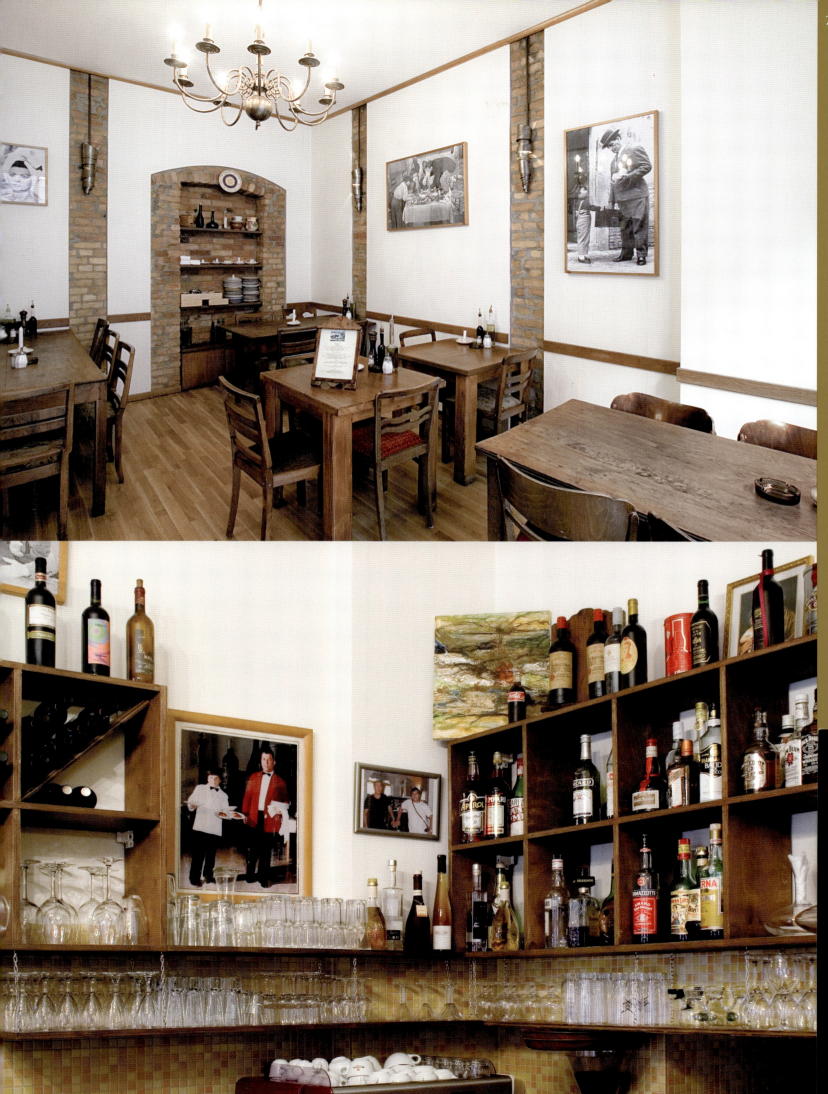

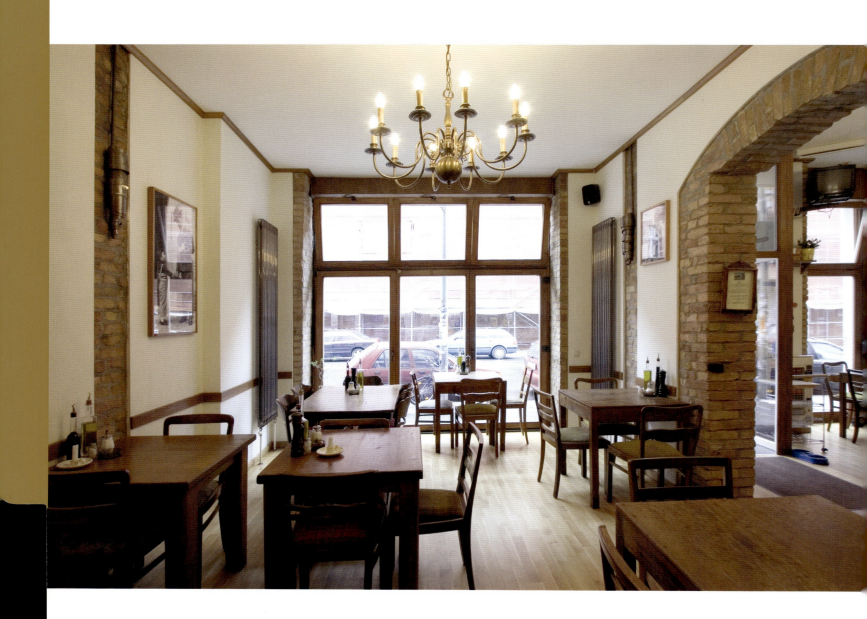

Restaurants

Schneeweiß

Simplonstraße 16, 10245 Berlin
☏ +49 30 29 04 97 04
www.schneeweiss-berlin.de
Ⓢ Warschauer Straße Ⓤ Samariterstraße, Warschauer Straße

Alpine dishes, from German cheese Spätzle (a traditional pasta dish from south Germany) to Italian meat dishes, are served here in modern Alpine ambience, designed by award-winning unit-berlin. Some guests even make the journey from Charlottenburg to enjoy the cosiness of an Alpine chalet in city guise.

Open: Mon–Sun 10am–1am.
Interior: The hexagon, reminiscent of a snowflake, is found on the logo, the wallpaper and the leather upholstery.
X-Factor: Like a winter's day in the mountains: radiantly white and with very good hut-fare. Don't forget to reserve a table in advance!

Öffnungszeiten: Mo–So 10–1 Uhr.
Interieur: Das Sechseck, das an Schneekristalle erinnert, findet man vom Logo über die Tapete bis zur Lederpolsterung immer wieder.
X-Faktor: Wie ein Wintertag in den Bergen – strahlend weiß und mit sehr guter Hüttenküche. Rechtzeitig reservieren!

Horaires d'ouverture : Lun–Dim 10h–1h.
Décoration intérieure : L'hexagone, rappelant le cristal de neige, est présent dans le logo, le papier peint et le capitonnage en cuir des banquettes.
Le « petit plus » : Tel un jour d'hiver en montagne – un blanc éclatant et une très bonne cuisine. Réserver à temps !

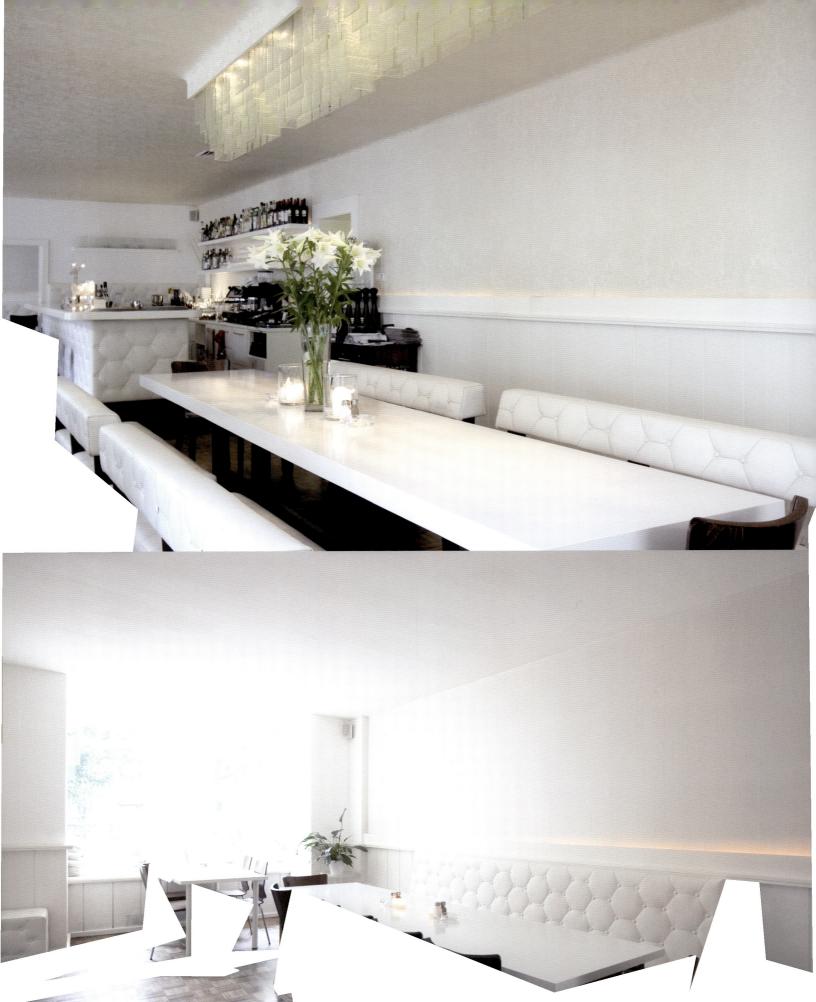

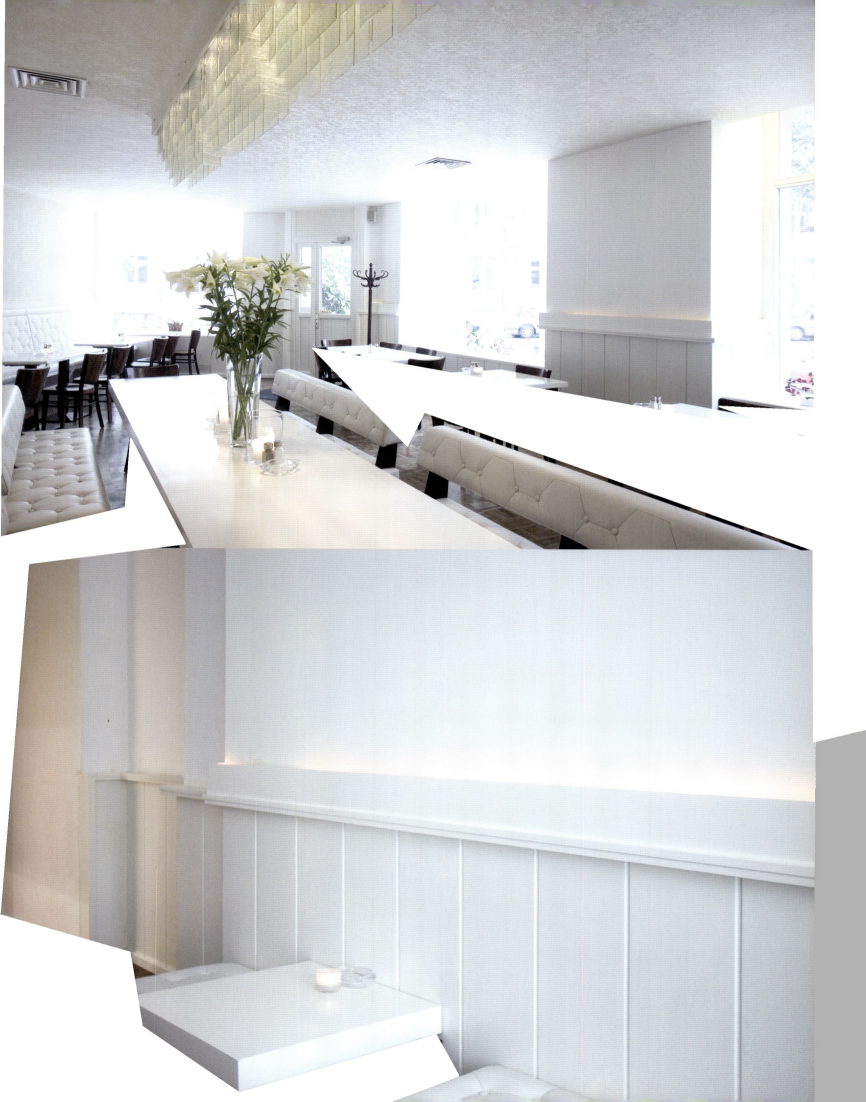

Shops

Charlottenburg | Wilmersdorf
- 294 Jil Sander
- 296 Chocolatier Erich Hamann
- 300 Manufactum
- 302 Bücherbogen am Savignyplatz
- 306 Emma & Co.
- 310 Galerie Hans-Peter Jochum
- 312 Steiff
- 314 Harry Lehmann

Kreuzberg
- 318 Paul Knopf
- 322 DIM

Mitte
- 326 TASCHEN
- 330 Departmentstore Quartier 206
- 334 Fundusverkauf
- 338 KPM
- 340 The Corner Berlin
- 344 1. Absinth Depot Berlin
- 348 Schönhauser Design
- 350 Andreas Murkudis
- 354 Adidas Originals Store
- 356 Lebensmittel in Mitte
- 358 Blush & Balls
- 362 Buffalo
- 366 Bless Shop
- 370 R.S.V.P. Papier in Mitte
- 374 Erzgebirgskunst Original
- 376 Thomas Wild Teppich- & Textilkunst
- 378 Jünemann's Pantoffeleck

Prenzlauer Berg
- 382 Wochenmarkt am Kollwitzplatz
- 386 in't Veld Schokoladen
- 390 Santi & Spiriti

Grunewald
- 394 Villa Harteneck

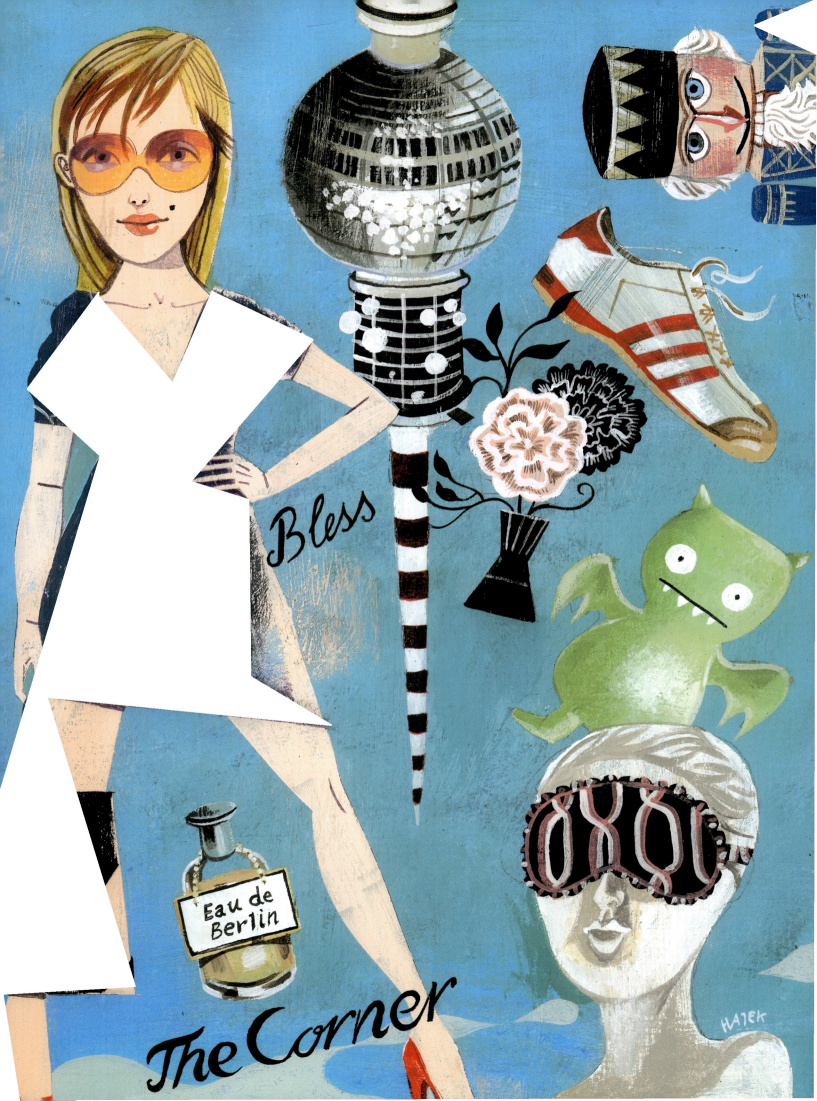

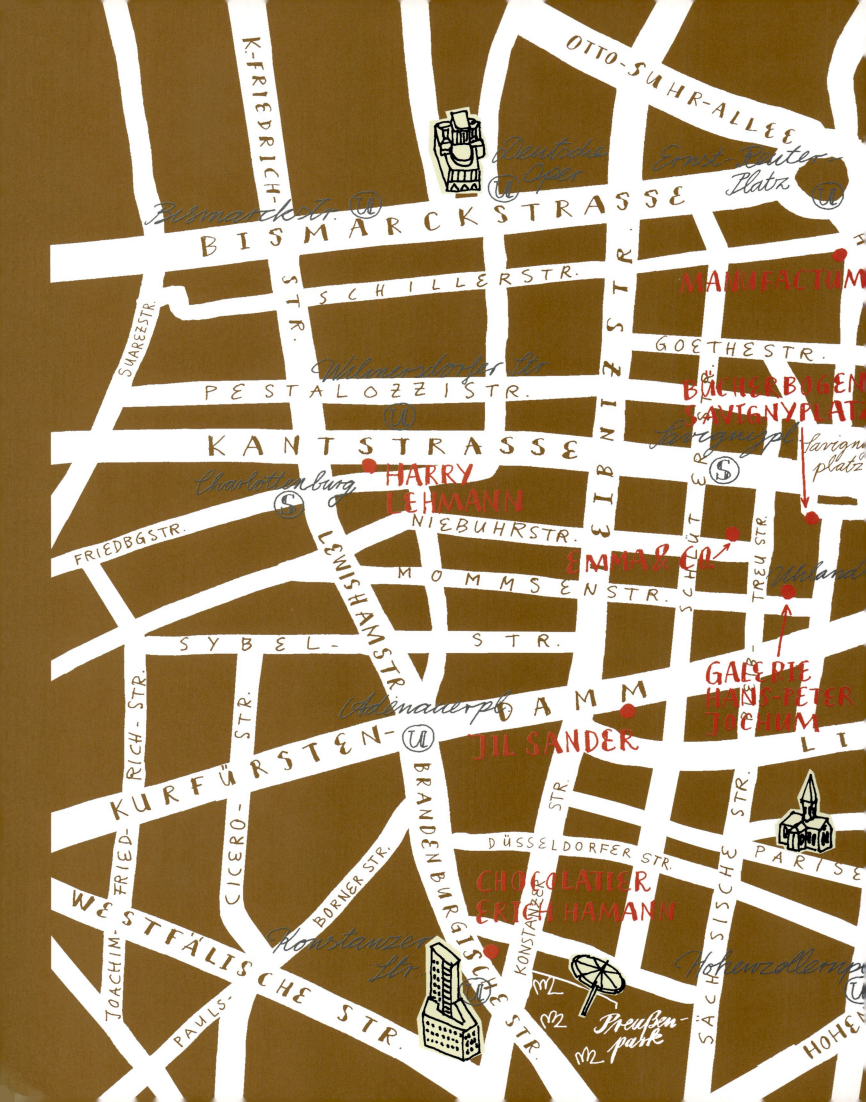

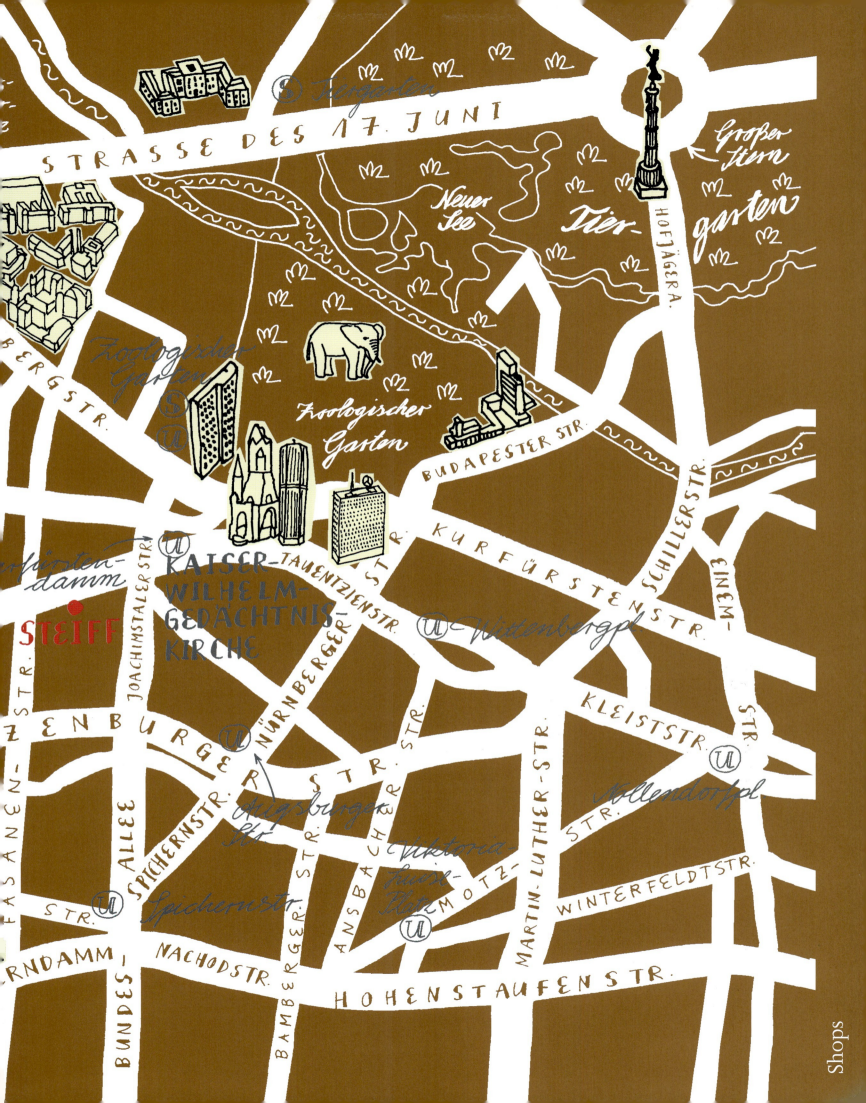

Jil Sander

Kurfürstendamm 185, 10707 Berlin
☎ +49 30 8 86 70 20
www.jilsander.com
Ⓤ Kurfürstendamm

The tug-of-war surrounding Jil Sander and her company has been going on for years: first it was sold to the Prada group, then the founder reappeared, only to be separated from the company yet again. The only truly international fashion label that's emerged from Germany has a name and a face again at last: Raf Simons. His designs are radical, with cleaner and simpler lines than his predecessor's, yet still sexy. Simons's work leads the original Sander look into the 21st century. He adds occasional brilliant flashes of orange among all the black and grey — the result is always molto elegante.

Open: Mon–Fri 10am–7pm, Sat 10am–6pm.
Interior: The Munich-based architects Meier-Scupin & Partner created the pure and elegant design of the Berlin flagship store.
X-Factor: Raf Simons's collection of shoes, handbags and accessories was launched in 2007.

Verkauf an die Prada-Gruppe, Wiedereintritt der Gründerin, abermalige Trennung: Das jahrelange Gezerre um Jil Sander und ihre Firma trägt alle Züge eines Dramas. Seit Kurzem hat die einzig wirklich internationale Modemarke aus Deutschland endlich wieder ein Gesicht: Raf Simons. Noch radikaler, noch klarer, noch schlichter, dabei sexy — Simons führt den Stil der Gründerin des Sander-Looks ins 21. Jahrhundert. Da deren hanseatisches Dunkelblau oft etwas bieder wirkte, leuchtet jetzt hier und da ein kräftiges Orange zwischen viel Schwarz und Grau — aber immer molto elegante.

Öffnungszeiten: Mo–Fr 10–19, Sa 10–18 Uhr.
Interieur: Das puristische und edle Design des Berliner Flagship-Stores entwarfen die Münchner Architekten Meier-Scupin & Partner.
X-Faktor: Die 2007 neu lancierte Schuh-, Taschen- und Accessoires-Kollektionen unter der Leitung von Raf Simons.

Vente au groupe Prada, retour de la fondatrice, nouvelle rupture : les relations tumultueuses entre Jil Sander et son entreprise ont tout de la dramaturgie. Depuis peu, l'unique maison de couture allemande de renom international a de nouveau un visage : Raf Simons. Encore plus radical, plus clair, plus dépouillé, tout en étant sexy, Simons transpose le style de la créatrice du look Sander au 21ᵉ siècle. La collection s'illumine désormais de quelques touches d'orange vif parmi beaucoup de noir et de gris — mais toujours molto elegante.

Horaires d'ouverture : Lun–Ven 10h–19h, Sam 10h–18h.
Décoration intérieure : Le design puriste et élégant du flagship store berlinois a été conçu par les architectes munichois Meier-Scupin & Partner.
Le « petit plus » : Les nouvelles collections de chaussures et d'accessoires lancées en 2007 sous la direction de Raf Simons.

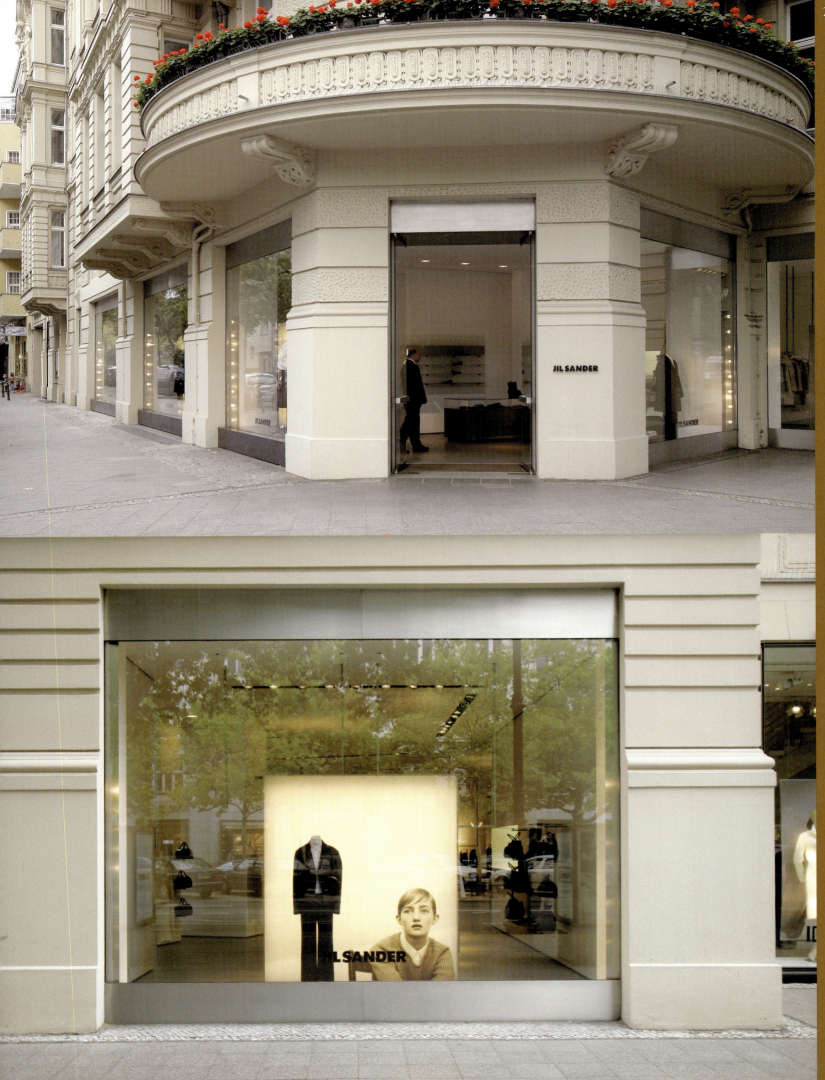

Chocolatier Erich Hamann

Brandenburgische Straße 17, 10707 Berlin
☎ +49 30 8 73 20 85
Ⓤ Konstanzer Straße

This Berlin chocolatier is worth a visit even if you don't care for chocolate. The traditional company was founded in 1912, and in 1928 moved into the Hamann Works in Brandenburgische Straße, a building designed by Bauhaus icon Johannes Itten. The shop and factory have remained unchanged since then, and a third generation of owners is producing and selling this chocolate. The unusual Bauhaus-style packaging of the chocolate has achieved brand cult status. Ideal for a little gift – unless you give in to temptation and eat it yourself!

Open: Mon–Fri 9am–6pm, Sat 9am–1pm.
Interior: Designer Johannes Itten was creative director of the Weimar Bauhaus from from 1919 to 1923. The chocolate shop dating from 1928 is a prime example of his clear and modern style and his eye for form and colour.
X-Factor: The most famous house brand is the "Edelbitter" made with 70 % cocoa. Opt for the impressive 200-gram-bar in the original design.

Ein Besuch bei dem Berliner Chocolatier ist selbst dann ein Erlebnis, wenn man gar keine Schokolade mag. Das Traditionsunternehmen wurde 1912 gegründet und zog 1928 in die von der Bauhaus-Ikone Johannes Itten entworfenen Hamann-Werke in die Brandenburgische Straße. Seither sind Ladengeschäft und Produktionsstätte unverändert, und in dritter Generation wird Schokolade hergestellt und verkauft. Das für Süßigkeiten untypische Verpackungsdesign in der strengen Formensprache des Bauhauses ist Markenzeichen mit Kultstatus und als Mitbringsel bestens geeignet – falls man denn so lange widerstehen kann.

Öffnungszeiten: Mo–Fr 9–18, Sa 9–13 Uhr.
Interieur: Designer Johannes Itten war von 1919–1923 künstlerischer Leiter am Bauhaus in Weimar. Das Schokoladengeschäft von 1928 ist ein Musterbeispiel für seine klare, moderne Formen- und Farbsprache.
X-Faktor: Die „Edelbitter" mit 70 % Kakaomasse ist die berühmteste Marke des Hauses. Am besten gleich als imposante 200-Gramm-Tafel im Originaldesign kaufen.

Une visite chez ce chocolatier est un événement, même pour ceux qui ne sont pas amateurs de chocolats. Fondée en 1912, cette entreprise familiale a emménagé dans les fabriques Hamann de la Brandenburgische Straße, érigées par l'icône du Bauhaus Johannes Itten. Le magasin et l'atelier de production n'ont pas changé depuis et l'on y fabrique et vend des chocolats dans la plus pure tradition depuis trois générations. La boîte d'emballage au design Bauhaus, tout à fait atypique pour des confiseries, est devenue un symbole culte de la marque et fera un parfait cadeau – à condition de résister à la tentation.

Horaires d'ouverture : Lun–Ven 9h–18h, Sam 9h–13h.
Décoration intérieure : Le designer Johannes Itten fut directeur artistique (1919–1923) au Bauhaus de Weimar. Ce magasin de chocolats (1928) illustre la modernité.
Le « petit plus » : Avec 70 % de cacao, la marque « Edelbitter » est la plus célèbre de la maison. Prenez la tablette de 200 grammes dans son dessin d'origine.

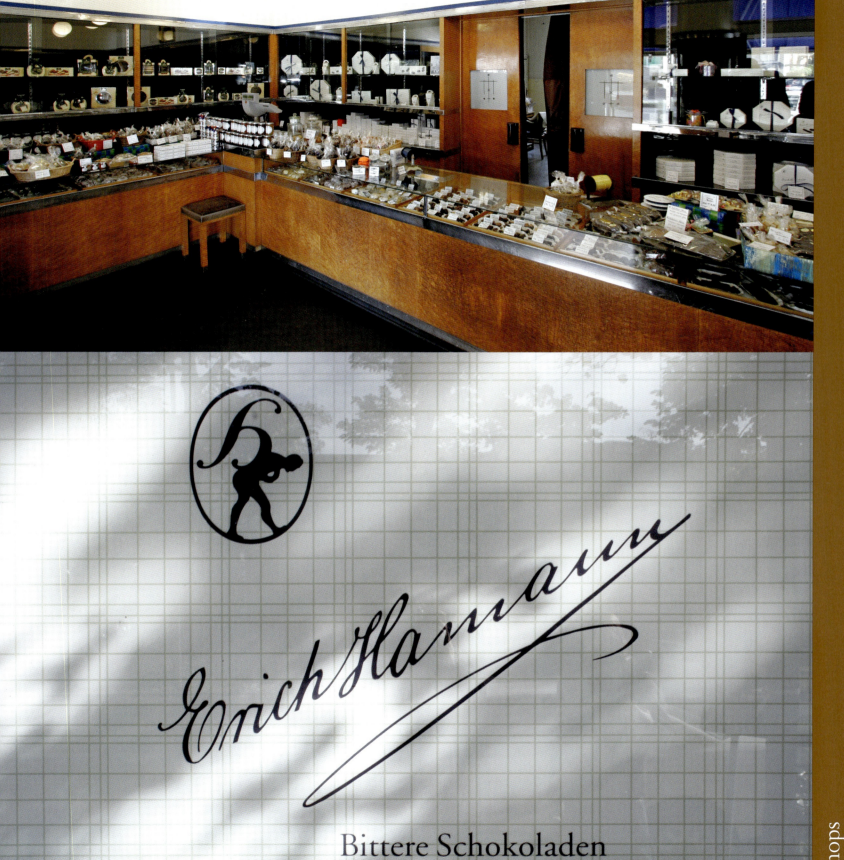

Bittere Schokoladen

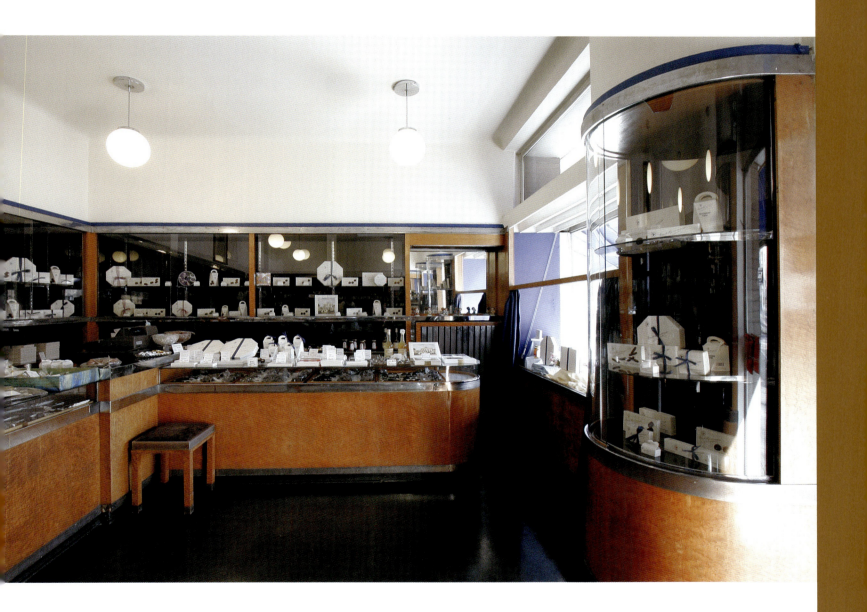

Manufactum

Hardenbergstraße 4–5, 10623 Berlin
Department store: ☏ +49 30 24 03 38 44
Manufactum Brot&Butter: ☏ +49 30 26 30 03 46
www.manufactum.de
Ⓤ Ernst-Reuter-Platz

"The good things are still around," is the trademark slogan of the German concept store Manufactum. In this case, "good" means lavishly produced, reliable and durably designed products made from high-quality materials. Household goods, toiletries, furniture and textiles are all part of the product range. Most of the 8,500 products are also sold over the Internet. You can browse the range of products at Haus Hardenberg on Ernst-Reuter-Platz. The grocery shop Manufactum Brot&Butter is situated next door and advertises its products with the same slogan.

Open: Mon–Fri 10am–8pm, Sat 10am–6pm.
Interior: Paul Schwebes built Haus Hardenberg in 1955/56. It used to house the Kiepert bookshop. Today, Manufactum's complete range is presented over two floors.
X-Factor: The unique series "Gutes aus Klöstern" (Fine items from monasteries), with over 200 products. Some of the recipes are over 1,500 years old.

„Es gibt sie noch, die guten Dinge", lautet der Slogan des deutschen Concept-Stores Manufactum. „Gut" bedeutet in diesem Fall: aufwendig gefertigt, funktionstüchtig, langlebig und materialgerecht gestaltet. Zum Sortiment zählen Haushaltswaren, Körperpflegemittel, Möbel und Textilien. Die meisten der 8 500 Produkte werden auch via Internet verkauft. Im Haus Hardenberg am Ernst-Reuter-Platz kann die Produktpalette begutachtet werden. Nebenan liegt das Lebensmittelgeschäft Manufactum Brot&Butter, das mit dem gleichen Slogan wirbt.

Öffnungszeiten: Mo–Fr 10–20, Sa 10–18 Uhr.
Interieur: Das Haus Hardenberg baute Paul Schwebes 1955/56. Früher war hier die Buchhandlung Kiepert untergebracht, heute wird das gesamte Manufactum-Sortiment auf zwei Etagen angeboten.
X-Faktor: Die einzigartige Produktserie "Gutes aus Klöstern", mit mehr als 200 Waren, die aus Klöstern in ganz Europa kommen. Manche Rezepte sind über 1 500 Jahre alt.

« Les bonnes choses existent encore » est la devise du concept store allemand Manufactum. Ici « bon » signifie : fabriqué avec soin, fiable, durable et fait avec des matériaux de bonne qualité. En magasin, vous trouverez des articles ménagers, des cosmétiques, des meubles et tissus. La plupart des 8 500 produits sont également en vente sur Internet. Vous pourrez juger de la qualité par vous-mêmes en vous rendant à la Maison Hardenberg sur la Ernst-Reuter-Platz. Juste à côté, le Manufactum Brot&Butter, spécialisé dans l'alimentation, répète le même slogan.

Horaires d'ouverture : Lun–Ven 10h–20h, Sam 10h–18h.
Décoration intérieure : Paul Schwebes a construit la Maison Hardenberg en 1955/56. Anciennement librairie Kiepert, elle propose aujourd'hui tous les articles de Manufactum sur deux étages.
Le « petit plus » : La série « Gutes aus Klöstern » avec plus de 200 produits issus de monastères de toutes l'Europe. Certaines recettes datent de plus de 1500 ans.

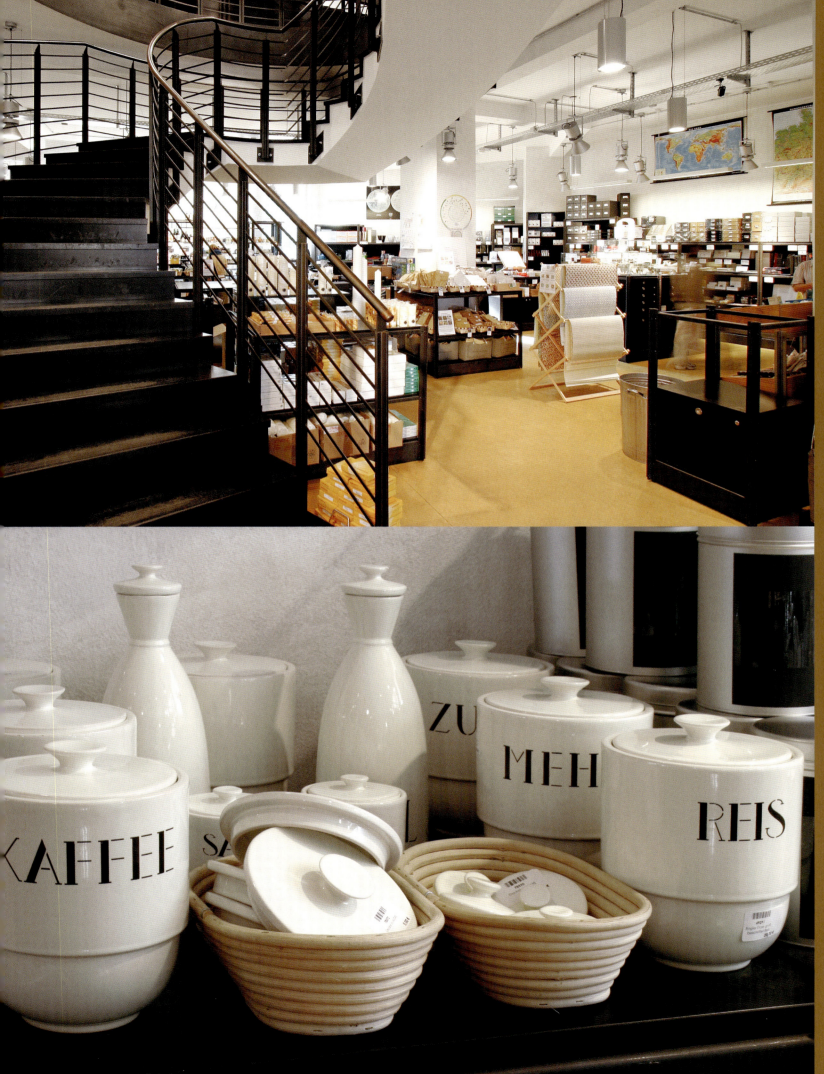

Bücherbogen am Savignyplatz

Stadtbahnbogen 593, 10623 Berlin
☏ +49 30 31 86 95 11
www.buecherbogen.com
Ⓢ Savignyplatz

Founded in 1980 by Ruth Spangenberg and renovated by the architectural firm of Gerhard Spangenberg, this was one of the first bookshops to specialise in art, architecture and design. Bibliophiles like Karl Lagerfeld really appreciate the shop's excellent selection. Beware: the books are heavy!

Der 1980 von Ruth Spangenberg gegründete und vom Architekturbüro Gerhard Spangenberg umgebaute Laden war eine der ersten Buchhandlungen, die sich auf Kunst, Architektur und Design spezialisierten. Die exquisite Auswahl des Ladens wird bei Büchernarren wie Karl Lagerfeld hoch geschätzt. Achtung: Bücher sind schwer!

Cette librairie, fondée en 1980 par Ruth Spangenberg et rénovée par le bureau d'architectes Gerhard Spangenberg, a été l'une des premières à se spécialiser dans le livre d'art, d'architecture et de design. L'excellent assortiment des livres ravit les bibliomanes comme Karl Lagerfeld. Mais attention, les livres, ça pèse !

Open: Mon–Fri 10am–8pm, Sat 10am–6pm.
Interior: The shop occupies five arches underneath the fast-train station Savignyplatz, and the unusual architecture and the exquisite selection of books form an apt partnership. There are branches in the Neue Nationalgalerie and the Museum Berggruen.
X-Factor: The international range is complemented by theoretical works, artists' books, exhibition catalogues and catalogues raisonnés.

Öffnungszeiten: Mo–Fr 10–20, Sa 10–18 Uhr.
Interieur: Unter fünf Bögen des S-Bahnhofes Savignyplatz gehen die Architektur und die exquisite Buchauswahl eine passende Verbindung ein. Filialen gibt es in der Neuen Nationalgalerie sowie im Museum Berggruen.
X-Faktor: Das internationale Sortiment wird ergänzt durch kunsttheoretische Abhandlungen, Künstlerbücher, vergriffene Kataloge sowie Werkverzeichnisse.

Horaires d'ouverture : Lun–Ven 10h–20h, Sam 10h–18h.
Décoration intérieure : Sous cinq voûtes en brique de la gare sur la Savignyplatz, l'architecture s'harmonise avec le choix de livres international. Il existe des filiales : à la Neue Nationalgalerie et au Museum Berggruen.
Le « petit plus » : Choix international de livres complété par des études de l'histoire de l'art, des ouvrages d'artistes, des catalogues épuisés et par des registes d'œuvres.

Emma & Co.

Niebuhrstraße 2, 10629 Berlin
☎ +49 30 88 67 67 87
www.emmaundco.de
Ⓢ Savignyplatz

This is the best place in Berlin for children's clothing, accessories, toys and furniture. An excellent selection displayed in spacious and cheerful surroundings. The range includes brand names like Petit Bateau, Eddie Penn and Antik Batik, as well as shoes by Gallucci and children's bed linen in Emma & Co. design. Their gift-wrapping is gorgeous!

Berlins beste Adresse für Kinderkleidung, Accessoires, Spielzeug und Möbel. Die ausgezeichnete Auswahl wird in großzügiger und heiterer Umgebung präsentiert. Zum Angebot gehören Marken wie Petit Bateau, Eddie Penn, Antik Batik, dazu Schuhe von Gallucci und Kinderbettwäsche im Emma & Co.-Design. Alles wird auch noch wunderschön verpackt!

La meilleure adresse de Berlin concernant les vêtements, les jouets et les meubles pour enfants. L'excellent assortiment est présenté dans un espace vaste et amusant. Des marques comme Petit Bateau, Eddie Penn, Antik Batik y sont représentées ainsi que les chaussures de Gallucci et le linge de lit pour enfants dans le style de Emma & Co. Les cadeaux sont également admirablement empaquetés !

Open: Mon–Fri 11am–7pm, Sat 11am–4pm.
Interior: This wonderful, classical Berlin building was designed by Albert Gessner in the early 20th century as part of an ensemble of buildings on the Niebuhr- and Mommsenstraße.
X-Factor: You can have cradles, pillows and featherbeds specially made in the prettiest of French fabrics.

Öffnungszeiten: Mo–Fr 11–19, Sa 11–16 Uhr.
Interieur: Den klassischen und wunderschönen Berliner Altbau errichtete der Architekt Albert Gessner Anfang des 20. Jahrhunderts als Teil eines Gebäudeensembles in der Niebuhr- und Mommsenstraße.
X-Faktor: Hier kann man Wiegenwäsche, Kissen- und Bettbezüge aus den schönsten französischen Stoffen individuell anfertigen lassen.

Horaires d'ouverture : Lun–Ven 11h–19h, Sam 11h–16h.
Décoration intérieure : Partie d'un ensemble de bâtiments entre la Niebuhrstraße et la Mommsenstraße, cette magnifique maison berlinoise a été construite par l'architecte Albert Gessner au début du 20ᵉ siècle.
Le « petit plus » : Vous pouvez faire recouvrir la literie du berceau, les coussins et les couettes des plus belles étoffes françaises.

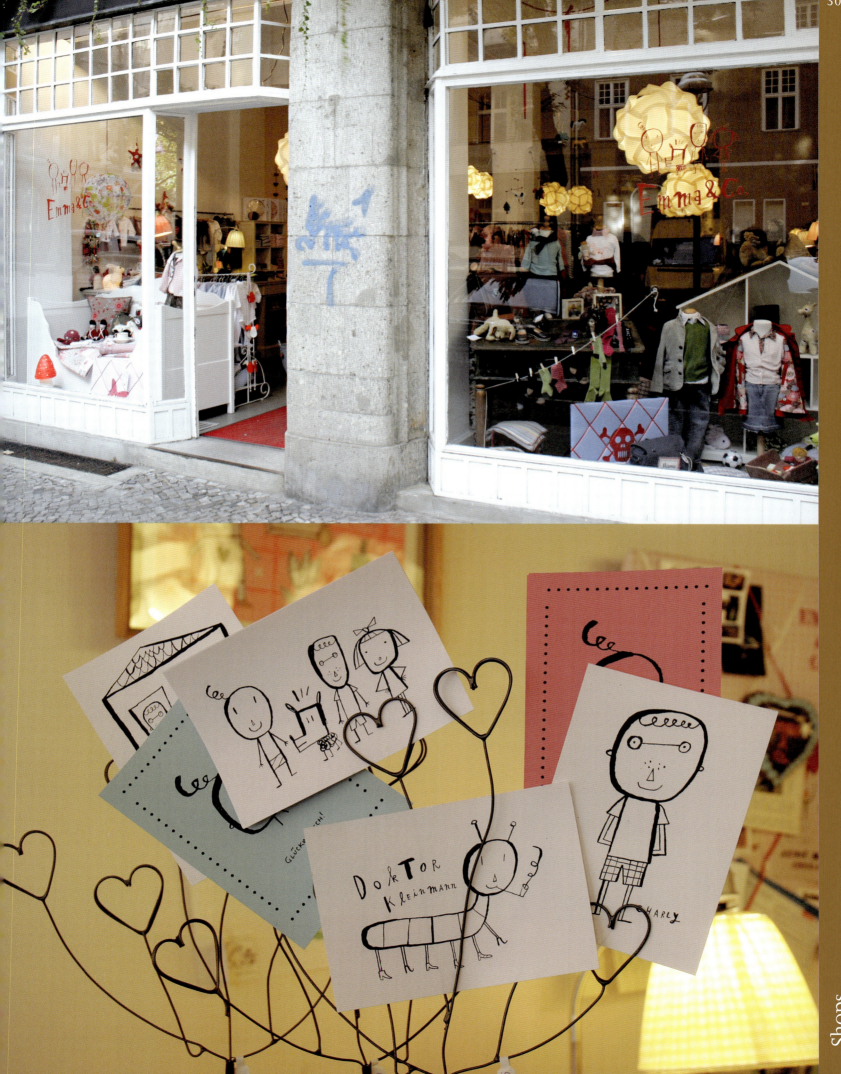

Galerie Hans-Peter Jochum

Bleibtreustraße 41, 10623 Berlin
Entrance: Mommsenstraße
☎ +49 30 8 82 16 12
www.hpjochum.de
Ⓢ Savignyplatz Ⓤ Uhlandstraße

The gallery, opened in 1981, attracts a sophisticated clientele to match its own exquisite selection of 20th-century design classics. The furniture on display in these small, classy premises includes pieces by designers you'd expect, like Eames, Jacobsen and Panton, along with a skilfully curated collection of furniture by designers who haven't yet entered the mainstream, like Nana Ditzel, Vittoriano Viganò or Gino Sarfatti.

Die 1981 eröffnete Galerie zieht mit ihrer exquisiten Auswahl von Designklassikern des 20. Jahrhunderts eine ebenso exquisite Klientel an. In den kleinen, stilvollen Geschäftsräumen findet man nicht bloß Möbel der üblichen Verdächtigen wie Eames, Jacobsen und Panton, sondern auch kompetent ausgesuchte Stücke von Designern, die noch nicht zum Mainstream gehören – wie Nana Ditzel, Vittoriano Viganò oder Gino Sarfatti.

Ouverte depuis 1981, cette galerie expose une excellente sélection de classiques du design du 20ᵉ siècle qui attire une clientèle toute aussi sélect. Dans ses petites pièces, on ne trouve pas seulement des meubles créés par Eames, Jacobsen et Panton, mais aussi des pièces de choix de designers qui ne font pas encore partie du mainstream – tels que Nana Ditzel, Vittoriano Viganò ou Gino Sarfatti.

Open: Mon–Fri 2pm–6.30pm, Sat 11am–2pm.
Interior: This typical old Berlin building with stucco ceilings and wooden floors forms a wonderful contrast to the minimalist vintage furniture on display there. A second branch opened at Knesebeckstraße 65 in 2009.
X-Factor: Jochum concentrates on historical designs from 1930 to 1980 and on Italian design since 1945.

Öffnungszeiten: Mo–Fr 14–18.30, Sa 11–14 Uhr.
Interieur: Ein typischer Berliner Altbau mit Stuck und Dielen bildet einen schönen Kontrast zu den minimalistisch präsentierten Vintage-Möbeln. Seit 2009 gibt es eine weitere Dependence in der Knesebeckstraße 65.
X-Faktor: Schwerpunkte legt Jochum auf historisches Design von 1930 bis 1980 sowie auf italienisches Design ab 1945.

Horaires d'ouverture : Lun–Ven 14–18.30h, Sam 11–14h.
Décoration intérieure : Ce bâtiment berlinois avec stucs contraste avec les meubles vintage présentés de façon minimaliste. En 2009, il a ouvert une seconde dépendance, Knesebeckstraße 65.
Le « petit plus » : Jochum se concentre surtout sur le design des années 1930 à 1980 et sur le design italien après 1945.

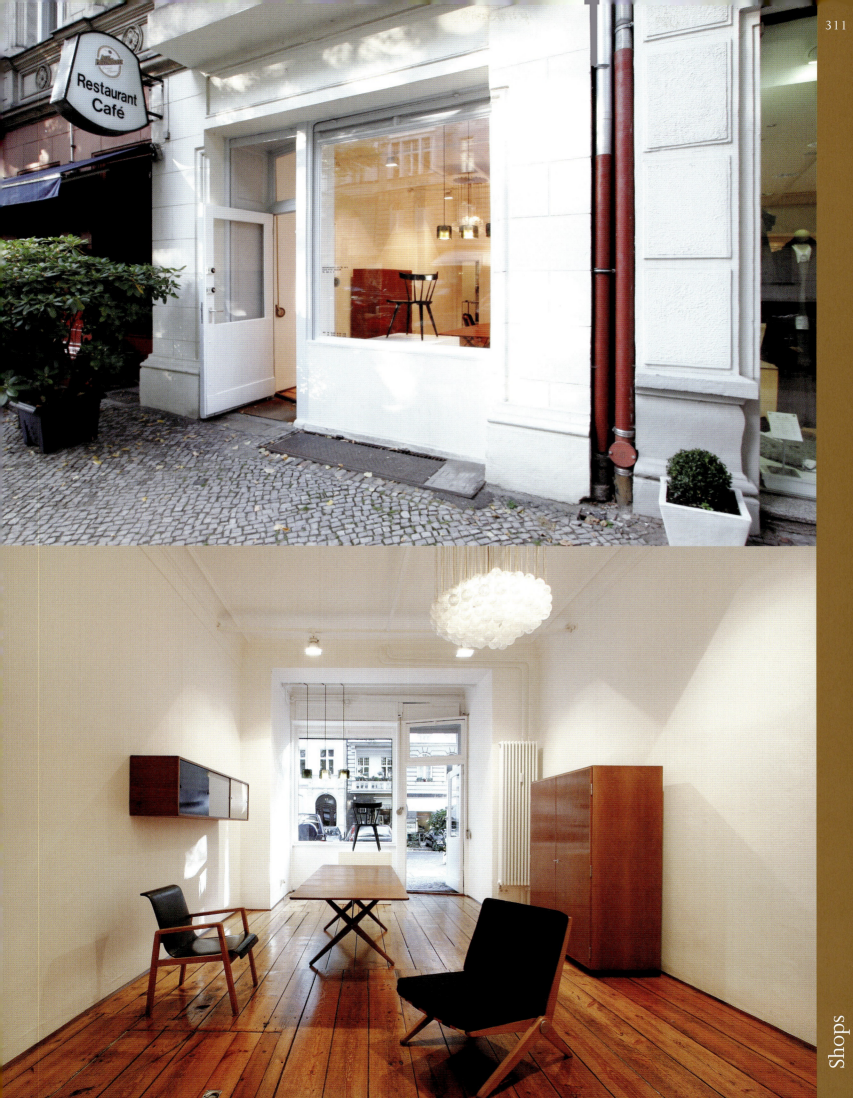

Steiff

Kurfürstendamm 220, 10719 Berlin
☎ +49 30 88 62 51 58
berlin@steiff-galerie.de
www.steiffberlin.de
Ⓤ Uhlandstraße

The original Steiff teddies are handmade from mohair, not synthetic fibre, and they have an inimitable character. Always a great gift for a newborn. Margarete Steiff founded the company in 1877 when she was just 30 and confined to a wheelchair. Her fascinating life story was made into a film starring Heike Makatsch.

Die originalen Steiff-Teddys sind handgefertigt, bestehen aus Mohair statt Kunstfaser und haben einen unvergleichlichen Charakter. Immer ein gutes Geschenk zur Geburt. Die Biografie von Margarete Steiff, die das Unternehmen im Rollstuhl sitzend 1877 im Alter von 30 Jahren gründete, ist hochspannend und wurde mit Heike Makatsch in der Hauptrolle verfilmt.

Les authentiques nounours Steiff sont faits à la main, en mohair au lieu de fibres synthétiques et ont un charme incomparable. Toujours un parfait cadeau pour un nouveau-né. La biographie de Margarete Steiff, qui a créé cette entreprise en 1877 à l'âge de 30 ans alors qu'elle était dans un fauteuil roulant, est passionnante et a été adaptée au cinéma (le rôle de l'héroïne étant interprété par Heike Makatsch).

Open: Mon–Sat 10am–8pm.
Interior: More practical than beautiful.
X-Factor: To mark the 100th anniversary of the death of Margarete Steiff, the original teddy bear was produced in a limited edition in 2009.

Öffnungszeiten: Mo–Sa 10–20 Uhr.
Interieur: Eher praktisch als ästhetisch.
X-Faktor: Zum 100. Todestag von Margarete Steiff wurde 2009 der originale Teddybär in limitierter Anzahl wieder aufgelegt.

Horaires d'ouverture : Lun–Sam 10h–20h.
Décoration intérieure : Plutôt pratique qu'esthétique.
Le « petit plus » : À l'occasion du centenaire de la mort de Margarete Steiff en 2009, une édition limitée du nounours d'origine était disponible.

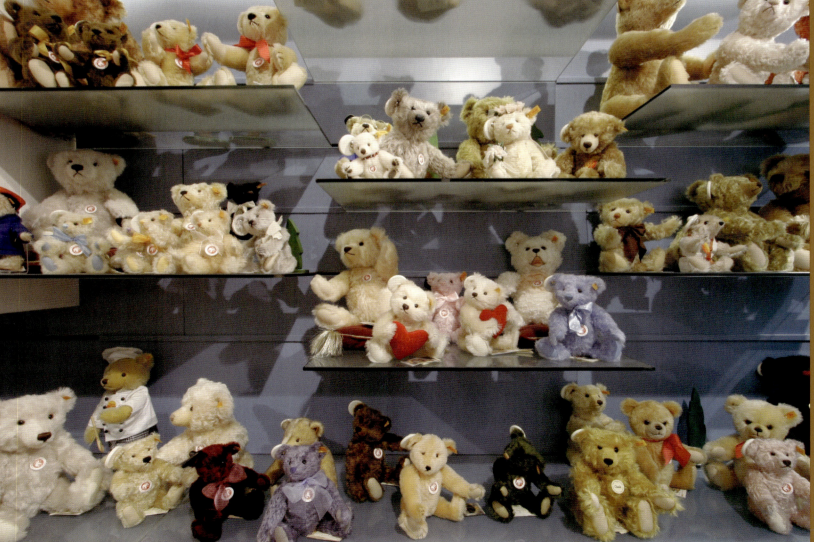

Harry Lehmann

Kantstraße 106, 10627 Berlin
☎ +49 30 3 24 35 32
www.parfum-individual.de
Ⓢ Charlottenburg Ⓤ Wilmersdorfer Straße

This is one of the last remaining shops in Berlin that stands as evidence of Germany's economic miracle. Harry Lehmann opened the store in 1958 to sell fragrances he had created himself, along with artificial flowers and handmade corsages. The shop front and its interior have remained quite unchanged up to the present day. The prices of goods are calculated by the millilitre here and you can buy, for example, "Eau de Berlin" as a souvenir, as well as perfumes named after film stars of the 1950s, such as Nadja Tiller.

Dies ist einer der letzten Läden Berlins, die noch von der Kultur der Wirtschaftswunder-Zeit in Deutschland zeugen. Harry Lehmann eröffnete 1958 das Ladenlokal, um selbst kreierte Düfte, Kunstblumen und handgemachte Korsagen zu verkaufen. Bis heute sind Fassade und Interieur des Geschäfts völlig unverändert. Man kann hier, nach Milliliter berechnet, zum Beispiel „Eau de Berlin" als Souvenir kaufen oder Düfte, die nach 1950er-Jahre-Filmstars wie Nadja Tiller benannt sind.

Une des dernières boutiques à Berlin témoignant de la culture de l'époque du miracle économique en Allemagne. Harry Lehmann a ouvert son commerce en 1958 pour y vendre des parfums créés sur place, des fleurs artificielles et des bustiers faits main. La façade et l'intérieur de la boutique n'ont pas changé. Vous pouvez y acheter, au millilitre, de l' « Eau de Berlin » ou des parfums dont les noms évoquent des stars du cinéma des années 1950, Nadja Tiller par exemple.

Open: Mon–Fri 9am–6.30pm, Sat 9am–2pm.
Interior: Gems in the interior, dating from 1958, are the old chemist's weighing scales on which the perfume quantities are precisely measured.
X-Factor: The 50 fragrances can be blended so that each client can have their own personal perfume mixed.

Öffnungszeiten: Mo–Fr 9–18.30, Sa 9–14 Uhr.
Interieur: Schmuckstücke des Interieurs aus dem Jahr 1958 sind die antiken Apothekerwaagen, auf denen die Parfümmengen exakt bemessen werden.
X-Faktor: Die rund 50 Parfümnoten sind untereinander mischbar – so kann sich jeder Kunde seinen persönlichen Duft zusammenstellen lassen.

Horaires d'ouverture : Lun–Ven 9h–18h30, Sam 9h–14h.
Décoration intérieure : Les petits trésors de cet intérieur datant de 1958 sont les anciennes balances d'apothicaire qui servent à définir le poids exact des parfums.
Le « petit plus » : Les 50 notes de parfum peuvent toutes s'associer l'une avec l'autre, de sorte que chaque client obtiendra une fragrance personnalisée.

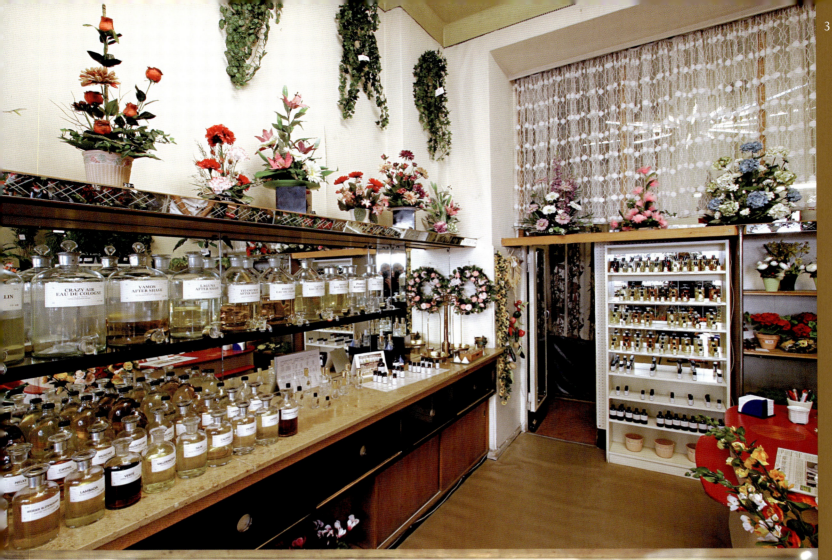

HARRY LEHMANN

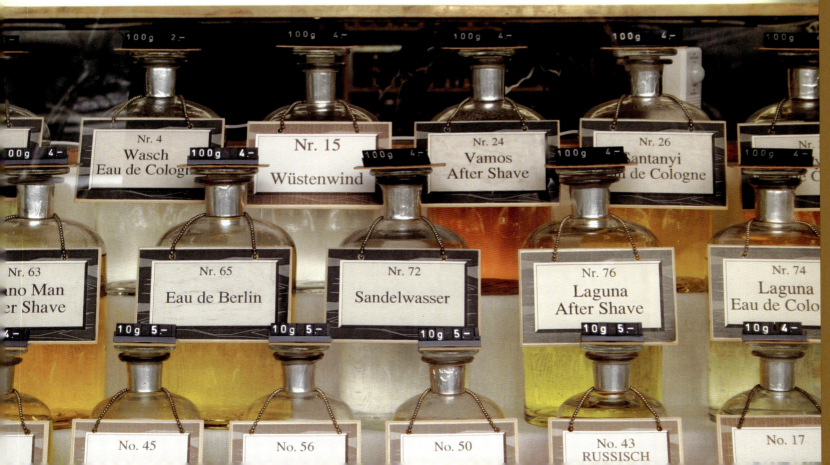

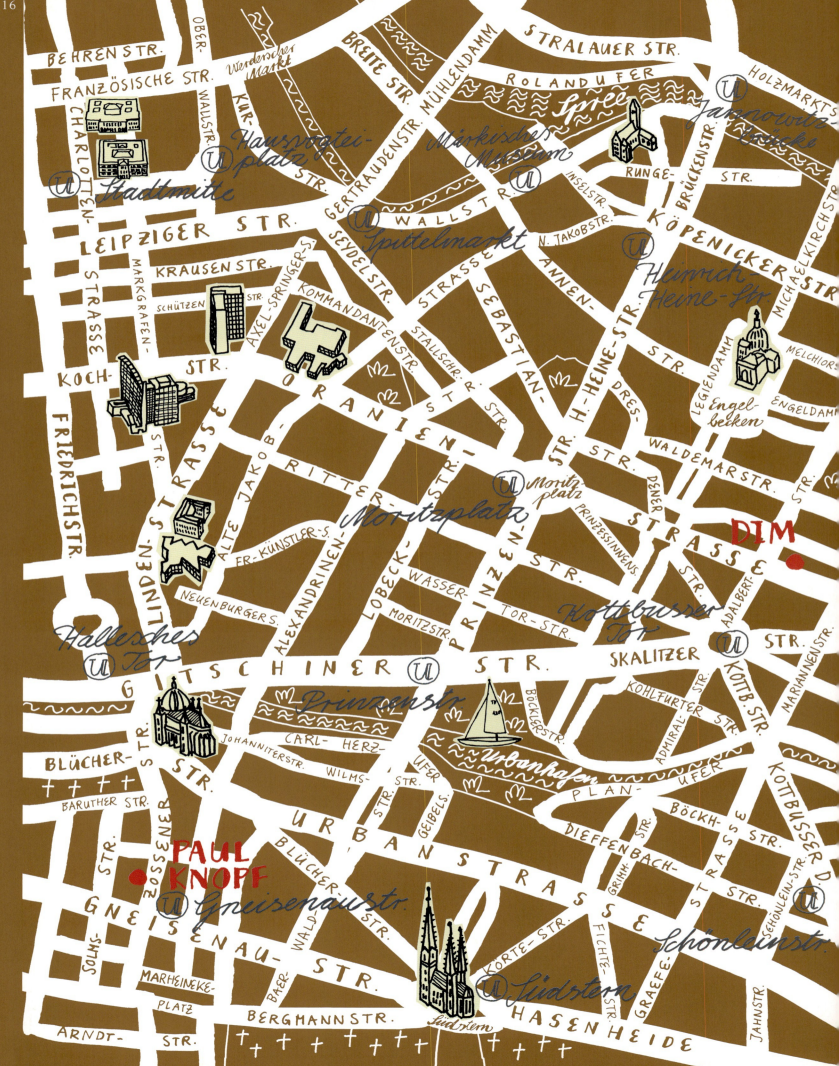

Shops

Paul Knopf

Zossener Straße 10, 10961 Berlin
☏ +49 30 6 92 12 12
www.paulknopf.de
Ⓤ Gneisenaustraße

From leather, glass or horn, fruit stones, snails or shells: Paul the Button's range includes buttons made from a great variety of materials and in every imaginable colour and shape – a total of about 100,000 different types. When just a boy he swapped and sold buttons at flea markets; later he made his hobby into his job and opened his first shop in Berlin in 1979. In 1987 it moved to Kreuzberg, a haven for all costume directors and fashion designers, and a help for all those little daily emergencies.

Open: Tue–Fri 9am–6pm, Wed/Thu 2am–6pm.
Interior: The boxes piled up to the ceiling, and leaving not even a centimetre of wall space free, also contain historical buttons, for example from old Prussian military uniforms.
X-Factor: You can even order buttons to your own design.

Ob aus Leder, Glas oder Horn, Obstkernen, Schnecken oder Muscheln: Knopf-Paul hat Knöpfe aus den verschiedensten Materialien und in allen erdenklichen Farben und Formen im Sortiment – rund 100 000 Versionen sind es insgesamt. Schon als Junge tauschte und verkaufte er Knöpfe auf dem Flohmarkt; später machte er sein Hobby zum Beruf und eröffnete 1979 seinen ersten Laden in Berlin. 1987 zog der Shop nach Kreuzberg um – er ist ein Paradies für Kostümbildner und Modedesigner und hilft bei alltäglichen kleinen Notfällen.

Öffnungszeiten: Di–Fr 9–18, Mi/Do 14–18 Uhr.
Interieur: In den Schachteln, die sich bis unter die Decke stapeln und keinen Zentimeter Wand frei lassen, verbergen sich auch historische Knöpfe – etwa von alten preußischen Militäruniformen.
X-Faktor: Auf Wunsch werden hier sogar Modellknöpfe nach Maß angefertigt.

Comme son nom l'indique Paul propose des boutons fabriqués dans toutes sortes de matériaux, qu'il s'agisse de cuir, de verre ou de corne, de noyau, de coquille d'escargot ou de coquillage, et dans toutes les formes et couleurs imaginables – il en a environ 100 000 en tout. Tout jeune, il échangeait et vendait déjà des boutons aux Puces ; faisant plus tard de sa passion un métier, il a ouvert en 1979 sa première boutique à Berlin, et s'est installé en 1987 à Kreuzberg. Véritable paradis pour les costumiers et les créateurs de mode, la boutique dépanne aussi lors des petits accidents quotidiens.

Horaires d'ouverture : Mar–Ven 9h–18h, Mer/Jeu 14h–18h.
Décoration intérieure : Dans les boîtes empilées jusqu'au plafond et sur toute la surface du mur se cachent aussi des boutons historiques, comme ceux d'anciens uniformes prussiens.
Le « petit plus » : Des modèles de boutons peuvent même être fabriqués sur demande.

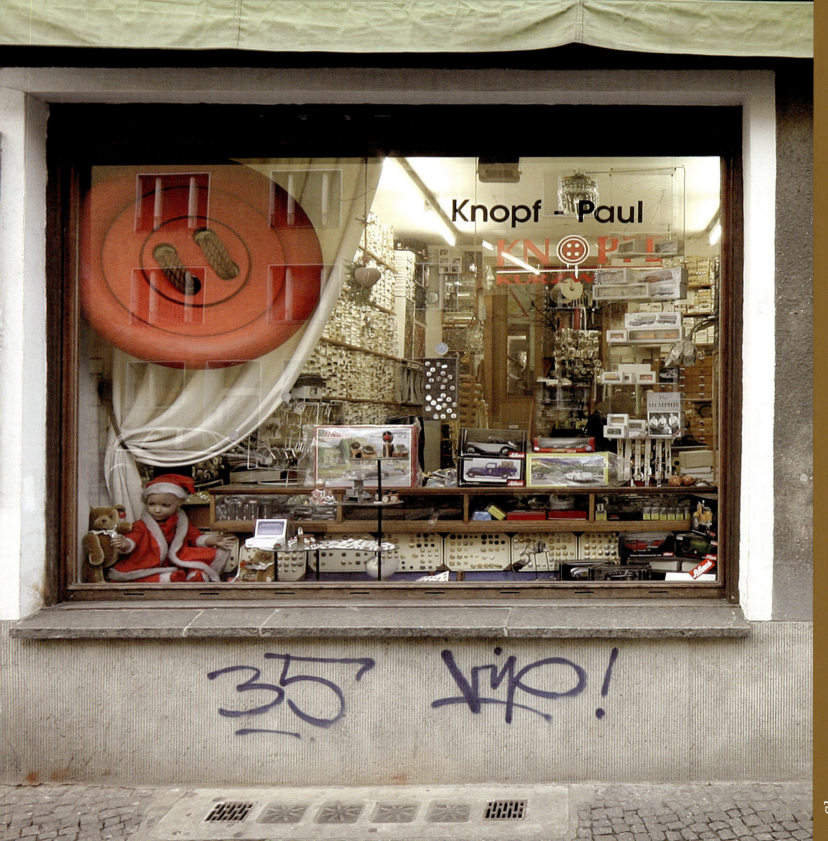

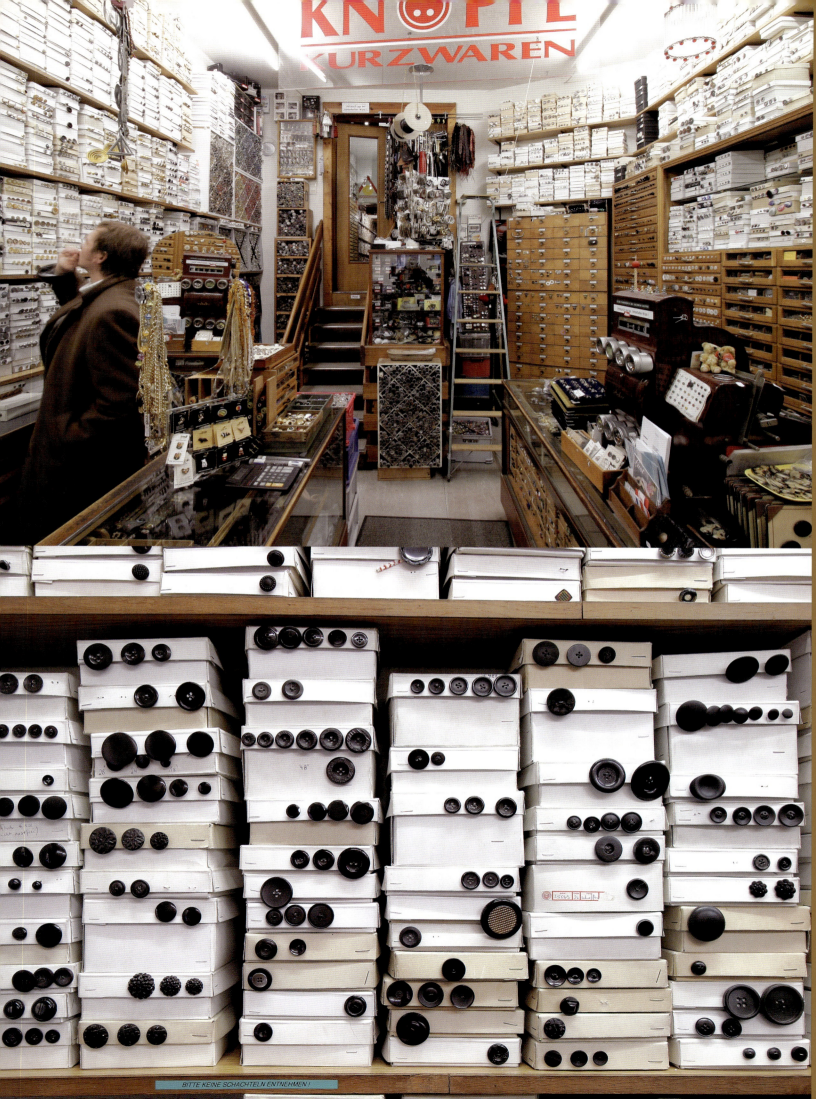

DIM

Oranienstraße 26, 10999 Berlin
☏ +49 30 2 85 03 01 21
www.blindenanstalt.de
U Kottbusser Tor

For about 130 years now, wickerwork and brushes made by physically and mentally handicapped people in the building next door have been on sale here. The store, with its old counters, has remained pretty much the same over the years. The only thing that's changed is the variety of the products on offer, some of which are designer creations.

Hier werden seit rund 130 Jahren Korb- und Bürstenwaren angeboten, die nebenan von körperlich oder geistig behinderten Menschen produziert werden. Das Ladenlokal mit seinen alten Verkaufstresen ist weitgehend unverändert geblieben, nur die Vielfalt der zum Teil von Designern gestalteten Produkte ist neu.

Depuis 130 ans, on vend chez Dim des brosses et paniers qui sont fabriqués dans la maison voisine par des handicapés moteurs ou mentaux. La boutique avec son ancien comptoir est restée dans son état d'origine ; seule la diversité des produits – œuvres en partie de créateurs – est nouvelle.

Open: Mon–Fri 10am–7pm, Sat 11am–4pm.
Interior: The shop is in the former Blind Institution, an over 100-year-old listed building. Inside, the articles are arranged in orderly glass display cases, chemist-shop style.
X-Factor: The Berlin Brushes, highly original souvenirs in the shape of the Brandenburg Gate and the Berlin Bear.

Öffnungszeiten: Mo–Fr 10–19, Sa 11–16 Uhr.
Interieur: Der Laden ist im mehr als 100 Jahre alten Gebäude der ehemaligen „Blindenanstalt" untergebracht, das unter Denkmalschutz steht. Innen liegen die Artikel fein säuberlich aufgereiht in Glasvitrinen im Apothekerstil.
X-Faktor: Die originellen Souvenirs „Berliner Bürsten" in Form des Brandenburger Tors und des Berliner Bären.

Horaires d'ouverture : Lun–Ven 10h–19h, Sam 11h–16h.
Décoration intérieure : Le magasin se trouve dans le bâtiment plus que centenaire et classé, qui abritait autrefois une institution pour aveugles. À l'intérieur, les articles sont sagement alignés dans des vitrines comme dans une pharmacie.
Le « petit plus » : Les souvenirs originaux des « brosses berlinoises » en forme de porte de Brandebourg et d'ours berlinois.

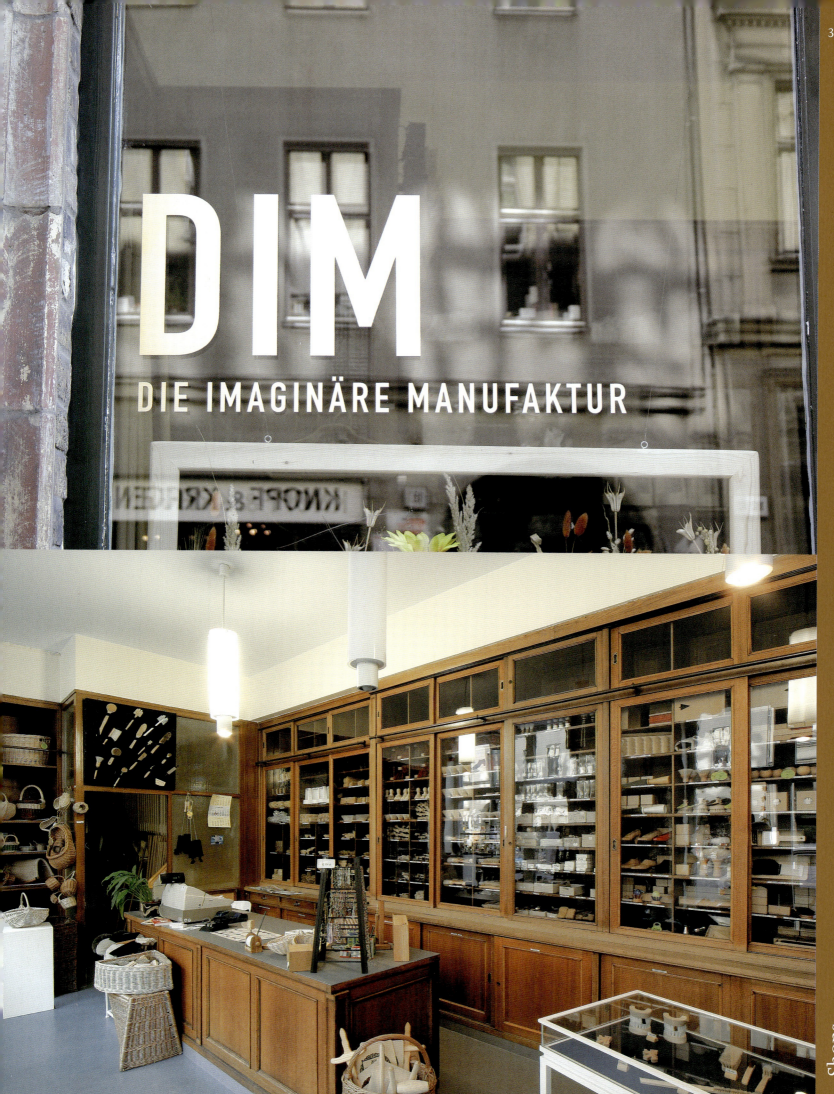

TASCHEN

Friedrichstraße 180–184, 10117 Berlin
☎ +49 30 25 32 59 91
www.taschen.com
🅄 Stadtmitte, Französische Straße

Since May 2009 Berlin has also had a TASCHEN Store – conveniently located on Friedrichstraße and with the entire publisher's list in stock – from the small art series to the XL limited "Collector's Editions". The 80-square-metre shop was designed by Philippe Starck and is as elegant as it is extravagant: shelves with crown-like tops stand in front of high concrete walls, and above the wavy gold counter hangs a vintage chandelier designed in 1930 for Fontana Arte by Gio Ponti and Pietro Chiesa.

Seit Mai 2009 besitzt auch Berlin einen TASCHEN Store – ideal an der Friedrichstraße gelegen und mit dem gesamten Verlagsprogramm ausgestattet; von der kleinen Kunstreihe bis zu den limitierten „Collector's Editions" im XL-Format. Das Design des 80 Quadratmeter-Ladens stammt von Philippe Starck und ist so edel wie extravagant: Vor hohen Betonwänden stehen Regale mit kronenartigen Aufsätzen, und über dem gold gewellten Haupttisch schwebt ein Vintage-Lüster, den Gio Ponti und Pietro Chiesa 1930 für Fontana Arte entwarfen.

Depuis mai 2009, Berlin possède elle aussi un store TASCHEN dont l'emplacement sur la Friedrichstraße est idéal. Il vous propose l'ensemble du programme de la maison d'édition, de la petite collection d'art aux « Collector's Editions » à tirage limité. Conçu par Philippe Starck, le design de ce magasin de 80 mètres carrés est à la fois chic et extravagant. Les étagères coiffées de couronnes s'appuient contre de hauts murs de béton et la table principale aux ondulations dorées est éclairée par un lustre vintage imaginé par Gio Ponti et Pietro Chiesa en 1930 pour Fontana Arte.

Open: Mon–Sat 10am–8pm.
Interior: Perfectly suited to the new old centre of Berlin. The golden pillar in the middle of the shop is particularly striking.
X-Factor: At the back of the shop, decorated with sophisticated mirrors, you will find, in addition to books, a gallery of framed prints from the limited "Collector's Editions".

Öffnungszeiten: Mo–Sa 10–20 Uhr.
Interieur: Passt perfekt ins alte neue Herz Berlins. Besonders beeindruckend ist die goldene Säule mitten im Raum.
X-Faktor: Im hinteren und raffiniert verspiegelten Teil des Shops entdeckt man neben Büchern eine Galerie mit den gerahmten Prints der limitierten „Collector's Editions".

Horaires d'ouverture : Lun–Sam 10h–20h.
Décoration intérieure : Cadre bien avec l'ancien nouveau cœur de Berlin. La colonne dorée au milieu de la salle est particulièrement impressionnante.
Le « petit plus » : Outre les livres on découvrira au fond de la boutique, dans un cadre raffiné de miroirs, une galerie présentant les estampes des « Collector's Editions » à tirage limité.

Departmentstore Quartier 206

Friedrichstraße 71, 10117 Berlin
☎ +49 30 20 94 68 00
www.departmentstore-quartier206.com
Ⓤ Stadtmitte, Französische Straße

Before she opened Departmentstore in 1997, Anne Maria Jagdfeld travelled round the world buying a collection of lifestyle products – then at last Berlin could compete with cities like Paris, Milan and New York. On an area of 2,500 square metres and in stylish surroundings you will find not only haute couture and avant-garde fashion, but also shoes, jewellery, cosmetics and books. On the lower floor Anne Maria Jagdfeld has installed a boutique with her own furniture and home accessories.

Ehe sie den Departmentstore 1997 eröffnete, reiste Anne Maria Jagdfeld rund um die Welt und erstand eine Kollektion an Lifestyle-Produkten – dann endlich konnte Berlin Metropolen wie Paris, Mailand und New York Konkurrenz machen. Auf 2 500 Quadratmetern und in stilvollem Ambiente findet man hier nicht nur Haute Couture und Avantgarde-Mode, sondern auch Schuhe, Schmuck, Kosmetik sowie Bücher. Im Untergeschoss hat Anne Maria Jagdfeld eine Boutique mit eigenen Möbelentwürfen und Wohnaccessoires eingerichtet.

Avant d'ouvrir le Departmentstore en 1997, Anne Maria Jagdfeld a parcouru le monde et acheté une collection d'articles Lifestyle – et Berlin a enfin pu rivaliser avec Paris, Milan et New York. Sur une surface de 2 500 mètres carrés, des espaces élégants ne proposent pas seulement des vêtements haute couture et la mode d'avant-garde, mais aussi des chaussures, des bijoux, des produits de beauté ainsi que des livres. Au sous-sol, Anne Maria Jagdfeld a installé une boutique proposant sa propre ligne de meubles et d'objets de décoration intérieure.

Open: Mon–Fri 11am–8pm, Sat 10am–6pm.
Interior: The very elegant two-floor Departmentstore 206 was designed by Anne Maria Jagdfeld and is the centre of the Quartier 206, designed by New York architects Pei Cobb Freed & Partners.
X-Factor: Exclusive labels are available, such as Balmain, Prada, Dolce & Gabbana, Donna Karan, Lanvin, Marc Jacobs and Tom Ford, as is an outstanding range of jeans.

Öffnungszeiten: Mo–Fr 11–20, Sa 10–18 Uhr.
Interieur: Der von Anne Maria Jagdfeld hoch elegant gestaltete Departmentstore 206 ist mit seinen zwei Etagen das Herzstück des Quartier 206, das die Architekten Pei Cobb Freed & Partners entworfen haben.
X-Faktor: Exklusive Label wie Balmain, Prada, Dolce & Gabbana, Donna Karan, Lanvin, Marc Jacobs sowie Tom Ford. Und eine hervorragende Auswahl an Jeans-Marken.

Horaires d'ouverture : Lun–Ven 11h–20h, Sam 10h–18h.
Décoration intérieure : Décoré avec élégance par Anne Maria Jagdfeld, le Departmentstore 206 constitue le cœur du Quartier 206, conçu par Pei Cobb Freed & Partners.
Le « petit plus » : On y trouve des marques branchées : Balmain, Prada, Dolce & Gabbana, Donna Karan, Lanvin, Marc Jacobs et Tom Ford. Excellent choix des meilleures marques de jeans.

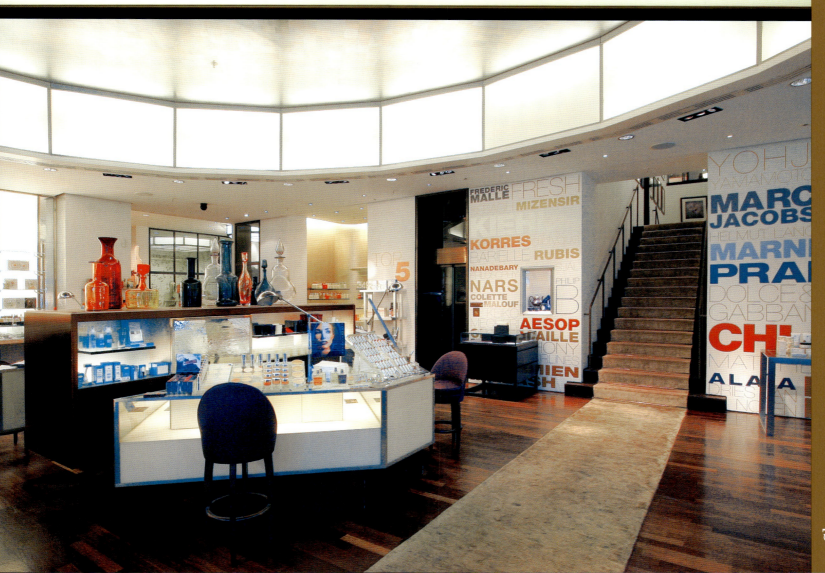

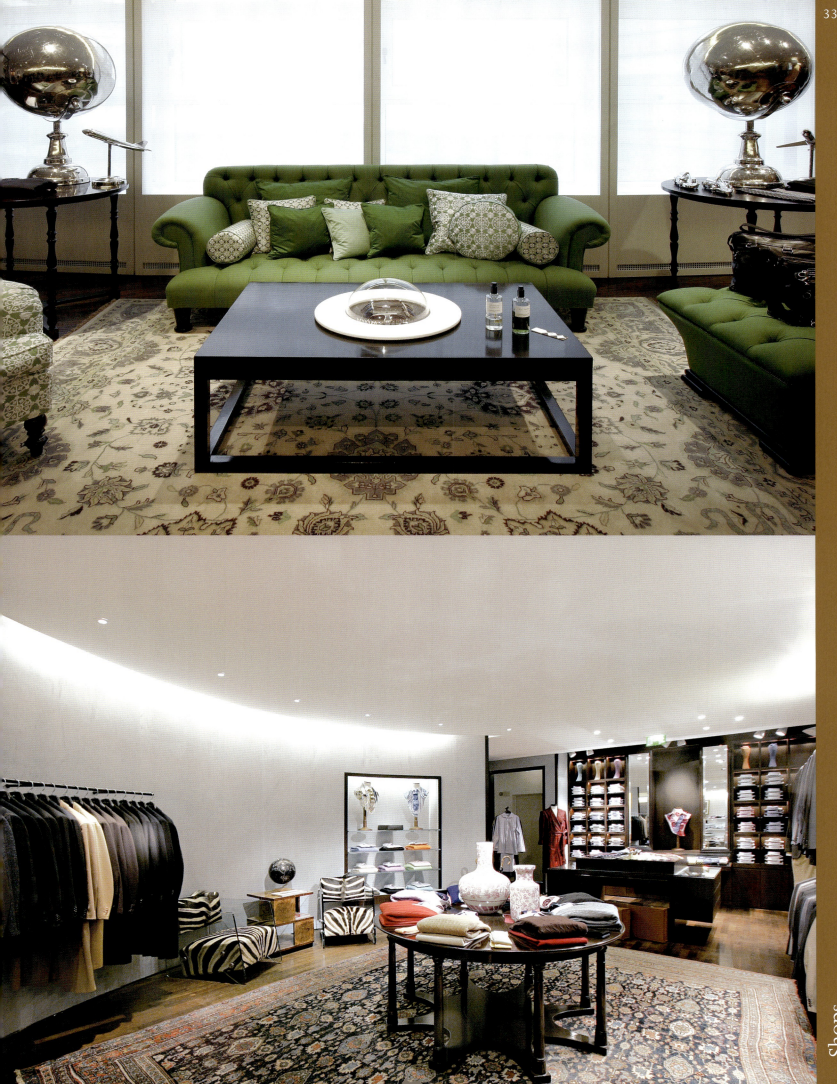

Fundusverkauf

Behrensstraße 14, 10117 Berlin
☎ +49 30 20 45 02 03
Ⓢ Unter den Linden Ⓤ Französische Straße

Plagiarism is a principle here: Fundusverkauf, diagonally opposite the Komische Oper, is the place to find replicas from various Berlin theatres and from film, TV and revue productions. If you want to wear the historic-looking ball gowns, powdered wigs or Golden Twenties-style sequined dresses in matching surroundings, you can also buy oil paintings, elaborate mirrors and candelabras. Sometimes the assortment of goods includes curiosities like marble columns made of cardboard or carousel horses with a patina.

Open: Irregular; phone for information.
Interior: The objects are displayed in a city palace built by the Berlin architect Heinrich Theising in 1898, with high-ceilinged rooms, some decorated with stucco.
X-Factor: With the items on sale here you can make a great impact for relatively little money.

Hier ist das Plagiat Prinzip: Im Fundusverkauf schräg gegenüber der Komischen Oper findet man Repliken aus verschiedenen Theatern Berlins sowie von Film-, Fernseh- und Revueproduktionen. Wer die historisch anmutenden Ballroben, gepuderten Perücken oder Paillettenkleider à la „Golden Twenties" in passendem Ambiente tragen möchte, kann zudem Ölgemälde, Prunkspiegel und Kerzenleuchter erstehen – bisweilen umfasst das Sortiment auch Kurioses wie Marmorsäulen aus Pappe oder Karussellpferde mit Patina.

Öffnungszeiten: Unregelmäßig; sie können telefonisch erfragt werden.
Interieur: Die Objekte werden in den hohen und zum Teil mit Stuck verzierten Räumen eines Stadtpalais ausgestellt, welches der Berliner Baumeister Heinrich Theising 1898 errichtete.
X-Faktor: Mit diesen Fundstücken erzielt man viel Wirkung für verhältnismäßig wenig Geld.

Situé presque en face de l'Opéra comique, ce point de vente pour costumes et accessoires de théâtre est le royaume de l'imitation : on y trouve des copies provenant de divers théâtres de Berlin ainsi que de productions de cinéma, de la télévision ou de spectacles. Celle qui veut porter des robes de bal comme au temps jadis, des perruques poudrées ou des robes à paillettes inspirées des Années folles dans le décor adéquat peut aussi acheter des tableaux, des miroirs d'apparat et des chandeliers. Les amateurs d'objets insolites pourront parfois y trouver des colonnes en carton ou des chevaux de manège savamment patinés.

Horaires d'ouverture : Irréguliers ; renseignements par téléphone.
Décoration intérieure : Les objets sont présentés dans les salles hautes de plafond et ornées de stucs d'un hôtel particulier construit en 1898 par le Berlinois Heinrich Theising.
Le « petit plus » : Beaucoup d'effet pour peu d'argent en comparaison.

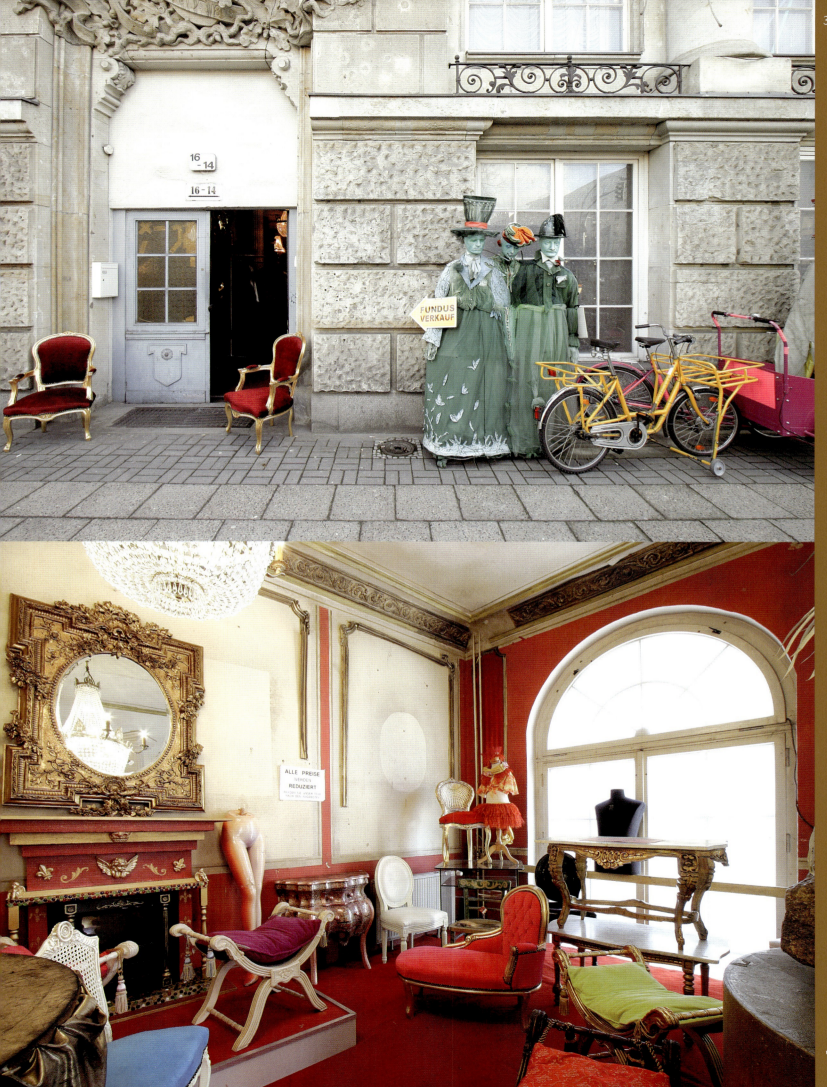

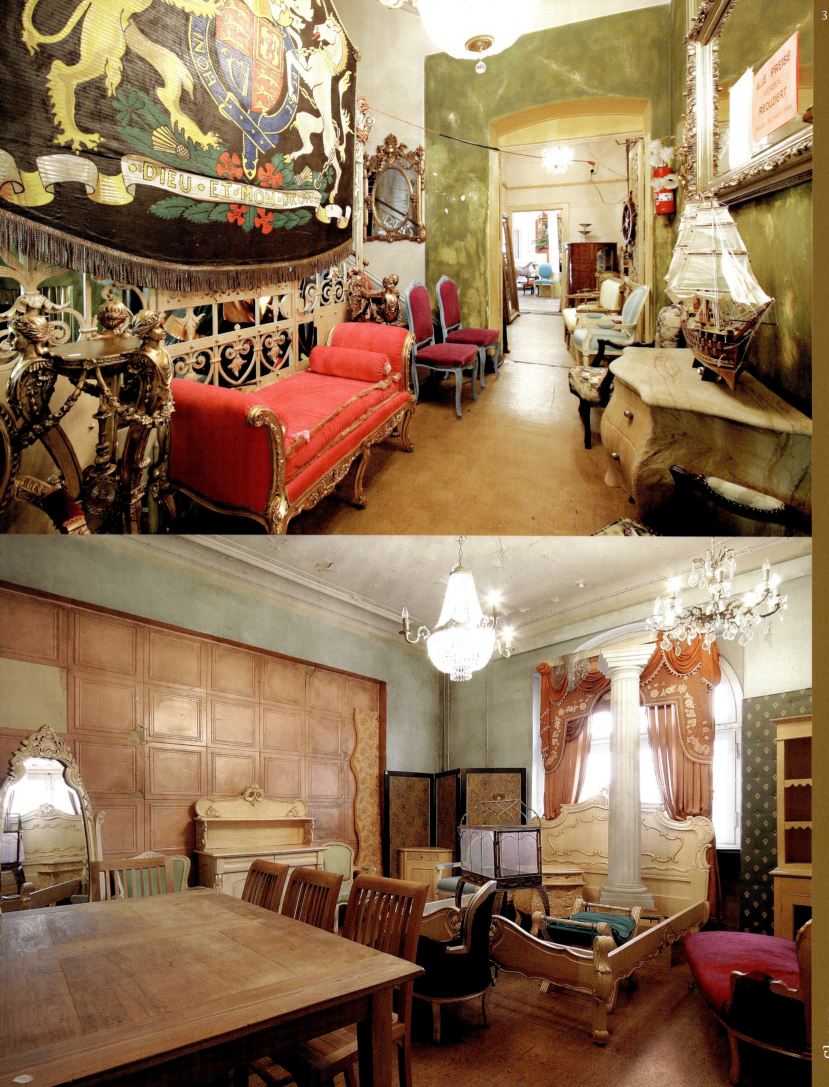

KPM

Königliche Porzellan-Manufaktur
Unter den Linden 35, 10117 Berlin
☎ +49 30 2 06 41 50
www.kpm.de
Ⓢ Ⓤ Friedrichstraße Ⓤ Französische Straße

The three major German porcelain factories are Meissen, Nymphenburg and KPM. It was Frederick the Great himself who founded the Königliche Porzellan-Manufaktur (Royal Porcelain Manufactory) in 1763 and gave it the royal blue sceptre as its trademark. The service "Neuosier" has been manufactured, unchanged, since 1770. A lovely little souvenir would be a vase by Karl Friedrich Schinkel, the god-father of German architecture.

Die drei großen deutschen Porzellanmanufakturen sind Meissen, Nymphenburg und KPM. Kein geringerer als Friedrich der Große gründete 1763 die Königliche Porzellan-Manufaktur mit dem königsblauen Zepter als Wahrzeichen. Das damals entstandene Service „Neuosier" wird seit 1770 unverändert produziert. Ein wunderschönes Mitbringsel ist eine Vase vom Architektur-Übervater Karl Friedrich Schinkel.

Les trois grandes manufactures de porcelaine allemande sont celles de Meissen, Nymphenburg et KPM. C'est Frédéric le Grand en personne qui a fondé en 1763 la manufacture prussienne royale avec le sceptre bleu roi comme emblème. Le service « Neuosier » est toujours produit à l'identique depuis 1770. Un très beau cadeau souvenir est un vase du mentor de l'architecture Karl Friedrich Schinkel.

Open: Mon–Fri 10am–8pm, Sat 10am–7pm.
Interior: The elegantly laid tables are an inspiration. In addition to porcelain, you can also buy glasses and cutlery here.
X-Factor: Even today, each individual piece is unique, handmade in keeping with traditional techniques and painted with filigree motifs.

Öffnungszeiten: Mo–Fr 10–20, Sa 10–19 Uhr.
Interieur: Inspirierend sind die elegant eingedeckten Tische im Raum – neben dem Porzellan kann man Gläser und Besteck ebenfalls im Laden kaufen.
X-Faktor: Noch heute wird jedes Stück nach überlieferten, traditionellen Techniken von Hand gefertigt, mit filigranen Motiven bemalt und ist somit immer ein Unikat.

Horaires d'ouverture : Lun–Ven 10h–20h, Sam 10h–19h.
Décoration intérieure : Les tables élégamment dressées dans la salle sont source d'inspiration. Outre la porcelaine, on peut également acheter des verres et des couverts.
Le « petit plus » : Aujourd'hui, chaque pièce est encore fabriquée à la main suivant des techniques traditionnelles et peinte avec des motifs filigranes, devenant ainsi une pièce unique.

The Corner Berlin

Französische Straße 40, 10117 Berlin
☎ +49 30 20 67 09 50
www.thecornerberlin.de
Ⓤ Französische Straße

Fashionistas have been complaining for years that there is nowhere to do any sophisticated shopping in Berlin. The concept store The Corner has now solved this problem. This store sells fashion for men and women, jewellery, shoes, handbags, beauty products and vintage designer furniture from the 1950s, 1960s and 1970s, as well as books, CDs and DVDs. Here you can find the hip labels du jour: Balenciaga, Alexander McQueen, Alaïa, Fendi, Stella McCartney, Pierre Hardy, Christian Louboutin and Comme des Garçons. Some hip visitors from London told me that The Corner's selection is even better than at Colette in Paris.

Open: Mon–Sat 10am–8pm.
Interior: Pierre Jorge Gonzalez and Judith Haase designed this shop like a loft, the result being that it stands out from the Neoclassical façades around the Gendarmenmarkt.
X-Factor: This is not just a matter of (insider) labels, it's also a matter of style.

Jahrelang stöhnten Fashionistas, dass man in Berlin unmöglich niveauvoll shoppen könne. Dieses Problem ist nun mit dem Concept-Store The Corner gelöst. Der Laden bietet Mode für Damen und Herren, Schmuck, Schuhe, Handtaschen, Schönheitsprodukte, Vintage-Designmöbel aus den 1950er, 1960er- und 1970er Jahren sowie Bücher, CDs und DVDs. Hier gibt es Labels, die gerade hip sind: Balenciaga, Alexander McQueen, Alaïa, Fendi, Stella McCartney, Pierre Hardy, Christian Louboutin und Comme des Garçons. Mir wurde sogar schon von hippen Besuchern aus London gesagt, die Auswahl bei The Corner sei besser als bei Colette in Paris.

Öffnungszeiten: Mo–Sa 10–20 Uhr.
Interieur: Pierre Jorge Gonzalez und Judith Haase haben den Shop wie ein Loft designt, um ihn von den neoklassizistischen Fassaden rund um den Gendarmenmarkt abzuheben.
X-Faktor: Hier geht es nicht nur um (Insider-) Label, sondern um Stil.

Pendant des années, les inconditionnels de la mode ont regretté de ne pas pouvoir faire du shopping dans un concept store à Berlin. Le problème est désormais réglé avec The Corner. La boutique propose une mode féminine et masculine, bijoux, chaussures, sacs à main, produits de beauté, meubles design vintage des années 1950, 1960 et 1970 ainsi que des livres, des CDs et des DVDs. On y trouve des marques qui sont tendance : Balenciaga, Alexander McQueen, Alaïa, Fendi, Stella McCartney, Pierre Hardy, Christian Louboutin et Comme des Garçons. Des amis londoniens très branchés m'ont même confié qu'il y a plus de choix chez The Corner que chez Colette à Paris.

Horaires d'ouverture : Lun–Sam 10h–20h.
Décoration intérieure : Pierre Jorge Gonzalez et Judith Haase ont conçu la boutique comme un loft afin de la démarquer des façades néo-classiques du Gendarmenmarkt.
Le « petit plus » : Ici, il n'est pas seulement question de label (pour initiés), mais aussi de style.

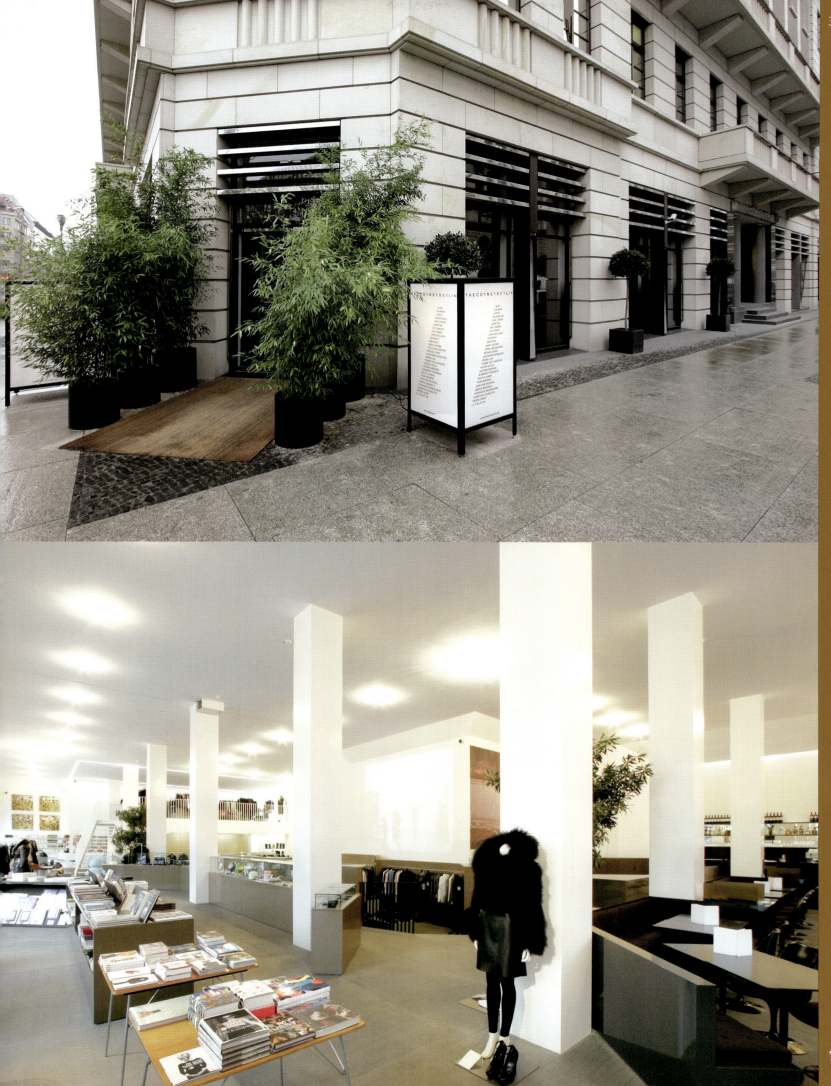

1. Absinth Depot Berlin

Weinmeisterstraße 4, 10178 Berlin
☏ +49 30 2 81 67 89
www.absinth-berlin.de
🚇 Weinmeisterstraße

This shop tells the story of absinthe – the legendary drink that was first distilled about 200 years ago in the Swiss mountains as a kind of panacea. Because of its green colour it was then known as "la fée verte" (the green fairy). At the end of the 19th century absinthe was considered the favourite drink of bohemian Paris because of its hallucinogenic effect. Later this "liquid joint" was banned and allowed again only in a modified form. Here the best sorts of absinthe from all over the world can be tasted and bought.

Dieser Laden erzählt die Geschichte des Absinth – des legendären Getränks, das zum ersten Mal vor rund 200 Jahren in den Schweizer Bergen als eine Art Allheilmittel gebraut wurde. Wegen seiner grünen Farbe nannte man es damals „la fée verte" (die grüne Fee). Ende des 19. Jahrhunderts galt Absinth dank seiner halluzinogenen Wirkung als Lieblingsgetränk der Pariser Boheme; später wurde der „Joint zum Trinken" verboten und erst in modifizierter Form wieder erlaubt. Die besten Sorten aus aller Welt kann man hier verkosten und kaufen.

Ce magasin raconte l'histoire de l'absinthe, cette boisson mythique distillée il y a environ deux siècles dans les montagnes suisses et considérée alors comme un remède à tous les maux. À la fin du 19ᵉ siècle, la « fée verte » était la boisson préférée de la bohème parisienne en raison de son effet hallucinogène ; interdit plus tard, le « pétard liquide » est aujourd'hui fabriqué sous une forme moins nocive. On peut déguster et acheter ici les meilleures absinthes du monde entier.

Open: Mon–Fri 2pm–midnight, Sat 1pm–midnight.
Interior: There is a strong touch of nostalgia in the advertising signs, the gold-framed mirrors and the historical pictures.
X-Factor: Here you will find all the right accessories – richly decorated absinthe spoons, the bonques glasses in which absinthe was "smoked" and fountains with several taps.

Öffnungszeiten: Mo–Fr 14–24, Sa 13–24 Uhr.
Interieur: Mit alten Werbetafeln, goldgerahmten Spiegeln und historischen Bildern nostalgisch dekoriert.
X-Faktor: Hier bekommt man auch das passende Zubehör wie reich verzierte Absinthlöffel, Bonques, in denen Absinth „geraucht" wird, sowie Fontänen mit mehreren Hähnen.

Horaires d'ouverture : Lun–Ven 14h–24h, Sam 13h–24h.
Décoration intérieure : Le décor est nostalgique : vieux panneaux publicitaires, glaces aux cadres dorés et tableaux historiques.
Le « petit plus » : On vous donne ici tous les accessoires nécessaires, comme les cuillères à absinthe richement décorées, la pipe à absinthe et les fontaines à plusieurs robinets.

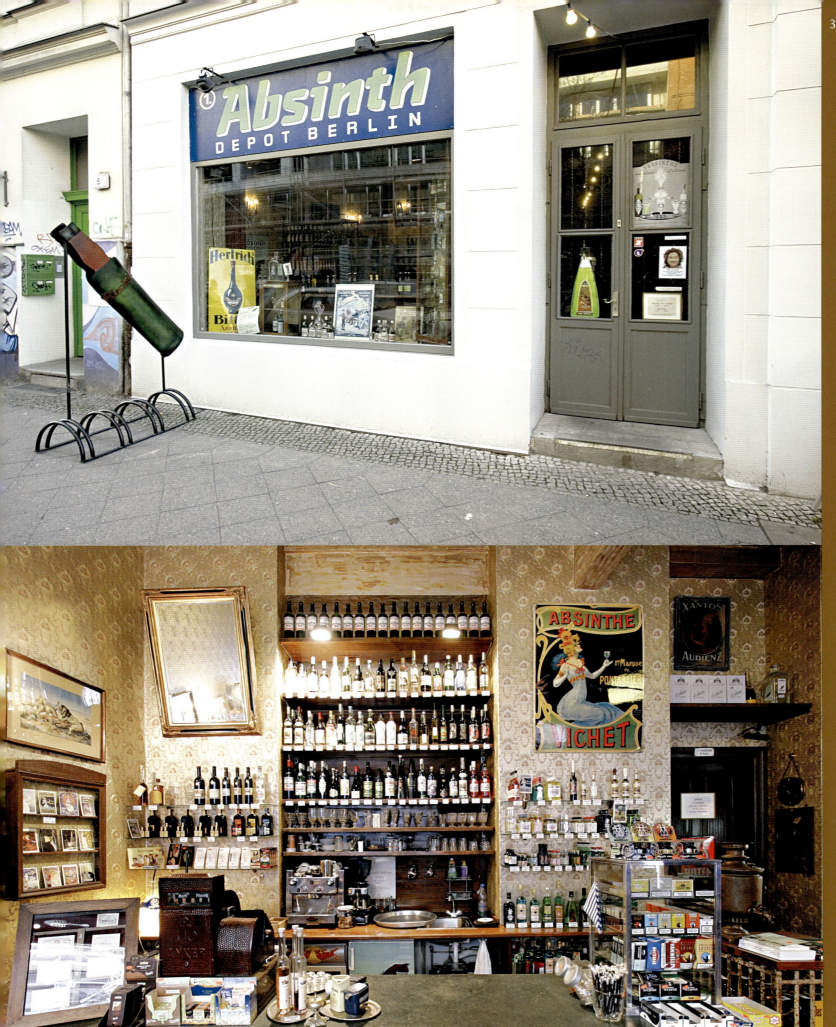

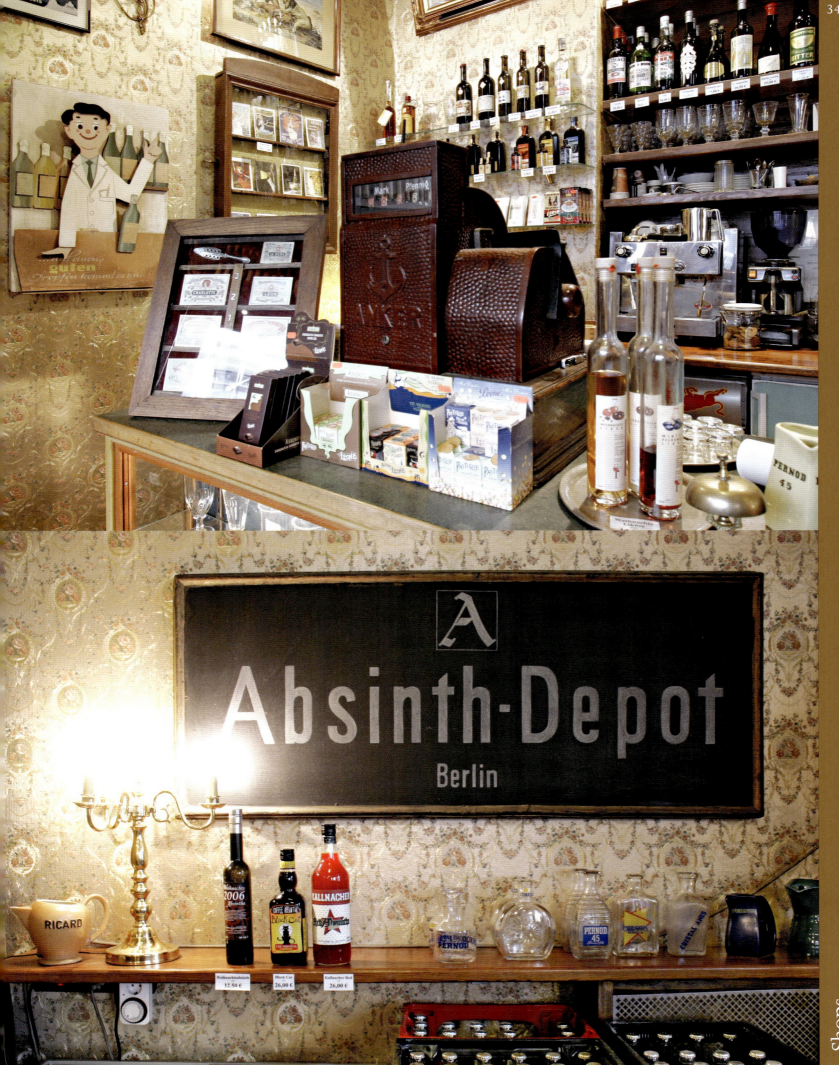

Schönhauser Design

Neue Schönhauser Straße 18, 10178 Berlin
☎ +49 30 2 81 17 04
www.schoenhauser-design.de
Ⓢ Hackescher Markt Ⓤ Weinmeisterstraße

The design store was opened in 1997 by Martin Furtner and Sabine Anweiler. They have an excellent selection of items; the main focus is on original design furniture of the 1950s, 1960s and 1970s (Verner Panton, George Nelson, Charles Eames, Joe Colombo etc.). The vintage range is rounded out with some carefully chosen design books and some amusing little gifts.

Open: Mon–Fri midday–8pm, Sat 11am–5pm.
Interior: Objects by various designers are well coordinated, providing ideas that you might want to imitate at home. There are two other branches: Kastanienallee 55 and Weinmeisterstraße 12–14.
X-Factor: Some thought has also been given to smaller clients. The range includes children's clothes and toys.

Der gut sortierte Designladen wurde 1997 von Martin Furtner und Sabine Anweiler eröffnet. Schwerpunkt sind Designmöbel aus den 1950ern, 1960ern und 1970ern (Verner Panton, George Nelson, Charles Eames, Joe Colombo etc.). Das Vintage-Sortiment wird ergänzt durch vorzüglich ausgewählte Bücher zum Thema Design und witzig gemachte Geschenkartikel.

Öffnungszeiten: Mo–Fr 12–20, Sa 11–17 Uhr.
Interieur: Hier werden Objekte unterschiedlicher Designer gut kombiniert und geben Ideen zur Nachahmung für Zuhause. Zwei Dependancen gibt es in der Kastanienallee 55 und in der Weinmeisterstraße 12–14.
X-Faktor: Auch an kleine Kunden hat man gedacht – und Kinderkleidung sowie Spielzeug.

Martin Furtner et Sabine Anweiler ont ouvert cette boutique de design bien achalandée en 1997. On y trouve surtout des meubles design des années 1950, 1960 et 1970 (Verner Panton, George Nelson, Charles Eames, Joe Colombo etc.). L'assortiment vintage est complété par des livres admirablement choisis sur le design et des articles cadeaux amusants.

Horaires d'ouverture : Lun–Ven 12h–20h, Sam 11h–17h.
Décoration intérieure : Présentés judicieusement, les objets des différents créateurs donnent des idées pour la maison. Il existe deux dépendances : Kastanienalle 55 et Weinmeisterstraße 12–14.
Le « petit plus » : On pense aux plus petits : le magasin propose des vêtements pour enfants ainsi que des jouets.

Andreas Murkudis

Münzstraße 21, 10178 Berlin
☏ +49 30 30 88 19 45
www.andreasmurkudis.net
Ⓢ Hackescher Markt Ⓤ Weinmeisterstraße

Hidden away in a courtyard, this shop is difficult to find. And that's the point. But for those who persevere, a visit to Andreas Murkudis's shops is an absolute must because of his impressive selection of cutting-edge labels. You can find Kostas Murkudis, Haltbar Murkudis, Martin Margiela, Lutz, Y's, Pulver (a young Berlin brand) — all in an utterly unpretentious setting.

In einem Hinterhof gelegen und — mit Absicht — schwer zu finden. Ein Besuch der Läden von Andreas Murkudis ist trotzdem ein Muss, denn die Auswahl an Cutting-Edge-Labeln ist beeindruckend. Hier findet man Kostas Murkudis, Haltbar Murkudis, Martin Margiela, Lutz, Y's, Pulver (ein junges Berliner Brand) — und das alles in völlig unprätentiöser Umgebung.

Une adresse située dans une arrière-cour et — volontairement — difficile à trouver. Se rendre dans les magasins d'Andreas Murkudis est toutefois un must, car le choix y est impressionnant. On y trouve Kostas Murkudis, Haltbar Murkudis, Martin Margiela, Lutz, Y's, Pulver (une jeune marque berlinoise) — le tout dans un environnement sans prétention.

Open: Mon–Sat midday–8pm.
Interior: The design is by the Berlin architects Pierre Jorge Gonzalez and Judith Haase.
X-Factor: Since 2009 a showroom specialising in the well-curated display of design objects is located in an old Berlin-style apartment in the front building.

Öffnungszeiten: Mo–Sa 12–20 Uhr.
Interieur: Das reduzierte Design, das an Kunstgalerien erinnern soll, stammt von den Berliner Architekten Pierre Jorge Gonzalez und Judith Haase.
X-Faktor: Im Vorderhaus in einer Altbauwohnung befindet sich seit 2009 außerdem ein Showroom für sorgfältig kuratierte Designobjekte.

Horaires d'ouverture : Lun–Sam 12h–20h.
Décoration intérieure : Le design minimaliste, évoquant les galeries d'art modernes, est signé Pierre Jorge Gonzalez et Judith Haase, architectes berlinois.
Le « petit plus » : Le show-room, depuis 2009 dans un appartement ancien de la maison du devant, abrite des objets design dont on prend grand soin.

Shops

Adidas Originals Store

Münzstraße 13–15, 10178 Berlin
☏ +49 30 27 59 43 81
www.adidas.de
Ⓢ Hackescher Markt | Ⓤ Weinmeisterstraße

After the brothers Adolf and Rudolf Dassler decided to go their separate business ways in 1948, Rudolf founded Puma and Adolf the Adidas company. The three stripes and the leaping puma both became world-famous trademarks. The huge Adidas flagship store in Münzstraße sells not only classic sneakers in all colours but also articles designed exclusively for Adidas. A paradise for fans of the three stripes.

Open: Mon–Sat 11am–8pm.
Interior: This first Adidas Originals Store worldwide in Berlin was designed by the Viennese company EOOS. All the tables, clothes racks and even the changing cubicles are mobile elements, which can be rearranged at will.
X-Factor: Star pianist Lang Lang designed his very own sneakers with gold stripes for this shop in 2008 and presented them during a private concert in the premises.

Nachdem sich 1948 die Brüder Adolf und Rudolf Dassler beruflich getrennt hatten, gründete Rudolf die Firma Puma und Adolf die Firma Adidas. Die drei Streifen und der springende Puma wurden weltberühmt. Der riesige Adidas-Flagship-Store in der Münzstraße bietet neben den klassischen Sneakern in allen Farbvariationen auch Artikel, die exklusiv für Adidas entworfen wurden. Ein Paradies für jeden Fan der drei Streifen.

Öffnungszeiten: Mo–Sa 11–20 Uhr.
Interieur: Den weltweit ersten Adidas Originals Store in Berlin gestaltete das Wiener Unternehmen EOOS. Alle Tische, Kleiderstangen und sogar Umkleiden sind mobile Elemente, die immer wieder neu arrangiert werden können.
X-Faktor: Für den Laden entwarf Starpianist Lang Lang 2008 einen eigenen Sneaker mit Goldstreifen und präsentierte ihn bei einem privaten Konzert in diesem Shop.

Après que les frères Adolf et Rudolf Dassler se sont séparés professionnellement en 1948, Rudolf a créé l'entreprise Puma et Adolf l'entreprise Adidas. Les trois bandes et le puma sont devenus célèbres dans le monde entier. L'énorme flagship store Adidas dans la Münzstraße propose, outre les sneakers classiques déclinés dans toutes les couleurs, des articles exclusivement conçus pour Adidas. Un paradis pour les fans des trois bandes.

Horaires d'ouverture : Lun–Sam 11h–20h.
Décoration intérieure : Premier magasin Adidas au monde, il a été aménagé par l'entreprise viennoise EOOS. Les tables, les tringles à vêtements et même les cabines d'essayage sont des éléments mobiles variables à volonté.
Le « petit plus » : En 2008, le grand pianiste Lang Lang a dessiné pour le magasin une sneaker avec des bandes dorées qu'il a présentée dans la boutique lors d'un concert privé.

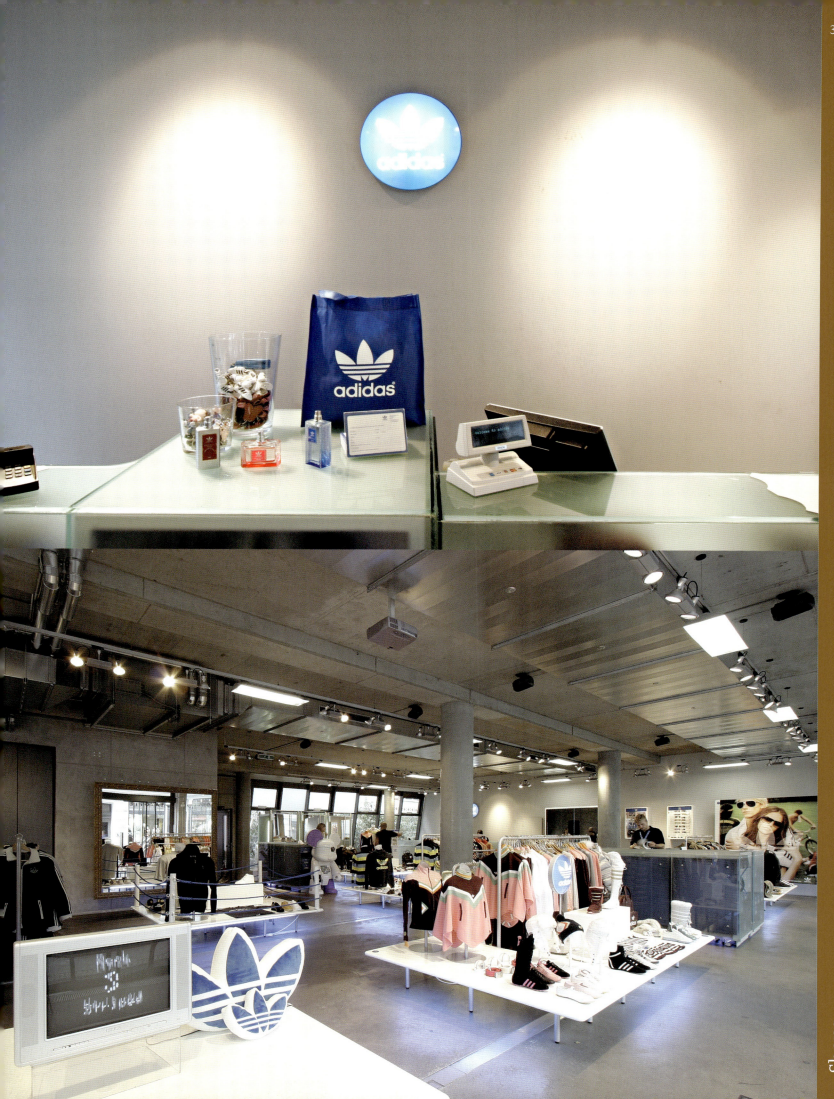

Lebensmittel in Mitte

Rochstraße 2, 10178 Berlin
☎ +49 30 27 59 61 30
Ⓢ Hackescher Markt | Ⓤ Weinmeisterstraße

Just the right place for you if you appreciate organic and additive-free foods from small, select German businesses. The potato and sausage salad, the soups and the buttered pretzels are ideal as in-between snacks, and the Georgensenf mustard from Halle makes a very nice present. Afterwards, go next door and drink the best espresso in Berlin-Mitte, at Buscaglione's, Rochstraße 3.

Wer unverfälschte Lebensmittel aus kleinen, ausgewählten deutschen Betrieben schätzt, ist hier richtig. Der Kartoffel- und Wurstsalat, die Suppen und Butterbrezeln eignen sich als Snack für zwischendurch, und der Georgensenf aus Halle ist ein schönes Mitbringsel. Anschließend kann man nebenan bei Buscaglione in der Rochstraße 3 den leckersten Espresso von Berlin-Mitte trinken.

Si vous appréciez les aliments naturels des petits commerces allemands, alors vous êtes à la bonne adresse. La salade de pommes de terre et de mortadelle, les soupes et les bretzels au beurre calmeront une petite faim et la moutarde Georgensenf de Halle est un joli souvenir. Ensuite, vous pourrez prendre le meilleur espresso de Berlin-Mitte chez Buscaglione dans la Rochstraße 3.

Open: Mon–Fri 11am–midnight, Sat 10am–midnight.
Interior: An old-fashioned "corner shop": the foodstuffs are displayed on simple shelves, in boxes and cases.
X-Factor: The shop is a popular meeting place for lunch – and the Cheese Spätzle is a favourite dish. In summer it's great to sit outside on the street and people-watch.

Öffnungszeiten: Mo–Fr 11–24, Sa 10–24 Uhr.
Interieur: Altmodischer Tante-Emma-Laden: Die Lebensmittel liegen in schlichten Regalen, Kisten und Vitrinen.
X-Faktor: Der Laden ist ein beliebter Lunch-Treffpunkt – besonders gerne bestellen Gäste die Käsespätzle. Im Sommer sitzt man am schönsten draußen.

Horaires d'ouverture : Lun–Ven 11h–24h, Sam 10h–24h.
Décoration intérieure : Épicerie vieillotte : les produits sont posés sur des étagères, dans des caisses et des vitrines toutes simples.
Le « petit plus » : Lieu de rencontre très prisé à l'heure du lunch, les clients raffolent des spätzle au fromage. En été, il est agréable de s'asseoir dehors.

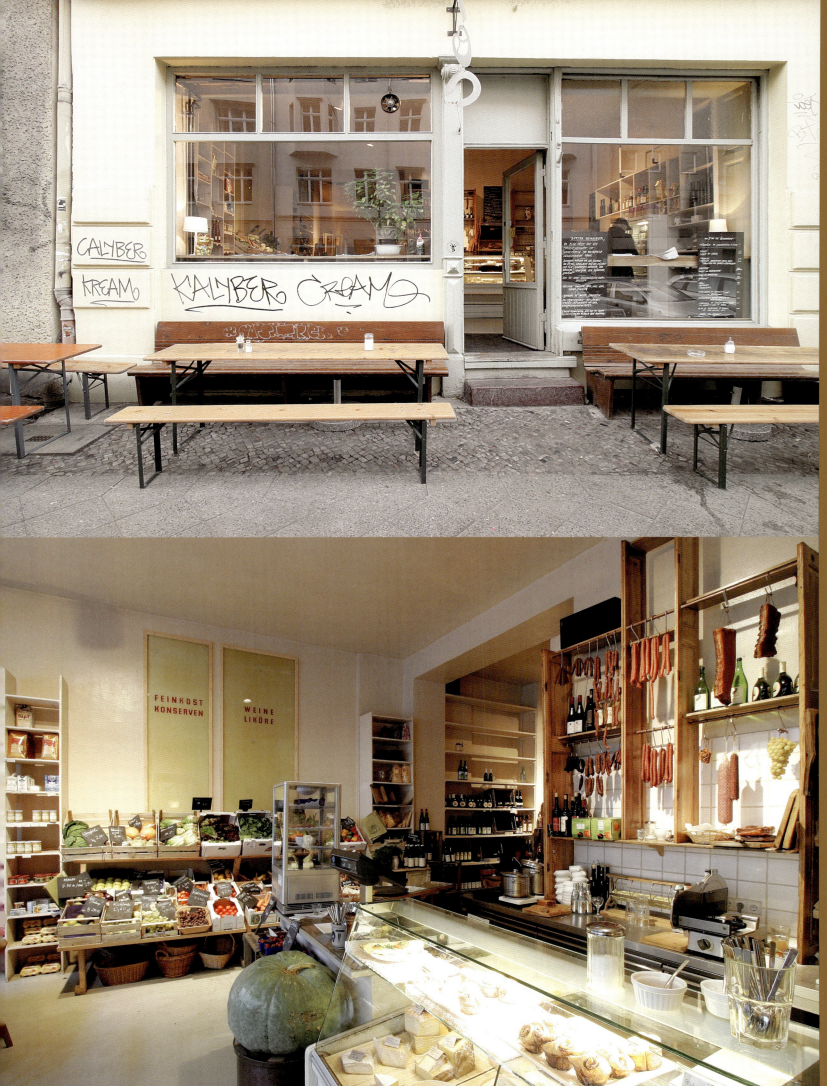

Blush & Balls

Rosa-Luxemburg-Straße 22, 10178 Berlin
☏ +49 30 28 09 35 80
www.blush-berlin.com | www.balls-berlin.com
Ⓢ Alexanderplatz Ⓤ Rosa-Luxemburg-Platz

There is a non-stop stream of Hollywood stars in this shop during the Berlin Film Festival. Here tastefully selected lingerie is presented in a pleasant setting, including such brands as Fifi Chachnil, Malizia, La Perla, Chloé, Huit as well as Blush's own label. (Thong panties with a strategically placed Berlin icon, like the television tower or a Berlin bear, make a very nice souvenir.) I really admire the discipline of anyone who can escape from this shop without buying one expensive item. Now men, too, can buy their clothes next door at Balls (Hanro, Zimmerli, Jockey, Armani, Björn Borg).

Wenn Hollywood-Stars zur Berlinale in Berlin einfliegen, geben sie sich hier die Klinke in die Hand. In angenehmer Atmosphäre werden mit Geschmack ausgewählte Dessous präsentiert von Marken wie Fifi Chachnil, Malizia, La Perla, Chloé, Huit und dem Hauslabel Blush (Strings mit gut platzierten Berliner Symbolen wie Fernsehturm oder Berliner Bär – ein schönes Souvenir). Wer hier ohne ein teures Stück den Laden verlässt, den bewundere ich für seine Disziplin. Seit Neuestem können sich auch Männer bei Balls nebenan einkleiden (Hanro, Zimmerli, Jockey, Armani, Björn Borg).

Lorsque les stars de Hollywood viennent à la Berlinale, elles défilent toutes ici. Une lingerie de choix y est présentée dans une ambiance agréable. Vous trouverez les marques comme Fifi Chachnil, Malizia, La Perla, Chloé, Huit et Blush, la marque de la maison (des strings avec des symboles berlinois bien placés comme la Tour de télévision ou l'ours de Berlin – un joli souvenir). Si vous sortez de Blush sans avoir fait de folies, alors je vous admire pour votre retenue. Depuis peu, les hommes peuvent s'habiller aussi à côté, chez Balls (Hanro, Zimmerli, Jockey, Armani, Björn Borg).

Open: Mon–Fri midday–8pm, Sat midday–7pm or by arrangement.
Interior: Blush is decorated like a feminine bedroom. For the men's section, Balls, owner Claudia Kleinert has chosen second-hand 1950s bachelor-room furniture.
X-Factor: Female clients receive good advice here on bikinis.

Öffnungszeiten: Mo–Fr 12–20, Sa 12–19 Uhr oder nach Vereinbarung.
Interieur: Blush ist wie ein feminines Schlafzimmer eingerichtet. Für die Männerabteilung Balls verwendete Inhaberin Claudia Kleinert die Second-hand-Möbel eines Junggesellenzimmers aus den 1950ern.
X-Faktor: Hier werden Kundinnen auch beim Bikini-Kauf gut beraten.

Horaires d'ouverture : Lun–Ven 12h–20h, Sam 12h–19h ou sur rendez-vous.
Décoration intérieure : Blush est aménagé comme une chambre de jeune. Pour le rayon hommes, la propriétaire Claudia Kleinert a utilisé les meubles d'une chambre de célibataire des années 1950.
Le « petit plus » : Les clientes sont aussi bien conseillées pour l'achat d'un bikini.

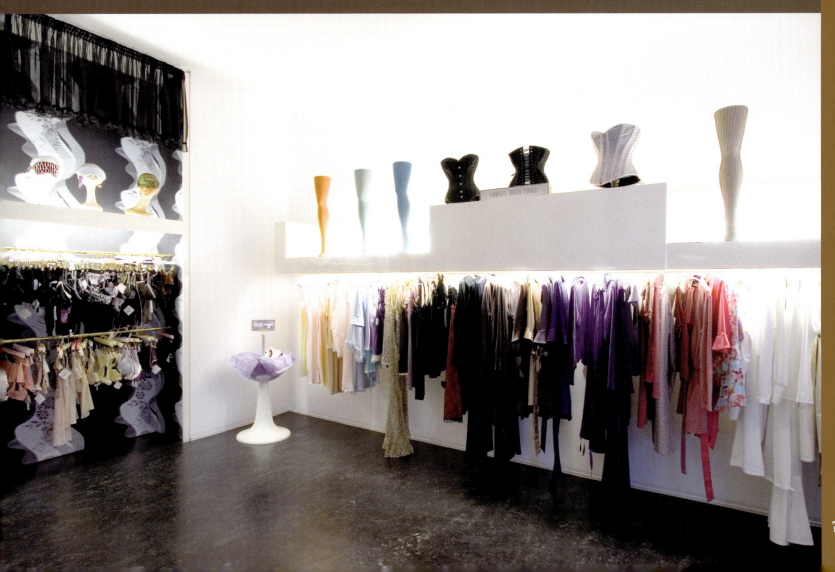

Buffalo

Rosenthaler Straße 46/47, 10119 Berlin
☎ +49 30 24 04 70 92
www.myspace.com/buffaloberlin
Ⓢ Hackescher Markt or Weinmeisterstraße

Mitte is a Mecca for shoes — and Buffalo is a truly adorable shop. The whole store is decorated in pink, from the walls above the sofa in French palace style right down to the orchids. A chandelier, candelabras and gilded consoles lend a touch of glamour, and the window decoration has cult status: the outsize model of a cream gâteau on which the collection is presented is the talk of the town.

Mitte ist ein Schuhmekka — besonders außergewöhnlich ist der Shop der Schuhkette Buffalo. Von den Wänden über das Sofa im französischen Palaststil bis hin zu den Orchideen ist der Laden ganz in Rosé gehalten. Ein Kronleuchter, Kerzenhalter sowie vergoldete Konsolen verleihen ihm Glamour, und die Schaufensterdekoration ist Kult: Das überdimensionale Sahnetortenmodell, auf dem die Kollektion präsentiert wurde, sorgte in ganz Mitte für Gesprächsstoff.

Le Mitte est le nec plus ultra de la chaussure — et la boutique de Buffalo est tout simplement adorable. Tout est rose ici, des murs aux orchidées en passant par le canapé qui semble tout droit sorti d'un château français. Un lustre, des bougeoirs et des consoles dorées donnent un air glamour au magasin et la décoration des vitrines est l'objet d'un culte : tout Berlin-Mitte a parlé de la maquette géante de gâteau à la crème sur laquelle la collection a été présentée.

Open: Mon–Fri 11.30am–7.30pm, Sat midday–6pm.
Interior: The manager is responsible for the interior and the thematic display windows: Marcel Hertel also communicates his ideas in videos on the shop's website.
X-Factor: If you are looking for suitable shoes for a particular dress, bring it along with you and you will be individually advised in a separate room.

Öffnungszeiten: Mo–Fr 11.30–19.30, Sa 12–18 Uhr.
Interieur: Das Interieur und die thematischen Schaufensterdekorationen sind Chefsache: Marcel Hertel zeigt seine Ideen auch in Videos auf der Shop-Website.
X-Faktor: Wer passende Schuhe zu einem Kleid sucht und dieses mitbringt, wird in einem separaten Raum individuell beraten.

Horaires d'ouverture : Lun–Ven 11.30h–19.30h, Sam 12h–18h.
Décoration intérieure : C'est le chef qui s'occupe de la décoration intérieure et des vitrines à thèmes : Marcel Hertel présente aussi ses idées dans des vidéos sur son site web.
Le « petit plus » : Si vous cherchez des chaussures allant avec votre robe, apportez celle-ci et l'on vous conseillera dans une pièce à part.

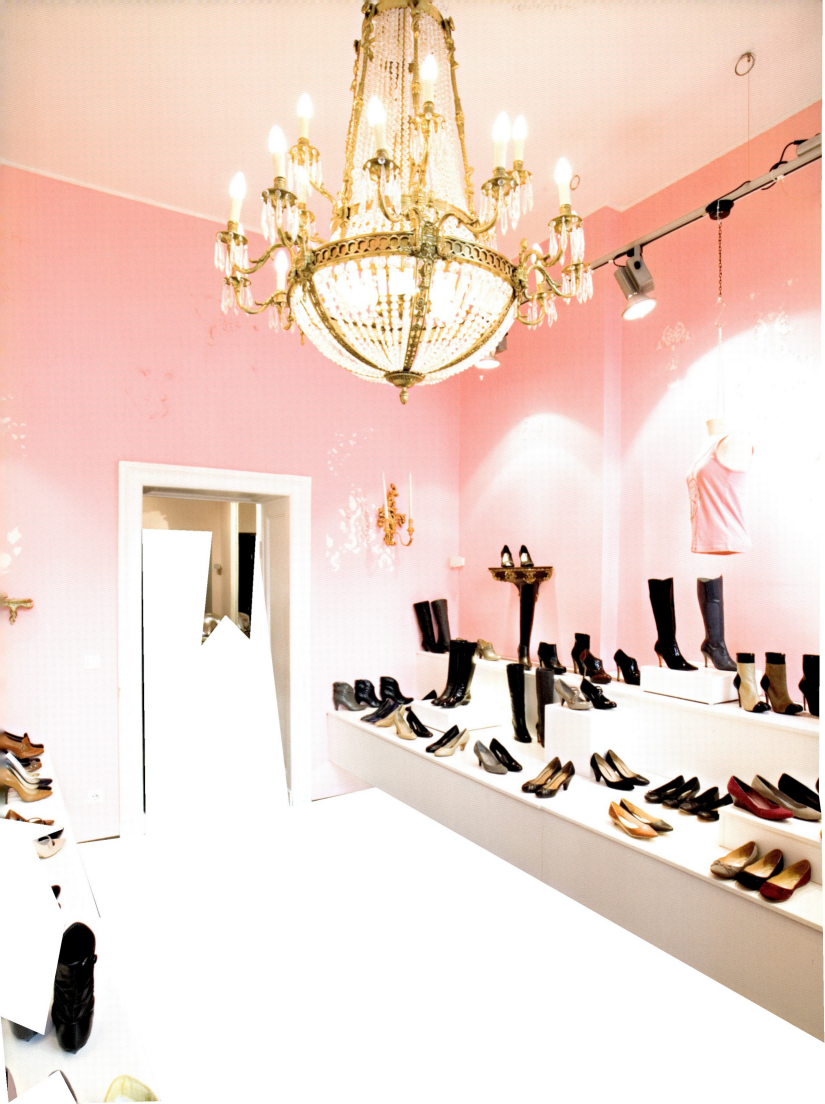

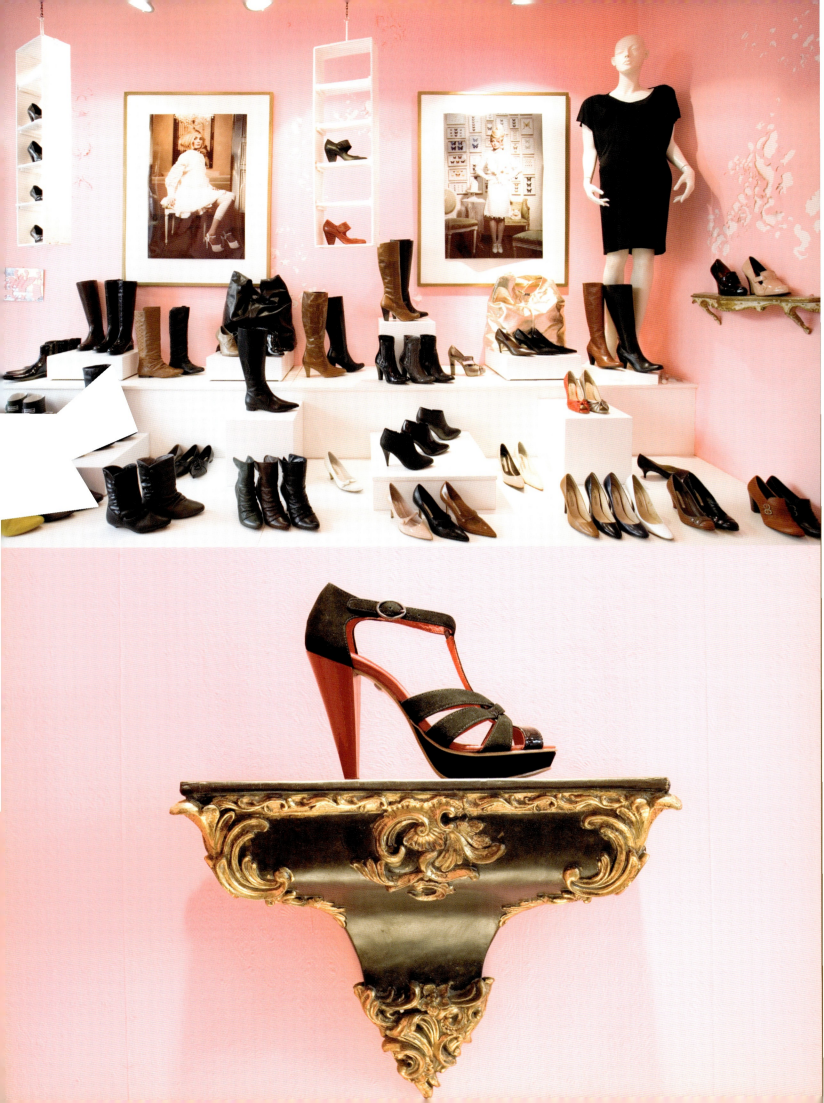

Bless Shop

Mulackstraße 38, 10119 Berlin
☎ +49 30 44 01 01 00
www.bless-service.de
Ⓢ Hackescher Markt Ⓤ Weinmeisterstraße

The small and charming Mulackstraße is attracting more and more trendy fashion stores. Here you can find one of the few A. P. C. shops worldwide, or Nicole Hogerzeil with her exquisite range, Lala Berlin and Bless, a label founded in 1997 by Ines Kaag and Désirée Heiss that has meanwhile had international success. Bless sells out-of-the-ordinary fashion.

Open: Mon, Wed–Fri 2pm–7pm, Sat midday–6pm.
Interior: In a minimalist atmosphere you can buy creations combining fashion and art – in the tradition of the fur wigs that Martin Margiela's models wore on the catwalk in 1997 and that made Bless internationally famous.
X-Factor: The knitted leather shoes.

Die kleine pittoreske Mulackstraße lockt immer mehr trendige Modegeschäfte an. So gibt es hier einen der weltweit wenigen A. P. C.-Läden, dazu Nicole Hogerzeil mit ihrem exquisiten Sortiment, Lala Berlin und Bless, ein mittlerweile international erfolgreiches Label, das Ines Kaag und Désirée Heiss 1997 gegründet haben. Der Laden bietet ausgefallene Mode.

Öffnungszeiten: Mo, Mi–Fr 14–19, Sa 12–18 Uhr.
Interieur: In minimalistischem Ambiente werden Kreationen verkauft, die Mode und Kunst verbinden – ganz in der Tradition der Pelzperücken, die Martin-Margiela-Models 1997 auf dem Laufsteg trugen und damit Bless international bekannt machten.
X-Faktor: Die aus Leder gestrickten Schuhe.

La Mulackstraße, petite rue pittoresque, attire toujours plus de boutiques de mode tendance. Vous y trouverez un des rares magasins A. P. C., Nicole Hogerzeil et son assortiment exquis, Lala Berlin ainsi que Bless, une marque fondée en 1997 par Ines Kaag et Désirée Heiss et qui connaît aujourd'hui un succès international. La mode proposée ici sort de l'ordinaire.

Horaires d'ouverture : Lun, Mer–Ven 14h–19h, Sam 12h–18h.
Décoration intérieure : Dans une ambiance minimaliste, on vend ici des créations alliant la mode et l'art – tout à fait dans la tradition des perruques en fourrure portées par les mannequins de Martin Margiela en 1997 et qui ont rendu Bless célèbre dans le monde entier.
Le « petit plus » : Les chaussures en cuir tricoté.

R.S.V.P. Papier in Mitte

Mulackstraße 14, 10119 Berlin
☏ +49 30 28 09 46 44
www.rsvp-berlin.de
Ⓢ Hackescher Markt Ⓤ Rosa-Luxemburg-Platz, Weinmeisterstraße

For all those who, even in the age of text messages and e-mail, like to send classical invitations with the request "R.S.V.P." (répondez s'il vous plaît; reply is requested), this shop supplies beautiful and rare writing paper from all round the world. The range of products is continually renewed; the cards by young artists and designers are particularly sought after. Nor have stylish pens and pencils been forgotten — unusual brands such as OHTO from Japan and Koh-I-Noor from the Czech Republic are also sold.

Für alle, die auch im Zeitalter von SMS und E-Mail gern klassische Einladungen mit der Bitte „R.S.V.P." (répondez s'il-vous-plaît; um Antwort wird gebeten) verschicken, bietet dieser Laden schöne und seltene Briefpapiere aus aller Welt an. Das Sortiment wird immer wieder neu zusammengestellt; besonders begehrt sind die von jungen Künstlern und Designern gestalteten Karten. An stilvolle Stifte wurde ebenfalls gedacht — hier bekommt man seltene Marken wie OHTO aus Japan oder Koh-I-Noor aus Tschechien.

À l'époque des SMS et des courriels, il existe des gens qui aiment envoyer des invitations classiques portant la mention « R.S.V.P. » (répondez s'il-vous-plaît). La boutique leur propose des papiers à lettres beaux et rares provenant du monde entier. La gamme fait l'objet de constants remaniements ; les cartes créées par de jeunes artistes et designers sont particulièrement demandées. Et pour écrire sur ces beaux papiers on peut acheter ici des crayons et stylos élégants de marques rares comme la japonaise OHTO ou la tchèque Koh-I-Noor.

Open: Mon–Fri midday–7pm, Sat midday–6pm.
Interior: The shelves seem to hover weightlessly in this wood-dominated interior.
X-Factor: A number of their products can be bought online, including the pretty travel notebooks, ideal companions on holiday.

Öffnungszeiten: Mo–Fr 12–19, Sa 12–18 Uhr.
Interieur: Holz dominiert die Inneneinrichtung. Die Regale wirken sehr leicht und fast schwebend.
X-Faktor: Eine Auswahl der Produkte kann im Online-Shop gekauft werden; darunter die hübschen Reisenotizbücher, die ideale Urlaubsbegleiter sind.

Horaires d'ouverture : Lun–Ven 12h–19h, Sam 12h–18h.
Décoration intérieure : Le bois est dominant. Les étagères ont l'air très légères, presque aériennes.
Le « petit plus » : Certains produits peuvent être achetés dans la boutique en ligne, dont les jolis carnets de voyage qui vous accompagneront durant vos vacances.

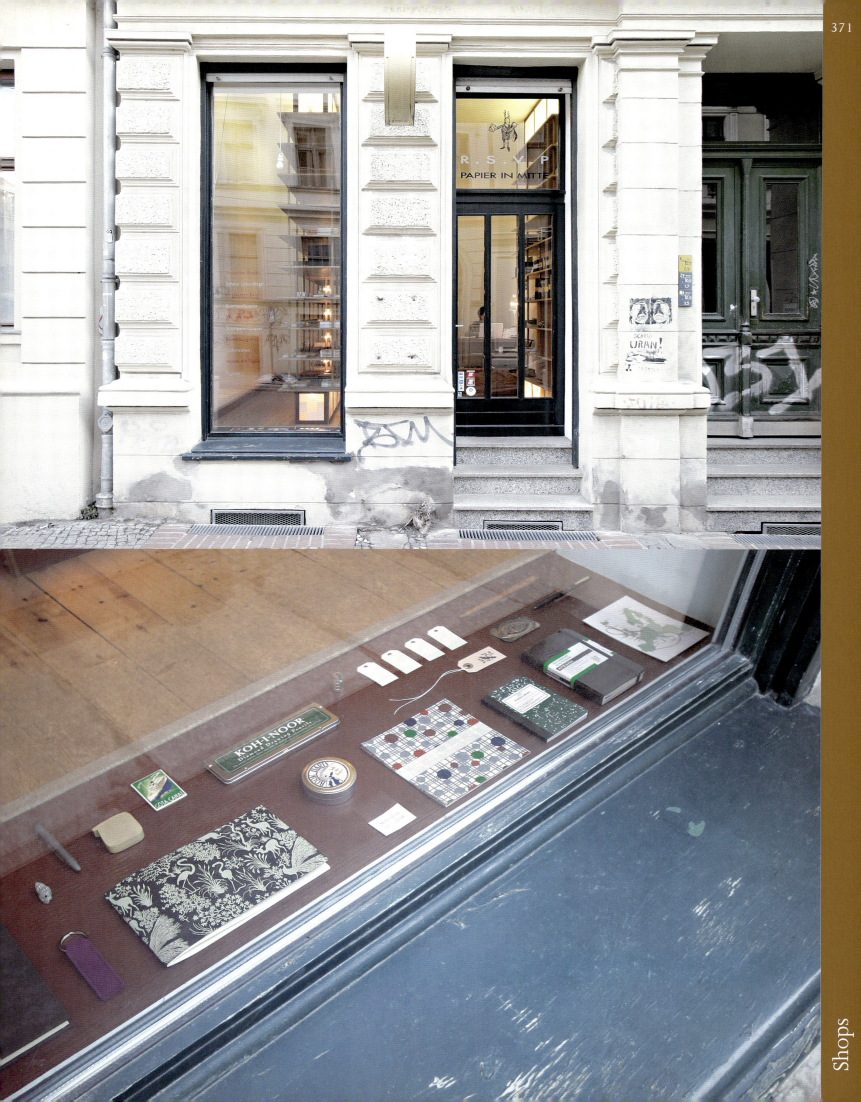

Erzgebirgskunst Original

Sophienstraße 9, 10178 Berlin
☎ +49 30 2 82 67 54
www.original-erzgebirgskunst.de
Ⓢ Hackescher Markt　Ⓤ Weinmeisterstraße

The Erzgebirge, a mountain range between Saxony and Bohemia on the border of the Czech Republic, is a centre for traditional German handicrafts. The most popular export items are the famous wooden incense smokers, nut crackers and Christmas pyramids. If you are looking for a small, typical German present, this is just the place for you.

Das Erzgebirge – zwischen Sachsen und Böhmen entlang der Grenze zu Tschechien gelegen – ist eines der Zentren deutscher Volkskunst. Exportschlager sind die berühmten hölzernen Räuchermännchen, Nussknacker und Weihnachtspyramiden. Wer ein typisch deutsches Mitbringsel sucht, ist hier genau richtig.

Le Erzgebirge entre la Saxe et la Bohême, le long de la frontière tchèque, est un des centres de l'art populaire allemand. Les articles ayant le plus de succès à l'exportation sont les brûleurs d'encens, les casse-noisettes et les pyramides de Noël en bois. Si vous cherchez un cadeau souvenir, vous êtes à la bonne adresse.

Open: Mon–Fri 11am–7pm, Sat 11am–6pm.
Interior: Owner Johanna Gräf-Petzoldt uses every single centimetre of shop space to display the wooden figurines originating from the region where she was born.
X-Factor: The figures are all carved and painted by hand.

Öffnungszeiten: Mo–Fr 11–19, Sa 11–18 Uhr.
Interieur: Besitzerin Johanna Gräf-Petzoldt nutzt jeden Zentimeter für die Holzfiguren aus ihrer Heimat.
X-Faktor: Alle Figuren sind handgefertigt und handbemalt.

Horaires d'ouverture : Lun–Ven 11h–19h, Sam 11h–18h.
Décoration intérieure : La propriétaire Johanna Gräf-Petzoldt remplit chaque centimètre avec les figurines en bois de sa patrie.
Le « petit plus » : Toutes les figurines sont fabriquées et peintes à la main.

Thomas Wild Teppich- & Textilkunst

Gipsstraße 12, 10119 Berlin
☎ +49 30 28 38 57 60
www.thomaswild.com
Ⓢ Hackescher Markt Ⓤ Weinmeisterstraße

As an expert in antique carpets from Morocco and Tibet, and as a lecturer and museum adviser, Thomas Wild had already made his name before he opened this gallery in 1998. Here he offers carefully chosen textiles to interior designers and collectors – Berber carpets from the High Atlas, for example, or carpets for sitting or sleeping on, from central Tibet. His prize exhibits also include killims and valuable, centuries-old fragments of silk.

Als Experte für antike Teppiche aus Marokko und Tibet sowie als Dozent und Berater von Museen hatte sich Thomas Wild bereits einen Namen gemacht, ehe er 1998 diese Galerie eröffnete. Hier bietet er Innenarchitekten und Sammlern sorgfältig ausgewählte Textilien an – zum Beispiel Berberteppiche aus dem Hohen Atlas oder Sitz- und Schlafteppiche aus Zentraltibet. Zu den Schmuckstücken seiner Exponate zählen zudem Kelims und sehr wertvolle, jahrhundertealte Seidenfragmente.

Avant d'ouvrir cette galerie en 1998, Thomas Wild s'est fait un nom en tant que spécialiste de tapis marocains anciens ainsi que maître de conférences et conseiller auprès des musées. Il propose ici à des architectes d'intérieurs et des collectionneurs des textiles soigneusement sélectionnés – par exemple des tapis berbères du Haut Atlas ou des tapis pour s'asseoir ou dormir, fabriqués dans le centre du Tibet. On trouve ici de véritables joyaux : des kelims et de précieux fragments de soieries vieilles de plusieurs siècles.

Open: Tue–Fri midday–6pm, Sat midday–5pm.
Interior: The ceiling-to-floor windows all around this shop make it ideal for window-shopping. It is always a delight to see the constantly changing goods on display.
X-Factor: Small items of antique furniture, which Thomas Wild has discovered on his travels, are also sold.

Öffnungszeiten: Di–Fr 12–18, Sa 12–17 Uhr.
Interieur: Der gut einsehbare Laden mit Fenstern rundum vom Boden bis zur Decke eignet sich auch hervorragend zum Windowshopping. Der Anblick der ausgestellten, immer wieder neuen Ware ist ein Hochgenuss.
X-Faktor: Antike Kleinmöbel, die Thomas Wild bei seinen Recherchen und Reisen entdeckt, werden ebenfalls zum Kauf angeboten.

Horaires d'ouverture : Mar–Ven 12h–18h, Sam 12h–17h.
Décoration intérieure : Le lèche-vitrines est un véritable plaisir devant cette façade vitrée du sol au plafond, qui ne cache rien de l'intérieur. La vue des articles qui changent régulièrement est un régal pour les yeux.
Le « petit plus » : Des petits meubles anciens, découverts par Thomas Wild lors de ses recherches et de ses voyages, sont également proposés à la vente.

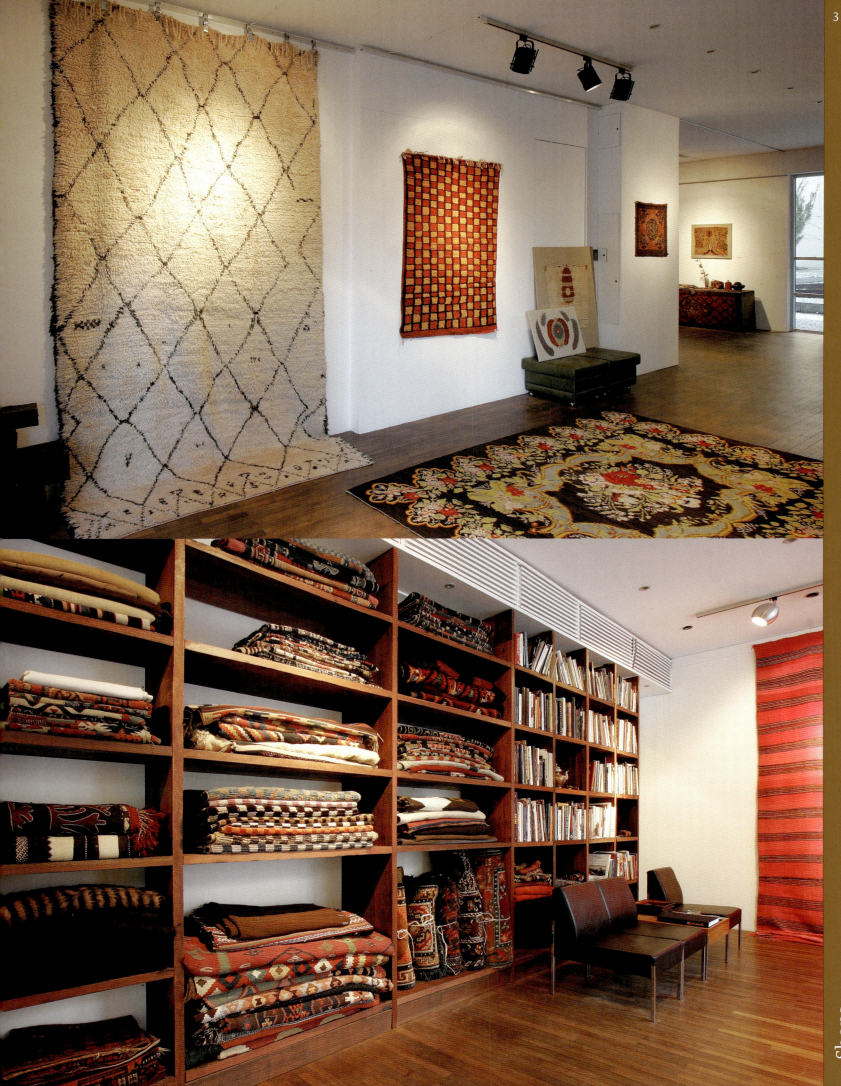

Jünemann's Pantoffeleck

Torstraße 39, 10119 Berlin
☎ +49 30 4 42 53 37
www.pantoffeleck.de
🄤 Rosa-Luxemburg-Platz

The hen-pecked husband is called a "slipper hero" in German, and he has made slippers legendary. The original slipper is manufactured and sold here in unchanged form. You can choose between classic grey or checked, and a handmade pair of slippers costs you around 10 euros.

Der deutsche Pantoffelheld ist Legende, in diesem kleinen Laden wird der Ur-Pantoffel seit 1908 in unveränderter Form hergestellt und verkauft. Man kann zwischen klassisch grauen oder karierten Modellen wählen, das handgefertigte Paar kostet um die 10 Euro.

Un paradis pour les pantouflards ! Dans ce petit magasin, la pantoufle est réalisée et vendue sous la même forme depuis 1908. On peut choisir entre un modèle classique gris ou un modèle à carreaux, la paire faite à la main coûte environ 10 euros.

Open: Mon/Wed/Fri 9am–5pm, Tue/Thu 9am–6pm.
Interior: Slippers ranging from children's sizes to outsize 52 are stored on the old, almost ceiling-high wooden shelves.
X-Factor: Their special models, like the BVG slippers, whose pattern is that of the seat covering in Berlin's busses and trains.

Öffnungszeiten: Mo/Mi/Fr 9–17, Di/Do 9–18 Uhr.
Interieur: In den alten, fast raumhohen Holzregalen liegen Pantoffel von Kindergröße 23 bis Übergröße 52.
X-Faktor: Die Sondermodelle wie z. B. die BVG-Pantoffel – gemustert wie die Sitze der Berliner Busse und Bahnen.

Horaires d'ouverture : Lun/Mer/Ven 9h–17h, Mar/Jeu 9h–18h.
Décoration intérieure : Sur les vieilles étagères en bois, qui montent presque jusqu'au plafond, se trouvent des pantoufles dont la pointure va du 23 au 52.
Le « petit plus » : Les modèles spéciaux, comme les pantoufles BVG, dont le dessin est le même que celui des sièges des bus et trams berlinois.

379

!!! Aus der Kollektion der BVG !!!
Hier erhältlich, denn von uns
hergestellt....

Preis 25,- Euro

Shops

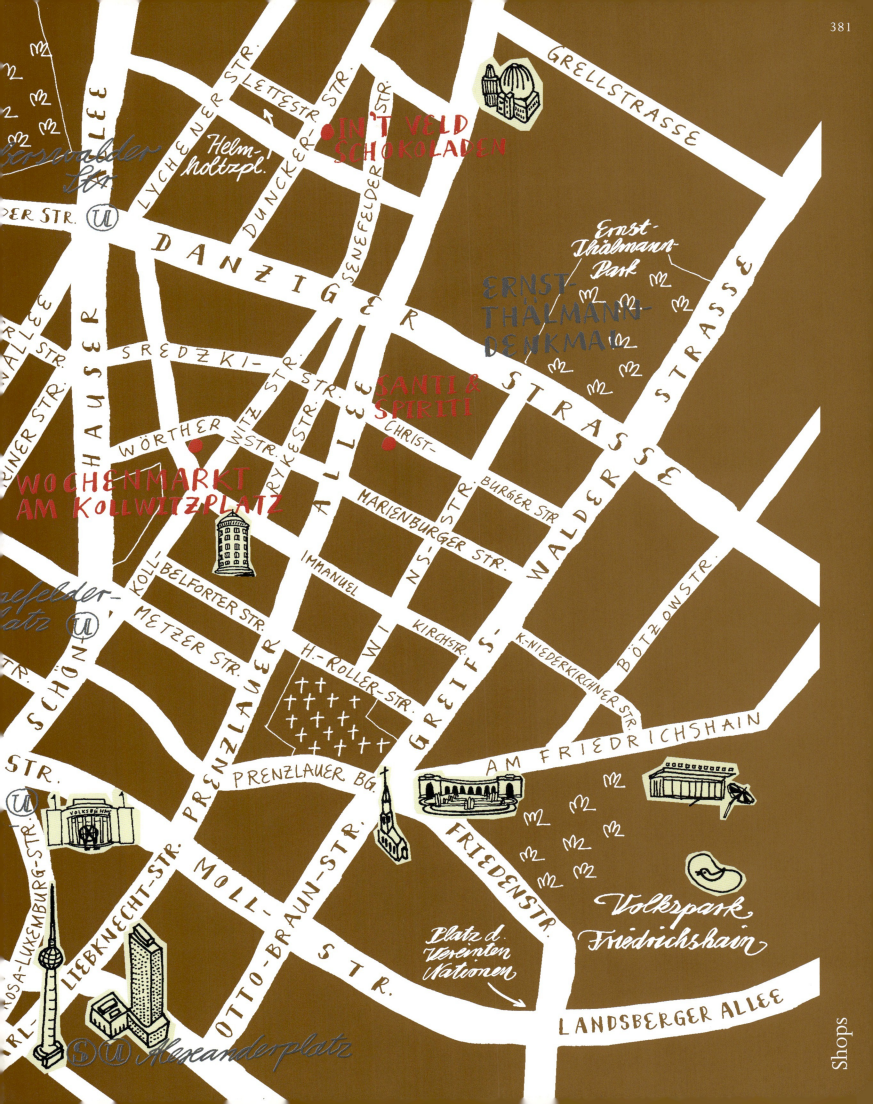

Wochenmarkt am Kollwitzplatz

Kollwitzplatz, 10405 Berlin
U Senefelderplatz

On Saturdays and Thursdays shoppers come here not only for fruit and vegetables, meat and fish, but also for exotic spices, fresh Italian pasta and pesto, and Turkish flatbread. The numerous cafés in the district are ideal places to drink a café au lait and do some people-watching after the shopping.

Hier bekommt man samstags und donnerstags nicht nur Obst und Gemüse, Fleisch und Fisch, sondern auch exotische Gewürze, frische italienische Pasta und Pestos sowie türkisches Fladenbrot. Die vielen Cafés des Viertels sind ideal für den Milchkaffee nach dem Einkauf und fürs Peoplewatching.

Le samedi et le jeudi on peut acheter ici des fruits et des légumes, de la viande et du poisson mais aussi des épices exotiques, des pâtes italiennes et des pestos tout frais ainsi que du pide (pain plat) turc. Après avoir fait ses emplettes on peut boire un café au lait dans l'un des nombreux cafés du quartier et regarder les gens passer.

Open: Sat 9am–4pm, Thurs midday–7pm.
Interior: This market was founded in summer 2000. Today about 80 traders set up their stalls here every week.
X-Factor: The food sold at the market's snack stands cover the whole range, from oysters to Currywurst.

Öffnungszeiten: Sa 9–16 Uhr, Do 12–19 Uhr.
Interieur: Gegründet wurde der Markt im Sommer 2000. Heute bauen hier rund 80 Händler ihre Stände auf.
X-Faktor: Die Snacks an den Imbissbuden auf dem Markt für jeden Geschmack – von Austern bis zur Currywurst.

Horaires d'ouverture : Sam 9h–16h, Jeu 12h–19h.
Décoration intérieure : Aujourd'hui, 80 vendeurs installent leur étal sur ce marché fondé en été 2000.
Le « petit plus » : Toutes sortes d'en-cas sont vendus dans les baraques sur le marché, on y trouvera aussi bien des huîtres que des saucisses au curry.

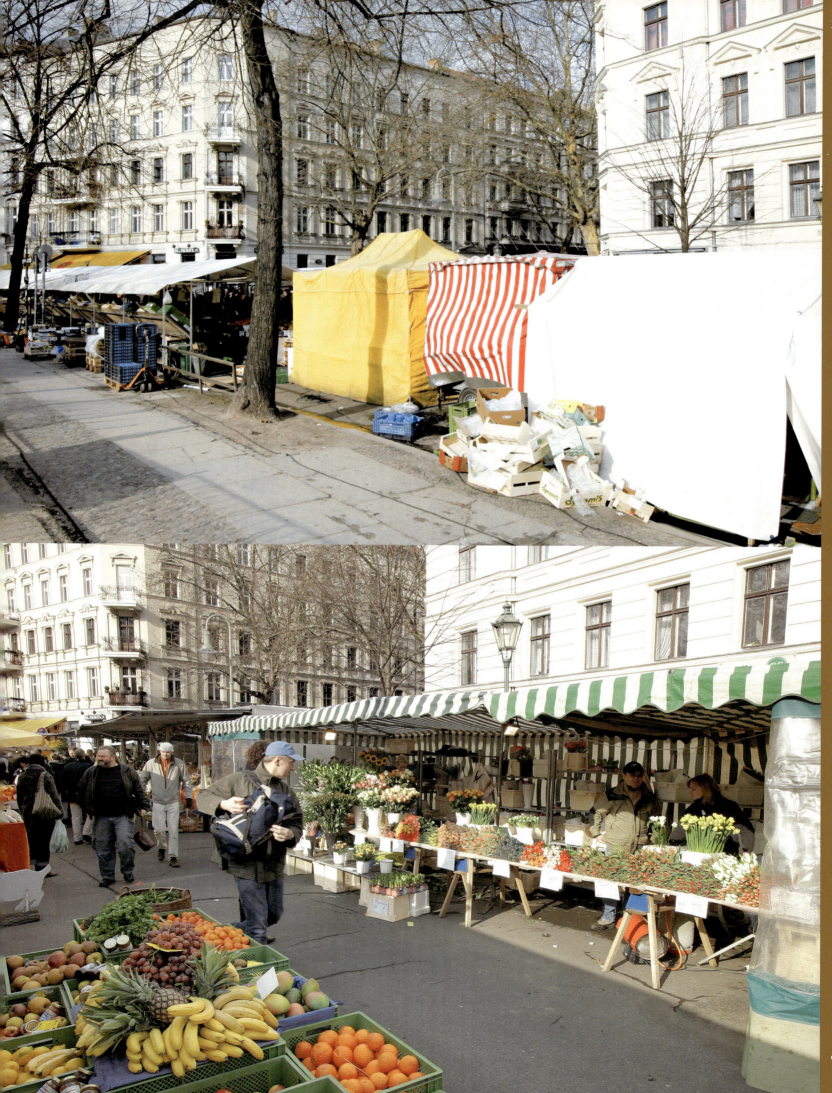

in't Veld Schokoladen

Dunckerstraße 10, 10437 Berlin
☎ +49 30 48 62 34 23
www.intveld.de
Ⓢ Prenzlauer Allee Ⓤ Eberswalder Straße

The ultimate paradise for chocoholics. The Dutchman Holger in't Veld and his team have searched the world and compiled a unique range of the best products, including Dolfin, Valrhona, Bonnat, Blanxart, Zotter and Hamann (see p. 296). His search for the best beans led him to produce his own product. Its beautiful label is decorated with a ship. Next door you can drink hot chocolate, with a touch of chili, if you prefer, in a café imaginatively designed by Astrid Pankrath.

Das ultimative Paradies für Schokoholics. Das Team um den Holländer Holger in't Veld hat weltweit recherchiert und ein einzigartiges Sortiment der besten Produkte zusammengestellt, zum Beispiel von Dolfin, Valrhona, Bonnat, Blanxart, Zotter und Hamann (s. S. 296). Am Ende der Suche nach der besten Bohne stand die Eigenproduktion. Das mit einem Schiff verzierte Label ist wunderschön. Nebenan kann man heiße Schokolade – zum Beispiel mit Chili – in einem von Astrid Pankrath originell eingerichteten Café trinken.

Le paradis pour les mordus du chocolat. L'équipe du Hollandais Holger in't Veld a effectué des recherches dans le monde entier et composé un assortiment unique des meilleurs produits de Dolfin, Valrhona, Bonnat, Blanxart, Zotter et Hamann (p. 296), entre autres. Une fois la meilleure fève trouvée, il ne restait plus qu'à produire. Le label décoré d'un navire est superbe. À côté de la boutique, vous pourrez prendre un chocolat chaud – par exemple au piment – dans un café aménagé de manière originale par Astrid Pankrath.

Open: Mon–Fri 11am–8pm, Sat 11am–6pm.
Interior: Because of the dark-brown wooden blocks and indirect lighting, even the shelves here remind you of pieces of chocolate.
X-Factor: Just around the corner in Raumerstraße is the in't Veld Manufaktur. Among the chocolates made here is one with salt and goat's milk.

Öffnungszeiten: Mo–Fr 11–20, Sa 11–18 Uhr.
Interieur: Dank dunkelbrauner Holzquadrate und indirekter Beleuchtung erinnern selbst die Regale an Schokoladenstücke.
X-Faktor: In der gleich um die Ecke gelegenen Raumerstraße befindet sich die Manufaktur in't Veld. Hier wird z. B. Schokolade mit Salz und Ziegenmilch hergestellt.

Horaires d'ouverture : Lun–Ven 11h–20h, Sam 11h–18h.
Décoration intérieure : Avec leurs carrés en bois sombre et l'éclairage indirect, même les étagères rappellent des morceaux de chocolat.
Le « petit plus » : La chocolaterie in't Veld se trouve juste au coin, dans la Raumerstraße. On y fabrique, par exemple, du chocolat au sel et au lait de chèvre.

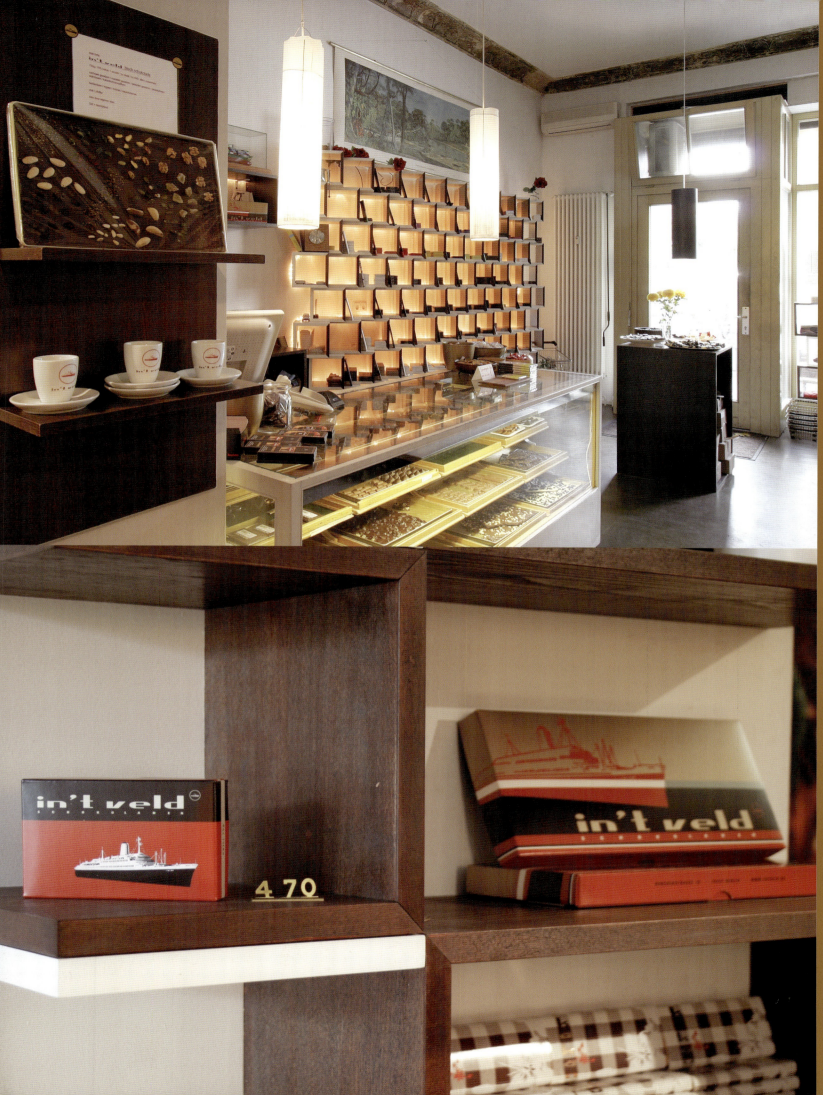

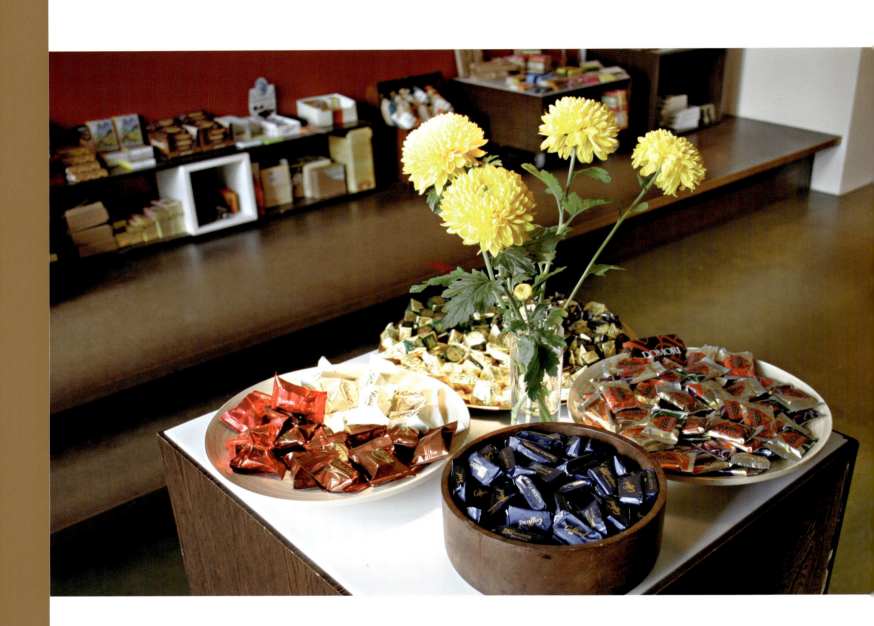

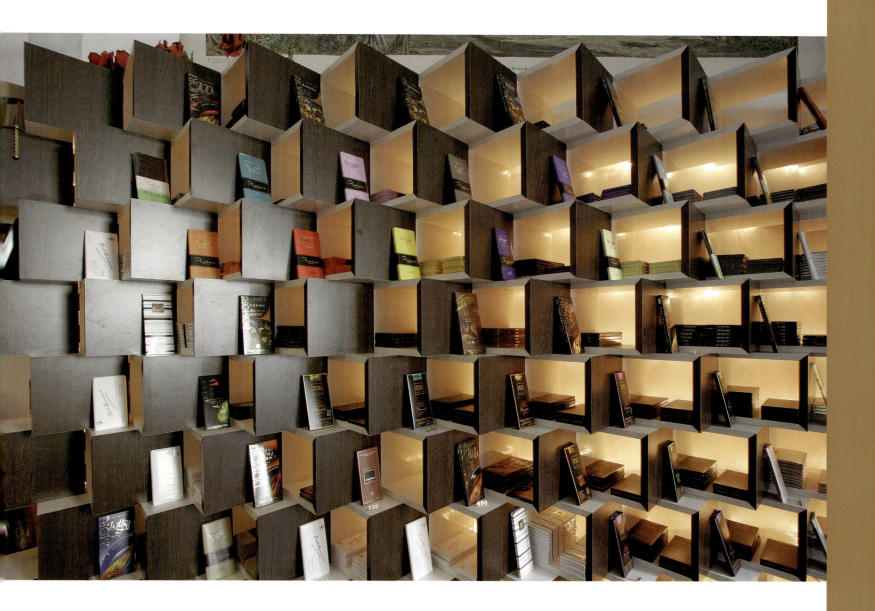

Santi & Spiriti

Christburger Straße 6, 10405 Berlin
☎ +49 30 44 04 39 02
Ⓢ Prenzlauer Allee Ⓤ Senefelderplatz

This small shop has been selling selected wines and lesser-known fine spirits since 2005. Its speciality is good wines for under 10 euros a bottle, with a focus on German and Italian wines.

Seit 2005 werden hier ausgesuchte Weine und eher unbekannte Edelspirituosen verkauft. Dabei konzentriert sich der kleine Laden auf gute Weine unter 10 Euro. Der Schwerpunkt liegt auf Weinen aus Italien und Deutschland.

Des vins de choix et des liqueurs plutôt inconnues sont vendus dans cette petite boutique depuis 2005. Vous y trouverez nombre de bons vins en dessous de 10 euros. L'accent est mis sur les vins italiens et allemands

Open: Tue–Fri 4pm–8pm, Sat midday–4pm.
Interior: Beautifully grained wood, stucco and a chandelier make up the noble-rustic atmosphere.
X-Factor: You can taste some of the particularly costly spirits before buying.

Öffnungszeiten: Di–Fr 16–20, Sa 12–16 Uhr.
Interieur: Schön gemasertes Holz, Stuck und ein Kronleuchter sorgen für nobelrustikales Flair.
X-Faktor: Besonders hochwertige Spirituosen kann man vor dem Kauf verkosten.

Horaires d'ouverture : Mar–Ven 16h–20h, Sam 12h–16h.
Décoration intérieure : Le bois joliment veiné, les stucs et le lustre créent une ambiance rustique et cossue.
Le « petit plus » : Dégustation possible des meilleurs spiritueux avant l'achat.

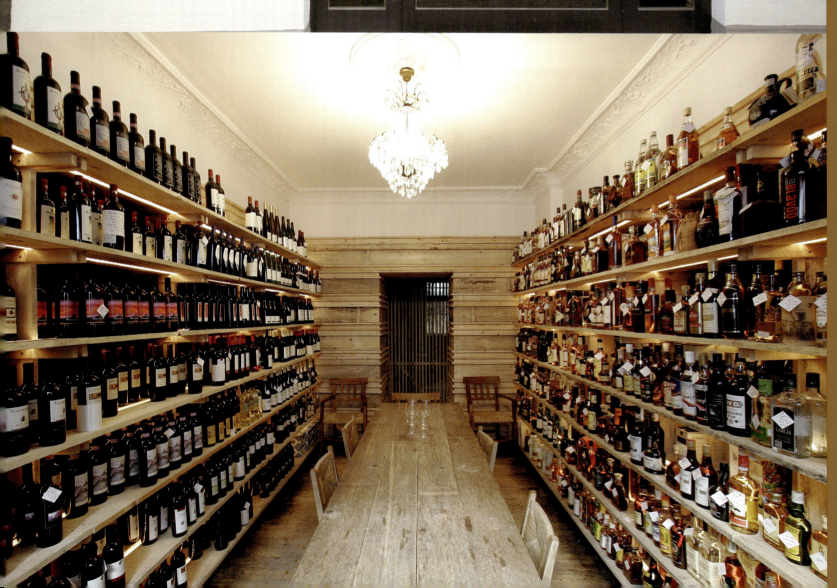

Shops

Villa Harteneck

Douglasstraße 9, 14193 Berlin
☎ +49 30 89 72 78 90
www.villa-harteneck.de
Ⓢ Grunewald

An old, grand villa with a terrace and a garden in Grunewald serves as an impressive showroom for furniture, vases, curtains and various objets d'art. It is a rare pleasure to wander through the items on display here. What's more, the proprietors, Frank Stüve and Gisela von Schenk, have succeeded in making this wonderful location a landmark for Berlin society. You can find the most beautiful flowers in all Berlin here!

Open: Mon–Fri 10am–7pm, Sat 10am–6pm.
Interior: The Neoclassical villa was built in 1911 according to plans by Adolf Wollenberg. The impressive rooms are opulently and luxuriously decorated.
X-Factor: The owners also organise private events for their clients, plus galas, product presentations and dinners.

Eine alte, großbürgerliche Villa mit Terrasse und Garten im Grunewald dient heute als beeindruckender Showroom für Möbel, Vasen, Vorhänge und diverse Dekorationsobjekte. Es ist ein Genuss, zwischen den ausgestellten Stücken herumzulaufen. Die Besitzer Frank Stüve und Gisela von Schenk haben es darüber hinaus geschafft, diese wunderbare Location zu einem Fixpunkt der Berliner Gesellschaft zu machen. Und es gibt hier die schönsten Blumen Berlins!

Öffnungszeiten: Mo–Fr 10–19, Sa 10–18 Uhr.
Interieur: Erbaut wurde die neoklassizistische Villa 1911 nach Plänen von Adolf Wollenberg. Die repräsentativen Räume sind opulent und luxuriös eingerichtet.
X-Faktor: Die Besitzer organisieren auch private Events für Kunden und veranstalten Galas, Produktpräsentationen sowie Dinner.

À Grunewald, une ancienne villa bourgeoise avec terrasse et jardin sert de nos jours de showroom pour des meubles, vases, rideaux et divers objets de décoration. C'est un vrai plaisir de déambuler entre les pièces exposées. Les propriétaires Frank Stüve et Gisela von Schenk ont en outre réussi à faire de cet endroit magnifique un rendez-vous prisé de la société mondaine de Berlin. Vous y verrez les plus belles fleurs de la capitale !

Horaires d'ouverture : Lun–Ven 10h–19h, Sam 10h–18h.
Décoration intérieure : Cette villa néo-classique a été construite en 1911, d'après les plans d'Adolf Wollenberg. Les salles ont été décorées avec luxe et opulence.
Le « petit plus » : Les propriétaires organisent aussi des réceptions privées, ainsi que des galas, des présentations de produits et des dîners.

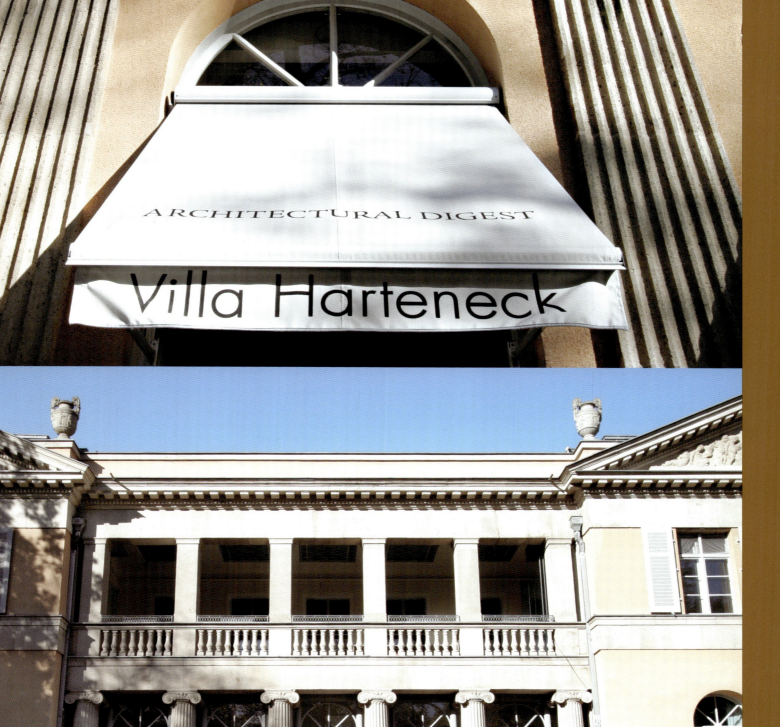

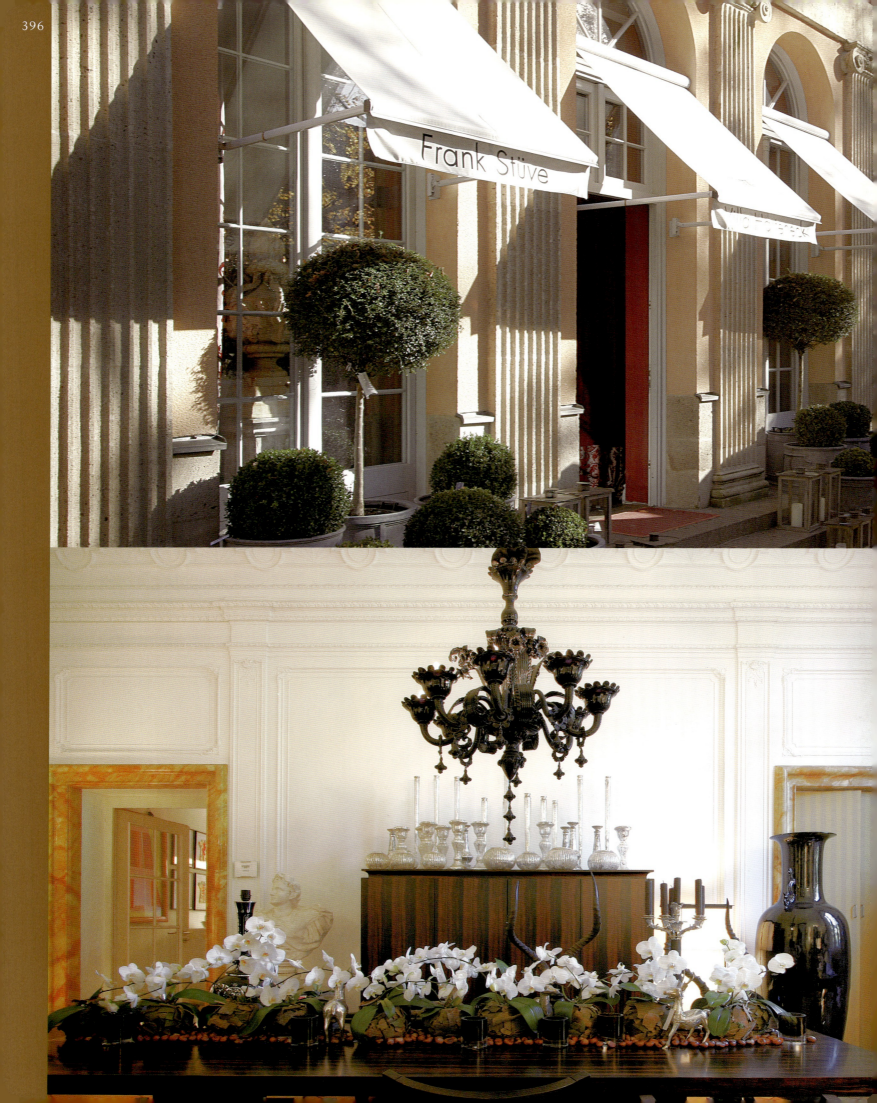

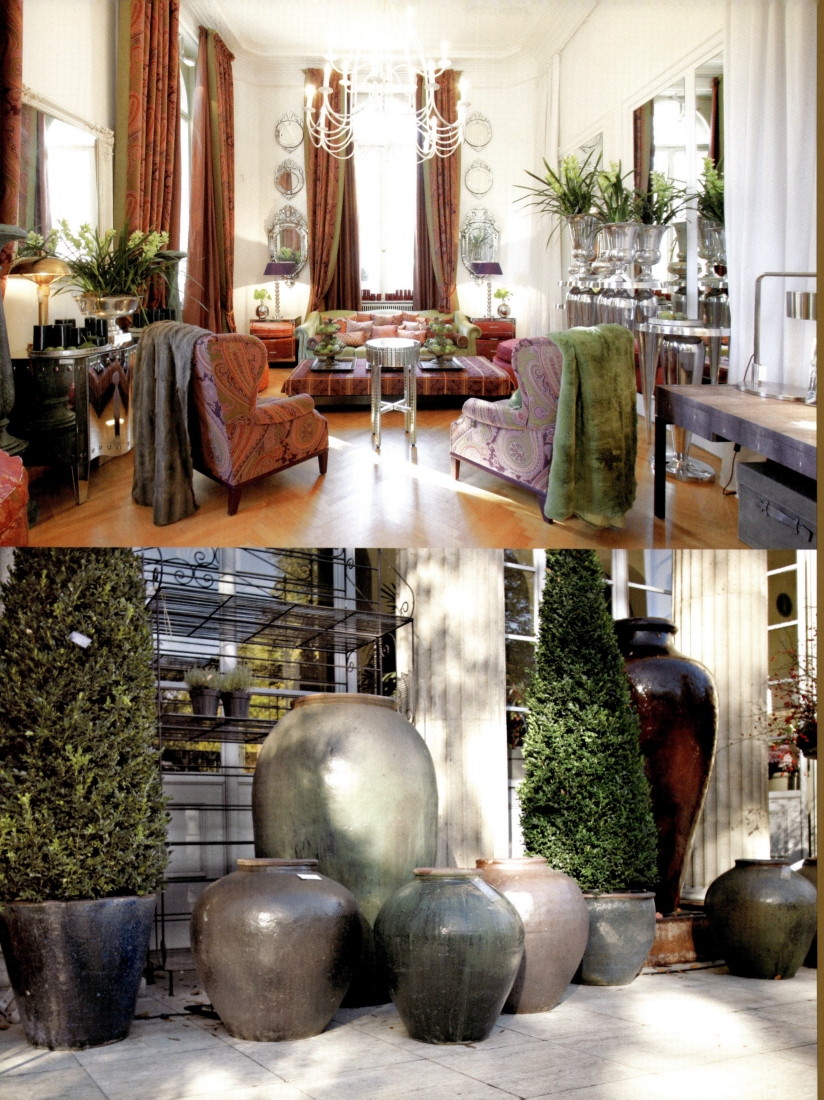

Index | Index | Index

Dolores 232
Edd's 212
Galão A Pastelaria 250
Galerie Bremer 170
Green Door 180
Greenwich 240
Grill Royal 228
Hasir 198
Henne 192
Der Imbiss W 252
Konnopke's Imbiß 262
Kumpelnest 3000 216
Manzini 172
Miseria e Nobiltà 280
Paris Bar 152
Prater Garten 256
Restaurant Schönbrunn 272
Rum Trader 166
Schneeweiß 284
Si An 264
Times Bar 150
Victoria Bar 208
Vox Bar 220
Wohnzimmer 266
Zur letzten Instanz 222

Shops

1. Absinth Depot Berlin 344
Adidas Originals Store 354
Andreas Murkudis 350
Bless Shop 366
Blush & Balls 358
Bücherbogen am Savignyplatz 302

Buffalo 362
Chocolatier Erich Hamann 296
The Corner Berlin 340
Departmentstore Quartier 206 330
DIM 322
Emma & Co. 306
Erzgebirgskunst Original 374
Fundusverkauf 334
Galerie Hans-Peter Jochum 310
Harry Lehmann 314
in't Veld Schokoladen 386
Jil Sander 294
Jünemann's Pantoffeleck 378
KPM 338
Lebensmittel in Mitte 356
Manufactum 300
Paul Knopf 318
R.S.V.P. Papier in Mitte 370
Santi & Spiriti 390
Schönhauser Design 348
Steiff 312
TASCHEN 326
Thomas Wild Teppich- & Textilkunst 376
Villa Harteneck 394
Wochenmarkt am Kollwitzplatz 382

Imprint | Impressum | Imprint

© 2010 TASCHEN GmbH
Hohenzollernring 53, D-50672 Köln
www.taschen.com

Compiled, Edited, Written & Layout by
Angelika Taschen, Berlin

General Project Manager
Stephanie Paas, Cologne

Illustrations
Olaf Hajek, www.olafhajek.com

Maps
Julia Pfaller, Berlin

Graphic Design
Eggers + Diaper, Berlin

Lithograph Manager
Thomas Grell, Cologne

German Text Editing
Christiane Reiter, Hamburg

French Translation
Thérèse Chatelain-Südkamp, Cologne
Cécile Carrion, Cologne

English Translation
Kate Chapman, Berlin
Pauline Cumbers, Frankfurt am Main

Printed in China
ISBN 978-3-8365-1120-9

The published information, addresses and pictures have been researched with the greatest of care. However, no responsibility or liability can be taken for the correctness of the details. The information may be out of date due to current changes, which have not yet been incorporated. Please refer to the relevant websites for current prices and details.

Die veröffentlichten Informationen, Adressen und Bilder sind mit größter Sorgfalt recherchiert. Dennoch kann für die Richtigkeit keine Gewähr oder Haftung übernommen werden. Die Informationen können durch aktuelle Entwicklungen überholt sein, ohne dass die bereitgestellten Informationen geändert wurden. Bitte entnehmen Sie den jeweiligen Websites die aktuellen Preise und Angaben.

Bien que nous ayons recherché avec soin les informations, les adresses et les photos de cet ouvrage, nous déclinons toute responsabilité. Il est possible en effet que les données mises à notre disposition ne soient plus à jour. Veuillez vous reporter aux différents sites web pour obtenir les prix et les renseignements actuels.

To stay informed about upcoming TASCHEN titles, please request our magazine at www.taschen.com/magazine or write to TASCHEN, Hohenzollernring 53, D-50672 Cologne, Germany; contact@taschen.com; Fax: +49-221-254919. We will be happy to send you a free copy of our magazine which is filled with information about all of our books.